# A Snake's Tail full of Ants

D1344971

With magnificent zeal, artists project themselves and a picture of a world to a more and more distracted public that no longer cares what they like or think. In a few countries artists are punished, art is considered dangerous. On the whole, however, art is free, shameless, irresponsible; the movement is intense, almost feverish, like a snake's tail full of ants. The snake is long since dead, eaten, deprived of poison, but the skin is full of meddlesome life.

*Ingmar Bergman*

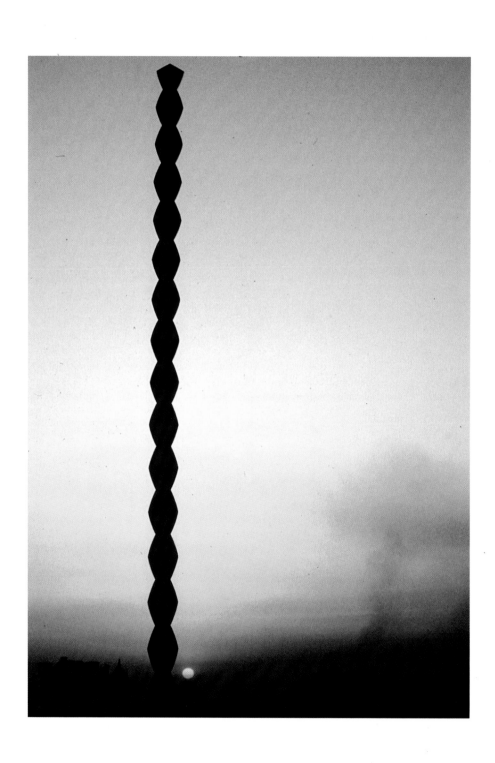

# A SNAKE'S TAIL
# FULL OF ANTS

## ART, ECOLOGY AND CONSCIOUSNESS

JOHN LANE

A RESURGENCE BOOK

A Resurgence Book
published in 1996 by Green Books Ltd
Foxhole, Dartington, Totnes, Devon TQ9 6EB

Cover and book design by The Big Picture, Bristol

Typeset in Sabon and Gill Sans by Chris Fayers, Lower Soldon, Devon

Printed by Biddles Ltd, Guildford, Surrey

Frontispiece: Constantin Brancusi's *Endless Column* (1937-8).
*Cast iron.*  2935 X 122 X 152.5 cm. Public Park, Tîrgu-Jiu, Romania.
Photo Eric Shanes © ADAGP, Paris & DACS, London 1996.

Front cover photograph by Adam Eastland of Puck in
Yukio Ninagawa's production of *A Midsummer Night's Dream*

A catalogue record for this book
is available from The British Library

ISBN 1 870098 65 X

# CONTENTS

# CONTENTS

# ACKNOWLEDGEMENTS

THIS BOOK COULD NOT have been written without the help and encouragement of a number of people, including the authors on whose work I have drawn in writing this book. To acknowledge all these debts would be a daunting task—probably an impossible one—since I am certain I would overlook some of them. I would nonetheless like to express my gratitude to those whose value to this book, whatever its merits, I know to have been substantial: to my editor Lindsay Clarke for his absolute support but crucial suggestions; to John Moat, Brian Nicholson and Ivor Stolliday for their generosity and kindness in reading drafts and proposing improvements. I am also indebted to Ilya Shoot for help with the musical references and Jon Allen for his contribution to the architectural section in chapter six and those who responded to my call for photographs. Finally, I would like to thank Maurice Ash for his generosity and also Satish Kumar, Kathleen Raine and John Elford for other kinds of support.

# TWO EXPLANATIONS ABOUT WORDS

I BEGAN THIS BOOK with the intention of acknowledging both the male and female genders in equal measure. I paired 'man' with 'woman' and 'he' with 'she' until the sheer clumsiness of it discouraged further usage. I also tried 's/he' and 'hir'. Correct this may be, but aesthetically dire. For the sake of readability I have therefore thrown my best intentions to the winds and largely adopted the male form. But the terms 'he', 'man' and 'mankind' should never for one moment be taken to infer the superiority of the male of the species over the female. They are intended as a generic description of humanity as a whole. The entire thrust of the book should make this abundantly clear.

The word 'art' presented further difficulties. If there were a better word I should have used it, but lacking a more exact term I have to speak of creative activity within the vernacular and traditional societies as art. According to one of my dictionaries, the word means 'human skill as opposed to nature'. I have therefore used the word to describe not only painting and sculpture, music and drama, architecture and poetic utterance, but also all the crafts including gardening and child-rearing. In Indian culture, as in other traditional cultures, there is no such thing as 'art' in the reified sense of the word; 'art' is specifically in the service of, or incorporated into, a ritual context. It is directly a part of the religious life of the country, and the religious life of the country is a seamless totality which incorporates every aspect of existence.

In contrast, the post-Renaissance concept of Art is laden with assumptions for which there are no non-Humanist equivalents. The concept carries overtones of aesthetics, self-directed professionalism, self-consciousness and Art for Art's sake. Whereas art (with a small 'a') is closely interwoven with the activities of everyday life, Art (with a capital 'A') is characterised by loftiness and unapproachability. I refer to those imbued by these concepts as Artists; those unaffected by the Humanist world-view I call artists, with a lower case 'a'.

For Truda, with love

Sensate Western culture and society are given a categoric ultimatum: either persist on the road to over-ripe sensate culture and go to ruin, to a life uncreative, devoid of any genius, painful and inglorious; or shift, while there is still a possibility of doing so, to another road of ideational or idealistic culture. In the same dilemma, the ideational and idealistic culture of the Middle Ages, when it became exhausted of its God-given creativeness, shifted then to the road of sensate culture, with the result that Western society continued magnificently in its creative mission for five centuries. At the present time this road has brought it to a blind alley of exhaustion of the sensate creative forces. The salvation again lies in a shift to another form of culture.

*Pitirim Sorokin*

Once men sat under grinding tyrannies, amid violence and fear so great, that nowadays we wonder how they lived through twenty four hours of it, till we remember that then, as now, their daily labour was the main part of their lives, and that their daily labour was sweetened by the daily Creation of art; and shall we who are delivered from the evils they bore, live drearier lives than they did? Shall men, who have come forth from so many tyrannies, bind themselves to yet another day upon day of hopeless, useless toil? Must this go on worsening till it comes to this last – that the world shall have come into its inheritance, and with all foes conquered and nought to bind it, shall choose to sit down and labour for ever amidst grim ugliness? How, then, were all our hopes cheated, what a gulf of despair should we tumble into then?

In truth it cannot be; yet if that sickness of repulsion to the arts were to go on hopelessly, nought else would be, and the extinction of the love of beauty and imagination would prove to be the extinction of civilisation. But that sickness the world will one day throw off, yet will, I believe, pass through many pains in so doing, some of which will look very like the death throes of Art.

*William Morris*

Yet when life is reduced to its barest essentials, art and poetry turn out to be among those essentials. In Eskimo, the word 'to make poetry' is the word 'to breathe'; both are derivatives of anerca – the soul, that which is eternal: the breath of life. A poem is words infused with breath or spirit.

*Edmund Carpenter*

What is creativity but another name for spirit?

*Ken Wilber*

# INTRODUCTION

*The crisis itself is not first of all an ecological crisis. It is not first of all a crisis concerning our environment. It is first of all a crisis concerning the way we think. We are treating our planet in an inhuman, god-forsaken manner because we see things in an inhuman, god-forsaken way. And we see things in this way because that basically is how we see ourselves.*

Philip Sherrard[1]

HUMANISM, that singularly European consciousness of man's power and glory, has had a long run: half a millennium. First in Europe, then in North America, now in almost every country of the world, it has transformed rural life, mechanised labour, caused great cities to be built and, as this book explores, created an exclusive reserve or ghetto which we call Art. Humanism believes that humans are entitled to full dominion over nature. It believes that man (especially the white man) has some God-given right to all that is around him, that he has been created superior to the rest. Its product, industrialism, now permeates the dominant societies across the globe.

On the table where I write there is a dictionary—the Collins New English. It is illustrated by what were some of Humanism's greatest achievements; the Avro Vulcan B1 bomber, a drilling platform off the coast of Trinidad and the skyscrapers of Lower Manhattan. It was printed in 1956, the year in which Shostakovich's eleventh symphony was first performed and Patrick White published *Voss*. My father, whose book it was, died in its editor's belief that we are living in the best of all possible worlds.

His son sees differently. He sees Humanist triumphalism—the history of the European ascendancy—drowned in blood, indignity and injustice. He sees how the basic framework of modern social goals—maximum economic growth generated by maximised corporate profit, fuelled by mass production, fuelled by mass consumerism—is inducing a culture of mindless frivolity, addiction and passivity. He sees the breakdown of social networks and families that held civil society together and the degradation of our planetary environment worsening annually. He also sees the convulsive desacralisation of the spirit of the West and the abortions, mockery and decadence of its contemporary Art itself a simulacrum

of the most private recesses of our souls.

Humanism has fulfilled its promise of universal material prosperity, but to do so it has sacrificed a great deal. Clean air and undisturbed wilderness, for a start, but also the loss of cultured landscapes, human skills, species and communities, environmental and human health and priceless natural resources. But the inner consequences of our society's narcissistic definition of prosperity, including the subjugation of the majority's creative needs, are a no less important feature of the price that continues to be exacted. The number of people in whom this impulse has been frustrated or denied is large and growing, as is, according to the psychiatrist Anthony Stevens, the psychiatric problem this denial represents.[2] This may go some way to explaining something of the deep and abiding lack of authenticity that people sometimes feel about their lives, a quality of having lost part of themselves.

One of the most remarkable men of our time, the Swiss psychologist Carl Gustav Jung, reported that the people who came to consult him were not, on the whole, suffering from disorders susceptible to neat clinical diagnosis; they were suffering from the aimlessness and futility of their lives.[3] Jung, who came to regard this feature as a malaise typical of the twentieth century—he called it 'the general neurosis of our age'—had no hesitation in attributing the problem to the emergence of a society which alienated its members from their million-year-old archetypal natures. Our current alienation from the artist in ourselves is, I believe, an aspect of this problem. It puts at risk more than our mental health and emotional well-being: it puts in jeopardy our whole culture and, quite possibly, our species. Care of our imagination is integral to our survival as a civilisation.

Having disclosed at least one of the concerns of this book, it is time to express some of the problems attendant on its production. In tracing the origin of the modern deviation from the end of the Middle Ages, the rise and fall of Humanism and the emergence of another civilisational phase, I have often been obliged to over-simplify the rich and subtle contraries on which all life is based, and address areas which are not my specialism. Whatever its failings, I have written this book as much out of a concern for the current crisis of the Arts as a desire to explore the possibilities of an art appropriate to the emerging world-view. It is therefore my hope that if only because the reader like me is searching for the awakening of a sense of the sacred, is attempting to develop the capacities

of soul required for this present age of change and instability, is longing to be free of the mental manacles forged by the rational philosophers and the materialist scientists, that he or she will be able to forgive any noticeable transgressions.

Over the last three or four decades there is evidence of a sea-change in Western consciousness and this, as fundamental as those marked by Socrates, by Augustine, by the Renaissance, by Descartes, will surely have a substantial and widespread affect upon the nature of imaginative work. In these pages I will attempt to trace the history and characteristics of Humanism and the Humanist Arts—to explain why they arose, what they were intended to do, their achievement and their shadow. But I will also explore the creative and imaginative possibilities, ramifications and extensions that exist for the cultural revolution that is unfolding. We need to create new perspectives and visions. We need to repair the damage to the external world and renew our inner selves. The time has also come to attempt a new art.

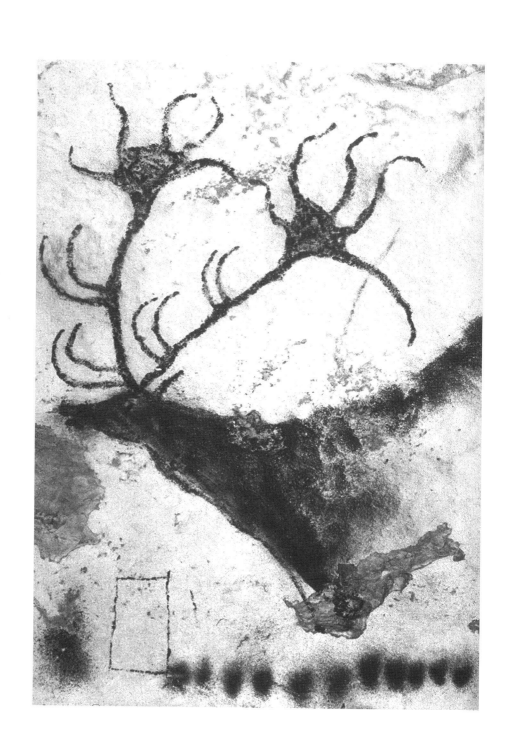

CHAPTER ONE

# THE MYTHIC VISION:
## CULTURE OUTSIDE TIME

*A well-ordered humanism does not begin with itself, but puts things back in their place. It puts the world before life, life before man, and respect for others before love of self. This is the lesson that the people we call 'savages' teach us: a lesson in modesty, decency and discretion in the face of a world that preceded our species and that will survive it.*

Claude Levi-Strauss[1]

UNTIL RECENTLY it was thought that the earliest evidence of human life to bear the imprint of aesthetic intention had occurred only in the last fifty thousand years, but according to Desmond Morris, an object discovered on the Golan Heights has pushed the beginnings of the creative human act back to three hundred thousand years.[2] The newly found sculptural object, the most ancient man-made image in the world, is a small stone figurine of a woman—probably a goddess. It is a crude thing, but the head is clearly separated from the body by an incised neck, and the arms are indicated by two vertical grooves apparently cut by a sharp flint tool. It is a discovery that establishes the antiquity of that human fascination with symbolic images which distinguishes us from other successful species.

Further and more substantial evidence of the importance of symbolic images is to be found in France and Spain. Along the great limestone valleys of the Dordogne and in the foothills of the Pyrenees, the cliffs are riddled with caves and almost every one shows some signs of ancient habitation. From the objects that have been found in them—bone needles and sinew to sew clothes of skin and fur, and carefully carved multi-barbed bone harpoons for catching fish—we now know a great deal about these people who lived some 35,000 years ago; even that they spoke a language that was fluent and complex.

Plate 1. Cave painting; Running Stag. c15,000 BC.
Lascaux, France.

It is in some of the most remote parts of these caves, sometimes in passages and chambers that could only have been reached after hours of crawling, that early man painted designs on the walls. Amongst the most memorable of these are the famous interlacing ribbon-like lines on the walls at Altimira in Northern Spain which date from about thirty thousand years ago. In other caves and at more recent dates—at Les Roc de Sers, Les Trois Frères (where there are over 500 images of animals), Lascaux, Altamira, Pech-Merle and elsewhere—further magnificent and amazing paintings have been discovered and many more probably remain to be found. There are no landscapes and only very rarely human beings. Scattered among the animals, there are abstract designs—parallel lines, squares, grids and rows of dots, curves that have been interpreted as female genitalia, chevrons that might be arrows.

Even now, though speculation abounds, we do not know why these ancient people painted; but the general consensus is that they served the purposes of power. 'These prehistoric caves are cult places,' writes Herbert Kühn in his book *The Rock Pictures of Europe*, 'comparable in their essence with the rock-cut temples of Ellora or Ajanta in India... Magic and wizardry had their holy places in the Ice Age, places where beasts were enchanted and by supernatural means brought under the power of man. In the same cave of Les Trois Frères, there are other pictures of shamans or magicians. One of these wears upon his shoulders a bear's pelt and is playing a flute. So we may gather that music, of some sort, was used in the ceremonies of the Palaeolithic cults. Also in this cavern is the engraving of a naked man disguised in a bison's mask. He is also shown dancing. The bent upper part of the body, the flexed knees, the outstretched arms, the leg held high all remind us of some of the cult dances performed to this day by African, Amerindian and Asiatic tribes.'[3]

It bears repeating that the sacramental cave paintings of the Lower Palaeolithic and Neolithic cultures are in all probability the longest uninterrupted tradition of 'art' to have existed. The most ancient of the paintings is thought to be about 30,000 years old; the youngest may be 10,000. The interval between these dates is about six times the length of the entire history of Western civilisation.

A later, but extensive phase of human development, lasting for a shorter period than the Palaeolithic—Neolithic culture—begins about 9,000 BC and ends with the inception of an archaic form of state organisation, or civilisation, *circa*

5,000 BC in the Middle East, but widely varying in time around the world. These archaic societies embrace people who are 'primitive', who are in transition from 'primitive' to peasant status or who have been converted to fully-fledged peasants, culturally influenced by, and economically dependent upon, market centres. The vast majority of the world's population has always lived—and still live—in one or other of these forms of society and on land masses outside modern Europe. The estimated number of indigenous people—those, that is, who have continued their way of living for thousands of years according to their original instructions—is about five hundred million.

It is as well to remember the significance of the facts I have related. Mankind has practised symbolism and decoration for at least three hundred thousand years and even the most cursory glimpse of the scale of the world's land mass will reveal the relatively tiny area which we inhabit. Thus the Western contribution has been both briefer and less widespread than formerly supposed. The narrative of our Art as the unchallenged norm of human artistic expression, the highest pinnacle of human achievement, is also surely no less a fiction than the pre-eminence once ascribed by European males to their own societies. Even a cursory study of the art of the vernacular (or so-called 'primitive' and 'tribal') cultures and the developed traditional civilisations such as India and China, will reveal a world of creation, natural diversity and compelling refinement.

This is something only very recently possible. For almost five hundred years since Columbus's landfall in the Bahamas it was an assumption of European rule that the subject peoples were at an inferior level of development; Western art historians, collectors and critics ignored or despised their art and consigned it to museums of natural history or regarded it as a study fit only for anthropologists, ethnographers and even zoologists.

Nineteenth century attitudes to non-European painting, sculpture and architecture were consistently contemptuous. 'In the field of art,' wrote E. F. Howard, a nineteenth-century colonial British education officer, 'an African is not capable of reaching even a moderate degree of proficiency.' The great nineteenth-century art critic and champion of Turner, John Ruskin (1819-1900), considered Indian art 'in great part diseased and frightful' while Fergusson, whose study of Indian architecture was an important work, warned his readers that 'it cannot, of course, be for one moment considered that India ever reached the intellectual supremacy of Greece or the moral greatness of Rome.' B. G. Baden-Powell also

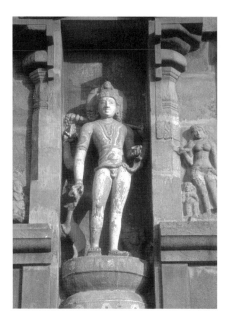

Plate 2. Figure of Shiva c1010, *stone.*
Brihadishvara Temple, Thanjavur, Southern India. photo: John Lane.

warned that 'in a country like India we must not expect to find anything that appeals to mind or deep feeling.' At much the same time the official handbook to the Indian section of the Victoria and Albert Museum stated that 'sculpture and painting are unknown, as fine arts, in India... Nowhere does their figure-sculpture show the inspiration of true art. They seem to have no feeling for it...'

Today, of course, we are more guarded and even wiser. Yet as recently as 1950, the distinguished art historian E. H. Gombrich devoted only 26 pages out of 469 to the arts of the non-European societies and civilisations in his classic *The Story of Art.*[4]

## THE UNIVERSALITY OF PLAY &
## THE IMPORTANCE OF THE CREATIVE IMAGINATION

*You and I have intrinsically the capacity to be happy, to be creative, to be in touch with something that is beyond the clutches of time. Creative happiness is*

*not a gift that is reserved for the few... Creative happiness is for all and not for the few alone. You may express it in one way and I in another, but it is for all.*

<div align="right">Krishnamurti[5]</div>

However economically impoverished, however technologically primitive, however 'backward' in every other respect, human societies have always fulfilled through some form of expression the underlying biological proclivity for creative play.

Homo sapiens is indeed Homo ludens, as described by the Dutch historian Johan Huizinga (1872-1945) in his book *Homo Ludens: A Study of the Play Element in Culture*, in which he argues that 'pure play is one of the main bases of civilisation.'[6] In her book *Homo Aestheticus: Where Art comes From and Why*, Ellen Dissanayake goes further. She regards art as being as normal and natural in human evolution as the use of language or tools. She argues that human beings universally display a unique propensity for aesthetic behaviour. She insists that everyone is an artist, that art-making is practised by everyone in pre-modern cultures. 'Only a few societies have thought of it even remotely as we do,' she says. 'In traditional societies, "art for life's sake," not "art for art's sake," is the rule.' There is no lack of evidence of this statement, which is one of the presuppositions of this book.[7]

In *The Lost World of the Kalahari* the writer and explorer Laurens van der Post has described one of the most 'primitive' communities on earth, and has done so with an enviable compassion and respect. 'Their arrows, spears, skins, ropes and snares,' he writes, 'were not merely functional but beautifully marked in a manner which showed that they were also an image of the spirit. The older women, in their spare moments, made beads out of broken ostrich shells and strung them into necklaces or the broad shining bands which they wore around their heads for ceremonial occasions. Hour after hour they would sit chipping nimbly and delicately with the sharp end of a springbuck ram's bone at a fragment of shell in order to produce one little round white disk from the brittle and fragile raw material...'[8]

Later, in the same book the author describes their music-making:

Sometimes the women would sit together beside their shelters, in the long level light of the evening sun, their beads and necklaces like gold upon them. Each would hold

a handful of long dry grass and they would all sing together, beating time with the grass, and stroking the stems with the tips of their fingers like the strings of a guitar. The melody was charged with all the inexpressible feelings that come to one at the going down of the sun over the great earth of Africa. They called the song the 'Grass Song' and with the difficulty of interpretation neither Dabe nor the singers could readily explain it. I can only recall the feeling and render the words inadequately:

> This grass in my hand before it was cut
> Cried in the wind for the rain to come:
> All day my heart cries in the sun
> For my hunter to come.

They would sing this over and over again, the song becoming more charged and meaningful by repetition... We concluded music was as vital as water, food and fire to them for we never found a group so poor or desperate that they did not have some musical instrument with them. And all their music, song, sense of rhythm and move-ment, achieved the greatest expression in their dancing. They passed their days with purpose and energy, but dancing, too, played the same deep part of their lives, as attributed to the Bushmen of old in legend and history.

That the aesthetic and expressive dimension can flower so richly in conditions which are by our own standards so deeply uncongenial, is illustrated by another example, one out of hundreds of thousands. In an essay about the Pygmies of the Congo, Denise Paulme writes:

> This capacity to recognise and to appreciate what one must call beauty has long been denied to the pygmies of the Congo forest—to cite only one example: it was alleged that their ceaseless wanderings did not allow them this luxury. It was only after the first sound recordings in the field that we came to realise that they had not only an admirable music but also that they had a feeling for ritual which made a return from the hunt the equivalent of a great musical drama, whose several movements follow and balance one another in an ever-growing crescendo which culminates in a final apotheosis.[9]

In contrast to the significance of these kinds of experience to the peoples of the

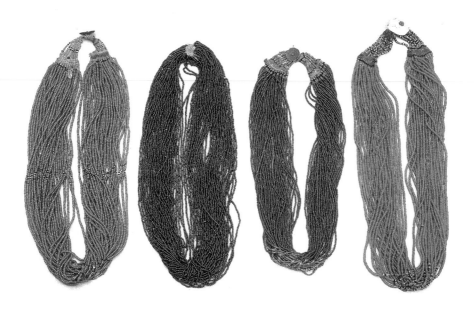

Plate 3. Naga Bead Necklaces.
Contemporary. Northeast India.

Palaeolithic ages, the Pygmies and Bushmen of Africa, ritual and creativity in our society are no longer important. Cut off from the concerns of ordinary life, reduced to a matter of individual appreciation rather than a matter of communal experience, Art has been relegated to the status of a dispensable luxury, not important to human life in the way that food, breath and shelter are to the peoples of the vernacular societies. Such an attitude towards our propensity for aesthetic behaviour has caused and is causing, I suggest, not only considerable personal and social distress but widespread aesthetic blight. When all is said and done, the average Westerner inhabits a world that is uglier than any that has previously existed and is himself less creative than the most materially impoverished tribesman.

Take an example: in the remote Naga lands, where about half a million people live in the extremely steep, rugged terrain of the Assam region of northeastern India, the people enjoy a simple level of existence and a vibrant material culture

and make bead necklaces and body cloths of an extraordinary refinement.[10] In the West only our finest craftsmen could match the level of their accomplishment; amongst the Nagas, although specialists exist, most production is the concern of the household group, which produces its own needs. Yet how many household groups resident in London or New York, enjoying levels of affluence, amounts of time and access to resources incomparably greater than those available to the Peoples of the Hills, create jewellery for their own use? How often are they able to make their own clothing? How many domestic artifacts have they ever made? When did they make music for themselves? How often have they become involved in rituals or creative celebrations of any kind? For the vast majority the answer must be none and never.

How can we then reactivate the dormant powers of our imagination? How can we hatch the unhatched abundance inside us that we ourselves have not prepared? How can we shift our gaze, alter the focus of our attention, and step forward as artists in our own right? A first step towards a rehabilitation of this kind could be the unlearning of much that is now subsumed under the Humanist concept of Art. To liberate ourselves from the shackles of false presuppositions it may be helpful to consider the arts of cultures with aesthetics different from our own. Yet in no sense are these 'arts' to the people who make them; I use the word here as a shorthand expression for a whole range of activities with many different purposes.

## 'MY ANCESTORS HAD NO WORD FOR ART: IT WAS ALL-PERVASIVE'

It is extremely difficult for us to understand that (what we describe as) Art has, as such, no place in the traditional and vernacular cultures. In mediaeval Europe, a Gothic cathedral—or in nineteenth century Tanzania, a high-backed Nyamwezi Chief's stool—would not have been created with exclusively aesthetic ends in mind; they originated in a desire to serve religious, social or practical functions that were, by our standards, non-aesthetic. Just as today we would judge a garden fork or a kitchen whisk by their capacity to fulfil a certain function, so in their time and place the cathedral and the high-backed stool would have been assessed by their exclusive ability to achieve their different functions. For those who made them there must have been, of course, an undoubted element

of personal satisfaction, but their purpose lay entirely elsewhere: in their ability to express devotion, to express hierarchy and otherwise fortify the harmonious functioning of their society's metaphysical order.

The sense of personal achievement valued by Humanism has no meaning to the Nyamwezi people; nor, according to Edmund Carpenter, an authority on Inuit culture and society, to the Inuit. 'No word meaning "art" occurs in Eskimo,' he says, 'nor does "artist": there are only people. Nor is any distinction made between utilitarian and decorative objects. The Eskimo simply says, "A man should do all things properly." '[11] Another difference between their concept of creativity and our own is that the Inuit language does not possesses any 'real equivalents to our words "create" or "make", which presuppose imposition of the self.'

The same is true of other cultures. 'In pre-European days,' the contemporary Maori artist John Bevan Ford says, 'my ancestors had no word for art; it was all-pervasive.'[12] The Sanskrit language also possesses no equivalent for the word as it is used in the modern European languages. In fact the Indian word for art, *shilpa*, embraces a wide range of activities that include not only what in the West would be called crafts, but also ritual and such skills as cooking, perfumery, love-making, and engineering. Only recently (and solely in urban centres) has the word been reinterpreted in the modern Western sense of Art for Art's sake. Nor is there an old word in most of the thousand or so languages that are still spoken in Africa that well translates as 'Art'. In Bali, too, boasting one of the richest expressive traditions of the human race, there is no word to describe those activities for which the peoples of Europe and North America have developed not only an expansive vocabulary, but an impressive tradition of philosophical, moral and critical literature. Among the latter, appreciation of an 'artwork' invariably involves developing an awareness of its place within a tradition of influence and innovation among other artworks; in Bali, learning to appreciate an art involves *participation*: picking up a flute or sitting at a gamelan and playing it in accordance with the time-honoured Balinese tradition.

Surprising as it may seem, there was even no word in the seventeenth-century English language that carried exactly the burden of meaning now attributed to the word 'Art'. The idea of Art as something made for looking at, for appreciation, or for reflecting back to an observer the glory of his human condition, was almost foreign.

The ways of thinking about it to which we have subsequently become accustomed only began to take something of their modern shape during the European Renaissance and Enlightenment. These include a distinction between the fine and decorative arts, an understanding that Art (produced by Artists) exists solely for its own sake, that it must confront people with an alternative view of the world to that which their society conforms and that it must be assessed in the manner we call 'aesthetic'. Nonetheless, not every feature of this conception is new. A passion for beauty has always characterised even the most materially impoverished of the pre-industrialised peoples, including the Pygmies of the Congo, the Nyamwezi and, as we shall see, the Rabaris.

## THE UBIQUITY OF IMAGINATIVE EXPRESSION:
## RABARI EMBROIDERY, MUSIC MAKING & DANCING IN AFRICA

The Rabaris of Northern India are recognised by their extraordinary capacity for survival and adaptation in the arid regions of Gujarat and Rajasthan.[13] Originally, Rabaris were camel herders, and some families still subsist by herding camels but others survive by herding sheep for wool, or goats, cows or buffalo for milk. If possible, herders move near their own villages and return by night, but many may be obliged to wander with their herds, returning home at least once a year. Their villages are well kept and clean, but the interior of their houses—which are normally of two rooms—are especially orderly and cared for.

In fact the Rabari women are renowned for the creative genius that they apply to every aspect of their domestic world: they arrange their brass pots, always shining, in order of size to create beautiful designs; they mould clay images of the goddesses and toys for their children; they decorate the backs of their hands, the arms, the neck, the feet, with tattoos; they decorate the storage niches, cupboards and chests, even whole walls of their simple houses, with white-painted, elaborately decorated, mud-formed sculpted bas-relief patterns glittering with inlaid mirrors. The exteriors of their houses are also decorated with abstract symbolic designs and a highly sophisticated employment of sumptuous colour washes.

But the handiwork for which the Rabari women are most renowned are their embroidered garments, bags, household decorations and animal trappings. Some

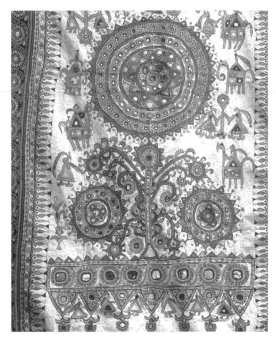

Plate 4. Embroidered Wall-hanging, Contemporary.
Saurashtra, Gujarat, Western India.

of these emphasise particular customs. Others preserve the Rabari memory of their origins as desert-dwelling camel herders. Yet others are employed for ceremonial use. Rabari grooms, for example, wear elaborately embroidered long *adan* jackets and *chorani* pants; the brides wear *ghaggharo* skirts. As with verbal language, the elements of this medium are manipulated according to rules. The style is understood as an entity and used by all members of the community in the same way.

To this profusion of expression can be added the music and dancing engendered not only by the great collective moments of the year's full cycle of festivals and rites but by the passages of birth, death and marriage. For some of the Rabari clans, marriages are held collectively on the feast day of the goddess. Preparations begin a week beforehand; houses are decorated with leafy branches while an intricately embroidered *torana*, symbolising respect for the divinity and welcome to the guests, is hung over the door-frame. Women sing propitiatory

songs and prepare food in huge brass cauldrons. A wedding is followed by the traditional five days of festivities. 'Artistic expression in the Indian village festival,' writes Richard Lannoy, 'is ecstatic in character. The Hindu festival, with its oracles who fall into a state of possession, its orgiastic trance dances and collective rapture, is in the deepest sense a restoration of collective unity.'

But embroidery is not, of course, the only form of creative expression practised by indigenous societies throughout the world. Throughout Africa it is music and dance rather than handiwork which is enjoyed and practised with skill and enthusiasm, ubiquitously. Music and dance are integral to their religion, the success of their crops, the health of their families and the harmony of their villages. Every act is a celebration of life, and that celebration is itself the expression of their religion. In Africa, as John Miller Chernoff writes, music accompanies a huge variety of daily activities:

> Ashanti children sing special songs to cure a bed-wetter; in the Republic of Benin there are special songs sung when a child cuts its first teeth; among the Hausas of Nigeria, young people pay musicians to compose songs to help them court lovers or insult rivals; men working in the fields consider it essential to appoint some of their number to work by making music instead of putting their hands to the hoe; among the Hutus, men paddling a canoe will sing a different song depending on whether they are going with or against the current... Compared with Western societies, African societies have many more people who participate in making music, and they do so within specific groups and specific situations...
>
> The rich repertoire of music in many African cultures, in focusing people's activities on many specific occasions, speaks of a concern to develop a means of recognising the important moments of an individual's life and referring them to a common tradition. This quality music shares with myths, proverbs, and folklore. Moreover, as a group activity, music is a means for tradition itself to be organised and communicated.[14]

African music is never an élitist, artistic or tangential concern; it is a real, formidable and permanent aspect of millions of lives. So much so, in fact, that even when people are unable to play a musical instrument they can, and often do, join in the music by clapping their hands, wholeheartedly and often with remarkable skill.

Alongside music-making, dance and its accompanying symbolic representa-

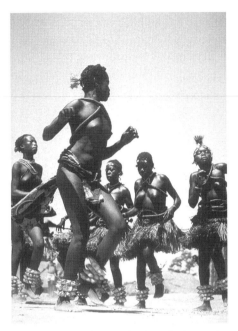

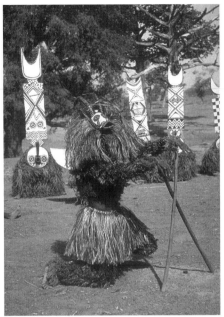

Plate 5. Dance of young Banda girls during the Gaza initiation rite, Central African Republic. photo: Michel Huet.

Plate 6. Dances of the Doyo masks at Houndé, The Kurumba (Nioniosi). Western Dry Savanna and S. Sahel. photo: Michel Huet.

tions may well be regarded, in all its varieties, as the distinctive and typical feature of Black African culture.

Yet again the dance is never simply performed for its own sake. It is never a show performed by trained professionals for a paying audience, but a method which gives back the natural energy, the vital force, to a community which, in turn, distributes it among its members. It is the dance that sets off the process of elucidating, perpetuating and transferring knowledge; it is the dance which gives the community a framework of common experience; it is the dance which legitimises the social and religious codes that must be respected and obeyed. Leopold Senghor, the poet, philosopher and former president of Senegal, has said that the goal of all religious ceremonies, all rituals and indeed all artistic endeavour in Africa is 'to increase the stock of vital force'.

A further difference between the African and modern Western societies is the degree of specialist training and accomplishment to be found in each. In Africa,

dance, the language of the body, is as universal as the language of the tongue. The contemporary European Artist must take responsibility for the invention of his own unique language.

## 'ART' AS AN ELEMENT IN A COMPLEX PATTERN
## OF NEEDS AND EXPECTATIONS

Rabari embroidery and African dance are then not luxuries but intrinsic to the meaning of life. Their motifs not only symbolise shared values but reinforce underlying metaphysical beliefs. In indigenous cultures this interweaving of what we call 'Art' and the recurrent events of everyday life are taken so much for granted that the way a man decorates his house door, waters his cattle, says his morning prayer, greets a guest, cares for his ailing wife and recites a poem after eating, are but acts reflective of an undivided vision of the different processes of life. The peoples of the vernacular societies hoe their soil, dance and dress their hair but the dancing is not necessarily more special than the upkeep of the fields. Both are necessary and important for life's proper sustenance.

Thus a Navajo drypainting can be intimately bound up with health and the maintenance of cosmic organisation, while game and dance songs may be as concerned with thanksgiving, the growing of crops and the healing of sickness. For the Navajo drypainting, healing, the cultivation of vegetables and singing are all elements in an interwoven pattern of needs, celebrations and expectations.

Unity of being also found expression in the lives of talented individuals of the undivided cultures. In the eleventh century, the Italian Fulbert studied mathematics, was a skilful practitioner of the liberal arts, was a great teacher, was advisor and tutor to princes and, as Bishop of Chartres, the instigator of its rebuilt cathedral. For its dedication he composed three responses which have consecrated his fame as composer and cantor. In the twelfth century, the Rhineland mystic and abbess Hildegard de Bingen wrote theological works, poetry, music, a play, a book of natural history and a well-observed study of the body and human illness. In the sixteenth century, the lama Tang Tong Gyelpo wrote Buddhist texts but also operas. He also designed bridges and was an eminent physician. People such as these, and others less famous, offered their skills for the benefit of their community or for the purposes of worship and propitiation.

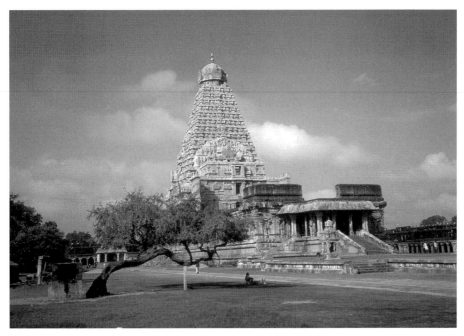

Plate 7. Brihadishvara Temple, c1010.
Thanjavur, Southern India. photo: John Lane.

## THE TIMELESS NATURE OF TRADITION
## IN VERNACULAR SOCIETIES

Another important feature of vernacular society is the way in which the concept of progress—defined by technological advancement and economic growth—has no validity; traditional ways of doing things remain unquestioned for centuries. Deeply steeped in this tradition, versed in its values and eager to be accepted by the group, the carver in wood, the metal-caster or the maker of pottery, the musician or the storyteller, like the farmer (whom he will almost certainly also be), will no more seek to redraw the parameters of possibility in technique and expression, than seek to question inherited social obligations. His work is governed by changeless principles and time-honoured skills oriented towards intangible and permanent truths, transmitting timeless and collective patterns of energies, immutable and eternal.

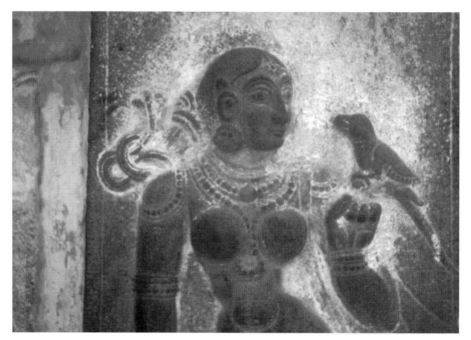

Plate 8. Lady with bird, Vardhamana Temple, 12th century and later.
Kanchipuram, Southern India. photo: John Lane.

Examples are legion. In the Orthodox Church, the icon painter is forbidden to express a transient personal view, but is required to conform to an ensemble of canons laid down to safeguard the purity and continuity of the tradition and its doctrinal unity. Its most famous manual compiled in the seventeenth century, that of the Athonite monk Dionysus of Fourna, was read by generations of monk-artists. Having no concept of speaking from the trivial daily mind, he was trained to work from archetypal models in which the universal ground had been distilled.

A similar spirit prevails within the Hindu tradition, where the design and construction of temples is determined by sacred treatises, the Shastras. The fashioning of the images of gods and goddesses is similarly governed by fixed laws which cannot be broken at the dictates of individual imagination; the Shastras enumerate the various poses, the prescribed proportions and specify the details for each figure. The arts of calligraphy and architecture practised throughout

Islam are likewise governed by the unchanging principles common to sacred art.

It can be argued that tradition limits originality, stifles imagination and leads to soulless repetition, but if that is so, how strange that the world's most memorable artifacts were created under its guidance. Inspired by the dictum of Theophilus—that 'neither for the love of men's praises, nor for the desire of temporal reward... but for the greater honour and glory of the name of God'—the mosaics in S. Vitale in Ravenna; the great mosque, Suleymainye, in Istanbul; the Brihadishvara temple in Thanjavur and the Parthenon in Athens were all constructed. This, too, was the spirit behind the art of Taoist China and Brahmanic India, the Buddhist art of the Far East and the Orthodox icons of Russia, Greece, Salonika, Yugoslavia and Jerusalem.

One of the first to study traditional art, A. K. Coomaraswamy (1877-1947) summarised the differences between it and the art of the modern world in his *Introduction to Indian Art* (1923). Although he is here writing about craftsmanship in one particular culture, his observations possess a broader cultural reference:

In India (art) is a statement of the experience of community in communion, and serves the purpose of life, like daily bread. Indian art has always been produced in response to a demand: that kind of idealism which would glorify the artist who pursues a personal ideal of beauty and strives to express himself, and suffers or perishes for lack of patronage, would appear to Indian thought far more ridiculous or pitiable than heroic.

The modern world, with its glorification of personality, produces works of genius and works of mediocrity following the peculiarities of the individual artists; in India, the virtue or defect of any work is the virtue or defect of that age. The names and peculiarities of individual artists, even if we could recover them, would not enlighten us. To understand at all, we must understand experiences common to all men of the time and place in which a given work was produced.

All Indian art has been produced by professional crafts-persons following traditions handed down in pupillary succession. Originality and novelty are never intentional. Changes in form distinguish the art of one age from that of another, reflect the necessities of current world-view and lifestyle, and not the intention of the genius; changes in quality reflect the varying, but not deliberately varied, changes in psychology, vitality and taste of the community.

What is new arises constantly in Indian tradition without purpose or calculation on the part of the craftsperson, simply because life had remained over long extended periods an immediate experience. Tradition is a living thing, and utterly unlike the copying styles which have replaced tradition in modern life.

No such failure of energy as archaism appears in Indian art before the 20th century.

Indian art has always an intelligible meaning and a definite purpose. An 'art for art's sake', a 'fine' or useless art, if it could have been imagined, would have been regarded as a monstrous product of human vanity. The modern 'fine' or useless arts are unrelated to life and speak of riddles—and hence the impossibility of inculcating a 'love of art' in the people at large.

A community producing great art, however, does so, not by its 'love of art' but by its love of life.[15]

The important thing to remember from Coomaraswamy's writing is that the sculptor, icon-painter or master mason of a traditional society never performs by mechanical rote. The Shastras and manuals—or more likely the time-honoured way of doing things passed on from father to son and from mother to daughter—undoubtedly predetermine the iconography and artistic form of the work in hand but always allow room for personal and spontaneous interpretation. No two temples, no two Buddhas, no two Shivas, no two cathedrals, have ever been the same.

But if this is true it is even more important to understand the place of the artist in the traditional cultures. 'As an individual,' writes Alistair Shearer, 'the artist does not consider himself fundamentally different from, or opposed to, society at large; he is a limb of the body, a cell of the organism, acting as a single entity yet inextricably part of the indivisible and organic whole... Stable in this identity, his role is faithfully to transmit those forms which preserve and continue the inherited structures and beliefs of his society; his brief is conservative not innovative, social as opposed to individual, educative rather than diverting. His concern is not to invent new forms, but to rekindle the vitality latent in the ancient ones. As a mediator of the sacred in daily life, his work is utilitarian rather than entertaining, and this is one reason why there is no division between the craftsman and the artist in traditional societies.'[16]

Yet if the traditional culture produces few named talents, no Bach or

Borromini, no Dante or Whitman, its entire tree is loaded. A comparable rich-
ness characterises the rural cultures whose stories and music have long provided
reassurance and enhancement for unlettered country people. 'Folk-art is the old-
est of the aristocracies of thought,' wrote W.B. Yeats, 'and because it refuses
what is passing and trivial, the merely clever and pretty, as certainly as the vulgar
and insecure, and because it has gathered into itself the simplest and most unfor-
gettable thoughts of the generations, it is the soil where all great art is rooted.'[17]
The *Mahabharata*, the *Odyssey*, the Norse Sagas, *Beowulf*, the *Mabigonian* and
Arthurian cycles, are incomparable evidence of his thesis. So indeed is the vast
repertory of folk song and story treasured, retold, sung and played throughout
the world. For hundreds of millions, learned and unlearned alike, these are not
unimportant but, like the sunrise and the cow, part of the sustenance of life itself.

## THE SACRED NATURE OF TRADITIONAL CULTURE

*The objects of Indians are expressive and not decorative because they are alive,
living in our experience of them. When the Indian potter collects clay, she asks
the consent of the river-bed and sings its praises for having made something as
beautiful as clay. When she fires her pottery, to this day, she still offers songs to
the fire so that it will not discolour or burst her wares. And, finally, when she
paints her pottery, she imprints it with the images that give it life and power—
because for an Indian, pottery is something significant, not just a utility but a
'being' for which there is as much of a natural order as there is for persons or
foxes or trees. So reverent is the Indian conception of the 'power' within things,
especially the objects created by traditional craftspeople, that among many
Indians, the pottery interred with the dead has a small perforation, a 'kill-hole',
made in the centre in order to release the orenda—'the spiritual power'—before
it is buried.*

Jamake Highwater[18]

Another belief upon which this book is based is that humans are, by nature,
open to the modalities of the religious experience and spiritual by nature. At all
times, in all societies and places, the personal self has yearned to be addressed
by something more comprehensive than itself. Sensing the constriction of its

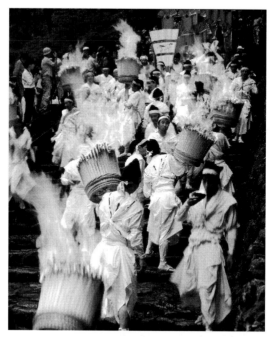

Plate 9. The Nachi-no-Hi Matsui (Fire Festival), Kii Peninsula, Japan. During this event portable shrines (mikoshi) are brought down from the mountain and met by groups bearing flaming torches.

own boundaries, it has longed to be met by a presence opening the gates of potentiality. It has worshipped the gods, it has communed with dreams and visions; it has experienced the wilderness; it has been transported by dancing, music and the other arts; it has fallen in love; it has consumed mind-changing drugs; it has done anything and everything to reach the beyond-self so as to lose itself and merge with the infinite. By walking alone through the great natural scene, by making love, by composing a poem or making music, people have sought to find the food for the greatest of all hungers that flesh and blood can feel.

Our secular culture is aberrant because it has largely limited the search for beyond-self to sex, drugs, the cinema and rock music. Yet to ignore the archetypal dimension is always dangerous. To neglect the sacred is to ignore the animate nature of the land and its creatures; that they have spirit. To ignore the transcendent function is to lose the psyche's means of evolution, through which it moves towards a fuller realisation of its destiny to become whole. To dismiss the value of the sacred is to jettison a vision of our dual nature—microcosm and macrocosm,

temporal and eternal. It is to lose the opportunity to transcend the mundane practices of subsistence, to stay stuck in the personal and the here-and-now. The philosopher Ludwig Wittgenstein (1889-1951), expressed this when he wrote: 'The work of art is the object seen *sub specie aeternitatis;* and the good life is the world seen *sub specie aeternitatis.* This is the connection between art and ethics. The usual way of looking at things sees objects as it were from the midst of them; the view *sub specie aeternitatis* sees them from outside, in such a way that they have the whole world as background.'[19]

This, as Wittgenstein knew, has been the view informing every vernacular and traditional society in which the sacred, however characterised, has permeated, enriched, and given meaning to life. In these societies, religion, like art, is never a separate activity; it permeates everything. The world, both animate and inanimate, is filled with living spirit. The borders between the visible and invisible allow contacts to be made across them daily. The sacred is rooted in daily relationships—right here, in a tree, a stone, a snake, the wind, the land, in eating and the preparation of a meal, even in the squalor that to us is its antithesis.

This sense of the cosmic mystery of existence may be common to every pre-industrial culture unaffected by secularisation, yet the dwellings and ceremonial structures of the once thriving cultures of the Plains and Forest Indians of the North American continent are an especially rich example of the human desire to be involved in the forces and temper of creation and in contact with the spirit world.

The teepee, the domed sweat lodge, the Sun Dance lodge, the Apache's wickiup and the longhouses of the woodland peoples, were never merely functional structures built according to a strictly instrumentalist ethic but, like the Hindu temple, models of the cosmic universe. The circular floor-plan of the Plains teepee and its central fire were symbolic of the Great Mysterious at the heart of the human. The Dineh hogan with a post 'planted' at each of the cardinal directions and two framing the doorway, itself facing the rising sun, likewise represented the cosmos. As the heavens are domed, so too was the hogan's roof, while its dirt floor, according to Anita Parlow, was 'ever in touch with Mother Earth'. 'We are on our Mother Earth's lap inside the hogan, and she is protecting us,' explains Roberta Blackgoat.[20]

Moreover the symbolism of cosmic correspondence, sacred geography and directions of the hogan's design never represented some other and higher reality;

it *was* that reality; it *is* that to which it refers. Everyday events like sewing clothes or making pottery were likewise regarded as activities in which the human and the cosmic realms were inextricably interwoven. The membrane between this world and the transcendent reality was especially thin for the Pima and O'oodham people, for whom gathering grasses, vegetable dyes and weaving baskets were regarded as recapitulations of the total processes of creation; for them the finished basket was not just a useful object but, at a deeper level, a microcosmic model of the Cosmos itself.

Participation in the cosmic community gave active voice to feelings of awe and reverence. In this timeless Omaha entreaty, the new-born child is lifted in presentation to the Universe:

> Ho' All ye of the heavens, all ye of the air,
> all ye of the earth:
> I bid you all hear me'
> Into your midst has come a new life.
> Consent ye, ye I implore ye, I implore'
> Make its path smooth...

The Navajo tradition also has this beautiful Night chant, which is daily recited in celebration and remembrance of the world's beauty. But the chant's recitation is more than a celebration of the world's wonder; its narrator is moved not merely to create beauty, but to think and live it as a continuous act. He is the voice through which nature breathes and lives; his are the hands through which she extends her subtle weave of harmony:

> With beauty before me, I walk
> With beauty behind me, I walk
> With beauty above me, I walk
> With beauty below me, I walk
> From the East beauty has been restored
> From the South beauty has been restored
> From the West beauty has been restored
> From the North beauty has been restore
> From the zenith in the sky beauty has been restored

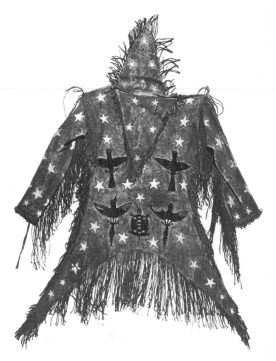

Plate 10. Arapaho Ghost Dance shirt, 79 x 53 cm. *Painted buckskin with fringes.* North America.

From the nadir of the earth beauty has been restored
From all around me beauty has been restored.[21]

Reverence for and knowledge of the beauties of nature are also to be found in the Native American's utensils and garments—in, for example, a sun-burst design embroidered by a squaw on her husband's hide jacket, or the fringed and beaded Apache Ghost dance shirt, with its birds, stars, turtle and man, illustrated above.

## THE DIVINE ORIGIN OF MUSIC AND DANCE

The cosmic dimension is also apparent in the Navajo's eye-dazzling shoulder blankets, whose origins have been told in the legend of Spider Woman:

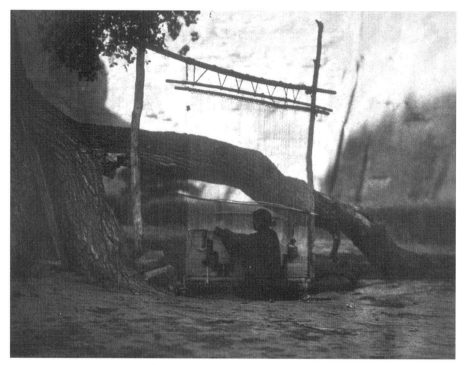

Plate 11. The Navajo Blanket Weaver.
photo: Edward S Curtis.

Spider Woman instructed the Navajo women how to weave on a loom which Spider
Man told them how to make. The crosspoles were made of sky and earth cords, the
warp sticks of sun rays, the healds of rock crystal and sheet lightning. The batten was
a sun halo, white shell made the comb. There were four spindles: one a stick of zigzag
lightning with a whorl of cannel coal; one a stick of flash lightning with a whorl of
turquoise; a third had a stick of sheet lightning with a whorl of abalone; a rain
streamer formed the stick of the fourth, and its whorl was white shell.[22]

As the icon painter prayed that the spirit of Christ might move through his
being, as the Hindu sculptor underwent ritual purification that he might bring
the divine image he had seen into being, so the Navajo weaver prepared herself
to become transparent to Spider Woman:

Oh our Mother The Earth, oh our Father The Sky
Your children are we, and with tired backs
We bring you the gifts that you love.
Then weave for us a garment of brightness;
May the warp be the white light of morning,
May the weft be the red light of evening,
May the fringes be the falling rain,
May the border be the standing rainbow.
Thus weave for us a garment of brightness
That we may walk fittingly where birds sing,
That we may walk fittingly where the grass is green
Oh our mother The Earth, oh our Father The Sky.[23]

Such intimacy with the cosmic community, such a love affair with the universe, is shared by all the theocentric cultures who believe that the forces of the soul are rooted in the ancient, grounded religious way. Thus for them the divine origins of music, dance and craftsmanship, even the work of the artisan, all stem from Divinity. Craftsmanship is not below the divine, but is itself divine. 'This tradition can be traced back from apprentice to master until one reaches the Lord Seth, the son of Adam,' an old comb-maker in the city of Fez told Titus Burckhardt.[24] The Hindus attribute the creation of dance and music to Shiva; the Javanese attribute the creation of music to the King of the Gods, Sang Hjang Batara Guru; the Greeks attributed the origin of theatre to Dionysus; while the Japanese believe that a feminine deity, Ame no Uzume, originally invented the arts of music and dance. For them the arts are something in which the Divine is present or which are charged with divine energies. Just as we cannot talk about the sea without presupposing salt, they are unable to practise the arts without presupposing God.

## THE IMPORTANCE OF THE ACT OF CREATION ITSELF

In these cultures the preservation of a completed work is therefore of little consequence. Creation is about worship, prayer, propitiation, praise and use, not conservation. It is the act which matters—the *making*, not the preservation; the *process* rather than the product, the *intention* rather than the result. Edmund

25

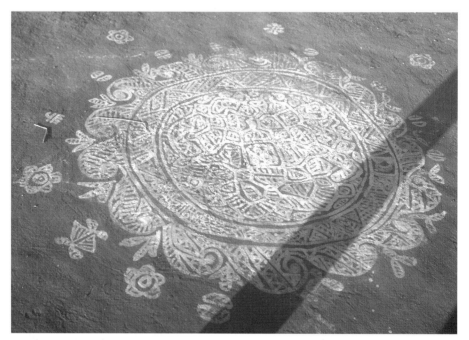

Plate 12. Kolam drawn in rice powder. Contemporary.
Thiruvedagam, Southern India. photo: John Lane.

Carpenter tells about the Inuit peoples who, unlike us, have no conception of keeping possessions because of their intrinsic value. 'Art and poetry are verbs, not nouns,' he writes, 'Poems are improvised, not memorised; carvings are carved, not saved. The forms of art are familiar to all; examples need not be preserved. When spring comes and igloos melt, old habitation sites are littered with waste, including beautifully designed tools and tiny carvings, not deliberately thrown away, but, with even greater indifference, just lost.'[25]

For anyone who really wants to know what this means in practice I would ask them to visit Tamil Nadu and observe how the beautiful kolams, drawn on the ground with rice powder, are scuffed away by passing footsteps by noon. Yet the following morning they are recreated. Or see the clay statues of the gods being thrown into the rivers; these, too, are remade when the occasion demands. The concepts of heritage and conservation, unheard of in more confident societies, are secular in origin.

## 'THE FILTHY MODERN TIDE'

Although attracted by the vital energy and wisdom of the vernacular way of life, I have no first-hand experience of cultures (apart from that of India) that have remained unchanged for countless generations. I therefore lay myself open to the charge of romanticising them; and that could be the case. Nonetheless, it was never my intention to idealise a way of life that we can learn from but never follow. We can never go back to the old magic of their ancient past and I have no desire to do so. Yet the implication remains that the 'primitive' may have found a more satisfactory answer to some of the problems of life than we have.

It is therefore my conviction that we now need to reconcile modern man and his Art with some of the ancient meanings and potencies of the forgotten 'primitive'. We need to examine the psycho-spiritual roots that have rendered the vernacular cultures so cohesive, and their deep ecological consciousness, whose reverent relationship with nature is so soundly based on need that, although wealth may be sought, no man goes hungry while others overeat, and no man is out of work. We might also benefit from a consideration of the nature of their expressive life which provides self-esteem and nourishment for the psyches of countless individuals. Since the contemporary crisis is one of psyche, not of politics or the environment, the lessons about peasant and 'primitive' art are surely worthy of study.

Looking at the coexistence of the archaic within the modern has another virtue. It can help us to consider the gains and losses of Western industrialism, whose benefits, though undoubted, have been purchased at a heavy human price. Traditional and vernacular man inhabited a thousand worlds, brighter, more poetic and terrible than the literal one in which we all think we live. He possessed a channel or framework with which to make things magical as part of his normal life; he enjoyed a life of exuberant creativity and, however materially impoverished, spent it completely surrounded by man-made and natural beauty. We ourselves have long lost these advantages: we have lost the ability to be possessed by 'the other mind' that lies beyond the confines of the conscious self; lost the confidence and the opportunities to experience a true imagination in passage; lost a place in beauty; lost habitation in the house of being. Yeats called this 'the filthy modern tide'. Its origins and outcome are the subject of the following chapters.

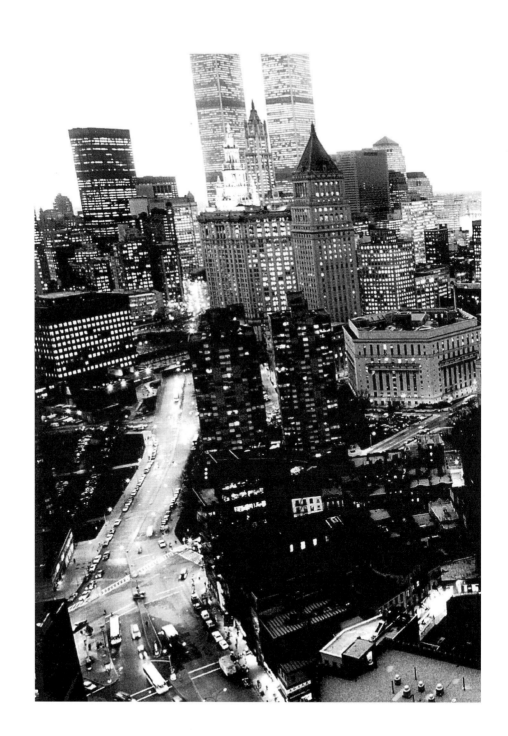

# WORLD-VIEWS

*'We are witnessing the end of the scientific era. Science, like other outmoded systems, is destroying itself...'*

*'So what will happen?' Ellie said.*

*Malcolm shrugged. 'A change.'*

*'What kind of change?'*

*'All major changes are like death,' he said. You can't see to the other side until you are there.'*

Michael Crichton[1]

## THE NATURE OF BELIEF

NO HUMAN NEED is more compelling than the necessity to make sense of life. As Victor Frankl, a survivor of Auschwitz, counsels us, meaninglessness is the one intolerable condition.

A thousand beliefs exist to meet this need. Each age and culture has conducted its life not primarily in terms of what it knows but rather in terms of what it can bear to believe. It has conceived its own insights into the mysteries of reality and each belief system, paradigm or philosophy of life has shaped the way its peoples have lived and understood themselves and their place in the cosmos. And every one of these beliefs, be it Fascism or Communism, Maoism or Shintoism, Buddhism or Calvinism, has energised the peoples who believed in it to build great temples, set up systems of communication and go to war in its defence or expansion.

The tragic consequences of these actions are legion. To take but one example: in 1519, Hernando Cortes, seeking in his own words 'to extend the knowledge, cult and splendour' of his Catholic faith, put to the sword many thousands

Plate 13. View overlooking Chinatown, New York. 1989.
photo: Patrick Zachmann/Magnum Photos.

of a different persuasion. He boasts to justify his actions: 'I burned more than ten towns, of more than three thousand houses... At dawn I fell upon a large town of more than twenty thousand dwellings. As I surprised them, they were unarmed. The women and children ran naked in the streets. And I fell upon them...'[2]

Or another. In the eighteenth century a small group of Franciscan monks encountered a tribe of Californian Indians, the Ohlone.[3] The Franciscans were not, of course, a depraved group of men who consciously sought the Indians' enslavement. They were Utopian missionaries who had come to the New World to set up the perfect Christian community of which the Indians were to be the beneficiaries. Their original plan was to wean them from their lives of supposed lewdness, idolatry and shameless nudity. It was then a sweet and holy plan (sweet and holy at least in terms of the Franciscan fathers' ingrained convictions) but unsurprisingly it resulted in epidemics—measles, mumps, smallpox, and syphilis—and appalling despair and suffering. The death rate at the missions reached horrendous proportions. Yet, although some of the monks blamed themselves—the stubbornness and bad health of the Indians being sent by God to punish them for their sins—most of the Franciscans simply redoubled their endeavours: the failings of the missions were a test, God himself was watching, and the holy fathers must not falter. They persisted for over sixty years. The damage to Ohlone life was irrevocable.

Although it might be thought that such folly characterised the behaviour of our ancestors only, the truth is less consoling. The twentieth century has seen a veritable outbreak of idiocies inspired by models of reality of both right and left. One example, a painful one, must be sufficient: the imposed collectivisation of agriculture in the early thirties in the Soviet Union. Stalin's campaign, which began by driving the most energetic farmers off the land in pursuit of the chimera of rural capitalism, soon developed into an all-out war of the state against the peasants who made up four-fifths of the population. In spite of every evidence to the contrary, Stalin never ceased to regard it as an unqualified success.[4]

Yet, as the evidence of Communism itself has shown, beliefs can lose their hold—and can do so with an amazing rapidity. Nothing is permanent; everything provisional—including our own belief in steadfast secularism, industrialism and unstoppable progress.

In the last chapter we considered world cultures that lived in a timeless, pre-

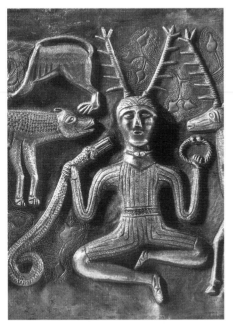

Plate 14. Detail of silver cauldron.
Gundestrup (Jutland), Denmark. c100BC.
National Museum, Copenhagen.

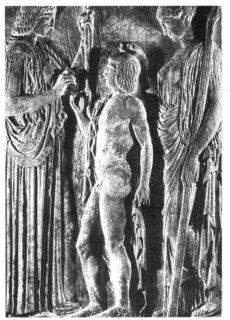

Plate 15. Scene from the Eleusinian
Mysteries. mid-6th century BC *Pentelic marble.*
National museum, Athens.

historic existence. In this we return to Europe to trace the transformations of its relatively short-lived but exceptionally disruptive history.

## THE FOUR TRANSFORMATIONS

According to the cultural historian Lewis Mumford (1895-1990) there have been in all four basic 'transformations' in the entire history of Western civilisation.[5]

The first of these we have already touched upon. Before agriculture and husbandry existed, human life was modelled on the cyclical structure of nature; life was approximately the same from day to day, changing only with the seasons and other external environmental fluctuations. Such early peoples lived by the spear and arrow: some societies still do, amongst whom can be counted the Pygmies and Bushmen, the Intuit and Australian Aborigines, all of whom display

(or have displayed) some expressive form of behaviour, as natural as the use of language or tools.

The first major European civilisation, that of the New Stone Age (Neolithic) farmers, the Germanic and Scandinavian tribes, the Assyrian and Sumerian, Greek and Celt, also exhibited forms of behaviour that embellished and enlarged life. Aspects of this have been discussed and there is no need to return to the subject here.

The second cycle, the Graeco-Roman, lasted from the time of the Homeric epics (some time around 900 to 700 BC) to the end of the Roman Empire in the West in 476 AD. Reflecting the mythopoeic consciousness from which it emerged, influenced by the mystery religions with which it was contemporaneous, forged through a dialectic with scepticism, empiricism and secular humanism, the thoughts of the great Greek philosophers and the work of her greatest sculptors and architects have imprinted an attitude at once idealist and rationalist in character upon the evolution of the Western mind over the last two and a half millennia.

Although Greek natural philosophers were the first to consider and analyse the physical workings of the world independent of the interventions of the gods and goddesses, so too in the visual arts the Greeks were the first to introduce the idea that art's primary function was to please the eye of the beholder rather than to placate or worship a deity. This, in itself, was a revolutionary step and one which was to lead not only to the idea of 'art for art's sake' but to the art collections of the Hellenistic kings. It is recorded that the kings of Pergamon in the second century BC paid enormous sums for Greek paintings.

## THE MEDIAEVAL WORLD-VIEW:
## THE INTERPENETRATION OF HUMAN LIFE
## WITH THE COSMIC LIFE OF THE WORLD

*You live in time; we live in space. You're always on the move; we're always at rest. Religion is our first love; we revel in metaphysics. Science is your passion; you delight in physics. You believe in freedom of speech; you strive for articulation. We believe in freedom of silence; we lapse into meditation. Self-assertiveness is the key to your success; self-abnegation is the secret of our survival. You're*

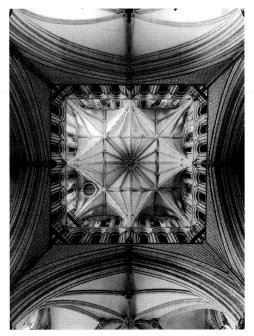

Plate 16. Vault of central tower, Lincoln cathedral, England. 1306-1311.
photo: Edwin Smith.

*urged every day to want more and more; we're taught from the cradle to want
less and less. Joie de vivre is your ideal; conquest of desires is our goal. In the
sunset years of life, you retire to enjoy the fruits of your labour; we renounce
the world and prepare ourselves for the hereafter.*

Hari N. Dam[6]

Although this quotation comes from an article about the differences between
East and West, it could with adaptation reflect the differences between our own
age and that of the European Middle Ages, no less theocentric than that of con-
temporary rural India.

It is true that mediaeval people (like the peasants living in India's seven hun-
dred thousand villages) often lived under conditions of severe material impover-
ishment. Their world was circumscribed and characterised by ignorance, by cru-
elty and danger. It is equally true that it was plagued by disease and obsessed by

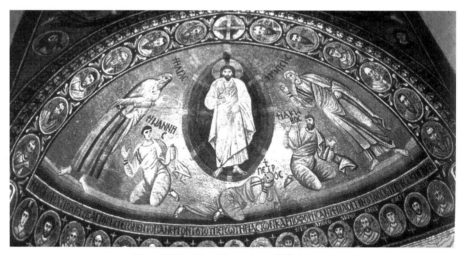

Plate 17. The Transfiguration. *c*540. *Mosaic.*
Church of the Virgin in the monastery of St Catherine, Mount Sinai.

money, greed and the flesh. There should be no illusions about the often tormented, painful and unstable conditions of 'primitive' and mediaeval man. Nonetheless, I would suggest that their lives can be most sympathetically apprehended not by comparison with those of our own but through the coinciding symbols of a transcendent faith.

The Church, of course, was the dominant force and it provided for learned and unlearned alike an incomparable temenos for archetypal spiritual yearnings. The purity and radiance of its buildings, the untainted luminosity of its music and our knowledge of its ritual, tell us that mediaeval life was not merely squalid; it was also visionary, inspirational and refined. It was informed, as the world of Islam was informed, with sacred meaning and intention.

Thus, as Pitirim Sorokin has observed:

Its architecture and sculpture were 'the Bible in stone'. Its literature, again, was religious and Christian through and through. Its painting articulated the same Bible in line and colour. Its music was almost exclusively religious: *Alleluia, Gloria, Kyrie Eleison, Credo, Agnus Dei, Mass, Requiem* and so on. Its philosophy was almost identical with religion and theology and was centred around the same value-principle: God. Its science was a mere handmaid of Christian religion. Its ethics and law were but an

elaboration of the absolute commandments of Christian ethics. Its political organisa-
tion, its spiritual and secular powers, were predominantly theocratic and based upon
God and religion. Its family, as a sacred religious union, was indissoluble and articu-
lated the same fundamental value. Even its economic organisation was controlled by
a religion prohibiting many forms of economic relationships, otherwise expedient
and profitable, and stimulating many forms of economic activity, otherwise inexpedi-
ent from a purely utilitarian standpoint. Its dominant mores, ways of life and mental-
ity stressed the union with God as the only supreme end, and a negative or indifferent
attitude toward this sensory world, with all its wealth, pleasures and values. The sen-
sory world was considered a mere temporary 'city of man' in which a Christian was
but a pilgrim aspiring to reach the eternal City of God and seeking to render himself
worthy to enter it. In brief, the integrated part of mediaeval culture was not a con-
glomeration of various cultural objects, phenomena and values, but a unified sys-
tem—a whole whose parts articulated the same supreme principle of true reality and
value: an infinite, supersensory, and super-rational God, omnipresent, omnipotent,
omniscient, absolutely just, good and beautiful, creator of the world and of man.[7]

## THE SENSATE, CARTESIAN OR SCIENTIFIC WORLD-VIEW

*That great historic process in the development of religions, the elimination of
magic from the world which had begun with the old Hebrew prophets and, in
conjunction with Hellenistic scientific thought, had repudiated all magical means
to salvation as superstition and sin, came here to its logical conclusion. The gen-
uine Puritan even rejected all signs of religious ceremony at the grave and buried
his nearest and dearest without song or ritual in order that no superstition, no
trust in the effects of magical and sacramental forces on salvation, should creep in.*
Max Weber[8]

*If the personality be once emptied of its subjectivity and come to what men call
an objective condition, nothing can have any more effect on it.*
Friedrich Nietzsche[9]

I have introduced a little-known author, Pitirim Sorokin, because his book *The
Crisis of Our Age*[10] remains a guide not only to the slow but inexorable decline

of the shared symbolic order of the Middle Ages and the materialistic, sensate form which replaced it, but to the latter's present exhaustion and decline. 'We are living and acting at one of the epoch-making turning points of human history,' he wrote in 1941, 'when one fundamental form of culture and society—sensate—is declining and a different form is emerging.'

According to historians, this form of culture, based upon the premise that true reality and value are sensory, began to emerge during the twelfth century and grew to dominance throughout the sixteenth and seventeenth. To this day there may be no acknowledged name for this paradigm but, depending on the context in which the word is used, it has been called, after Descartes, Cartesian, after another of its founding fathers, Newtonian; sometimes either Scientific or Mechanical or Humanist. I favour the latter if only because it embraces such later developments as industrialisation and economic globalisation, but the terms are largely interchangeable and I make use of them all.

Its evolution has been told innumerable times: how in 1455, the production of the Gutenberg Bible started the printing revolution; how in 1492, Columbus reached America and initiated the era of colonial expansion; how, too, in 1514 Copernicus hypothesised a heliocentric universe, etc. But as with the mediaeval cultural revolution several centuries earlier, technical inventions and philosophic-cum-scientific enquiry continued to play a pivotal role in the making of the new era, well into the seventeenth century. Developments of this kind included Kepler's vision of a landing on the moon in 1609; Francis Bacon's concept of knowledge as power in 1620; René Descartes' invention of the reductionist method in 1637 and fifty years later Isaac Newton's crowning of the new design with his conception of a mechanistic universe.

Earlier, Luther's posting of the Ninety-five Theses in Wittenberg in 1517 also played a critical role. It initiated or at least hastened what we call the Reformation, the Counter-Reformation and the state of acute metaphysical turmoil into which Europe was thrown with disputes between ever-multiplying religious sects over whose conception of the truth would prevail. In the context of this confusion, it is understandable why the need for a clarifying and unifying vision was so urgently and broadly felt. Thus the founders of science hoped that they could arrive at an absolute system of truth about nature, rising above the sectarian conflicts of the Catholics and Protestants and the bloodshed engendered by the Thirty Years War. I think this background helps to explain how

science has become a kind of religion for many of its followers, and why it was so attractive at the time. 'All science is certain, evident knowledge,' wrote René Descartes (1596-1650), whose vision of a mechanical universe took place on November 10th 1619 while he was in winter quarters as a mercenary. 'We reject all knowledge which is merely probable and judge that only those things should be believed which are perfectly known and about which there can be no doubts.'[11]

It is arguable that the decisive break in human consciousness and social experience in the West took place not at the Renaissance but at this time. Before the cataclysm of the Reformation, which in northern Europe looked so much like Cambodia's year zero, a unity of being had welded religion, ritual, art, guilds, processions and festivals into one seamless and indivisible whole; the artist and the artisan, the secular and the spiritual, the individual and the community, were closer than at any subsequent time. After it, Europe was a very different place: greyer, less coherent and largely ruled by what William Blake called 'a ratio of numbers'. Both orthodox Catholicism and puritanical Protestantism set their faces firmly against the celebration of the questing imagination, and the secularising thrust of the Western intellect took its place as the engine of future development. Expelled from the Church, one strain of the former went underground with the hermetic tradition, but it is hardly surprising that the majority of intellectuals, civic leaders and entrepreneurs rejected the sacred altogether, so perniciously had its powers been abused. Monasteries, abbeys, stained glass, statuary, rituals and tradition were destroyed with a thoroughness and venom which still astounds us, but the real damage was inside people's hearts and imaginations. About the middle of the seventeenth century the soul life began to lose its power and people began to live more meanly.

That the analytical procedures of Western thought introduced at this time have brought astonishing gains for consciousness is, of course, indisputable. I admire these and acknowledge the extent to which our civilisation has benefited from clear-headed rational thought uninformed by superstition and ignorance. But the method has its limitations and its usage has become repressive and distorted over time. Rupturing the ancient union with the deep ground of our being in the feminine, it has introduced a number of related developments which had—and continue to have—severely damaging consequences. The first

of these is the failure of a purely cerebral consciousness to grasp the principle of the indivisibility of being. Descartes himself lived exclusively in the intellect, withdrew from any emotional commitment to the usual events of human life and even defined himself metaphysically as nothing more than his own rational thought: *Je pense, donc je suis*. For him, the only thing that existed beyond all doubt was 'I':

> I thence concluded that I was a substance whose whole essence or nature consists only in thinking, and which, that it may exist, has no need of place, nor is dependent on any material thing; so that 'I', that is to say, the mind by which I am what I am, is wholly distinct from the body, and even more easily known than the latter, and is such, that although the latter were not, it would still continue to be all that it is.[12]

Mind and matter were thus seen as separate and distinct entities, with the mind and its thought processes as the primary interpreter and source of knowledge concerning the physical, bodied world. Less widely reported, however, is the fact that Descartes also split the mind into conscious and unconscious, and persuaded European culture to side with one half, the 'light', against the other, the unlit depths, so that people came to identify themselves exclusively with the conscious 'tip' of the mental iceberg, and to ignore or disown the unconscious bulk that lay beneath the surface. In adopting these partial approaches Descartes not only broke the complex unity of nature into tiny fragments (which could not be easily reassembled into any coherent picture) but restricted attention to aspects of human nature and culture which could be construed in narrow, rationalistic terms.

It has been argued that in Descartes' case, his entire philosophical achievement was an intellectual expression of his essentially schizoid character. That could well be true. Nonetheless, under his influence it became the fashion to doubt everything till it was proved by science, a view that has led to the virtual elimination of intuition and feeling as acceptable modes of apperception. To *know* something with the intellect or head—this, it became obvious, could be trusted. To *feel* something with the heart or body—this, it was argued, cannot be trusted.

The rationalist denigration of all forms of feeling has had serious consequences for the way we experience ourselves. The cult of the ironic, distanced

observer, aware of his own awareness, unable to break out of his solipsistic construction of himself and his society, is one of these. A no less damaging consequence has been the split between values and thought, between instinct and reason, and ultimately between Art and technics, inducing a schizoid attitude of mind and culture. The defining effect of an exaggerated cerebrality has resulted in the widespread denigration of creative expression and of Art being shunted from the centre to the outermost margins of Western life.

This tendency to push Art into a sphere of private fancy—that is, to a place where public obligations no longer apply—was exacerbated by another cultural development: Galileo Galilei's (1564-1624) procedures for analysing phenomena, which became the basis for testing theories. Galileo argued that to make accurate judgements concerning nature, scientists should consider only precisely measurable 'objective' qualities (size, shape, number, weight, motion), while merely perceptible qualities (colour, sound, taste, touch, smell) should be ignored, being ephemeral and subjective and therefore merely personal. Only by means of an exclusively quantitative analysis could science attain certain knowledge of the world. Given the establishment of the quantitative experiment as the final test of hypotheses, it was inevitable that the world of myth, symbol and dream should lose their ancient authority; they were either a primitive fabrication, a childish fantasy, a harmless entertainment, or all three.

The ends of human life were to be no longer defined in relation to a cosmic order, but according to the dictates of a new kind of religion: quantitative science. The catastrophe of our time is rooted here.

## THE CATASTROPHE OF OUR TIME

*The press, the machine, the railway, the telegraph are premises whose thousand-year conclusion no one has yet dared to draw.*

Friedrich Nietzsche[13]

It can, of course, be questioned whether the scientific take-over has been as totalitarian as I have described it on the previous pages. In the sphere of the imagination there has always been a minority prepared to both challenge and resist its claims. Some of these, like Blake, who discerned where the thought of Bacon,

Locke and Newton would lead, or W.B. Yeats, who hated science and called it 'the opium of the suburbs', will be considered in later chapters. It has also included painters like Turner and Samuel Palmer, poets like Rilke and Leopardi, composers like Beethoven and Berlioz, who have sought to re-envision a lost, enchanted world. Their testimony and that of others is an indication that, though severely marginalised, the poetic imagination can never be completely annihilated.

Nonetheless, the new scientific order built a world increasingly characterised by the utilitarian, the economic, the secular and literal. It pioneered new technologies and a human order built on industrial manufacture. It spawned new conurbations and a life-style based on consumption. It encouraged an ethic of self-interest and personal greed. It was a development that affected—and continues to affect—every aspect of Western (and increasingly non-Western) life from the growth and design of cities, the manufacture of goods, the treatment of health and what passes as education. Nothing has remain unaffected; everything is informed by the spirit of a closed world of logic devoid of the sacred. But maybe its most damaging and long-lasting effect has been the way it has induced a widening split between human beings and nature.

A remark by a Scottish highlander, John Dunbar, to W.Y. Evans-Wentz at the beginning of this century may illustrate how quickly nature was transformed from independent subject into manipulable object, commodity and resource. 'I believe people saw fairies,' he said, 'but I think one reason no one sees them now is because every place in this parish where they used to appear has been put into sheep, and deer, and grouse, and shooting...'[14] 'The spirits of the hills are not what they were,' a Kalahari Bushman confided to Laurens van der Post, 'they are losing their power.'[15]

However, neither Dunbar nor the Bushman were the first to register their sense of the impoverishment of nature as a living theology. In the closing decades of the eighteenth century Blake had complained about the loss of nature as an ensouled, living organism and its replacement by a lifeless Newtonian world, divided, weighed and measured by the instruments of empirical science. Wordsworth, too, had been among the first to protest against the desecration of landscape when he famously attacked the proposed Kendal to Windermere Railway line. 'Is there no nook of English ground secure from rash assault?' he pleaded in 1844. But it was the critic of art and society, John Ruskin, who most

fiercely challenged the prevailing mores of a culture intent on profit at the expense of life. He called it 'the mystery and shame' of 'the English death—the European death of the nineteenth century'.[16]

In the 1870s Ruskin began to keep notes on what he took to be changes in the weather; he became convinced that he could detect the presence of a storm-cloud which lowered ominously in the sky, often accompanied by a plague wind of diabolic aspect. By the end of the decade, such references were frequent in his writings. He was recording 'perpetual darkness—and yesterday the old diabolic trembling light', 'the air one loathsome mass of sultry and foul fog like smoke', and, in 1879, he found 'the roses in the other garden, putrefied into brown sponges, feeling like dead snails—and the half ripe strawberries all rotten at the stalks.' Four years later he was 'utterly horror-struck and hopeless about the weather. The plague wind now constant and the sun virtually extinguished.'

In 1884, Ruskin delivered two public lectures at the London Institution entitled *The Storm-Cloud of the Nineteenth Century*, in which he reported on the meteorological effects he had been noticing since 1871. The main phenomena were a 'plague-wind', causing a continuous trembling of leaves, and the darkening of the sky by spreading an opaque white cloud. Ruskin described the effects of the new weather as 'Blanched Sun—blighted grass—blinded man', an uncanny premonition of the tragedies of Hiroshima, Nagasaki, Chernobyl and Bhopal, and the ecological devastation of our planet a century later.

It is interesting to note that the last piece of writing Ruskin completed, the closing part of his autobiography, *Praeterita*, was written at Seascale on the Cumberland coast in 1889. As he tried to piece together the fragments of his life, he took trips into the surrounding district, to Muncaster Castle and Calder Abbey, and must have looked out from the dunes, of which he made two drawings in 1881 and at least one water-colour, one of his last recorded paintings. It shows the beach less than two miles south of Windscale. What he would today see there has only too fully materialised his prophetic nightmare in the Cumbrian skies: Sellafield Nuclear Power Station, the towers of Nirex UK, and the suite of reprocessing plants known as Thorp.

But Ruskin, like other critics of European industrialism—Charles Dickens, Karl Marx, William Morris, amongst them—was a lonely exception; for the majority, its achievements were self-evidently triumphant. Most of his contemporaries felt themselves to be nothing less than part of a culture ascending·in

wealth, power and prosperity; they had no desire to listen to criticisms of a way of life which promised affluence, progress and convenience. Indeed by the century's end, the omnipotence of technology, the priority of economics, and the supremacy of growth—attitudes that hold that we should allocate the greatest number of goods to the largest number of people (capitalism and socialism being merely different theories on how best to achieve that goal)—had already introduced enormous material benefits. In this century, or at least up until the 1960s, the promise of industrialism intensified to the extent that technological innovation was believed to be the sole means by which society could solve its problems and produce a better world. Unlimited optimism, unlimited wants and unlimited growth, a world where everyone, rich and poor alike, get richer and richer, faster and faster, was repeated like a mantra by the faithful. After the Second World War, especially in the fifties, Utopia seemed to be getting really close.

Fifty years later, as global warming, pollution and resource depletion escalate into crisis, the future appears increasingly less attractive. After four hundred years, the planet has begun to provide ever more disturbing and distressing warnings of which the growth of population and the continued devastation of conditions on life are perhaps the most significant. Deep down, people may have begun to recognise that unlimited growth in a limited system is an adolescent fantasy: they may be beginning—just beginning—to realise the potential costs of the reparation of decades of environmental abuse. They may also be beginning to become aware that they themselves are contributing to an agonising and irreversible breakdown in the order and coherence of their children's futures. Meanwhile, the widespread desire of people to get away from the horror and dullness of mainstream life through tourism and the use of legal and illegal drugs is an indication of basic lack of entrepreneurial spirit towards creativity, expression and enjoyment for its own sake, in our society. Simple happiness is an experience of the past.

The history of many civilisations shows that a society and its culture may ultimately collapse when the dynamic of its prevailing paradigm loses its meaning. Divergence between faith and lived experience is the sort of cognitive schizophrenia which brought the Middle Ages to its end; then there was a desire for liberation from an almost total feeling of domination by mediaeval institutions, especially the Church. Now, too, in a culture which is transforming diversity into homogenisation, cities into featureless expanses, landscapes into

agricultural factories and oceans into rubbish tips, a minority has sensed that we have created a world in which we no longer belong.

## THE END OF HUMANISM AND THE GREAT TRANSFORMATION

'There are good reasons for suggesting that the modern age has ended,' President Vaclav Havel said recently. 'Today, many things indicate that we are going through a transitional period when it seems that something is on the way out and something else is painfully being born... Today, for instance, we may know immeasurably more about the universe than our ancestors did, and yet it increasingly seems they knew something more essential about it than we do, something that escapes us. And thus today we find ourselves in a paradoxical situation. We enjoy all the achievements of modern civilisation that have made our physical existence on Earth easier in so many important ways. Yet we do not exactly know what to do with ourselves, where to turn... We understand our own lives less and less. In short, we live in the post-modern world, where everything is possible and almost nothing is certain.'[17]

As Havel points out, there is a growing but inexorable sense of loss and attenuation—of faculties dimmed, of possibilities denied and energies foreclosed; a sense of unease and irresponsibility, laxness and uncertainty. The arrival of a global economy and the information technology that knits it together and produces huge flows of money, people and power, only exacerbates the conviction, felt rather than voiced, that we are no longer in control of our own destinies. Our lives and the life of our culture *happen* to us; they are no longer chosen. This confusion, this living meanly, finds expression in all the contemporary Arts.

Something of a similar kind happened in the Hellenistic period, when from the ruins of the classical world the Middle Ages was gradually born. It happened during the Renaissance when the thousand-year old maturation of the West asserted itself in a series of enormous cultural convulsions that gave birth to the modern world. It is happening again. A series of revolutionary scientific and technical discoveries and a crisis involving the whole way of life, thought and conduct of Western society are directing us towards a new horizon. Mumford's fourth transformation is in the process of being joined by an fifth, almost certainly ideational in character, as yet without a name.

## THE FIFTH TRANSFORMATION

*All thinking worthy of the name must now be ecological.*

Lewis Mumford

In essentials, the new vision that finally overcomes the Cartesian split between mind and matter will have not only important scientific and philosophical consequences, but will also have tremendous practical implications. It will change the way we relate to each other and to our living natural environment, the way we deal with our health, our educational systems, our political and social institutions and our Art. It will do this because in many ways it is the opposite of the current ruling philosophy. Where the latter advances on ungovernable tides of secular materialism, the former rejects the convulsive desacralisation of the spirit; where the latter finds power in the control of parts, the former rejects the fragmentation of wholes; where the latter emphasises the importance of consumable products and what René Guenon called *The Reign of Quantity*,[18] the former rejects the view that the essence of civilisation is the multiplication of wants. It argues for quality and human scale, the local and the intimate. It also argues that the assumption that the earth is a heap of raw materials given to man by God for his exclusive profit and use will end in catastrophe; that the solution to this problem lies in our need to enter into a new relationship with the natural world; that our civilisation's two thousand year old bewitchment with knowledge needs to be translated into a concern for meaning; that dualism must be replaced by holism; that we need to rethink the ingrained idea of a substantial Self and accept the contingent existence (rather than the reification) of all that surrounds us. Other characteristics of ecological systems thinking include a shift of perspective from parts to the whole, from objects to relationships, from contents to patterns. As Fritjof Capra says, to regain our full humanity, we have to regain our experience of connectedness with the entire web of life.[19]

Not only is it difficult to summarise a wide range of complex themes; the much greater problem will be that of reversing the tide and translating ideas into practice. There may be growing agreement that the general spiritual catastrophe has maimed and paralysed us and dangerously degraded the planetary environment; that to survive we need a new metaphysics and a new epistemology; a change in the pattern of our thought and a life-style designed for permanence,

but how we move from these conclusions to their understanding and accommodation must be the major project not only for ourselves but for future generations.

This book is not so much about that transformation as the forms of imaginative energy which can accompany it. A new sense of spirituality which is not tied to past religions, a new sense of the depth of the universe and our connections to it, an engagement with wholeness and holistic thinking, are modes of understanding which have yet to discover their own delicate, searching, naked forms of expression. The Renaissance initiated a distinctly new kind of society and a distinctly new kind of Art in keeping with it. The new paradigm can, of necessity, do the same. In the following chapters we shall explore the consequences, ramifications and extensions of both forms of expression.

CHAPTER THREE

# DAYBREAK: BIRTH OF THE MODERN SELF

*'See,' Ochwiay Biano said, 'How cruel the whites look. Their lips are thin, their noses sharp, their faces furrowed and distorted by folds. Their eyes have a staring expression; they are always seeking something; they are always uneasy and restless. We do not know what they want. We do not understand them. We think that they are mad.'*

*I asked him why he thought the whites were all mad.*

*'They say that they think with their heads,' he replied.*

*'Why of course. What do you think with?' I asked him in surprise.*

*'We think here,' he said, indicating his heart.*

*I fell into a long meditation. For the first time in my life, so it seemed to me, someone had drawn for me a picture of the real white man. It was as though until now I had seen nothing but sentimental, prettified colour prints. The Indian had struck our vulnerable spot, unveiled a truth to which we are blind.*

C.G. Jung[1]

EUROPEAN CULTURAL HISTORY has gone through several transformations since the phenomenal flowering of Greek classicism in the fifth century BC, of which the Parthenon is the prime and enduring symbol. These changes in the assumptions about life and art shared by the dominant group are often summarised by shorthand: Republican Rome, Imperial Rome, the Dark Ages, Gothic Europe, the Renaissance and so on. Such terms mislead of course if they suggest that historical periods are sharply distinguishable from one another. They are not. They grow from roots planted deep in the previous centuries of civilisation, yet contemporaries are usually oblivious of the breaks which later peoples have found it convenient to make in their past.

Still, in spite of the truth of this assertion, something happened in the early

decades of the fifteenth century, at least in the Arts, and to a considerable degree in Florence. In this city there emerged the germ of a new, and distinctly different, interpretation of the nature of human life, to that which had preceded it. To a degree this was the product of disillusion with the great projects of the recent past. Instead of the confident faith of the central Middle Ages, the new Humanism[2] retreated into the pagan past; it saw the scholar and the merchant, the banker and the republican, rather than the clergy, as the guardians of culture; it sought inspiration in literature rather than theology, and the nobility of man was expressed in his struggle to discover the world rather than in his capacity for transcendence. A new faith in human omnipotence, a new sense of individual personality, was born at this time. The Arts documented, confirmed and interpreted these changes.

Aspects of this faith inform innumerable aspects of Florentine culture, the republican home of Humanism, fostering some of the greatest achievements of Western painting, sculpture and architecture. Yet if that suggests a bewildering variety of objects, it is only necessary to consider one or other of these to penetrate the essence of the spirit of the Renaissance. To do so I have selected a work by Sandro Botticelli (1445-1510), a painter able, and possibly eager, to respond to the spell of the classical past; no archaeologist, his concern was the poetic recreation of antique mythology. Nevertheless it is to his portraiture that I would first like to turn and especially to the open eyes and confident bearing of the young man illustrated at the beginning of this chapter (Plate 18). Unidentified by name, he stares fearlessly forwards with a look of grave assertion, at once clear-minded, inquisitive, yet at home in this earthly world; a world in which the exaltation of sensory perception dominated all. By 1480-5, when the portrait was painted, the modern self had already consolidated its being.

No such portrait exists in mediaeval art. Speaking very generally, the social structure of that period was based on status, not on individuality, so no comparison with what might be called the Gothic psyche is therefore possible. Nonetheless, the heads which do survive—of, for example, saints and apostles—have none of the incorrigible extroversion of the Botticelli portrait; they have an inwardness in keeping with the spirit of their time. In contrast, the *Portrait of a Young Man* (painted at a time when Botticelli was also painting religious scenes in the Sistine Chapel) faithfully reflects the predominantly secular, individualistic premise of the new Humanist philosophy—expansive and

rebellious, energetic and ambitious, open-eyed and curious, yet sceptical—something like the character of the sitter—and, I suggest, of ourselves. Its style, then, is this-worldly; its purpose not only the celebration of an individual distinct from other individuals, but implicitly the glorification of man in his physical and intellectual prowess as the 'measure of all things', the supreme achievement of Creation.

Humanism is, of course, a capacious word. It was uniquely characteristic of the Renaissance that it produced the man who not only painted the *Mona Lisa* (1513-16) but articulated in his notebooks the three fundamental principles—empiricism, mathematics, and mechanics—that would dominate modern scientific theory. From its beginnings with Petrarch, Dante, Giotto, Boccaccio and Brunelleschi, through Michelangelo and Montaigne, to its final expression in Shakespeare, Cervantes, Bacon and Galileo, the Renaissance created a prodigious widening of human consciousness on a scale unseen since the sixth century BC. For Erasmus, Marsilio Ficino, Giordano Bruno and John Donne, Humanism was a word with which they would have been proud to have been associated. But that is where our problem begins.

These figures, all giants, lived at a time when man appeared to have vaulted into superhuman status and the future promised unlimited possibilities. Yet today, with historical hindsight, its burgeoning promise of knowledge, creativity and exploration is freighted with the sickness of its decline. To take but one small example: in 1478 Botticelli created what is probably his most famous work, *Primavera* (Plate 19). It is a painting that embodies not only the central elements of Neo-Platonic philosophy but all the wonder and the beauty of that unparalleled time. The action takes place during a Florentine spring and its figures, or at least seven of them—Venus, Flora, the Three Graces, Mercury and Chloris—are standing or dancing upon the ground of a richly flowering meadow. Of the 550 or so individual specimens represented in the painting, sixty or seventy are merely tufts of grass. Of the reminder, about 138 real individual plants have been identified of which forty-two different species or genera have been classified. These include the daisy, the sweet violet, the bellflower and the orchid.

Just under five hundred years later—it was in 1962—Rachel Carson drew attention to 'a persistent and continuous poisoning of the whole human environment'. She did so on the basis of her observations of the deadly effects of toxic chemicals not only on weeds but the reproduction of birds, the nitrate content of

Plate 19. SANDRO BOTTICELLI. Detail of flowers and grasses in Primavera. c1480.
*Tempera on wood on a gesso ground.* Uffizi, Florence.

corn and sugar beets and the lives of ruminants such as deer, antelope, sheep and goats. In *Silent Spring* she talks about a 'small world made lifeless' and concludes with the following words: 'The "control of nature" is a phrase conceived in arrogance, born of the Neanderthal age of biology and philosophy, when it was supposed that nature exists for the convenience of man... It is our alarming misfortune that so primitive a science has armed itself with the most modern and terrible weapons, and that in turning them against the insects it has also turned them against the earth.'[3] Since her death, efforts have been made to refine the use of herbicides and pesticides, but their use has multiplied; the all-encompassing technocratic world has inexorably magnified. For while Botticelli could paint forty-two individual species and genera in a relatively small area, a contemporary British meadow might have as few as twenty different species. It can, of course, be argued that Botticelli invented his flower meadow and that it had no basis in reality. That could certainly be true. But the calculation that the world has lost one third of its arable land over the last forty years can hardly be ascribed to

poetic fancy.[4] Nor that at least ninety-nine per cent of Britain's species-rich hay meadows, fifty per cent of its ancient woodlands, fens and wetlands and 368,000 kilometres of hedgerows have been lost since the 1940s? Nor that during the eighteenth century, perhaps twenty species of living beings became extinct; during the nineteenth century, eighty two; during the first part of this century, one species a year. Now one species becomes extinct about every five hours. In 1981 the official endangered species list stood at 230; now it stands around 40,000. By the end of the century, one species may become extinct every twenty minutes.[5]

'The overwhelming trend of the Humanist-dominated present,' writes David Ehrenfeld, 'is towards more ruined soils, more deserts, more children with anomie, more shattered, violent societies, more weapons whose horror passes imagination, more techniques of autocratic suppression, and more mechanisms for isolating human beings from one another.'[6]

There are, then, both a bright and a 'shadow' side to Humanism, and it is time to recognise the latter for what it is and for the damage it has done and continues to do to us and our planetary home. Humanism's greatest gift has been, I believe, the astonishing gains for consciousness won by the analytical procedures of Western thought. But its failures, compulsions, limitations and excesses are legion. Its assumption of control and domination; its arrogance and condescension towards others; its unbalanced commitment to rationality; its development of the disengaged, particular self; its failure to unite with the deep ground of its being in the feminine and its massive commitment to secularisation, have had and continue to have profoundly damaging effects across the world. The absence of grounding in the 'lived body' is also well-attested, as is Humanism's persistent, exaggerated and insatiable greed. 'We are troubled by a disease of the heart for which gold is the only remedy,' was Hernando Cortez's answer to Emperor Montezuma when the latter asked why the Spaniards had come to his country. In Prospero's demonisation and subjection of the native Caliban is also told the history of later centuries, the story of the death of many races. I mention these aberrations for no other reason than because of their effect upon the Arts of Europe in the first half of the modern period. As this chapter discloses, they had this effect not just peripherally or incidentally, but integrally. The Arts, like science, reflect but rarely transcend their social context. The substance of Humanism is the substance of its music and its architecture, its painting and its literature. The one is the microcosm and expression of the other.

In tackling such a vast theme it is probably wisest to consider certain elements in depth rather than the entire field more superficially. I have therefore limited myself to three of Humanism's most important characteristics. The first of these is individualism. Humanism stands out against all previous civilisations in its portrayal of the particular individual. It departs from the traditional social cohesion and breaks with the classical preference for the archetypal and the universal. This change expresses and reinforces the demise of the community. It also introduces the objectivisation of consciousness that fits the experience of the disengaged, particular self. The second feature I shall be considering by representative example is the massive shift from the supernatural to the natural which engulfed European culture from the end of the twelfth century onwards. A final factor which permeated the Humanist aesthetic was the assumption of human control and domination which informed—and continues to inform—almost every aspect of our society.

## THE INFLUENCE OF INDIVIDUALISM

Consciousness of individuality, which is as old as the First Person Singular, was not, of course, unknown before the Renaissance. Two rooms in the Capitoline Museum in Rome are filled with the portrait busts that decorated the libraries, villas and gardens of the wealthy in ancient times. They are of Romans of the first centuries AD and of Greek politicians, scientists and literary figures. A fascination with individual consciousness is also evident in the fact that Plutarch (c46-c120 AD) described the lives of forty-six Greeks and Romans, while in 400 AD Augustine (354-430 AD) wrote about much of his own early life in his *Confessions*. It is hardly an exaggeration to say that it was Augustine who introduced the inwardness of radical reflexology and bequeathed it to the Western tradition of thought. The step was a fateful one because, as Charles Taylor has observed, 'we have certainly made a big thing of the first-person standpoint.'[7] The modern epistemological tradition from Descartes onwards, and all that has flowed from it in modern culture, has made this strand fundamental.

The social historian Norbert Elias speaks of 'the extraordinary conviction carried in European societies roughly since the Renaissance by the self-perception of human beings in terms of their isolation, the severance of their own "inside" from

everything "outside".' Indeed autonomy, separation, a sense of independence—in a word, individualism—have been amongst the most defining characteristics of Humanism from its start and therefore manifest at many levels of cultural reality, including the Arts. The modern goal of creating the greatest possible freedom for the individual—from superstition, from restrictive religious beliefs, from codes of behaviour, from obligations, from oppressive political and social structures, from the family, from parents, the community and society itself—has similarly influenced all of them. By the same token, any historic institution, inherited technique or traditional philosophy that imposed limits or retarded change, has been viewed as a sign of human backwardness. For everywhere the ubiquitous image of Humanism holds us captive. To paraphrase the philosopher Ludwig Wittgenstein, it lies in our language, and language repeats it inexorably.

The value placed on individualism and progress in the Arts is in full evidence in Florence; the features of the architect Filippo Brunelleschi (1377-1446) were preserved in a death mask, and the sculptor Ghiberti (who wrote an account of his achievements) included a self-portrait on both of his pairs of bronze doors, the earlier pair set up in 1424. At about the same time the sculptor Donatello's marble *St George* (*c*1416), armoured and alert, is very much a person before he is a saint. Yet the interest in individualism was no less apparent in northern Europe—in, for example, the portraiture of the painter Jan van Eyck (*c*1390-1441). With him, says Ludwig Baldass, 'there begins a new era in the history of painting.'[8] There certainly begins a newish consciousness of the separate existence of the self, what Yukio Mishima once described as being 'drenched up to my neck in the existence that was *myself*'. This sense of separation is embodied in innumerable forms, even, for example, on the frame of the polyptych of the *Adoration of the Lamb* in Ghent, where a Latin quatrain proudly states: 'The painter Hubert van Eyck, than whom none was greater, began it; Jan, second in art, having completed it...'

## VAN EYCK AND THE RISE OF PORTRAITURE

Earlier portrait studies—Graeco-Roman portraits fixed on the lids of coffins and mummy-cases—had, of course, existed, but in the whole history of Art there is nothing more prodigious than Jan Van Eyck's double portrait of the Italian merchant from Lucca, Giovanni(?) Arnolfini and his wife, painted in 1434. Its nerve-tingling

Plate 20 . JAN VAN EYCK. The Portrait of Giovanni (?) Arnolfini and his Wife Giovanni Cenami (?)
('The Arnolfini Marriage'). 1434. *Oil, perhaps with some egg tempera, on oak, painted surface.*
National Gallery, London. Reproduced by courtesy of the Trustees, The National Gallery, London.

verisimilitude must have been especially extraordinary to the people represented.

The merchant and his elaborately dressed wife stand in a room with a window. They are frozen in time, surrounded by quotidian and familiar objects, even down to the portrait of their wiry terrier and the centrally located *trompe l'oeuil* reflection that indicates the use of a camera lucida, the painter's navigational tool. Between them hangs a polished brass chandelier and a wall-mirror in which two figures are reflected standing at the entrance to the chamber. They might be witnesses to a wedding (even, it has been suggested, that of van Eyck himself) but were perhaps included simply to draw attention to the artist's extraordinary skill at depicting reflections in a mirror. The room is also filled with other objects painted with the same degree of immaculate perception—oranges from the South, a rug from Anatolia, a bed, a pair of wooden pattens—all held together by the creation of illusion through the unifying depiction, definition and evocation of space. As Columbus and other explorers were soon to make maps of the

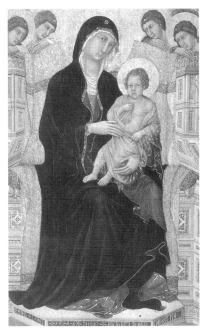

Plate 21. DUCCIO. Maesta (detail of the Virgin enthroned). 1308-1311.
*Tempera on wood panel.*
Museo dell' Opera del Duomo, Siena.

unexplored outdoors, Jan van Eyck was the first to create an extensive explo-
ration of the indoors. For it was the empirical world of the here-and-now, rather
than the soul's interior abundance, which for Van Eyck now possessed authority.

## DUCCIO, MACHAUT AND DUFAY

A sense of the soul's interior abundance is to be found in the pure and confident
lyricism of vision of Duccio's (*c*1255/60-1318/19) Virgin in Adoration or
*Maesta*, painted in 1311. Yet even here the new individualism leaves its mark.
The Virgin sits on a throne with her feet on a beautiful foot-rest. The foot-rest is
no minor detail, for it bears what was originally the altarpiece's sole inscription.
It contained in fact the only signature, the only record of the painter's name and
his achievement, on any of Duccio's surviving works: MATER SCA DEI / SIS
CAUSA SENIS REQUIEI / SIS DUCCIO VITA / TE QUIA PINXIT ITA—Holy

Mother of God be thou the cause of peace for Siena, and, because he painted thee thus, of life for Duccio.[9]

Peace, internal and external peace, the cherished and for the most part end-lessly unrealised hope of every Italian city, is the first request. For the Artist it is life eternal and, implicitly, eternal fame and recognition that is asked. Yet the very fact of the inscription reflects the beginning of a change in the hopes and aspirations of Artists. The names of the architects of Durham cathedral and the Sun Temple at Konarak are unknown, as are the painters of the Book of Kells and the composers of plainchant, yet in the Court of Heaven Duccio was unabashed to inscribe his name in large letters.

A contemporary of Duccio's and the most representative musical figure of the fourteenth century, Guillaume de Machaut (c1300-1377), was similarly pos-sessed of his musical worth. Machaut was one of the first to produce polyphonic settings of secular poetry and to write a significant amount of polyphony for four voices instead of three. He was also the first to write a complete polyphonic set-ting of the Mass Ordinary.

Towards the end of his life Machaut appears to have gathered all his works together, carefully arranged them by genre and had them copied onto a series of luxurious illuminated manuscripts which he proceeded to send round some of the most important centres of patronage in Europe, where they continued to influence composers for decades. As a result, Machaut's output is not only by far the largest to survive of any mediaeval composer, but the one which seems to pre-figure the later concept of a complete consciously planned *oeuvre*. Such an action tends to reinforce a feeling it is difficult to resist once one begins to explore Machaut's output: that it embodies a newly liberated sense of self.

A comparable example of individual assertion is also to be found in the next century. Towards the end of his life, Guillaume Dufay (c1400-1474), whose music we possess in greater quantities than that of any earlier composer, was commissioned to write a four-part mass, *Ave Regina Coelorum* (Hail, Queen of Heaven), in which the Virgin is asked to intercede on behalf of 'Thy dying sup-plicant, Guillaume Dufay'. By the values of a culture where Divinity was central it would have been an act of exceptional presumption for a composer to sign his composition, and include himself in it. Yet by the mid-fifteenth century it was acceptable, even normal.

Duccio, Machaut and Dufay were amongst the first to place importance on

Plate 22. MASACCIO. The Trinity with Mary, John and two supplicants. About 1427. *fresco.* Sta Maria Novella, Florence, Italy.

Plate 23. MASTER DIONYSIUS. Crucifixion of Christ. 85.1 x 52.1 cm.. 15th/16th century. *egg tempera on board.* Tretyakov Gallery, Moscow.

their own achievements. From Michelangelo to Wagner, from Balzac to Picasso, Humanist Art has been the story of their successors. It is the story of exceptionally talented, named and sometimes inflated individuals, described by the word genius.

## TWO CRUCIFIXIONS: MASTER DIONYSIUS
## AND MASACCIO COMPARED

To pursue the depths and limits of the traditional and Humanist aesthetics a stage further, I shall compare two works, one of which is almost contemporaneous with the portrait of Arnolfini and his wife. This is Masaccio's (1401-28) fresco of *The Trinity with Mary, John, and Two Supplicants.* The other is an icon of the *Crucifixion of Christ* by Master Dionysius (c1450-1505), trained at the school of Andrei Rublev's successor and working in a tradition of painting which flourished in Russia as late as the eighteenth century.

The former painting, created about three years before Masaccio's death in 1428, is in one of Florence's largest churches, Santa Maria Novella. Here, in an interior of pointed, perhaps patterned arches, with frescoed angels and saints in niches overhead and multi-figured murals around, it must have stood out as austerely different, almost profane as architecture and speaking a new, unfamiliar language. Thus at a stroke Masaccio broke with tradition, introduced novelty and a standard of 'realism' by which the painting of the next five hundred years was to be judged—and brought divinity down to earth. At first sight it might be considered a later work than Master Dionysius' *Crucifixion of Christ* (c1500), but it was in fact painted about fifty to seventy years earlier.

In contrast to the monumental substantiality of Masaccio's painting, the first impression of the icon is its lack of naturalism; its Christ is elongated and insubstantial; its background flat; its figures without shadows; its colours unrealistic. The fainting Virgin, the three mourning women, John the Evangelist and the centurion Longinus are slender, equally two-dimensional and ethereal. Yet in place of the naturalism of the Florentine, a constellation of symbolism permeates the icon, a visual scripture in itself. Look for example at the footrest on which Christ rests His feet; this symbolises the balance of destiny: the two opposing kingdoms which the Cross unites. Or consider the Cross itself, a symbol with both cosmic and universal meaning. It soars towards the four cardinal points. It is the axis connecting the three cosmic levels: the firmament (heaven with its angelic hosts); earth (our terrestrial and human realm) and the lower world of Hell, into which the Tree of Salvation plunges its redeeming roots. It has been raised on Mount Golgotha, the sacred space considered in biblical tradition to be the centre of the earth. It has been anchored in the *omphalos* (Greek meaning navel) of the world: the black cavern where Adam's skull is buried.

In this icon four angels also play a role that would have been understood by all levels of Orthodox culture, whether educated or unlettered. Two have their hands veiled—the Byzantine sign of respect. By their adoration, these call our attention to the divine sphere. The others serve a different function. The one on the left is guiding a figure who personifies the Church; the one on the right drives away a figure with a woman's head, personifying the Synagogue; she turns to have a final anguished look. In this work Christ's eyes are closed, for he is truly dead. And yet what a feeling of peace, of communion and of dignity the image conveys! In it we cross over the threshold between two worlds: we cross

from earth to heaven. A creamy golden white, a serene reminder of the redemptive peace of Christ's act of salvation, permeates the icon with the leaven of Paschal joy.

Its virtual opposite is the Masaccio. This shows us a mystery, but does so in a palpably material way. The action takes place at a particular time, in a particular place and in the presence of two particular people who kneel before it piously yet confidently and solidly, their place assured in the scheme of salvation. This is one of the Lenzi family and his wife, both represented at the same size as their sacred intercessors. Thus in this fresco man is seen as the 'measure of all things'; so much so, in fact, that the perspective of the barrel vault only makes sense when seen from the point of view of one individual.

Like Jan van Eyck, Masaccio embodied the spirit of his age, and picked up well on one of its cardinal features: the loss of the world beyond. That is why his figures walk the solid earth, inhabit not Infinity but space, not Eternity but time. In his fresco, space is organised on a three-dimensional stage and, significantly, the viewer stands outside the image. There is here a new distance between subject and object and they are clearly situated relative to one another. By contrast the reality manifested in the earlier, iconic tradition had no such deterministic situation; in the crucifixion by Master Dionysius, 'subject' and 'object' could not be definitely placed, either within or without. Thus Masaccio prepares us for a culture in which nothing exists beyond the here-and-now. Man is now the centre of the universe. We stand not only at the beginning of the more naturalistic, rational, would-be scientific modes of painting but at the beginning of the modern secular age.

## THE INVENTION OF ART

Throughout the mediaeval period all kinds of creative artisans—monk-craftsmen, lay craftsmen working in towns and court painters—worked at their labours as productive, respected but unpretentious members of their communities. Painters, for example, fulfilled a wide range of commissions; as well as altarpieces and murals for churches, they painted shields and escutcheons, chests and furniture. Their work was comparable to goldsmiths and masons. Their social position was no higher, their payment lowly.

By the fifteenth century this situation had (at least in Florence) begun to

change. Some time in the middle of the century, painters, sculptors and architects, among them Leonardo and Michelangelo, began to question their status, demand equality with poets and begin to disassociate themselves from 'mere' craftsmen. Inspired by the consciousness of individualism, their ambition was to attain recognition of their professions and in their discussions on the subject, they made it their business to bring out all the most intellectual elements of their work. 'I would wish the painter to be as learned as he can in all the Liberal Arts,' wrote Alberti (c1404-72) in his Latin treatise on painting (1435), where a full Humanist doctrine is formulated for the first time.[10] The enthusiastic propaganda which accompanied that development—especially the support given to it in writing—has had a significant effect. Painters like the Sienese, who lacked contemporary literary champions, have been assessed retrospectively by the standards of Alberti and condemned for their lack of truly Florentine qualities. Fantasy and decoration, the numinous and the beautiful, have subsequently been regarded as inferior to the rational and this-worldly.

The ambitions of the Florentine painters and sculptors were, as we know, realised. In due course they were to be accepted as full members of Humanist society, and in the process to establish a hitherto inconceivable concept and realm. It was the idea of Art as a self-validating, self-referential domain. It was the idea of Art as an autonomous activity existing beyond all ethical and social considerations. It was the concept of the work of Art as a luxury object or activity with no other purpose than aesthetic delectation, and therefore distinct from objects or activities of practical utility. This was the turning point, marking the end of the anonymous craft tradition and the beginning of the modern concept of the Artist as hero, the Artist with his unique vision. Given the increasing complexity and specialisation of modern society, a development of this kind was probably inevitable, yet that professionalism has subsequently exercised its power and made the majority impotent.

It is impossible to say whether—if at all—the people of the time, in particular Alberti, were aware of the consequences of this change in the status of Artists. Aware, for instance, that the Arts would eventually become a special preserve, a kind of segregated area in which imaginative creativity—which pervades every activity in traditional societies—could exclusively take place. Aware, too, that in this reserve (something like Indians on reservations, animals in game parks, the mad in asylums), the Artist would cease to be accountable to the community in

which he lived but become the agent of a pursuit devoid of all practical aims and goals. And no less aware of the consequences for the majority of craftsmen and artisans, suddenly disenfranchised, even disempowered, by the elevation of a tiny minority into Artists.

Another element to characterise this transformation was the shift from local to metropolitan, rural to urban. Within decades of the invention of the Artist, rural areas and cities like Florence were to suffer a steady drain of native talents abroad: Michelangelo, Raphael, Bramante, Palestrina and Poussin were attracted to Rome, and increasing numbers have subsequently migrated to Paris, London, Berlin and New York. The present concentration of able people in centres of power, industry and culture is having and will continue to have a damaging effect on human creativity and appreciation in rural areas. This may sound radical, but only because the modern mentality has been formed in almost perfect disregard for the quality of rural life.

## THE HUMANIST RITE OF OPERA

A further consequence of the growth of individualism that so clearly characterised the end of the magical world-view was its effect on public life. The transition from public to private space, hastened by the spread of the printed word and the growth of literacy, undoubtedly contributed to a new cultural ethos marked by increasingly private forms of communication and experience. At first the impact of this transition was quite trivial—for example, chairs began to replace benches and better mirrors were introduced into homes (the manufacture and distribution of silvered glass from about 1500 onwards is as accurate a register as any of the rise of individualism), but with the increase of silent reading and solitary reflection, Europe moved into a new phase. Whole new forms of expression were the result.

These forms were divided by class, a development revealed in the work of the Dutch painter Johannes Vermeer (1632-1675). One of his finest canvasses, *The Milkmaid* (c1658-1660), shows a kitchen maid pouring milk into an earthenware bowl in the corner of a simple, unadorned room. She is a working servant, and her musical tastes would have differed from those of her employers. The latter are seen in Vermeer's pictures leisurely making music in elegantly decorated rooms. They are singing, playing the virginals and a cittern; a bass viol

Plate 24. PIETRO OLIVERO. Interior of the Teatro Regio, Turin, Italy during a performance of
Arsace by Francesco Feo. 1740. 127 x 113 cm. *Oil on canvas.*
Archivio Fotografico; Museo Civico di Torino.

and guitar are also shown. The simple, overarching fact is that Art has migrated
from a shared experience to the leisured class.

It had also migrated from the home to the opera house, the great invention
and fascination of the Baroque period. From the Greek chorus to Gregorian
chant, singing had always been predominantly communal, but no sooner had the
individual broken free from the group than a new form was needed to accom-
modate the fates of solitary heroes and (although more rarely) heroines. The
process began with a group of self-conscious Florentine noblemen, scholars and
artists, who sought to recapture the emotional power that music and words had
achieved in classical Greece. These, the so-called Camerata, developed a form of
music-theatre to accommodate the solo voice. The first attempt in this direction,
the first opera, was made in 1597, when the Italian composer Jacopo Peri com-
posed music for Rinuccini's play *Dafne*.

Only ten years later Monteverdi's *Orfeo* was performed (in all probability) in one of the rooms of the Gonzaga palace in Mantua before an audience of a couple of hundred people. By 1637, the enthusiasm for opera, the most expressive and expensive of all Humanist rites, was sweeping throughout Italy: opera houses were opening to the public in Venice (for over twenty years, no less than seven different companies vied with each other), followed by other Italian cities. The chefs-d'oeuvre of Claudio Monteverdi (1567-1643) and Francesco Cavalli (1602-1676) were written and produced in the following decades. Yet from first to last, opera was a secular form of diversion. In adumbrating the fates of solitary individuals pitted against society, it was ideally suited to the profoundly individualistic, extroverted and gregarious mood of its age.

## THE RISE OF THE NOVEL

Another later but well-known reminder of the shaping power of individualism was the rise of the modern novel, a manifestation of the new consciousness in more than one way.

The invention of printing, attributed to Johann Gutenberg (*c*1397-1468)—his Vulgate Bible was printed in Mainz in 1455—encouraged a cultural trend marked by inwardness and separation. With its invention we stand at the beginning of the atomisation of society.

The study and exploration of personality, the eventual basis of the Western novel, was a marked trait from the earliest years of the Renaissance. Both Dante and Boccaccio permanently influenced later forms of narrative, fiction and drama. Dante (1265-1321) introduced new ways of presenting contemporary characters and events, while Giovanni Boccaccio (1313-1375) developed the idea of narrative fiction composed of multiple plots. His *Decameron* (1353), the first proto-novel, appeared only a few decades after the painter Giotto was developing proto-perspective, and both set their characters firmly upon earth. As with Massacio's approach, the principle implicit in Boccaccio's literary form was that the reader and viewer enjoyed, like spectators at a play, a privileged perspective.

Chaucer (1340-1400), like his precursors, also explored new modes for the representation of the self, the metaphysical keystone of Western thought. These included the implicit subject matter of most Humanist Art: individuated consciousness. This is evident not only in one of its greatest plays, *Hamlet*, but

also in its first novel, Cervantes' *Don Quixote*, both published in 1604. Don Quixote and his squire Sancho Panza are among the greatest characters ever created, and no matter what dreamland it is that guides their actions, we are never left with any doubt that they belong to a completely recognisable society—that of sixteenth-century Spain. The novel may be a vision, a comedy, a tragedy, a searching examination of life, but it must always be peopled with individuals who, however separate, relate to one another in a realistic world.

The novel reflects this isolation, and the consequent pressure on an individual to find diversion and adventure. And one of its most important functions is to heal those feelings of division, loneliness and terror which haunt the modern soul.

## THE SECULARISATION OF MODERN LIFE

Another major feature of Humanism, implicit in its faith in human omnipotence, was its replacement of belief in the supernatural by refined sensual enjoyment: relaxation, amusement, pleasure and entertainment. This was visible not only in the calculated barbarities and intrigues of the political arena, but also in the unabashed worldliness of Renaissance man's interest in nature, beauty and luxury for their own sakes.

One primary engine of the change from a spiritual to a secular tradition was the development of a capitalist economy. The process by which money became the universal means of exchange for labour, land and commodities (including works of Art) served only to exacerbate Protestant individualism, usury and the rise of private ownership. Such tendencies were already evident in fifteenth century Florence, where Cosimo de Medici (1389-1464), who controlled one of the world's first and most successful banks, was also a collector and patron of the Arts. We also find it in an even more developed form in sixteenth-century Amsterdam, where the competitive nature of Dutch society induced for the first time the production of unsolicited work. In this city, as also in Delft, paintings began to be created in response to a market increasingly motivated by the need for relaxation and escapism. Instead of arising organically out of the communal interplay of talent and need, they began their long decline into becoming luxury commodities for those who could afford them.

## THE SECULARISATION OF PAINTING AND MUSIC

*They transform into an entertainment that which had been created for no other purpose than to produce in the Christian soul a holy and salutary sadness.*
Parisian priest on a performance of Marc-Antoine Charpentier's
*Lecons de Tenebres*[11]

Secularism had made itself felt in painting as early as the twelfth century; by the fourteenth it was already ingrained, and by the fifteenth commonplace. The profound and irredeemable consequences of this assertion is evident in the two pictures illustrated on the following page. The earliest of these is by Duccio di Buoninsegna, whom we have already met. It is again the *Maesta*, completed in 1311. The other, by Paolo Uccello (1397-1475), is one of the three panels of the *Rout of San Romano*, commissioned by Lorenzo de Medici for his bedroom in the Medici palace.

The *Maesta*, the richest and most complex altarpiece to have been created in Italy, was a massive structure painted on both sides. The front of the altarpiece showed the Virgin and Child enthroned with angels and saints. The predella showed small narrative scenes from Christ's childhood; above were scenes from the last days of the Virgin. The back was divided into over thirty small-scale scenes showing the Ministry and Passion of Christ, dominated by the Crucifixion.[9] Although Duccio and his assistants created it, they worked on behalf of an entire community. This was Duccio's starting point. More than the expression of radiant religious fervour, the *Maesta* was inspired by a complex of civic, social and political ideas. For just as Siena's artists were closely involved with the life of society as a whole, so that society was deeply involved with the works those artists produced. Some impression of the latter can be gathered from the following passage, written towards the mid-century. It describes how the painting was carried in procession from Duccio's workshop to the high altar of Siena cathedral in 1311:

The shops were shut; and the Bishop bade that a goodly and devout company of priests and friars should go in solemn procession, accompanied by the Signori Nova and all the officers of the Commune and all the people; all the most worthy followed close upon the picture, according to their degree, with lights burning in their hands;

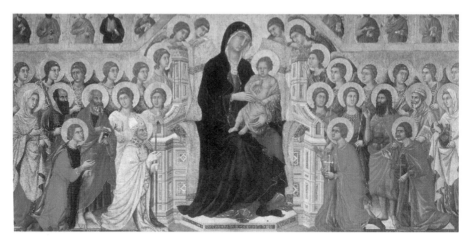

Plate 25. DUCCIO. The Virgin Enthroned with Angels and Saints (Maesta). 1308-1311. Original dimensions c500 x 470 cm. *Tempera on wood panel.* Museo dell'Opera del Duomo, Siena, Italy.

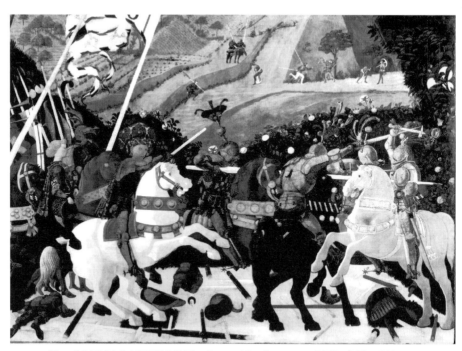

Plate 26. PAOLO UCCELLO. The Rout of San Romano. c1450s.. 182 x 320 cm.
*Egg tempera, perhaps with some oil, on poplar.* National Gallery, London.
Reproduced by courtesy of the Trustees, The National Gallery, London.

and then behind them came the women and children with their great devotion. And they accompanied the said picture as far as the Duomo, making procession around the Campo as is the custom, all the bells sounding joyously for the devotion of so noble a picture as this. And all that day they offered up prayers, with great alms to the poor, praying God and his Mother, who is our advocate, that He may defend us in His infinite mercy from all adversity and evil, and that He may keep us from the hands of traitors and the enemies of Siena.[12]

Although there is no definite date for the completion of Uccello's three panels, it is generally believed that they were begun after 1451, when the Medici Palace had been virtually completed. But unlike the *Maesta*, commissioned by the Cathedral authorities, the battle scenes were commissioned by an individual. There is, of course, an élitism in this private act. Only people who did not have to worry about where the next meal was coming from had time to devote to the disinterested contemplation of aesthetic form. Access, too, would have been limited to invitation.

The two paintings, one sacred, one secular; one based on symbol and analogy, the other proceeding from the assumption that only the visible is real; one devotional, the other heroic; one created for a civic community, the other for a private individual; one destined for a great public building symbolic of the civic pride of Siena, the other for a private bed-chamber; one glorifying the Queen of Heaven, the other, a recent historical event and the captain of a victorious battle; these two works are emblematic of the transformation wrought by Humanism in the Quattrocento.

At this time, only one in twenty paintings was painted with a non-religious subject. A century later there were five times as many works with secular subjects. Two centuries later, secularisation had become ubiquitous even within the Church itself. In 1727, Pope Benedict XIII donated twelve paintings to S. Maria degli Angeli, constructed above the Baths of Diocletian; Michelangelo had incorporated some of its ruins into his design for a church. With the Pope's gift, the building entered a new chapter. A Temple dedicated to God was transformed into a Temple dedicated to Art.

Much the same transformation later occurred in the musical field, where composers were quick to adapt themselves and subscribe to the growing secularism of the new Humanist faith. A century after the completion of Uccello's

panels of *The Rout of San Romano*, they were managing to straddle two inde-
pendent worlds: Church and court, public and private, sacred and profane, in
some kind of equilibrium. Orlande de Lassus (1532-1594), for example, worked
as a *maestro di capella* of the Bavarian court, where he composed some 70
masses and 100 magnificats, but at the same time over 400 Italian madrigals, vil-
lanellas and lieder. Palestrina's output reveals much the same balance of sacred
and profane. Yet fifty years later, when disruptive dissonance had enfeebled both
vocal modality and polyphonic unity, the sacred tradition was in rapid decline.
This revolution exactly complements the final acceptance of the Copernican sys-
tem, which by about 1600 was unequivocal.

## 'OUR ART IS ALL IMITATION OF NATURE'

The convergence of the open market and private ownership engendered two fur-
ther developments. One of these was the demand for innovation, which in both
Art and science became part of the impulse of modernity. The second was the
development of oil paint to represent the sensuality and lustre of what it repre-
sented. 'It defines the real,' John Berger observed, 'as that which you can put
your hands on.'[13]

As early as the mid-fifteenth century the quest for naturalism had become
something of an obsession; for the most 'advanced' painters and sculptors of the
generation of 1420, the literal rendering of the outside world according to the
principles of human reason was already the pre-eminent aim. According to the
painter and author Giorgio Vasari (1511-74), Uccello was so obsessed that he
would stay up all night studying vanishing points, ignoring his wife's calls to
come to bed.

Alberti, the theoretician of the Italian movement, was the first to give expres-
sion to this pursuit. In *Della Pittura* he writes, 'the function of the painter (is) to
render with lines and colours, on a given panel or wall, the visible surface of any
body, so that at a certain distance and from a certain position it appears in relief
and just like the body itself.'[10] Alberti was so serious about his commitment that
he cited the example of Narcissus as the first painter, since his image reflected in
water was an exact likeness of himself on a flat surface.

In this matter Alberti was unequivocal. At no point did he ever include in his
definition of the Arts any reference to the deity, let alone the multiple layers of

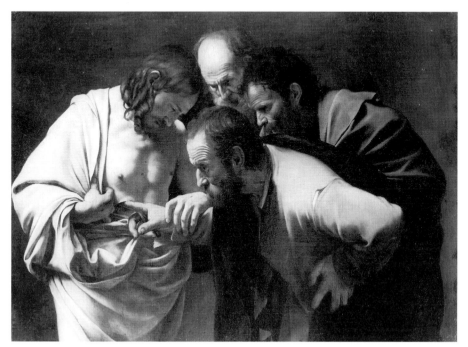

Plate 27. CARAVAGGIO. Doubting Thomas. c1600.
*Oil on canvas.* Sannouci Picture Gallery, Potsdam.

meaning inherent in the symbol; it was always framed in human terms with an emphasis on the rendering of the external world according to the principles of human reason. The rendering of 'reality' had to be solely one-pointed and literal. 'The arts,' he asserted in *De Statua*, a pamphlet on sculpture written in 1463, 'are learnt by reason and method; they are mastered by practice.' A century later, Vasari also believed that the foundation of any theory of painting should be based on the imitation of nature. One of his highest forms of praise was to say that the figures in a painting were so natural that they seemed alive. In the preface of his *Lives of the most excellent Italian Architects, Painters and Sculptors*, first published in 1550, Vasari writes: 'Our art is all imitation of nature.'[14]

In such a culture material values become paramount, beginning with omnipotent wealth and ending with the values which satisfy man's psychological needs and material comfort. This leads to an increasing neglect of the eternal values, which come to be replaced by temporary, or short-lived, considerations.

From generation to generation we can follow this process: the gradual disappearance of gilded backgrounds, suggestive of non-physical being, and their replacement by a style freed from any supersensory symbolism. From the middle of the sixteenth century there is a steady movement away from the tranced stillness and numinosity of such masters as Simone Martini (c1284-1344) and Ambrogio Lorenzetti (active 1319-47), towards an Art based on the study of sensory phenomena.

An enthusiastic embrace of this life as the stage for a full human drama finds expression in Caravaggio's (1573-1610) *Doubting Thomas* (c1600). With one of the apostles poking a finger into a wound in Christ's side to make sure it is really there, the painting can be seen as a metaphor for the reductionism and the materialism of his age and ours.

## THE TURN FROM THE SUPERNATURAL IN ARCHITECTURE

In 1418, when Brunelleschi was forty, the *Operai* (overseers of the works) of Florence Cathedral announced a public competition for its dome, to which masters from all over Italy were invited. Brunelleschi, who had just finished examining and measuring ancient buildings in Rome, entered the competition. He won with a design of surpassing audacity and courage.

The dome remains a wonder, as do Brunelleschi's other buildings. The first to be designed (it was erected between 1414 and 1424) was a work of memorable clarity: the loggia of the Foundling Hospital, the Spedale degli Innocenti. The lucidity and purity of its design is also to be found in the interiors of his two Florentine churches, the Basilica of S. Lorenzo and the Church of S. Spirito. In both, the procession of pillars upholding a rhythmic train of round arches, the continual play of basic forms and the logical clarity of the variations—of square against round, deep against flat—are perfect expressions of an attitude so largely dominated, as it was, by purely abstract and rational concepts.

A clue to the character of this Apollonian architecture may lie in the intensely clear and beautiful light which floods each interior; this, one senses, is a daylight world from which all mystery—except the mystery of harmonic proportions—has been deliberately expunged. The same perfect, if impersonal, balance; the same orchestration of space in depth; the same reserve and lack of feminine qualities; all speak of the subjection of the deeper dimension of ourselves in

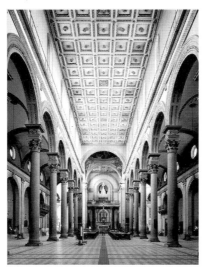

Plate 28. FILIPPO BRUNELLESCHI. S. Lorenzo. 1421-28. Florence
The Conway Library, Courtauld Institute of Art.

the interests of the new philosophy. In both these churches and in Brunelleschi's
Pazzi Chapel at Santa Croce (*c*1430), there is no sense of the illimitable. Logical,
light-filled, calm and exhilarating they may be, but awesome, visionary, holy,
they are not. As early as the first decades of the fifteenth century, anything that
could not be understood by the rational mind was dismissed as irrelevant or non-
existent.

A yet more telling symbol of this subjection of the unseen dimension of soul
can be found in Brunelleschi's unrealised conception for the first true centralised
church of the fifteenth century: the oratory of S. Maria degli Angeli (begun in
1434 but left unfinished in 1437). In the Gothic cathedral, the faithful press for-
ward under the soaring vaults to reach their transcendental goal; in the cen-
tralised church, man is the subject: 'the measure of all things'. At the centre of
the scheme he can experience no encounter with the holy. In this and other cen-
tralised Renaissance buildings—the church of Santa Maria della Consolazione
outside Todi, Bramante's designs for the Tempietto (1502) in Rome and St
Peter's—structures of personal consciousness had been substituted for transcen-
dental and cosmic ones. The function of Art is now to mirror humanity and
deepen awareness of the human condition.

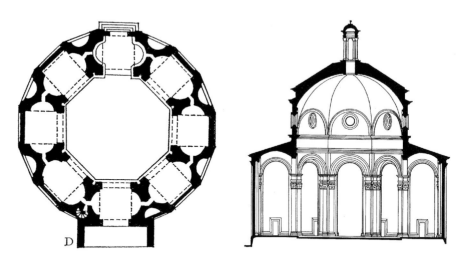

Plate 29. FILLIPO BRUNELLESCHI. Plans for S. Maria degli Angeli, Florence.
1434-7.

These buildings by Brunelleschi were the starting point of the revival of classical architecture in Europe. What seems curious was the suddenness of it, and its pervasive influence. Across Europe and America, from the Palazzo Farnese in Rome (1530-48) to the Hermitage in St. Petersburg (1754 onwards), to the Pantheon in Paris (1755-92), to Monticello in Virginia (1796-1806), the architecture of Humanism reigned supreme for four hundred years and even longer. Yet although often masterly, it lacks a full and heartfelt sense of the sublime. It does not posit any supersensory value behind the sensory forms. It does not precipitate in the soul a movement towards sanctity.

Take, for example, perhaps the most influential church design of the last four hundred years: the Gesù in Rome (1568). Its architect, Giacomo Vignola (1507-73), combined in his ground plan the central idea of the Renaissance with the longitudinal scheme of the Middle Ages. Following Alberti's Tempio Malatesta (see Plate 32), he conceived a facade (later adapted by Giacomo della Porta) that was subsequently repeated literally hundreds of times in other Baroque churches. The Gesù's interior is no less brilliant. Entering the church, the worshipper is overwhelmed (as it is intended that he should be) as much by its gold and precious stones as by the nave ceiling, painted with a vast fresco, *The Triumph of the Name of Jesus* (1672-85), composed of hundreds of tumbling figures rising

into the golden empyrean. Heaven here is theatre, but alas not real. The simple candle-lit interior of another Roman church, S. Maria in Cosmedin, which comes from—and goes to—the heart, is a more movingly exalted bridge between man and God.

## THE CONTROL AND DOMINATION OF NATURE

With Humanism, a series of technical advances facilitated opportunities for daring adventure and economic intercourse. Not only did the earth and the skies lie open to systematic investigation as never before, but another form of exploration concerned with the understanding, utilisation, and control of natural forces, originated at this time. So did the peril of numbers, stampeding with a mad geometrical progress over all forms of life. This included orderly time-keeping, space-measuring, account-keeping and mathematical laws. From the seventeenth century, the clock became a metaphor for the universe.

Iris Murdoch once suggested that to understand any philosopher's work we must ask ourselves what he or she is frightened of. So I ask: why did the desire to control nature come into existence at this time? And why, from the first exploration of the perimeter of Africa by the Portuguese in 1444 to the 'opening up' of the world's land masses in the nineteenth and twentieth centuries, has every century been dominated by *domination*—by slavery, economic pillage, conquest and the expansion of power? If only I could discover what terror lay behind these histories, what drove the European to sacrifice the traditional social order in the interests of greed and growth. I do not know, except that it had a great deal to do with the path to omnipotence implicit in Humanism.

### THE ART AND SCIENCE OF CALCULATION
### AND CONTROL: PERSPECTIVE

*When I say 'modern period,' I am talking about the stretch of time from the Scientific Revolution—say, the mid-sixteenth century—to the present. A whole series of disciplines has grown and flourished over the last four hundred years. Alchemy gave way to chemistry, astrology to astronomy, mythology to psychoanalysis, and, as noted, storytelling to professional academic history. Most of us*

*would agree that this shift represents an increase in our mode of understanding the natural and social world, specifically a gain in what we call 'objectivity.' And the essential feature of this mode of understanding is that of psychic distance, the existence of a rigid barrier between observer and observed.*

Morris Berman[15]

From Dante to Galileo, one aspect of the above-mentioned curiosity took the form of the exploration and mapping of space. In the *Divine Comedy* (1310-14) Dante gave such a minute physical description of the universe that even the measurements of Hell were calculated from it. The heavens were also explored by the great mathematician Paolo dal Pozzo Toscanelli (1397-1482), who inside the Cathedral of Florence devised the first meridian, or gnomon, for measuring the exact position of the sun during the summer solstice. From Toscanelli's astronomical calculations new maps were to be made, which later guided another Florentine, Amerigo Vespucci, and his celebrated contemporary Christopher Columbus (1451-1506), to the New World.

Given this obsession for space, calculation and control, it was probably inevitable that the art and science of perspective should have originated in Florence. Its discovery in or about 1410 is attributed to the sculptor, engineer and architect Filippo Brunelleschi, whose work we have already discussed. A few years later, Brunelleschi's elegant linear system was formulated in more practical terms by Leon Battista Alberti, who made extensive use of Euclidian principles in order to instruct Artists in the new technique. Brunelleschi's discoveries, experienced directly or relayed through Alberti, were to find their most vividly imaginative response in the paintings of Masaccio and the sculptures of Donatello, but the invention of perspective did more than enable Artists to represent the third dimension on a two dimensional surface. The mental and psychological attitudes it induced stimulated new ways of thinking and behaving. With it we stand at the beginning of that paradigm of thought that impels us to measure and organise the world for our own convenience and to do so as detached, impersonal observers.

Prior to this time, there had been no conception of space existing in its own right; the word 'space', in the sense of the interval or emptiness between objects, did not come into common use in the English language until the fourteenth century. As the art historian Suzi Gablik has observed, it is 'the lack of any observer (indicating an awareness of self as distinct from things, and a differentiation of

Plate 30. ANONYMOUS. Woodcut illustration from Johann II of Bavaria and Hieronymous
Rodler's *Ein schoen nuetzlich Buechlein und Unterweisung der Kunst des Messens.*
Simmern, Germany. 1531.

self and world) which accounts for the lack of depth in pre-Renaissance art.
Figures move about freely between natural and visionary spaces, but they only
move up and down. Renaissance space, by contrast, is architectonic and envi-
ronmental. Objects are disposed from a fixed point of view, relative to an ideal
observer, in a single moment of unified time.'[16]

Central to an understanding of this condition must be an awareness of per-
spective's basic premise: that of the detached, unmoving observer standing at a
physical remove from the picture plane and therefore alienated from the world.
The elements of this equation are illustrated in the German woodcut shown
above: there is the window which separates the observer from the world, there is
the observer and the object of his vision, the landscape beyond the room.

In several respects the print and the Dürer engraving (Plate 31) have certain
attributes in common. In both, the Artist proceeds on the assumption that only

Plate 31. ALBRECHT DÜRER. Artist Drawing a Nude through a Gridded Screen. *Engraving.*

the visible is real and that his relationship to the world is a purely objective one. He is a recorder rather than a participant, a voyeur rather than a lover. The point is an important one if we are to understand the relationship of the science of perspective to that of the scientific world-view. It is the genesis of what has become a more general condition: an analytical vision which decomposes the whole into parts so that it can more readily master the external world.

Camouflaged by its quaint context, its historic date, and seemingly innocuous subject matter, the woodcut illustration belies the fact that it is a metaphor for the distance we have put between ourselves and the world, between our senses and the world of which they make sense.

In Albrecht Dürer's (1471-1528) engraving of the *Artist Drawing a Nude through a Gridded Screen* (see above), we can observe a similar alienation. Here, the human body, with its erotic and sensuous tie to things, has already been abandoned, while the fixed eyes of the Artist, gazing with an intense, narrow, focused attention are now dominant. The fixed gaze is the abandonment of the body, and what begins here as a spectating eye cut off from movement, will become the style of self divorced from the living body of nature. These eyes are indeed important: they are, I suggest, the necessary prefiguration for an ethics of domination and control. They stand apart from nature and from all active participation. They accept the idea of a world purified of qualities; a world held at a distance and removed from our sensuous engagement. They are paradigmatic of the domination of the earth through the controlling scrutiny of an overseer for whom control at a distance is the primary source of knowledge.

The great ecological issues of our time have to do, in one way or another, with this condition of psychic distance. Our current inability to respond to the world erotically, our difficulties in seeing things whole, our commitment to abstractions and the isolated metaphysical self, all have their roots in perspective-vision—or, more accurately, to the cataclysmic inrush of secularisation and the craving for psychological security, which led to its invention.

## THE EXERCISE OF CONTROL
## IN COMPOSITION AND PERFORMANCE

Individualism and the control of nature, which lie at the heart of perspective and the modern scientific paradigm, similarly affected the composition and performance of music. As soon as the new concepts began to be accepted, the acoustically illogical and non-harmonic sounds of mediaeval instruments—the bells, drums, rattles, crumhorn, racket, bagpipe and sackbut—started to become increasingly unacceptable. In due course percussion was also excluded from the orchestra, until towards the end of the seventeenth century, when timpani, able to be tuned to a pitch, were re-admitted. At the same time new instruments such as the violin family and the keyboard, sustaining the bass line that generated harmony, all grew in acceptance. Throughout the sixteenth and seventeenth centuries the virginals were also popular; the modern piano was introduced in the first decade of the eighteenth. All these favoured individualism, rather than the co-operative music-making of, say, the late sixteenth century, the age of the English madrigals.

Today we take control and individualism so much for granted that we are unable to see the extent to which unseen Humanistic assumptions determine the form and nature of music-making. For example, outside the traditions of jazz and rock (and the music of such composers as John Cage, Morton Feldman and Witold Lutoslawski), conductor and performers always know exactly where they are within a performance. The eighteenth-century composer knew his way through the form of a sonata and understood how each element logically related to every other, and to the musical structure as a whole. European music also tended to be linear, in that functional harmony always drove it somewhere—to the next moment, and ultimately to the final tonic chord.

A similar, albeit unconscious, deference towards control can be found in the

fact that Western musical performances are normally placed within a double frame—a spatial and a temporal frame—designed to regulate and distance the listener's experience. Thus we take it for granted that Western music is performed in buildings set aside for the purpose, that performers and audience are carefully segregated, that the average concert consists of a prearranged sequence of works designed to last for a predetermined time and that the concert-goer will know his exact place in the auditorium, what he has come to hear, what movement he is listening to and approximately when the performance will end. Yet control does not end here. However excited he feels, he must barely move, never speak, and may not in any way participate in the performance.

This is the Western style, so normal, ubiquitous and unquestioned, that we take it for granted that there is no other way of making and listening to music. Indians, Africans, Kurds, and Berbers would not agree. Music for them is collective and responsorial, largely improvisatory, a shared potency rather than a private delight.

## WESTERN ART AS AN ABERRATION FROM THE NORM

In the context of the contrast between the Art of Humanism and that of vernacular societies, John Blacking, who studied the musical abilities of the Venda in Northern Transvaal, has raised a question which has been too often ignored: must the majority be made 'unmusical' so that a few may become more musical?

> If, for example, all the members of an African society are able to perform and listen intelligently to their own indigenous music, and if this unwritten music, when analysed in its social and cultural context, can be shown to have a similar range of effects on people and to be based in intellectual and musical processes that are found in the so-called 'art' music of Europe, we must ask why apparently general musical abilities should be restricted to a chosen few in societies supposed to be culturally more advanced. Does cultural development represent a real advance in human sensitivity and technical ability, or is it chiefly a diversion for élites and a weapon of class exploitation?[17]

A musician from another culture would be perplexed to witness the stifling nature of European performance conditions, the strait-jacket of fixed notation

and the general isolation of concert music from the other Arts. He might also be startled to discover the aesthetic and secular orientation of Western Art and the non-physical nature of musical appreciation. For if its music has achieved unparalleled heights of expressiveness, it is no more than a convenient fiction to believe that this has been acquired without a calamitous cost. In cherishing originality and individual creativity above virtually everything else, in regarding music as a self-contained practice and product to be contemplated for its own sake but only at special times and in special places set aside for the purpose, Art music has been banished from the lives of all but a small minority. The irrelevance of Mozart to the craftsmen who built the new opera house at Glyndebourne, or of Piero della Francesca to those who built the extension to the National Gallery in Trafalgar Square has never been attacked or redressed by those enriched by a culture that favours the rich and the educated. Better, it seems, to keep the populace in conditions of emotional and expressive passivity, that they may become both more malleable and dependent on consumption.

Thus for these workmen and their contemporaries, the voice of the poetic imagination and its unaffected enjoyment as an everyday occurrence is almost certainly absent; for them, music undoubtedly exists but it is rarely their own—it has been made for them to purchase and consume. By contrast, say what you will about the tribal societies, the record shows that they put in on average maybe four hours a day per person on tasks of hunting, gathering and cultivating, the rest of their time being devoted to song, dance, ritual, sex, eating, stories and games. I find it comforting to know that for some of the least 'developed' on this planet, music continues to be regarded as one of the skills of staying alive and well.

## EFFECTS OF THE PRINTED SCORE

The introduction of music printing from movable type which began about 1473 was only one of the factors eroding the immense repertoire of traditional or folk music. In place of the musical processes that involve cumulative experience, democratic co-operation and reciprocal intercourse with others, Humanism gave absolute power to the Baroque prince, the architect and the composer. Like the former, the latter increasingly acted alone, commanding unqualified obedience and regulating every note of his compositions. Thus the old conception of the score as

a recipe for performance to be altered at will was replaced by a concept of textual authority. 'Do not interpret my music,' the imperious Ravel instructed a young pianist, 'simply play what I have written.' Such totalitarian power induces not only arrogance but disdain for the less creative, as a remark by the composer Arnold Schoenberg illustrates: 'I have as little consideration for the listener as he has for me. All I know is that he exists, and in so far as he isn't indispensable for acoustic reasons (since music does not sound well in an empty hall) he's only a nuisance.' The awful truth that must lie at the heart of our idea of Art is that inequalities must exist and persist, in fact must grow. Individualism carried to the present extreme is inherently disregardful of the collective human fate.

## THE DESTRUCTION OF ORGANIC COMPLEXITY
## AND THE RISE OF THE ARCHITECT

In at least one respect, the architecture of Humanism was influenced by the same absolutism as a means of achieving and maintaining control. The workings of such minds was visible in the buildings and cities of the Renaissance: structures designed by architects, working in the service of an autocratic authority, according to a predetermined plan ready for instant execution.

The design and construction of Leon Battista Alberti's Tempio Malatestiano, illustrated on the next page, is an example of the now-familiar autocracy of the architect. Alberti, who was one of the most versatile talents of his age—a musician, mathematician, philosopher, playwright, athlete and influential theorist—believed that the design of the perfect building could only be achieved by virtue of reason, method and measurement, with nothing left to intuition or chance.

He designed a number of buildings: a palace in Florence, the facade of S. Maria Novella and churches in Mantua and Rimini. The latter, for the tyrant Sigismondo Malatesta, was realised at a distance and by correspondence with his assistant, one Matteo de' Pasto, to whom he left the actual construction.

According to John James, the key to the unity of the mediaeval cathedral lay in a method which made the permanent architect unnecessary. 'Having to start every operation from the existing stones,' he writes,' bred a sympathy for the work of one's predecessors.'[18] The cathedral, then, had no one designer and no initial master plan but was evolved by a cavalcade of masons responding on site to the location, the history, the materials and the common interests of the people who used

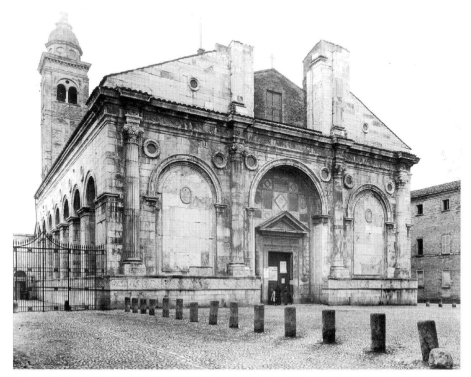

Plate 32. LEON BATTISTA ALBERTI. S. Francesco (the Tempio Malatestiano). 1446 onwards. Rimini, Italy. The Conway Library, Courtauld Institute of Art.

the building. Major buildings grew organically with revisions, adaptations, happy second thoughts and innovations introduced by later generations, all contributing to the final construction. 'It was a process rather than an act, in which decisions came from the immediate situation rather than an exactly premeditated plan.'

William Blake, commenting on Virgil in 1820, summarised the distinction between Gothic and Classical architecture: 'Grecian,' he wrote, 'is Mathematical form: Gothic is living form, Mathematic Form is eternal in the Reasoning Memory: Living Form is Eternal Existence.'[19] Thus one can see that, at least in Blake's mind, there is no essential difference between Gothic architecture and the metaphysical world of India's sacred architecture, based on symbolic and formal principles common to all the spiritual traditions.

The Minakshi Sundareshvara temple in Madurai, one of the largest Hindu

temples ever built, is a case in point. Here, in contrast to the Humanist esteem for the one polarising element in omnipotent control of the entire project, no records of its chief architect, its superintendent of works, its head stoneman and chief image-maker—a sutradhara—have been or are ever likely to be found. The suppression of the artist's personality was considered essential to the success of the creative work. As at Chartres, meaning here was primary, aesthetics only secondary.

Before concluding this chapter, I ask the reader to set aside at least some of the Humanist excesses I have ventured to trace. To set aside its quest for individualism which has led to the destructive atomisation and disintegration of communities. To set aside its scorn for the sacred which has led to the defilement of everything. To set aside its paranoiac need for control and domination which has led to the planet's degradation, much of it forever, even the furthest seas and lands. I ask the reader to balance these with the nobler parts of Humanism which include Masaccio's *Trinity*, Brunelleschi's Foundling Hospital and Shakespeare's *Hamlet*. Humanism is just beginning to get the kind of public scrutiny and intelligent criticism it needs, and that will allow people to make their own assessment of its strengths and weaknesses. With, I admit, the advantage of hindsight, in this chapter I have tried to consider the foundations on which our present assumptions about Art have been evolved; but nonetheless in writing it I have never been able to forget the ability of our Art to transcend and ennoble human frailty and, too, its capacity for exalted pleasure. In the next chapter I will attempt an understanding of other characteristics of the Art of Humanism, and also present criticisms of those alert to the dangers of its unquestioned faith in reason, and its refusal to recognise the dangers inherent in the idea of transcending limits.

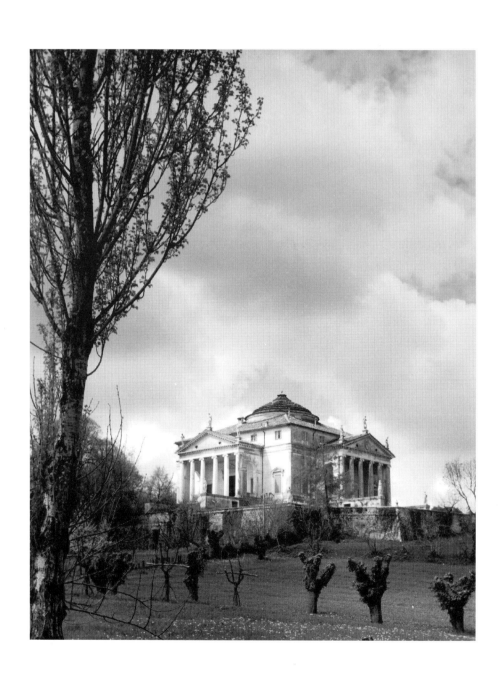

CHAPTER FOUR

# FROM HIGH NOON TO SUNSET

## THE ARTS OF THE SCIENTIFIC WORLD-VIEW FROM THE HIGH RENAISSANCE UP TO THE MIDDLE OF THE NINETEENTH CENTURY

BETWEEN THE SIXTEENTH CENTURY and the end of the Enlightenment, a new kind of man began to emerge in Europe. Unshakeable in his belief in the ascendancy of Western civilisation, in the European hegemony and the proud superiority of the masculine, he was, in all essentials, secularist in spirit. Mathematicians and scientists, explorers and entrepreneurs, were the figures he admired. A note of brisk rationalistic optimism runs through all the painted portraits of him.

Yet although it conferred status, for the nobleman, the merchant, banker and intellectual, Art was entirely secondary. Power, money and the things that money could buy were now his primary objectives. These attitudes are now taken so much for granted that we ourselves are unable to imagine an age not ruled by accumulation, titanic ambition, unlimited growth and the application over others of egoistic power.

## MICHELANGELO: THE PROMETHEAN MAN

Although the walls of our Art galleries and country houses are crowded with images of the new man, Michelangelo Buonarroti's (1475-1564) gigantic, free-standing statue of *David* (1503-4) was an early warning of what was to come.

There was, of course, nothing new about the heroic figure. From Achilles to mighty Paul Bunyan, folklore and literature abound with accounts of extraordinary beings. But with only a few exceptions these beings were not of our making; they were fashioned by nature or the gods, and like other mortals they had no

Plate 33. ANDREA PALLADIO. Villa Rotonda. 1550-1. Near Vicenza, Italy.
Photo: Edwin Smith.

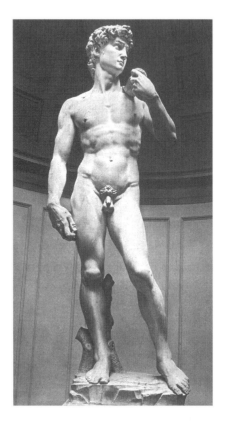

Plate 34. MICHELANGELO. David. 1501-4. Marble.
Galleria dell'Accademia, Florence.

ability to fashion life according to their own specifications. The *David*, carved for the new Republic as a symbol of its strength, is subtly different. In him there is a self-aggrandising manner; a mood of self-possession, masterful assertion and heroic self-reliance. He stands alone, defiant, messianic; he faces an empty world, he owes nothing to any man, he will be triumphant against all odds. His adolescent's cold, vain stare, strained, defiant neck and narcissistic love of his own strength, seem to elevate the human to new levels of autonomy and omnipotence. We stand at the beginning of the hubristic modern age.

Interestingly, but perhaps unexpectedly, something of the figure's narcissism characterised Michelangelo's attitude to his own work. Unlike the co-operative

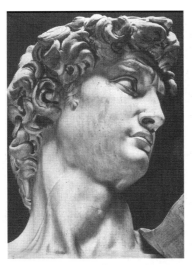

Plate 35. MICHELANGELO. Head of David. 1501-4.
Galleria dell'Accademia, Florence.

and interactive procedures of earlier periods when famed artists worked along-side assistants, he went out of his way to maintain a distance from his community. Vasari, his biographer, tells us that the sculptor of *David* 'began (the carving) in the Opera Sta. Maria del Fiore where he made an enclosure with the wall and with boards so as to surround the marble, and he continued to work on it so that no one could see him until he had brought it to perfection.' The path of purity patterned on a model of separation from the practices of everyday life has become such an ingrained feature of our understanding that the audacious impertinence of the method Michelangelo initiated has lost its power to astonish us. Embedded in his action, as well as in Humanism itself, is a subtle and far-reaching fiction concerning the autonomy of the self.

The statue of *David* (or at least a copy of it) stands today in Florence's historic centre, the Piazza della Signoria: it is a huge and dominating figure. This magnification of human importance is in dramatic contrast to the size of human in the Japanese landscape pictures painted by the Zen monks and artists of the fifteenth century.

These pictures are of mountainous lanscape seen from the viewpoint of one who has climbed to high places and now looks back and down on the panorama below him, and up to the heights still ahead. Vast cliffs and peaks soar in the

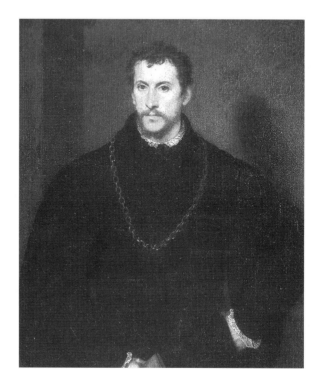

Plate 36. TITIAN. Portrait of a Man (so-called 'Young Englishman'). c1540-45. 111 x 93 cm. *oil on canvas*. Galleria Palatina. Palazzo Pitti, Florence.

background; a river or lake may flow through the scene. Yet the *tiny* figures—sometimes so small that it takes a few minutes to identify them—in this tremendous setting suggest the relative importance of man in the cosmos.

## TITIAN'S PORTRAITS OF THE NEW MAN

'Our modern view of reality was purchased at a fantastic price,' writes Morris Berman. 'For what was ultimately created by the shift from animism to mechanism was not merely a new science, but a new personality to go with it.'[2]

If features of this personality had been disclosed in Botticelli's *Portrait of a Young Man*, a later, more worldly, complex and mature interpretation is to be

found in the series of about a hundred oils painted by Titian (c1488-1576). These are the portraits of the first and second generation of Humanists—'the firstborn among the sons of modern Europe', as Jacob Burckhardt called them.[3] A distinguished example is the *Portrait of a Man*, sometimes called *The Young Englishman*, painted in 1545, almost sixty years later than the Botticelli.

On no occasion did Titian's portraits fail in verisimilitude; with the detached curiosity worthy of the new science, he presented the amiable gravity, the easy elegance and hubris of his contemporaries. Yet if the sitter for the *Portrait of a Man* has remained unidentified, it is obvious that he belonged to that class that was to rule Europe until the end of the eighteenth century. As such he was the model of those who patronised, amongst others, Bach, Bernini, Gainsborough, Haydn, Holbein, Le Nôtre, Palladio, Rameau, Rubens, Telemann and Velasquez. It was their tastes, their expectations and their money that were to mould the Arts of Europe for over three centuries.

So much may be implied, yet it is fascinating to consider how much he knew about the events taking place in his lifetime. Had he read, for example, Copernicus's *De Revolutionibus Orbium Coelestium* ('On the Revolution of the Celestial Orbs'), promulgating the heliocentric theory of the solar system, which had been published two years before the generally agreed date of the painting? Was he aware of the newly discovered continents? Did he know about Luther's rebellion against the Catholic Church? We shall never know. Yet, even if had been ignorant of these events, his portrait suggests that he possessed, in however rudimentary a form, a consciousness broadly similar to our own.

## PALLADIO, MATHEMATICS AND THE UNIVERSAL DESIGN

A decade later Andrea Palladio (1508-80), Titian's contemporary and the most influential architect of the High Renaissance, also found the current of his time flowing in a secular direction. Himself a deeply religious man, Palladio received but nine commissions for churches and monasteries as against a total of thirty-five for villas, palaces and public buildings.

One of these, the famous Villa Rotonda in the countryside around Vicenza was designed by Palladio for a wealthy client, a retired Monsignore who used it for parties. With its slender Ionic porticoes, its uniformity of plan, its centralised

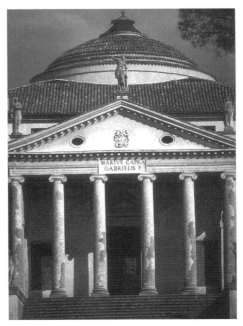

Plate 37. ANDREA PALLADIO. Villa Rotonda. 1550-1.
Near Vicenza, Italy.

design, its carefully placed few pedimented windows, it remains one of the happiest and most serene of Europe's secular buildings; it was also the first where husbanded landscape and building were conceived as belonging to one another in a kind of symbiotic relationship. The Humanist always looked on nature with suspicion unless it had been first tamed by man.

Yet the major achievement of the Villa Rotonda is its unrivalled lucidity of design. The architect's Humanist faith had taught him that the supreme order that permeated God's creation could and should be 'imitated' in the creations of man. For example, in his design for the Palazzo Chiericati in Vicenza (1550) Palladio created a building whose proportions corresponded to musical harmonies as measured in distances of a monochord: a fifth, unison, a major sixth and two octaves. Knowledge of the link between music and architecture came from Pythagoras, and had been introduced by Alberti into architectural theory a century before. To Palladio and his contemporaries it indicated a universal design, and a validation of their philosophy.

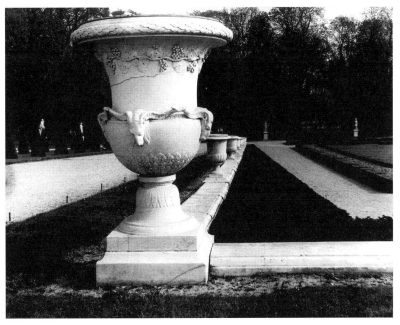

Plate 38. ANDRE LE NOTRE. A corner of the Gardens at Versailles. 1661-1667 onwards.
Photo: Peter Burton.

Thus in their search for abstract principles—their employment of harmonic and proportional relationships, their concern for measure and insistence on mathematics—Palladio, like those of his contemporaries who sought to reflect in their work the new cultural shift, were as much the children of their time as either Galileo or Francis Bacon.

## THE GARDENS AT VERSAILLES AS AN ICON OF MAN'S RULE OF NATURE

The new philosophy, with its untroubled belief in the efficacy of human control, similarly inspired the gardens of the Palace of Versailles, designed by Le Nôtre (1613-1700) for Louis XIV, the most absolute of the European monarchs. Le Nôtre's grand conception expressed absolutism: the king's absolute rulership over France, man's rulership over Nature and the subordination of both to his rule.

Only two decades before Descartes published one of the most famous texts in the French language, the *Discourse on Method* (1637), and his *Principia Philosophiae* (1644), which gave expression to the same belief in mathematics, absolute certainty and commitment to reason which guided Le Nôtre's concept of design, a vast team was employed on the unprepossessing country of marsh and forest near the village of Versailles. In point of fact the elimination of chance was a precondition of Le Nôtre's working methods. For him—as for his contemporaries—nature had to be tamed and forced into a pattern suitable for man's use and to the ideas of order on which he now depended in this, the most highly regulated of societies.

The rationalism which underlay Corneille's (1606-84) poetry, Colbert's economic plans or François Mansart's (1598-1664) architecture, was the basis of the designs for the gardens of Versailles laid out as a paean of homage to Euclid's postulates and, indirectly, to the spirit of the strict mathematics of Newton's *Principia Mathematica*, published in 1687. Thus nature was symmetrised to serve the greatness of a king whose bedroom window, positioned in the exact centre of the palace facade, looked across to a vanishing point on the distant horizon some three-quarters of a mile away. The gardens were planned with vistas; tall, trimmed, hedges cut to regular, predetermined, shapes; paths following geometrical patterns; seemingly endless parallel and radiating avenues and walks and fountains flowing along prearranged channels.

Yet, in all this activity, manned by thousands of labourers and soldiers— many of whom died of disease—there seems to have been something especially modern about the attitudes and methods employed. 'Who could help being repelled and disgusted at the violence done to Nature?' wrote Saint-Simon, the sanest amongst those who had fallen under the spell of power; a power which, when exercised without constraint, not only destroys and degrades nature but endangers social stability across the globe.

## 'THE IDEA OF SENSE, ORDER, PROPORTION' EVERYWHERE

Something of the same modernity is found in Le Nôtre's contemporary, the painter Nicolas Poussin (1593/4-1665), who had visited Paris at the command of the king and Richelieu, about a decade after he had painted in Rome some can-

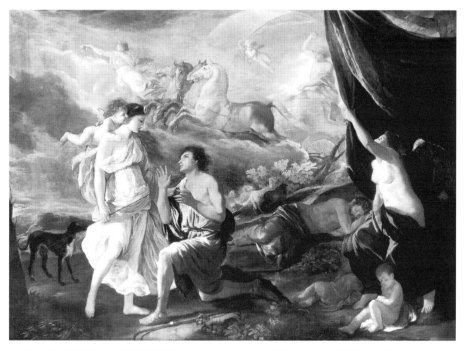

Plate 39. NICOLAS POUSSIN. Diana and Endymion. 1630. 121.9 x 168.9 cm. *Oil on canvas.*
© The Detroit Institute of Arts. 1995. Founders Society Purchase,
Membership and Donations Fund.

vasses based on mythological themes. With their sensuous colour, erotic themes and poetic spirit, the stories of Bacchus, Narcissus, Apollo and Daphne, Venus and Mercury, are amongst the finest he ever achieved. *Diana and Endymion* (c1630) is one of the most beautiful.

It is dawn. Aurora, followed by Apollo in his horse-drawn chariot, hot and golden in the melting light of the rising sun, sprinkles rose petals across the sky. The winged figure of Night, in a sweeping gesture, draws the curtain of darkness out of sight. At Night's feet are two putti, Sleep and Death; behind them, recumbent on the bare earth, Somnus lies asleep. Yet important as these figures are, their significance is dwarfed by the presence of the goddess of the moon and her mortal lover, Endymion, the latter doubly flushed by love and the soft glow of the morning light. Diana, her draperies fluttering in the wind, is saying goodbye to Endymion who kneels enraptured, submissive to her power, in a pose that

seems to adore and implore. Like the inside of a peach-coloured flower, the canvas glows; a colour harmony of ultramarine blue, chrome yellow, azure and browns, unites the figures with the surrounding landscape and calls to mind the hot intensity of the theme.

Yet—and this is the paradox of healthy, imaginative work—this canvas was created by the painter who later imbibed the fundamental rationality and desire to live by rules that characterised the consciousness of his time. Poussin's letters are informed by a belief in the essentially rational nature of the creative process. Painting, he writes, deals with human action, which must be presented in accordance with the principles of reason; and these actions must be shown in a logical and orderly manner, as nature would present them if she were perfect. The Artist's work, he argues, should appeal to the mind and not to the eye. A sensuous attraction like glowing colour should not be bothered with.

These ideas and the principles behind the space compositions of Palladio's work would be of no more than Art-historical interest were it not for the fact that the secular rationalism and the subject-object dualism which informed them continue to shape our industrial civilisation. As a result we live in a society whose criteria are essentially utilitarian and economic; a society disrespectful of nature, the communal and the aesthetic alike.

## JOHN WILMOT: THE FIRST INTIMATIONS OF DISILLUSIONMENT WITH THE NEW PHILOSOPHY

It was a later figure, the poet Alexander Pope (1688-1744), who most skilfully crystallised the spiritual narrowness of consciousness that Humanism engendered. Here, as elsewhere, he speaks memorably not only for himself but for the age in which he (and we) lived and live:

> Be sure yourself and your own reach to know,
> How far your genius, taste, and learning go;
> Launch not beyond your depth, but be discreet
> And mark the point where sense and dullness meet.[4]

The verse, characteristically of Pope, is witty, ironic, cheerful, refined, self-

conscious and sophisticated. In its own terms it is masterly, but those terms are small and shallow-rooted in comparison with the fertility and exaltation of seventeenth-century poetry, a poetry that never for one moment neglected a more feminine pattern with access to energies of growth and renewal that only it, and no other pattern possesses. Commenting on the growth of a massive superstructure of brilliant scientific achievement strung precariously over a chasm of meaninglessness, T.S. Eliot diagnosed the modern condition as a dissociation of sensibility: a widening rift between thought and emotion, intellect and sensation, a general failure to achieve 'unification of sensibility'. 'Something... had happened to the mind of England,' he wrote.[5]

From Dante to Pope, from Piero della Francesca to Vivaldi or Gainsborough, we move from the profoundly mysterious to the mere decoration of social life. The work of the latter can be heartbreakingly beautiful but it never merges with or emerges from a metaphysical Universe centred on the divine; it never recedes into some larger spirit, some greater harmony, some hunger for sanctity appeased.

Under the commodifying influence of capitalism, the rationalism of the Cartesian philosophy and, in the north, the materialist and democratising effects of Puritanism, the Arts of Europe moved inexorably from profundity to decency, from open-heartedness to scepticism, from the unreasonable imagination to the control of a reasonable mind; to a world, that is, where as Lord Shaftesbury observed, the 'Idea of Sense, Order, Proportion' had become ubiquitous.

Left to rot in the dark, the unconscious induced that hysterical and morbid strain which later flowered in the Romantic period. Early intimations of this strain are to be found in the work of John Wilmot, Earl of Rochester (1647-80), whose *A Satyr against Reason and Mankind*, written around 1675, is one of the first poems to challenge, with its unexpected misanthropy, irony and discomfort, rationalism's bright-lit world. The poem marks the culmination of Wilmot's revolt against the values of his time and is therefore an early instance, perhaps the earliest, of a genre which was to become commonplace as the world turned from unquestioned certainties to hazardous insecurity, became more urgent, unsettled, and threatening.

*A Satyr against Reason and Mankind* (part of which follows) expresses with an almost terrifying intensity the mood of indignation and disillusionment felt by those alive to the dangers of the new philosophy.

Were I, who to my cost already am
One of those strange, prodigious Creatures Man
A spirit free to choose for my own share
What case of Flesh and Blood I'd please to wear,
I'd be a Dog, a Monkey or a Bear,
Or anything but that vain Animal
Who is so proud of being Rational.
The senses are too gross, and he'll contrive
A sixth, to contradict the other five;
And before certain Instinct, will prefer
Reason, which fifty times for one does err.
Reason, an Ignis fatuus in the Mind,
Which leaves the Light of Nature (Sense) behind;
Pathless and dangerous, wandering ways it takes
Through Error's fenny Bogs and thorny Brakes;
Whilst the misguided Follower climbs with Pain
Mountains of Whimseys, heaped in his own Brain:
Stumbling from thought to thought, falls headlong down
Into Doubt's boundless Sea, where, like to drown
Books bear him up awhile, and make him try
To swim with Bladders of *Philosophy*;
In hopes still to'ertake the escaping Light
The Vapour dances in his dazzled Sight
Till spent, it leaves him to eternal Night.
Then Old Age and experience, hand in hand
Lead him to Death, and make him understand,
After a search so painful, and so long,
That all his Life he has been in the wrong:
Huddled in Dirt, this reasoning *Engine* lyes,
Who was so proud, so witty, and so wise...[6]

Surely this was the greatest poem written in these islands to express the central dilemma of the age. In the new mechanico-materialistic universe of Descartes, Hobbes (1588-1679) and the scientists, Wilmot feels that man is now no more than a 'reasoning *Engine*', an irrelevant accident. For the first time in thousands

of years he no longer knows what he is, the meaning of his personal and collective existence, his future destiny.

It was nihilism of this kind and degree that drove not only Rochester but Edmund Spenser (c1552-99), the poet John Donne and the philosopher Blaise Pascal (1623-1662) to the edge of existential despair. As early as the penultimate decade of the sixteenth century—*The Faerie Queen* was written between 1579 and 1589—Spenser expressed his fears about a world in the process of being drained of immanent meaning, made abstract and only understandable in terms of measurement.

> Me seems the world is runne quite out of square,
> From the first point of his appointed course,
> And being once amisse growes daily wourse and wourse.

The anxious theme, a hairline crack in an otherwise perfect world, was also expressed by Donne in his *An Anatomie of the World* of 1611. He, too, grapples with the impact of science's subversion on the coherence of a sacred world-view:

> And new Philosophy calls all in doubt,
> The Element of fire is quite put out;
> The Sun is lost, and th'earth, and no man's wit
> Can well direct him where to looke for it.
> And freely men confesse that this world's spent,
> When in the Planets, and the Firmament
> They seeke so many new: they see that this
> Is crumbled out again to his Atomies.
> 'Tis all in peeces, all cohaerence gone;
> All just supply, and all Relation:
> Prince, Subject, Father, Soone, are things forgot,
> For every man alone thinkes he hath got
> To be a Phoenix...

Pascal's reaction was summed up in a cogent phrase no less evocative of the new cosmic loneliness: 'The silences of the infinite spaces terrify me.'

Another poet, John Milton (1608-74), less caustic than Wilmot, more prolix

than Pascal, but no less prophetic of the consequences of a mechanical world-view, published Book I of *Paradise Lost* in 1667—about a century before James Watt's invention of the Improved Steam Engine and Arthur Young's description of his visit to Shropshire in 1776. On that occasion Young wrote about 'the noise of the forges, mills, &c with all their vast machinery, the flames bursting forth from the furnaces with the burning of the coal and the smoak of the lime kilns.' P.J. de Loutherbourg's painting of *Coalbrookdale by Night* (1801), with its orange sky lurid from the flames of tremendous fires, remains the perfect complement to Milton's description of the fallen angels setting to work to mine, forge and mould metals in the soil of hell.

> There stood a Hill not far whose griesly top
> Belch'd fire and rowling smoak; the rest entire
> Shon with a glossie scurff, undoubted sign
> That in his womb was hid metallic Ore,
> The work of Sulphur. Thither wing'd with speed
> A numerous Brigad hasten'd. As when bands
> Of Pioners with Spade and Pickaxe arm'd
> Forerun the Royal Camp, to trench a Field,
> Or cast a Rampart. *Mammon* led them on,
> *Mammon,* the least erected Spirit that fell
> From heav'n, for ev'n in heav'n his looks and thoughts
> Were always downward bent, admiring more
> The riches of Heav'ns pavement, trod'n Gold,
> Then aught divine or holy else enjoy'd
> In vision beatific: by him first
> Men also, and by his suggestion taught,
> Ransack'd the Center, and with impious hands
> Rifl'd the bowels of thir mother Earth
> For Treasures better hid. Soon had his crew
> Op'nd into the Hill a spacious wound
> And dig'd out ribs of Gold. Let none admire
> That riches grow in Hell; that soyle may best
> Deserve the pretious bane...

Plate 40. MEINDERT HOBBEMA. The Avenue at Middleharnis. 1689. *Oil on canvas.* National Gallery, London. Reproduced by courtesy of the Trustees, the National Gallery, London.

In accordance with expectations, the second half of the seventeenth century was characterised not only by the growing domination of the new materialist and quantitative concepts but a growing rejection of forms of life that impeded their development. Anything that did not permit a utilitarian control tended to be neglected, while sensory knowledge derived from observation of, and experimentation with, sensory facts became paramount—as we see, for example, in many pictures of the so-called Golden Age of Dutch Art. One of these is Meindert Hobbema's (1638-1709) life-like *The Avenue at Middleharnis*, itself an icon of the earth-bound, prosaic nature of seventeenth-century consciousness. In this landscape, all is clear and orderly. Man and nature are in accord, but the former, like the gardener pruning his trees in the corner of the painting, is unquestionably in control. The church tower and spire of St Michael point heavenward, but the well-ordered fields, the neat cluster of roofs and distant masts, speak of a world in which the transcendent plays little part.

## THE PESSIMISM OF CANDIDE

*The Avenue at Middleharnis* was painted in 1689, two years after Newton's *Principia* had made determinism irrefutable, and five years before the birth of Voltaire (1694-1778).

Apart from *Candide* (1759), Voltaire is today hardly read, yet throughout his life, plays, poems, philosophical tales, histories, essays and letters by the thousand poured from his restless pen. In these he fought for reason, challenged and denounced superstition, bigotry, intolerance and intellectual rigidity, all misuse of power, all obstacles to free enquiry and discussion, all claims, sacred or secular, to be above criticism and all excuses for war. For Voltaire—and the contemporary French *philosophes*—the fateful association between the hierarchical Christian world-view and the established socio-political structures of feudal Europe centring on the traditional figures of God, pope and king, was no longer plausible. The situation, he argued, demanded revolt for the larger good of humanity. Yet for all Voltaire's struggle against the constricting mediaeval darkness of Church dogma and popular superstition, a rationalistic optimism characterised almost all his work.

But not *Candide*, where behind the usual mockery of religious persecution there lies a dark pessimism, yawning depths of disgust and disillusion, exceptional in the daylight world of mid-eighteenth century France. Alexander Pope's *The Order'd Garden*, where all was light, can no longer be recognised here. As J.B. Priestley observes, 'strange weeds covered it and among them flowers, scarlet or deathly white, began to bloom mysteriously; and above it the moon was rising, to create fantastic shadows, in which reason was lost to romance.'[7] Less than half a century after the publication of *Candide*, the cellar door had been opened, the moon was at its zenith, the flowers had grown voluptuous and half-blind monsters roamed across the land.

## HAYDN & THE DISQUIET OF A LIVERIED SERVANT

The prevailing and almost complacent lack of awareness of the turmoil into which Europe was soon to be thrown—the French Revolution and English industrialism—finds undisturbed expression in a painting by Bartolomeo

Plate 41. BARTOLOMEO GAETANO PESCI. The Palace of Esterháza. 1780. Hungarian Museum of Architecture of the National Board for the Protection of Historic Monuments.

Gaetano Pesci which depicts the gardens of an extravagant, fairy-tale summer palace built for the Esterházys on the Neusiedler lake just within present-day Hungary. Here for almost thirty years the composer Franz Joseph Haydn (1732-1809) worked as Kapellmeister and ran the Esterházys' musical establishment. It was here, too, that Haydn created music of a formal ingenuity and mastery that still refreshes and uplifts the spirit more, perhaps, than that of any other composer. Nonetheless, Haydn was a feudal dependent; he wore livery, dined with the servants and produced quantities of music for the entertainment of the court. He loved it. 'My Prince,' he said, 'was always satisfied with my works; I not only had the encouragement of constant approval, but as conductor of an orchestra I could make experiments. I was cut off from the world, there was no one to confuse me, and so I was forced to become original.'

Like Versailles, the gardens of Eszterháza Palace had been constructed on the basis of a rectangular design. Regular paths, symmetrical beds, clipped trees, a tidy pattern of classical statuary, all formally disposed. Yet even in this neatly

ordered oasis, music embodying pungent harmonies and strangely sinister, dark-hued overtones were to be heard not as a pleasing titillation of the senses, but for their dramatic intensity. The panting, repeated quavers of the opening of Haydn's G Minor Symphony are almost hysterical, while the whirling scales of the last movement possess a frightening energy. Other works, including *La Passione*, No 49, the *Mourning*, No 44, the *Farewell*, No 45 (in the outlandish key of F sharp minor) and the Symphony No 46 (in the equally extraordinary key of B Major), were written between 1768 and 1772. In them Haydn points to a great and unknown imperative, gathering like the shadow of an apocalyptic storm over the life of his time. The hairline cracks in the foundations of Humanism had begun to widen.

## PREMONITIONS THAT THE TIDE IS TURNING

Yet if the gardens and palace of the Eszterháza remained undisturbed, the cities were beginning to register those seismic disturbances that were to throw Europe into the collective nightmare from which it has never fully recovered. Premonitions of the revolt against the iron rule of consciousness might—just—be traced to the middle of the eighteenth century. As early as 1741, J.E. Schlegel invited his audience 'to dream along with its hero'. Thirteen years later J.A. Hillier discussed the power of music as 'a riddle, which reason will not easily resolve, because it is presented with it only as in a dream'. Further intimations of the gathering breakdown came from Friedrich Maximilian von Klinger's (1752-1831) play *Sturm und Drang* (1776), which gave its name to a whole movement.

But it was in England, the centre of rationalism, where perhaps the most potent demonstration of the loss of rationality arose, generated as it always has been from rationality itself rather than from its absence. In 1763 the poet Christopher Smart (1722-71), who towards the end of his life was confined to a lunatic asylum for several years, wrote the most sharply fused and greatest of all his poems, *A Song to David*; and four years later his strangest, *Jubilate Agno* (Rejoice in the Lamb), which was not published until 1939, and not fully available until 1954. *Jubilate Agno*, for all its oddity, is not a work of madness but of invocation and celebration. It is a chorus or litany of praise to God for the wonders of his creation—including Smart's own cat, Jeoffry, to which one whole

section is devoted. It is the perfect and regenerative antidote of an exaggerated rationalism and a wonderful manifestation and affirmation of the feeling, caring and discerning elements of life so long denied by Western man. It was written in the summer of 1760.

> For I will consider my Cat Jeoffry.
> For he is the servant of the Living God, duly and daily serving
>     him.
> For at the first glance of the glory in the East
>     he worships in his way.
> For this is done by wreathing his body seven times round with
>     elegant quickness.
> For then he leaps up to catch the musk, which is the blessing of
>     God upon his prayer.
> For he rolls upon prank to work it in.
> For having done duty and received blessing he begins to consider
>     himself.
> For this he performs in ten degrees.
> For first he looks upon his fore-paws to see if they are clean.
> For secondly he kicks up behind to clear away there.
> For thirdly he works it upon stretch with fore-paws extended.
> For fourthly he sharpens his paws by wood.
> For fifthly he washes himself.
> For sixthly he rolls upon wash.
> For seventhly he fleas himself, that he may not be interrupted
>     upon the beat.
> For eighthly he rubs himself against a post.
> For ninthly he looks up for his instructions.
> For tenthly he goes in quest of food.
> For having consider'd God and himself he will consider his
>     neighbour.
> For if he meets another cat he will kiss her in kindness...

In this loving, closely observed, exuberant and totally original poem, the itemising of Jeoffry's particulars has something about it that resembles the knowing

innocence, the *participation mystique,* the capacity for merger with the timeless 'other', that exists beyond the time-haunted, mental consciousness of modern man.

## THE MAGIC FLUTE: MOZART'S MYSTICAL TALE
## OF SPIRITUAL DEVELOPMENT

It was Jean Jacques Rousseau (1712-78) who first articulated the deep energies of the unconscious which for so long had been ignored. His writings, including his *Confessions* (1765), recaptured and revisioned the archetypal holy innocence of childhood, the so-called 'unspoilt' savage, and advocated man's conscious unity with nature, both poetic and instinctual.

Yet for all Rousseau's far-reaching and sometimes dangerous influence, neither he, Smart, Schlegel nor Hillier ever achieved the imaginative affirmation of Mozart's *Die Zauberflöte* ('The Magic Flute', 1791), where what Wordsworth called 'the types and symbols of eternity' were heard again in prolonged and solemn cadence. In that respect alone, Mozart's music, allied to Emanuel Schikaneder's libretto, towers like a mountain above the flatlands of the Enlightenment.

Yet on any count *Die Zauberflöte* is a profoundly wonderful work whose expressive core operates on at least two levels. On one level it presents the elements of a traditional fairy-tale; there is a heroic prince (Tamino), a beautiful princess (Pamina) and a supposedly wicked magician (Sarastro). On a deeper level, the opera can be experienced as an archetypal rite dealing with the inner spiritual education of an individual who only escapes the regressive forces of material enslavement (represented by the Queen of the Night) by purification. This is achieved through a process of initiation involving trials by fire, water, the howling of the winds and the echoing of thunder in the caverns at the Temple of Wisdom. It seems, in fact, that Mozart was aware that Tamino's and Pamina's attainment of wisdom could never be achieved through the prevailing claims of reason and science to explain and command the world. Rather it would emerge from the 'unio-mystica' of the soul with the cosmic principle of light, as taught by a strain of mystical and esoteric Freemasonry known as Rosicrucianism. The symbolism of *Die Zauberflöte* reveals it to be, as has long been recognised, not merely a Masonic opera but more specifically a Rosicrucian one.

*Die Zauberflöte* is a densely layered work, with references drawn from many of the rich skeins of symbolism upon which post-Enlightenment thinkers and Artists were able to draw. 'For make no mistake about it,' writes Nicholas Till, 'this is a post-Enlightenment opera: a mystical tale of inner spiritual development, in which Enlightenment materialism and rationalism are rejected as surely as Tamino is repulsed from the Temples of Nature and Reason, to seek access finally to the Temple of Wisdom.'[8]

This search for inner spiritual wisdom and wholeness (pre-Jungian in its insight) would seem to have held as much, if not more power over Mozart's imagination than his Christian faith, important as this was for him. In this Mozart was not alone. For wherever the Christian faith had lost some of its hold over progressive thinkers, something else was yet required to fill the vacuum left by its departure. For a minority, like Wordsworth, this would be nature; for others it was to be Art. And if the fully developed religion of Art was not to find its definitive form for over a century, from 1800 onwards it was to become, at least for those disillusioned with the orthodoxies of religion and science, an important substitute for a lost religion. Henry James would hail it as 'a rival creation'.

## ROMANTICISM: THE SOUL'S PROTECTION

In the period between the death of Voltaire and that of Haydn, the eighteenth century—which prided itself on its rationality, its philosophy and, above all, its taste—was disturbed by an unprecedented succession of unsettling events: the storming of the Bastille in 1789, the execution of the French king in 1793, the crowing of Napoleon as Emperor and eight years later his retreat from Moscow with the loss of half a million men. Yet as if this these cataclysms were not enough to satisfy the movements of the collective unconscious, the north of England was simultaneously thrown into its own tumult. In a generation, the older economy of agriculture and domestic handicrafts was terminally impaired by the introduction of a system of industrial production based on the setting up of large-scale factories in the new towns, 'whence followed', wrote Samuel Bamford in 1850, 'an increase in population, a crowding towards the great hive, of many people of all industrial classes, and from all parts of the kingdom and the world.' At the same time other long-suppressed unconscious energies released

their own imaginative and healing powers.

There are at least two ways of interpreting what occurred. The first might be called psychological: the eighteenth century had built itself upon an unbalanced emphasis of the conscious mind against which a reaction was inevitable. Another way of looking at this revolution of human consciousness is from the perspective of soul, the love of the soul for the earth. I like the word soul, and Yeats's use of it when he claimed that: 'There is only one history, and that is the soul's.' Right there on the frontier of consciousness, the rise of soul fed the hunger for the spirit, for nourishment to face and fulfil the future, with a new vision of man's potential relationship with nature.

Savouring the possibilities of renewal, the life-force chose this moment to spawn an unprecedented number of visionaries—seers, shamans, prophets, poets and sensitives of all kinds—before darkness re-descended with the imposition of a system of industrial technology which reduced self-respecting artisans, with long traditions of craft and autonomy, to dependent wage-slaves. Many of Europe's most remarkable writers, painters, poets and composers were born between the years 1770 and 1799. In the seventies Beethoven, Coleridge, Hölderlin, Turner, Constable, Wordsworth and Caspar David Friedrich were all born. The eighties and nineties were scarcely less fertile. In the eighties, Byron, Leopardi, John Sell Cotman, von Weber and de Quincey; in the nineties, Keats, Schubert, Shelley, Carlyle, Pushkin, Delacroix and Edward Calvert were born. Outside the thirty year limit, but closely associated with its spirit, we can count Mozart (born in 1756), Blake (in 1757), Schiller (in 1759) and Samuel Palmer (in 1805).

These were the Romantics. These were our visionaries, without whom, as the Bible says, the people would have perished. But what had they in common? An earlier but deeply influential writer, Goethe (1749-1832), had written novels and poems which placed the Artist at the centre but always as a lonely figure, misunderstood by society at large, struggling against a hostile world yet in spiritual communion with nature. The archetype of the one who comprehends too much but is comprehended too little was entirely characteristic of the solitary Romantic; it is he who is the rejected lover in Schubert's songs and the wayfarer in Coleridge's greatest poem, *The Rime of the Ancient Mariner*. We also find the same stance of loneliness in the lives of the Romantic Artists themselves: in Blake isolated in London, deaf Beethoven and in Caspar David Friedrich painting his

lonely *Monk by the Sea* (1809): exiles, rebels or prophets—sometimes all three.

Intensity of individualism is one of the outstanding characteristics of these isolated dreamers, who, to escape from the 'real' world of the early nineteenth century, took refuge in the historic past, in dreams, the mysterious, the fantastic, the bizarre and the wish to reconstruct a world from scratch, whether in actual political terms, in the utopian dreams that preceded the apocalypse of the French Revolution, in religious terms, or in their Art. To understand them it is also necessary to bear in mind that in spite of their sometimes rebellious natures they were often conservative in spirit; in their rejection of oppressive traditional structures, in their high estimate of man's powers, in their restless quest for human freedom, fulfilment, and bold exploration of the new, they were Humanists almost to a man. The exception was William Blake.

## THE EXULTANT SPIRITUALITY OF WILLIAM BLAKE

Blake (1757-1827) was not only a radical thinker, but one of our greatest lyric poets, and a painter and engraver of genius.

As a young man he claimed to have read and rejected the natural philosophers and their materialistic interpretation of life. Throughout his life Blake continued to challenge Bacon, Locke and Newton as the architects of the mechanistic world-view in which the quantitative 'laws of nature' were believed to operate in space and time alone. This universe he condemned as a universe of abstractions and formulae, not of experience. It is, says Blake, the system, the vast machinery of order and uniformity; the system of technology, industrial production and moral law. It was everything except imagination, where, as he believed, everything is Holy and 'every particle of dust breathes forth its joy.'

For Blake, as for Coleridge, the imagination was the divine presence in man, and his theory of the imagination is one that makes him, in the only true sense, a religious artist—probably the only English religious artist of significance since the anonymous craftsmen of the Middle Ages, whom he in so many respects resembled.

In his famous colour print of *Newton* (c1795/c1805), Blake created an image of his challenge to the philosophy of Humanism: this, he says, is what happens when instead of attempting to make known the divine plan, man puts himself in

Plate 42. WILLIAM BLAKE. NEWTON. c1795 / c1805. 46 x 60 cm.
*Colour print finished in pen and water colour. Tate Gallery, London.*

the place of God. Totally immersed in his ocean of material space and time, the famous scientist is seated on a rock at the bottom of the sea. He is naked and staring fixedly ahead at a geometrical design, symbol of tyrannical imprisonment; his left hand grasps a pair of open dividers, another symbol of limitation and calculation not only endorsing inflexible laws but the idea of creation by reason unenlightened by imagination. Blake is telling us that Newton (and for Newton read all those who have subsequently internalised the mechanistic description of the universe), is blind to the duty we owe to forces greater than ourselves. Like every Humanist, he has become trapped within the confinement of his own calculations. 'He who sees the Infinite in all things sees God, he who sees the Ratio only sees himself.'

The colour print of *Newton* is one of a pair, the other half of which,

Plate 43. WILLIAM BLAKE. Nebuchadnezzar. c1795/c1805. 44.6 x 62 cm.
*Colour print finished in pen and water colour.* Tate Gallery, London

*Nebuchadnezzar*, is if anything even more desperate in its condemnation of the path of Western philosophy. In this painting, the former King crawling like an animal on all fours symbolises a further stage of man's degradation; the madness of the materialist with 'single vision', bestial in seeking sustenance in the life of material things alone. The disfiguration of the image of man in the West had never been more compellingly expressed. Criticism of the entire foundation of Western life had never been projected with such prophetic force.

Yet if his work presents a pitiless indictment of the Hells of our existence in a mechanised world, Blake never ceased to contrast this condition with its opposite: the Heaven of Innocence and purity. One such image is the hauntingly luminous water-colour, *The River of Life*, painted in c1805, and based on a passage in *Revelations*:

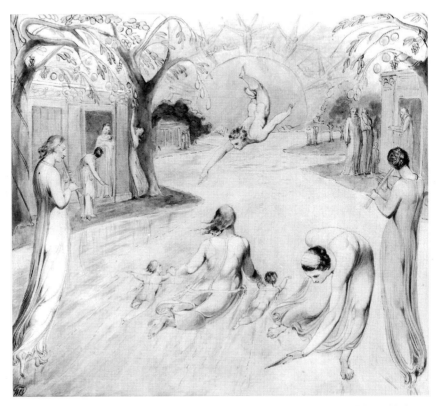

Plate 44. WILLIAM BLAKE. The River of Life. c1805. *Pen and water colour.* 30.5 x 33.6 cm. Tate Gallery, London.

And he shewed me a pure river of water of life, clear as crystal, proceeding out of the throne of God and of the Lamb. In the midst of the street of it, and on either side of the river, was there the tree of life, which bare twelve manner of fruits: and yielded her fruit every month: and the leaves of the tree were for the healing of the nations.[9]

In Blake's imagery, a figure (in all probability Christ) is seen leading two children through the stream of time towards the divine sun of Redemption; to his right, the Bride (the New Jerusalem) is swooping down in a gesture interpreted as the scooping up of water from the river of life. The river itself flows between two banks towards a monumental sun: on the left is the bank of innocence on which a young girl reaches up for fruit from the tree of life, and on the right, peopled

with three aged figures, is the bank of experience. Two musicians, clad in long vestments of white and pink, symmetrically frame the scene in which, centrally placed and accompanied by winged figures symbolising the eternal marriage, flies or floats the guiding spirit of St John the Divine. The association between innocence, the Arts and redemption, represented by the figure of Christ, is maintained by a pastoral and regenerative imagery no less pellucid than that of Blake's radiant illustrations of Dante.

Nothing of this kind had been seen in painting for a long time. Yet if the grandeur of Blake's mythological conceptions inevitably reminds us of the cosmic symbolism of traditional art, his advocacy looked forward to the future; to what he described as a 'New Age'. In this, he believed, the current materialist ideology would have been rejected; the primacy of the imagination, the innate divine principle in all things, would have been affirmed. For Blake, everyone was an Artist, and he who failed to act as one was a traitor to his own humanity:

> You Must leave Fathers & Mothers & Houses & Lands if they
>     stand in the way of Art.
> Prayer is the Study of Art.
> Praise is the Practice of Art.
> Fasting &c., all relate to Art.
> The outward Ceremony is Antichrist.
> The Eternal Body of Man is The Imagination, that is,
> God himself / The Divine Body...
> The Whole Business of Man is The Arts, & all Things Common.[10]

## SAMUEL PALMER SACRALISES NATURE IN THE DARENTH VALLEY

Describing Blake as an old man, the Artist Samuel Palmer (1805-81) wrote, 'He was a man without a mask, his aim single, his path straight forwards, and his wants few; so he was free, noble, and happy.' Blake was then in his seventy-seventh year, his admirer a young man of nineteen (they first met in October 1824). It was a meeting which was to inspire some of the most numinous paintings in Western Art.

Palmer's sense of a holy immanence in nature pervaded much of his early

Plate 45. SAMUEL PALMER. Pear Tree in a Walled Garden. c1829.
*Water colour and body colour. 22.2 x 28.2 cm. The Pierpont Morgan Library, New York.*
Gift of Mr. & Mrs E.V. Thaw, 1980.37

work, but it is in the water-colours and drawings he painted between his twenti-
eth and thirtieth years that his Art was most saturated with an aura of divinity.
Instead of mastering nature, Palmer attempts a tender touching, a non-interfer-
ing gaze, a receptive bonding with the earth and the other. The miracle of trans-
forming love reappears, and a new *anima mundi* with her rich welter of sensuous
experience in colour, scent, and texture.

The richly exuberant *Pear Tree in a Walled Garden*, one of a group of works
painted around 1829, is an example of this deep and empathetic communion
with a nature as yet barely tainted by the harsh realities of early nineteenth cen-
tury urban and industrial change. It has been suggested that it was painted in the
cottage garden of a Mr. Groombridge of Shoreham, where Palmer lived for seven
years from 1825 to 1832. The painter mentions Mr. Groombridge a few times in
letters written from this Kentish village in the Darenth valley, where I myself
once lived. His attitudes towards deity in nature were also described in a letter to
his friend the artist John Linnell, in December 1828. If the letter does not
describe the water-colour, it yet captures its spirit.

Terrestrial spring showers, blossoms and odours in profusion, which, at some moments, 'Breathe on earth the air of Paradise': indeed sometimes, when the spirits are in Heav'n, earth itself, as in emulation, blooms again into Eden...

The pear tree here, like other living organisms in Palmer's work, seems to be alive with magical sap and vitality, almost quivering before our eyes in its fructifying energies. The clotted solidity of its blossom, the juicy voluptuousness of the twisting bean plants, the creamy efflorescence of the cumulus cloud, the soil itself like magic plasm, all speak of a natural world on the edge of Paradise, glorious in itself and because it foreshadows a greater glory and fruitfulness out of this world. Mr. Groombridge's unexceptional garden is, it seems, poised here on the brink of some mystical revelation of nature.

Palmer himself once talked about receiving landscape 'into the soul', and his little water-colour can perhaps be seen, or so it seems to me, as a rhapsodic outburst of the miracle of fertility seen by soul. It tells us that the human can become an integral part of nature. It tells us that everything can be transfigured, sanctified and experienced as a numinous event. It teaches us that we can escape the prison of time and find the eternal present in the smallest of nature's processes and manifestations, even a cottager's prosaic plot. Looking at *Pear Tree in a Walled Garden* we experience, I suggest, something close to a new form of religious Art, one that, as Robert Rosenblum observes, 'would not be found again until the work of Van Gogh'.[11]

## WORDSWORTH'S UNKNOWN MODES OF BEING

Yet even as the young Palmer painted his private hymns of praise to nature in the Darenth Valley and Wordsworth (1770-1850) walked amongst his hills, the city of Manchester would soon, like the population of England, double its size. The industrial and technological age, the age of unrestrained profit, competition and innovation, had arrived and was advancing inexorably not only across the land but, as Carlyle observed, into people's hearts and minds. 'Men are grown mechanical in head and heart, as well as in hand,' he said.[12]

This period, when traditional rural modes of communal life gace way to the more impersonal and atomised forms of modern social organisation, has been

considered the second of two great transitions in the history of the human species, the first being the prehistoric shift from hunter-gatherer to settled, agrarian societies. Inevitably, the seductive catastrophe of industrialism had the most striking effect on the the customs and sensibility of society as a whole.

The population congregating in the new centres of production was now forming the mass of dispossessed and unskilled proletariat needed for the operation and minding of the new machines. In its wake came the destruction of countless craft-based skills and their replacement by labour-saving (and therefore money-saving) but monotonous work, that continues to constitute the daily labour of millions. 'A Machine is not Man nor Work of Art; it is destructive of Humanity & of Art,' Blake declared in his *Public Address* of 1810. Two years earlier he had already prophesied the physical and psychic injuries that 'the dark satanic mills' would bring to England's people and her once 'green and pleasant land':

> Then left the Sons of Urizen the plow & harrow, the loom,
> The hammer & the chisel and the rule & compasses...
> And all the Arts of Life they chang'd into the Arts of Death in Albion.
> The hour-glass contemn'd because its simple workmanship
> Was like the workmanship of the plowman, & the water-wheel
> That raises water into cisterns, broken & burn'd with fire
> Because its workmanship was like the workmanship of the shepherd;
> And in their stead, intricate wheels invented, wheel without wheel,
> To perplex youth in their outgoings & to bind to labours in Albion
> Of day & night the myriads of eternity: that they may grind
> And polish brass & iron hour after hour, laborious task,
> Kept ignorant of its use: that they might spend the days of wisdom
> In sorrowful drudgery to obtain a scanty pittance of bread,
> In ignorance to view a small portion & think that All,
> And call it Demonstration, blind to all the simple rules of Life.[13]

The intensification of the urban created its own reaction: a more self-conscious appreciation and appetite for nature and all things rural. The paintings of Constable and Turner, the poetry of Shelley, Keats and Coleridge, and later the novels of Thomas Hardy, all stem from this impulse to celebrate what was in the process of being lost and degraded. One of the first to commune in solitude with

mountains and rivers, clouds and moons and such was, of course, Wordsworth.

Wordsworth often spoke of 'unknown modes of being' and sought to show that a properly focused imagination could see and feel a correspondence between what he called the 'goings on of nature' and the mind of man. It was Coleridge, Wordsworth's disciple as far as his view of nature was concerned, who also wrote:

> We receive but what we give,
> And in our life alone does Nature live.

The importance of Wordsworth to our theme lies in his ability to relate to the natural scene through his unconscious, to return to the enchanted unity he had known in childhood. At these times he seems to lose the ego and the sense of separateness, the dichotomy between the mental and material worlds, the independence of the mind from nature, initiated by the scientific method. He talks for example of 'an intertwined togetherness' and 'a community of existence' and in the *Lines Composed a few Miles above Tintern Abbey* (1798) he heals the dualism between rational subject and material world, subject and object, *res cogitans* and *res extensa*:

> ...And I have felt
> A presence that disturbs me with the joy
> Of elevated thoughts; a sense sublime
> Of something far more deeply interfused,
> Whose dwelling is the light of setting suns,
> And the round ocean and the living air,
> And the blue sky, and in the mind of man;
> A motion and a spirit, that impels
> All thinking things, all objects of all thought,
> And rolls through all things.

## ST PANCRAS STATION AS AN EXERCISE IN ESCAPISM

Given the spiritual desolation that characterises industrial civilisation, the Romantic contribution cannot be exaggerated. Artists were the first to make

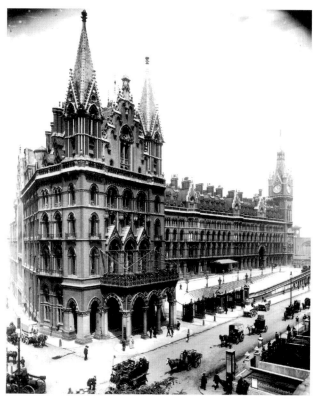

Plate 46. GILBERT SCOTT. St Pancras Station and Hotel. 1865.
RCHME © Crown copyright.

clear, in the words of Michel Foucault, the 'Great Refusal'. They were the first to re-sacralise the earth, to teach that we can no longer afford to reject the sacred, nor fail in the task of re-animating community. Their primary ecological insights viewed human Art not as anomaly or decoration, but as integral to the natural order.

Yet we know how meaningless their views and ambitions were to the urban proletariat and its wealthier masters. For the colliers labouring in the mines, the welders in the shipyards, the machinists in the cotton mills, the unskilled 'navvies' engaged in gangs that moved from place to place, digging canals, making roads and constructing embankments and tunnels for the new railways, the Art of Beethoven and Wordsworth did not exist. Not one of them would have

had the least time for it. For the new entrepreneurs, the bureaucracy of salaried managers and their clerks, Artists were also largely irrelevant. As a 'cultured' diversion to a busy life, their work might have been welcomed or tolerated, yet ignored or reviled when it questioned the status quo; but from first to last it was seen as peripheral and purely decorative. What mattered now were advances in health and wealth, the claims of science, the achievements of technology and the triumphs of engineering. It was proper for a civilised country to recognise the Arts—the life of the heart—but this interest should never impede the development of material advance.

No clearer symbol of this bifurcation can be found than in a building which gave self-assured expression to the nineteenth century's unquestioned belief in its hard-earned position at the pinnacle of civilisation: St Pancras station. The station building was conceived in 1865 by two kinds of designer: the engineers W.H. Barlow and R.M. Ordish, and the architect Gilbert Scott (1810-77); the former contributing the iron train sheds (1864-68), the latter the Grand Midland Hotel (completed in 1871)—the epitome of the Gothic Revival—whose façade faced the street. Each, judged in its own terms, is a superb achievement, but one can hardly ignore the ruthlessness with which the curve of the train shed sweeps across the fretted arches of the Gothic windows of the hotel. This dysfunctionalism, a kind of schizophrenia, though it might appear to defer towards 'Art', in practice regards usefulness as the higher priority. The 'Art' is presented as a facade; the function is a train shed.

The heraldic glory of St Pancras was also more than a train station: it was an exercise in escapism. Its Gothic silhouette, its principal staircase with its sky-painted vault, emblematic frieze and richly stencilled walls, its entrances with their cathedral-like porches, provided the perfect antidote to the grimy industrial towns to and from which its visitors travelled. This sense of unreality, and perhaps romance, was especially in evidence on the first floor where the *Garden of Deduit* was displayed. The painting showed a mediaeval castle beneath whose battlemented walls lovers dallied with their mistresses in a garden of lush trees, fountains and fluttering doves. For the nineteenth century, the creation of dream worlds was not only the real afflatus of Victorian art, but a necessary refuge from the harshly encroaching realities of what Dickens called Coketown.

To this encroachment contemporary Artists reacted in three different ways. Some withdrew from its ugliness into a kind of never-never world; they took

refuge in Art and in the land of dreams. Lord Leighton and Burne-Jones were of this kind. Others, whom I shall be discussing in the next chapter—Artists like van Gogh and Gauguin—set out to envision and make concrete what Dostoevsky called a 'new and hitherto unknown reality'. And yet others, like William Morris and John Ruskin, took as their subject the dehumanising dogma of industrial society and the threat it posed, and continues to pose, to the consciousness of modern man. The greatest of these was Charles Dickens (1812-70), a fierce critic of Victorian capitalism.

## DICKENS'S COKETOWN: THE DARK SATANIC MILL

*Without work all life goes rotten. But when work is soulless, life stifles and dies.*
Albert Camus

In 1865, the year St Pancras was designed, Charles Dickens finished writing *Our Mutual Friend*, the last of his late, great novels—the others include *Bleak House* (1852-3), *Little Dorrit* (1855-7) and the subject of this section, *Hard Times* (1854). In *Frankenstein*, Mary Shelley (1818) had voiced her fear of what might happen if the management of life fell into the hands of the scientists. 'You are my creator,' the monster tells the scientists at the end, 'but I am your master.' Forty years later, industrialism, and all that it meant for the hapless inhabitants of Coketown, *Hard Times*'s industrial location, suggests that those fears had been realised. Mr. Bounderby's cotton mill, a symbol for a life without compassion, without imagination, without the personal wishes of its workers, is run for two things and two things alone: profit and the self-aggrandisement of its owner.
In a letter to Charles Knight, Dickens wrote of *Hard Times*:

> My satire is against those who see figures and averages, and nothing else—the representatives of the wickedest and most enormous vice of this time.

Industrialism, as Dickens saw, ground down imaginative life by bondage to calculation and routine; in it and through it, the young were forced into line, moulded by a utilitarian education which prepared them and their parents to do nothing but mind machines. Thus the opening of *Hard Times* draws links between the

Plate 47. GEORGE CRUIKSHANK. London going out of Town
or the March of Bricks and Mortar. *Engraving.*

heartless schooling and the heartless factory discipline, the ugliness of Coketown
(based on a visit Dickens made to Preston) and the structure, pattern and tone of
English society in its author's time. Chapter One, 'The One Thing Needful', is as
savage an assault on the depersonalised world picture of the scientific and indus-
trial paradigm and its stultifying effect on people's lives as anything conceived by,
and since, Blake. The attack on so-called 'education', wherein youthful creativity
was forcefully and deliberately curtailed, went to the heart of its most sinister but
triumphant fallacy. The title of the second chapter, 'Murdering the Innocents', is
no less explicit; in it Dickens explores how creativity is almost totally annihilated
by the dictatorship of facts before it can mature.

*Hard Times* opens with a resounding declaration of utilitarian faith: 'Now
what I want is, Facts.' The words uttered by Thomas Gradgrind, who runs the
model school based upon utilitarian principles (the opposite of everything which
Dickens as a creative artist held closest to his heart), echo round the bare class-
room. 'Teach these boys and girls nothing but Facts,' he says. 'Facts alone are

wanted in life. Plant nothing else, and root out everything else. You can only form the minds of reasoning animals on Facts: nothing else will ever be of any service to them.'

In opposition to this Benthamite utilitarianism, Dickens contrasts an alternative world: the world of circus, alive with spontaneity and heartfulness untouched by the new materialism. The theme is established in the second chapter in which Gradgrind questions a young circus girl, Sissy Jupe, whose father, a clown, had brought her up to cherish animals, especially the horses with which the circus people travelled through the countryside. 'There was a remarkable gentleness and childishness about these people,' writes Dickens, 'a special inaptitude for any kind of sharp practice, and an untiring readiness to help and pity one another.'

In the classroom, Gradgrind asks Sissy to define a horse. It is a famous passage, but worth repeating because of its relevance to my theme:

(Sissy Jupe thrown into the greatest alarm by this demand)

'Girl number twenty unable to define a horse!' said Mr. Gradgrind, for the general behoof of all the little pitchers. 'Girl number twenty possessed of no facts, in reference to one of the commonest of animals! Some boy's definition of a horse. Blitzer, yours.'

…'Blitzer,' said Thomas Gradgrind. 'Your definition of a horse.'

'Quadruped. Graminivorous. Forty teeth, namely twenty-four grinders, four eye-teeth, and twelve incisive. Sheds coat in the spring; in marshy countries, sheds hoofs, too. Hoofs hard, but requiring to be shod with iron. Age known by marks in mouth.' Thus (and much more) Blitzer.

'Now girl number twenty,' said Mr. Gradgrind. 'You know what a horse is.'

Dickens' assault on false education—the elevation of the abstract and objective above the sensuous, palpitating world of lived experience—had never been more ferociously (or humorously) expressed. The abstract world, Gradgrind's world, Dickens warns us, can deliver only misery, while the world it despises, the world of nourishing imagination, spontaneity and art, the world of Slearly's circus, can bring us only enlightenment and delight. A century later the lesson has yet to be learnt by politicians and 'educationalists' alike.

Through the voice of Louisa, Mr. Gradgrind's unhappy daughter, Dickens

also speaks on behalf of all those, employees as well as children, who have been—and are being—injured by the consequences of a doctrine applied without regard for the fullness of human nature. Denied her right to be human, Louisa, with heart-felt feeling, pleads with her father to understand the effects of his behaviour and beliefs. It is a plea, still unheard, that still needs to be made:

> How could you give me life, and take from me all the inappreciable things that raise it from the state of conscious death? Where are the graces of my soul? Where are the sentiments of my heart? What have you done, O Father, what have you done, with the garden that should have bloomed once, in this great wilderness here... Would you have doomed me, at any time to the frost and blight that have hardened and spoiled me? Would you have robbed me—for no one's enrichment—only for the greater despoliation of this world—of the immaterial part of my life, the spring and summer of my belief...

With Dickens and some of his contemporaries—Carlyle and Ruskin especially, but also Disraeli, Charles Kingsley, Mrs Gaskell and Matthew Arnold—we have reached the age when Artists, especially writers, have become outright critics, denouncers and castigators of their societies. Tolstoy's late novel *Resurrection* (1899), with its virulent attack on his world—its callous greed and injustice—gives the flavour of the anger and despair, disapprobation and censure prevalent amongst an increasing number of European intellectuals as the century drew to its close. On its first page Tolstoy writes:

> What men considered sacred and important was not the spring morning, not the beauty of God's world given for the enjoyment of all creatures, not the beauty which inclines the heart to peace and love and concord. What men consider sacred and important were their own devices for wielding power over their fellow men.

But such a *cri de coeur* was not limited to Tolstoy nor to Russia, even if it was felt with exceptional intensity there. In Norway, in the playwright Henrik Ibsen; in Denmark and Germany, in the philosophers Kierkegaard and Nietzsche; in Sweden, in the playwright August Strindberg; in France, in the poets and novelists Baudelaire, Rimbaud and Zola; in America, in the poet Walt Whitman and the essayist Henry David Thoreau; in Russia, as well as Tolstoy, in the novelists

Maxim Gorky and Dostoevsky we discover in varying degrees writers repulsed by their societies, denouncing their disease and pointing in new directions. We also discover the melancholy strain of warnings of a future disaster. Yet facts and consequences that compromised the aims of industrialism were no less consistently ignored, downplayed, or attacked in the nineteenth century than they have been in the twentieth.

## DOSTOEVSKY'S PREMONITIONS OF A RELIGIOUS REVIVAL

Like Dickens, Fyodor Dostoevsky (1821-1891) was another key figure in the attack on nineteenth-century attitudes and behaviour. If ignorant of the effects of the Industrial Revolution in the north of England, Dostoevsky was nonetheless sensitive to the plight of individuals increasingly bereft of established certainties, suffering the despair and irrationality that lay beneath the surface of Western civilisation's seemingly inexorable advance. His portraits of isolated individuals racked by self-doubt brought to full articulation the naked concerns of human existence at that time: the loneliness and spiritual emptiness that characterises anonymous inner city life. In *Crime and Punishment* (1866), it is a nonentity who murders an old woman so as to 'become a Napoleon', but his brutal gesture, as meaningless as it is empty, is like a premonition of the casually violent delinquency of the serial killer, rapist, terrorist and vandal exacting revenge on a cold society that has rejected them and which they in turn reject.

As an outsider Dostoevsky was not only able to plumb the spiritual malady of a culture advancing, he believed, towards disaster along its God-forsaken path, but also intimate that solutions could not lie in technology, the application of money or any other Humanist variant, but in a root and branch revision of current premises. 'The main thing about me they don't understand,' he said, after making his triumphant speech at the unveiling of the memorial to Pushkin in Moscow in 1880. 'They extol me for not being satisfied with the present political condition of our century, but they don't see that I am showing them the way to the church.' In time, that 'church' may not have turned out to be the one that Dostoevsky had in mind but, nonetheless, against the tides of an increasing dependence on technology and the grip of reductionist and mechanistic paradigms, an increasing number of people are now in search of a life of value and

meaning. Perhaps, as the concluding paragraph from *Crime and Punishment* reveals, Dostoevsky had some heightened perception of the calls for the renewal of life and not a narrowing but an enlarging of consciousness:

> But that is the beginning of a new story, the story of the gradual rebirth of a man, the story of his gradual regeneration, of his gradual passing from one world to another, of his acquaintance with a new and hitherto unknown reality. That might be the subject of a new story—our present story is ended.

## MATTHEW ARNOLD'S DARKLING PLAIN

*Crime and Punishment* was finished towards the end of 1866, about a year before Matthew Arnold (1822-88) published *Dover Beach*, a poem registering in more melancholy key some of Dostoevsky's chosen themes; the sense of all-devouring solitude, mental poverty and desolate inconclusiveness which informed the spirits of many of their most sensitive contemporaries.

Yet images of sickness and fever are found throughout much of Arnold's poetry as he contemplates the wasteland of the Britain of his time, its people debilitated by

> this strange disease of modern life,
> With its sick hurry, its divided arms,
> Its heads o'ertaxed, its palsied hearts.

from which he urges his Scholar Gypsy (in the poem of that name) to 'Fly hence... Still fly, plunge deeper in the bowering wood!'—an invitation itself prophetic of the widespread escape from urban life, the engine of mass tourism.[14]

The title of Arnold's earlier narrative poem *The Sick King in Bokhara* likewise signals the presence of a spiritual, as well as a physical, malaise. 'There is something which infects the world,' the poet tells Fausta in *Resignation*. And in another poem, the *Stanzas from the Grande Chartreuse* of 1852, the poet contemplates the Carthusian retreat, home of the 'last of the people who believe', and grieves for his plight. In a strange and probably unconscious way, Arnold's poem is prophetic of our own time:

Wandering between two worlds, one dead,
The other powerless to be born...

Years hence, perhaps, may dawn an age,
More fortunate, alas! than we.
Which without hardness will be sage,
And gay without frivolity
Sons of the world, oh, speed those years;
But while we wait, allow our tears!

This twilight mood of poetic loneliness was characteristic of the late Victorian age. We find it in Tennyson's *In Memoriam*, the paintings of Burne-Jones, the often melancholy images of Odilon Redon, even in Berlioz's characterisation of Faust in the composer's dramatic rendering of Goethe's poem (1846).

*Dover Beach* is a short poem, but it is one of the great documents of nine-teenth-century Western life. It begins as Arnold and his companion—very proba-bly his newly wedded wife—stare out across the English Channel, but the emphasis is not so much descriptive as on their dual isolation from the meaning-less confusion of a world no longer 'peopled by Gods', as the poet writes in *Empedocles on Etna*. According to Arnold, delight in the beauty of nature should not deceive us into forgetting the indifference of the universe towards man. Only human love can sustain those values which are undiscoverable else-where.

The sea is calm to-night.
The tide is full, the moon lies fair
Upon the straits; —on the French coast the light
Gleams and is gone; the cliffs of England stand,
Glimmering and vast, out in the tranquil bay.
Come to the window, sweet is the night air!
Only, from the long line of spray
Where the sea meets the moon-blanch'd land,
Listen! you hear the grating roar
Of pebbles which the waves draw back, and fling,
At their return, up the high strand,

Begin, and cease, and then again begin,
With tremulous cadence slow, and bring
The eternal note of sadness in.
Sophocles long ago
Heard it on the Aegaean, and it brought
Into his mind the turbid ebb and flow
Of human misery; we
Find also in the sound a thought,
Hearing it by this distant northern sea.

The Sea of Faith
Was once, too, at the full, and round earth's shore
Lay like the folds of a bright girdle furl'd.
But now I only hear
Its melancholy, long, withdrawing roar,
Retreating, to the breath
Of the night-wind down the vast edges drear
And naked shingles of the world.

Ah, love, let us be true
To one another! for the world, which seems
To lie before us like a land of dreams,
So various, so beautiful, so new,
Hath really neither joy, nor love, nor light,
Nor certitude, nor peace, nor help for pain;
And we are here as on a darkling plain
Swept with confused alarms of struggle and flight,
Where ignorant armies clash by night.

*Dover Beach* was composed in 1851, eight years before the publication of *On the Origin of Species*, yet in the year in which the Great Exhibition spread its hospitable glass high over the elms of Hyde Park; and all the world—or at least that part of it tempted by the allure of industrialism—came to Britain to admire its wealth and progress that they too might learn to emulate it. No greater contrast between the two events can be imagined; on the one hand the

sweeping tides of triumphant modernism—a nation celebrating its manufacturing and trading achievements, its vast and varied Empire and leadership of the 'civilised' world—and on the other, the introverted ruminations of a lonely visionary voicing doubts about the 'sick hurry', the 'palsied hearts', the 'strange disease of modern life'. Yet if millions exulted in the nation's successes, Arnold was not entirely alone.

The Italian poet Giacomo Leopardi (1798-1837) had lamented that nature was no longer animate but mechanical. More contemporaneously, Thomas Carlyle had also warned that 'the Old has passed away but, alas, the New appears not in its stead.' It was however the greatest prophet of his age, John Ruskin, who most clearly observed how modern life was betraying all that was most worthwhile in the nation's intellectual, spiritual and artistic life.

He saw how laissez-faire capitalism was destroying 'the aesthetic dimension', pointed out the tasteless luxury of the rich and how society had been divided into two unequal parts: those 'who have gardens, libraries, or works of art,' and those 'who have none'. He also deplored how labour, formerly a source of pride and creativity, had been degraded into machine-minding for nothing but the sake of bread. 'It is verily this degradation of the operative into a machine,' he wrote in *The Stones of Venice* (1853), 'which, more than any other evil of the times, is leading the mass of the nations everywhere into vain, incoherent, destructive struggling for a freedom of which they cannot explain the nature to themselves... It is not that men are ill fed, but that they have no pleasure in the work by which they make their bread, and therefore look to wealth as the only means of pleasure.'

Even so, by the middle of the century, when faith in human progress remained largely unquestioned and Western culture promised a future even bigger, better, richer, quicker and more prosperous than of any previous civilisation, imperceptible doubts (like honey fungus growing at the base of a great tree) had begun to appear in the seemingly indestructible structure of Western civilisation. A mere five hundred years after its introduction, the future of Humanism was in question. The reactions by Artists, and their contributions to this re-evaluation of Western culture, form the subject of the next chapter.

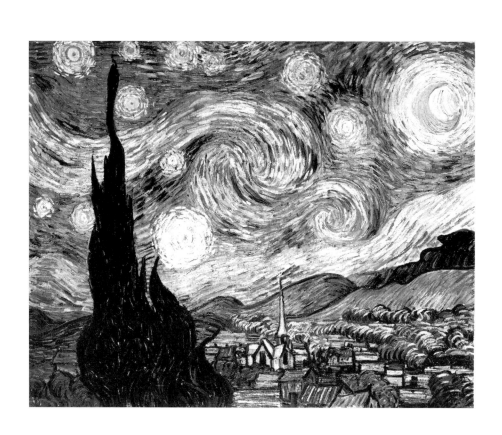

CHAPTER FIVE

# AS BREATHING AND
# CONSCIOUSNESS RETURN

*It is the imagination which gives shape to the universe.*

Barry Lopez[1]

THE TITLE OF THIS CHAPTER is taken from an essay of the same name by Alexander Solzhenitsyn, written at a time when a minority of Russians were beginning to envision a different society to the one they had always known. Yet in spite of the promise of a better life, Solzhenitsyn cautioned discretion and the need for wise counsel. He argued that 'a massive section of educated society is still stuck fast in the way of thinking which Sakharov has passed through and left behind.' And goes on to say:

> As breathing returns after our swoon, as a glimmer of consciousness breaks through
> the unrelieved darkness, it is difficult at first to regain our clarity of vision, to pick
> our way among the clutter of hurdles, among the idols planted in our path.[2]

The parallels that can be drawn between his experience and our own are, I suggest, many and instructive. In both cultures there was and continues to be a thaw, but entrenched resistance against fundamental change. In both there was and is a 'massive section of educated society' 'stuck fast' in inherited attitudes; in both too there was and is a small minority who think for themselves and reach for the light long obscured by the 'unrelieved darkness'.

In previous chapters I attempted to trace the origins of, and the reactions to, the 'darkness' which has clouded Western civilisation. In this one I take the story forwards from the middle of the nineteenth century and into our own.

As we have seen, the first signs of a more widely shared awareness of the

Plate 48. VINCENT VAN GOGH. The Starry Night. 1889. 73.7 x 92.1 cm. *Oil on canvas.*
The Museum of Modern Art, New York. Acquired through the Lillie P. Bliss Bequest.
Photograph © 1996 The Museum of Modern Art, New York.

West's spiritual catastrophe date from the closing decades of the nineteenth century. 'Our minds are infected with the despair of unbelief, of lack of purpose and ideal,' the Russian painter Wassily Kandinsky (1866-1944) warned. 'The nightmare of materialism which has turned the life of the universe into an evil, useless game, is not yet past; it holds the awakening soul still in its grip.' That nightmare found expression in Emile Zola's *Germinal*, Leo Tolstoy's *Anna Karenina* (1875-77) and Gustave Flaubert's novels of French bourgeois life, *Madame Bovary* (1856-7) and the unfinished *Bouvard et Pecuchet* of 1888, which minutely record the small-mindedness, shallow materialism and complacent spirit of the life of their time. Thirty or so years later E.M. Forster also presented a devastating picture of the effects of industrialism in his *Howards End* (1910). In describing the character, aspirations and life-style of the clerk Leonard Bast, who reads Ruskin and listens to Beethoven, Forster described millions of his own countrymen and now others in the industrialising nations:

> The three hurried downstairs, to find not the gay dog they expected, but a young man, colourless, toneless, who had already the mournful eyes above a drooping moustache that are so common in London, and that haunt some streets of the city like accusing presences. One guessed him as the third generation, grandson to the shepherd or ploughboy whom civilisation had sucked into the town; as one of the thousands who have lost the life of the body and failed to reach the life of the spirit. Hints of robustness survived in him, more than a hint of primitive good looks, and Margaret, noting the spine that might have been straight, and the chest which might have broadened, wondered whether it paid to give up the glory of the animal for a tail coat and a couple of ideas.[3]

This then was the kind of human being a century of misguided 'education', imperialist expansion and the urban-industrial approach to life, had prepared to administer its gigantic economic machine. Edvard Munch (1863-1944), in his *Evening on Karl Johan's Street* (1893), presents another view of the same urbanised unfortunates. 'I saw through them,' he wrote, 'and there was suffering—in them all—pale corpses—who without rest ran around—along a twisted road—at the end of which was the grave.' His Scandinavian contemporaries Henrik Ibsen (1828-1906) and August Strindberg (1849-1912) were hardly less bitter in their criticism of the mundanity of the societies in which they lived.

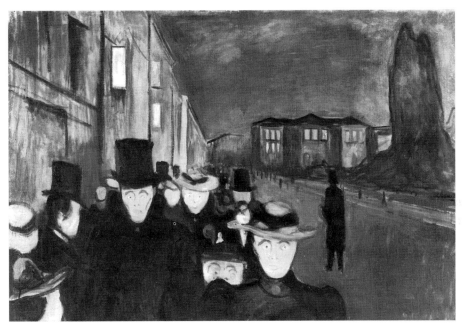

Plate 49. EDVARD MUNCH. Evening on Karl Johan Street. 1893 . 85 x 121 cm. *Oil on canvas.*
Rasmus Meyers Samlinger, Bergen.
© The Munch Museum/The Munch-Ellingsen Group/DACS 1996.

By the end of the nineteenth century, alarm at the deepening and fanatic industrialisation of Western life and its effect on people was experienced not only by Munch and his Scandinavian contemporaries but by a growing number of Artists, both repelled by and determined to challenge it. In general their response took one of two parallel forms: either the spiritual renewal of the existing society or the more desperate remedy—its wholesale destruction. In this chapter I shall attempt an understanding of both alternatives in turn.

In the absence of a robust and trustworthy spiritual authority, courting charges of heresy and madness, the task of renewal fell mainly upon those who either sought a more naked, ecstatic communion with nature or the inspiration of the eternal feminine, through whose cultivation past civilisations achieved new understandings. An example of the latter must be the work that Gustav Mahler composed in the summers of 1895 and 1896, which he originally—and significantly—called the Pan Symphony. It is his Third Symphony, a glorious and

deeply moving composition that in its all-embracing vision of free nature should be seen alongside the utilitarian, money-driven dream that imposed its own restricted vision of reality in terms of regulated pathways, inflexible thought and the shallow imaginative life of the time.

Those who urged the destruction of the rotten framework of Humanist society, the old and rigid patterns that were keeping Europe materially prosperous but spiritually weak, took a more revolutionary route. For them, it was purification by purgation. An example of this quest must be Pablo Picasso's *Les Desmoiselles d'Avignon* of 1907 (see Plate 52).

Regeneration and purgation have been the opposing poles of our century. In the first part of this chapter I shall therefore endeavour to discuss some of the Artists whose task was to provide a vision of human regeneration. I would like to introduce one of the first to enrich and ennoble the almost universal emotional poverty of European life: Vincent Van Gogh (1853-90).

## VINCENT VAN GOGH: A REVIVER OF ADORATION

Like his contemporaries, Van Gogh often painted the day-to-day world of his immediate environment—a patch of grass, some wayside irises, a chair, or his bedroom in Arles. Yet his record of these things differed from that of other painter's of the time. For where they set out to make a faithful record of empirical truth, he set out to enfold the soul's encounter with the soul-of-the-world. He set out, as he once declared, to 'eat nature'; to annihilate the detachment of Humanist thought by merging with the world. 'The nature we see and the nature we feel, the one out there and the one in here, both must permeate each other to last, to live,' he wrote in a letter to his brother Theo. Years before Martin Buber's (1878-1965) philosophic essay, van Gogh had opened his heart to the narrow ridge where I and Thou have always met.[4]

Exaltation was, in fact, the dominant theme of the work he produced in Provence, first in Arles and later at St Remy. Here he painted one of his most exultant, revelatory works, *Starry Night* (1889), which shares with Gerard Manley Hopkins' (1844-1889) poem *The Starlight Night*, much of the poet's ecstasy in the frothing bounty and untrammelled energy of nature:

Look at the stars! look, look up at the skies!
O look at all the fire-folk sitting in the air!
The bright boroughs, the circle-citadels there!

The visionary blaze of Van Gogh's painting (Plate 48), composed of yellows, blacks and a range of ultramarine blues, is an image of superabundant, over-brimming life. Stars stream through the firmament in huge gyrating spirals; the entire sky, in an apocalyptic and participatory dance, sizzles with electric forms. Beneath this cosmos of streaming heavenly bodies crackling with fiery life, the painter places the sleeping town of St Remy, its church spire, lamp-lit windows and angular roofs sheltered by a row of undulant foothills. The black flame of a cypress towers over the scene. For Van Gogh, as for Hopkins, the night sky pro-vided one of the most epiphanic metaphors for the cosmic mystery of existence. *Starry Night*, tilting the scales of reality towards some transcendent equilibrium, is a religious revelation of the divine macrocosm unmatched in European paint-ing for centuries.

'If we only take seriously what he is trying to say,' writes Gottfried Richter, 'it can only mean that what was formerly experienced as the Beyond, for which one could only set a sign, begins to break through into the Here and Now and that the Eternal—heaven and its most lofty spiritual being—is beginning to rise in the midst of the poverty and ugliness of the present age. What is transfigured in the most radiant way is ugliness itself, which he embraces with a genuine love.'[5]

## PAUL GAUGUIN & THE EMERGENCE OF
## THE ARCHETYPAL FEMININE

Another Artist equally rebellious against the consciousness of his time was Paul Gauguin (1848-1903), with whom Van Gogh enjoyed, or rather suffered, a brief relationship in Arles.

Gauguin was one of the first not only to escape from the limitations of indus-trial society but, like the composer Claude Debussy, to respond without patron-age to non-Western forms of creative expression. He received no formal art training, carried no academic prejudices and was inspired by many diverse 'prim-itive' forms of art: Egyptian, Assyrian and Far Eastern sculptures in the Louvre,

Romanesque carvings in Brittany and Japanese prints and other exotic material at the World Fair held in Paris in 1889. In 1890 he wrote that 'A great thought-system is written in Gold in Far Eastern art. The West has gone to rot, but a strong man could redouble his strength, like Anteus, just by setting foot in the Far East. A year or two later he could come back as a new man.' Gauguin's first encounter with this fantastic realm was Brittany, where he saw the locals, by contrast with Parisians, as simple, unspoilt children in mystical communion with nature. Adopting his own advice, he later settled in the South Seas where he saw, or believed he saw, a culture which in its unconsciousness of sin and corruption mirrored Eden. At one level the journey was a simple escape from the stranglehold of reason; at another it was a flight into the unconscious.

Like Wagner, Gauguin also looked for the truth in himself. 'My own work may be only relatively good,' he wrote, 'but I have tried to indicate the right to dare anything.' Wanting to get back to Nietzsche's 'terrible original text, *Homo natura...*', he searched for the primitive in himself and discovered something which the lonely, dominant, Western male had ignored and subjugated for millennia: the feminine aspects of the soul.

I am not about to suggest that this monstrous masculine egoist was the first to express the mystery which surrounds the feminine or anima dimension of life. To do so would be to ignore many others: Watteau and Renoir, Debussy and Mozart, Shelley and Keats. Yet, amongst other things, Gauguin was obsessed and inspired by the feminine in both her sexual and archetypal aspects. His mother was a Peruvian Indian (the painter lived his first seven years in Lima where he had been exposed to the different customs and beliefs of the Sierra Indians, Mestizos and ex-African slaves); he felt the animistic spirits of her heritage especially strongly.

In Martinique and French Polynesia, Gauguin took steps to immerse himself in Tahitian and Marquesian culture; he incorporated Polynesian art and mythology into his Symbolist-Theosophical works and became, according to Jehanne Teilhet-Fisk, not only the first Artist to recognise the aesthetic merit and contextual meaning of Polynesian art but a lay-anthropologist of no mean order.[6] He incorporated Tahitian mythology into his paintings, wood-engravings and sculpture; in 1892 he began to write his *L'Ancien Culte Mahorie*, heavily indebted to an earlier study, *Voyage aux iles du Grand Ocean* by Jacques Antoine Moerenhout, published in 1837.

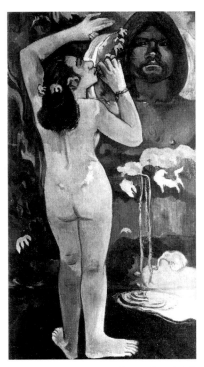

Plate 50. PAUL GAUGUIN. The Moon and the Earth (Hina Te fatou). 1893. 114 x 62cm. *Oil on burlap*. The Museum of Modern Art, New York. Lillie P. Bliss Collection. Photograph © 1997 The Museum of Modern Art, New York.

Amongst the extensive pantheon of Tahitian *atuas*, Gauguin was intuitively drawn to Hina, Goddess of the Moon, and Te fatou, the first woman in creation, ancestress of man, the spirit of the earth. He was also aware, as Moerenhout had been before him, of the complementary roles of male and female energy in the human psyche. He wrote of 'the coexistence of two principles which are God... the two composed, by their union all that exists in the universe.' Such thinking, stemming from the French revival of mysticism and the occult, was not uncommon; Balzac, in his Swedenborgian novel *Seraphita* (one of the painter's favourite books), follows a similar line of thought, as did the founder of the Theosophical Society, Madame Blavatsky (1831-91).

In 1893, Gauguin painted *Hina Te fatou: The Moon and the Earth*, informed not only, I believe, by these ideas but by a feeling for the conservation

and continuity of the natural order and—even if we are unfamiliar with Tahitian cosmology—a sense of the will of the *anima mundi*, rather than the self-will of a particular individual. The subject of the painting, which comes from a legendary dispute between Hina and Te fatou, is based on the legend of *Eternité de la matière* which Gauguin (following Moerenhout) describes in his *Ancien Culte Mahorie*. Hina, stretching to her full height, asks the earth if man can be reborn after death. She says to Te fatou, 'Make man live or rise again after death.' Te fatou replies: 'The earth shall die, its vegetation is dying, the men who are nourished by it must also disappear.' Hina then retorts that she will periodically bring the moon back to life, even if man does perish.

Although this interpretation is bewilderingly obscure (and Gauguin himself is unlikely to have understood the myth's full implications), it is nonetheless an extraordinary intuition of the role of the Goddess in urging an exhausted culture to rediscover the realm of instinctive feelings and everything to do with the imaginative and sexual aspects of human existence. Thus his Art entered the life of the world in the service of the feminine.

## CLAUDE MONET'S ANTICIPATION OF THE TRANSFORMATION OF WESTERN THOUGHT

Something of the same process of change in the European psyche is also to be found in the late canvasses of another French painter Claude Monet (1840-1926), who observed Nature with a focused rapture rarely equalled in the history of consciousness. In his early work Monet was committed to the recording of empirical truths in a manner perfectly attuned to the rational, positivist attitudes of his age, yet he was slowly to become, I believe, much more than an immensely gifted recorder of sunlight on fallen snow or the glitter of trees in water.

In 1886 at Belle Isle, he began with a working method of painting and repainting particular landscapes under different conditions of weather, time of day and season. In 1891 he began to paint the same scene repeatedly viewed from an identical position in space, but at different times of day. He portrayed the façade of the cathedral in Rouen in forty separate works, and a group of haystacks near his house in Giverny at least twenty-five times. He said: 'I well

Plate 51. CLAUDE MONET. Detail of Water Lily Decorations: Morning with Willows. c1916-26. whole painting 200 x 1275 cm. *Oil on canvas.* Musée de l'Orangerie, Paris.

realise that in order really to paint the sea, one must view it every day, at every time of the day and in the same place in order to get to know its life at that particular place; so I am re-doing the same motifs as many as four or even six times.' Viewing these studies when they are placed in sequence creates a cathedral and a landscape that begins to exist in time, as well as the three dimensions of space. Monet had seized upon a great but simple truth about time: an object must have duration besides three extensions in space.

From the fifteenth to the twentieth centuries, the vision of Western civilisation had been restricted to Euclidian co-ordinates. Then the seeds of doubt about the inviolability of the Euclidian conception of geometry began to sprout in the field of mathematics. Monet, though unaware of these doubts, yet became the first person to invent a radical new way to *see* time before anyone had devised a correspondingly new way to *think* about it.

By his later years—and especially in his paintings of the surface of a water-

lily pond—Monet had largely abandoned the three-dimensional perspectivist painting of a single moment of time which had characterised his earliest canvasses. In order to paint in such a manner he had had to *believe* in the simultaneity of the universal present. Yet in his later paintings Monet had already begun to accept the multiplicity of perception, the insubstantiality of 'reality' and the elusive, indeterminate nature of the observing self. Inadvertently he became the prophet of a world-view focused on the dynamics of relationship rather than a world-view based on disconnected parts.

We can see this very clearly in the nineteen elongated canvasses of water-garden motifs in a gallery built to house them after his death in 1926: the Musée de l'Orangerie in Paris. Standing in one or other of its two galleries, one's gaze is attracted by the shimmering prospect of two connected worlds—a sky world and a water world—making and unmaking themselves before our eyes. All is shifting and dynamically alive. Clouds float, as water seems to dissolve into patterns of colour—lilac, aquamarine and violet-pink. What is *in* the water, *on* the water, or reflected *upon* water, both air and light, space and solid, reflection and reality, paint and what it seeks to represent, appear to merge. Looking at the surface of a canvas we may observe a reflection of pinky clouds in cobalt waters or the hair-like tracery of falling willow branches or the buttons of water-lily leaves sketched in oval swirls of creamy paint; but what we feel is an erotic contact between ourselves and nature experienced in a new way. Without awareness of the revolutionary nature of his discovery, Monet had achieved liberation from uniform space, relative light, and linear time—at a date, too, when Newton's mechanical view of reality was at its most triumphant.

To appreciate the significance of Monet's work, it may help to be reminded of the breakthrough that occurred in physics at the start of the century. A year before Cezanne died in 1906, and as Monet was working on his water-lily series, Albert Einstein, an obscure patent official, published an article which would become known as the special theory of relativity.

Einstein's contribution took place against the backdrop of a belief in the omnipotence of classical mechanics. Newton's system had worked so well for more than two hundred years that many physicists at the turn of the century saw no reason to disturb it. Yet as a child Einstein had wondered what the world would look like if he could travel astride a speeding light beam; he had also asked himself how the wave would appear if he could dismount and travel beside

it at the same velocity. Lacking mathematical skills, he had had to wait until he was twenty-six years old before he was able to answer his own question. Then, turning Newtonian ideas about space, time and light on their heads, he declared that space and time are relative; only light-speed is constant.

Before Einstein, Westerners had conceived space and time as separate co-ordinates, as distinct as telling time on a clock was from measuring distance with a ruler. After Einstein, time and space could only be perceived as intimately inter-twined. As time dilates, space contracts; as time contracts, space dilates. A German mathematician, Hermann Minkowski, named this reciprocal relation-ship the *spacetime continuum*. Thus for Einstein's theory of relativity (as for Heisenberg's uncertainty principle), the position of the observer is of crucial importance. The nature of time, and therefore perception, is not held to be absolute but relative.

Monet's conception of the viewer enfolded within a world of sky and water was the poetic complement of the illimitable notions of space, time and light that simultaneously occurred in physics in the early years of the century.

## CLAUDE DEBUSSY AND THE PRESENT MOMENT

The quiet, almost unnoticed enfoldment of the human within the 'non-human' in Monet's Art was simultaneously envisioned by Claude Debussy (1862-1918), the first Western composer to regard musical sound not so much as inchoate mater-ial to be coerced by the force of human will into the service of human communi-cation, but as something to be relished, contemplated and loved for its own sake. In Debussy, only the present moment, the 'now' exists; there is neither causation nor consequence. The absence of will is a state of good in itself.

Christopher Small, author of *Music: Society: Education*, reiterates these observations when, in describing the opening of *Prélude à 'L'après-midi d'une faune'* (1894), he points out that the music '(with) its unaccompanied low-pitched flute sounds and sweeping harp glissandi leaving a dissonant chord unre-solved... does not look back to any lost world, but is rather a manifesto for a "potential society which lies beyond our grasp", a society living happily in the present, free from the constraints of clock time and the urge to domination. Pierre Boulez observed that modern music awakes with the flute of the Faun.'[7]

Listening to the chords of Debussy's music, regardless of whether they are in classical usage 'consonant' or 'dissonant', it is important to hear them as if for the first time—as we hear the sound of the sea in a sea-shell, or the song of a thrush; we should remember that they arise in Eden rather than in the concert hall. In his compassion for the natural world, Debussy rejected all memory, all desire, all hierarchy, all ambition, all ego, everything except the musical event itself. His appeal to nature as the expression of non-intention—no-mind—was itself a powerful antidote to linear, causal thinking and the masculine coercion of time.

*Prélude à 'L'après-midi d'une faune'* was written five years after Debussy, like Gauguin, encountered for the first time non-European forms of art at the Paris World Exhibition of 1889. It was here that he heard the Javanese gamelan and the musical theatre of Kitchen China. It was here, too, that he became the first Western musician to recognise and acknowledge the existence of a musical culture equal to his own. The effect of the exotic sounds startled and delighted many of their listeners; yet of those fascinated by the play of metallophone, gong and drum, it is highly probable that only the twenty-seven year old composer appreciated their long-term significance. 'Tonality, which is the basis of modern harmony, is in a state of crisis,' he wrote, '... The ancient modes are making a comeback, to be hotly pursued by the scales of the East in all their tremendous variety. Harmony, too, is bound to change and we shall see developments in rhythm, which has so far hardly been explored. From all this will spring a new art.'

That art found expression not only in *L'après-midi* (which took two years to write) but in the compositions of his later years, where Debussy employed the chord solely in terms of a timeless present, a present without past or future, where nature was restored to the foreground. In his finest music he seeks neither the domination and control of nature but an instinctual solidarity and surrender to it.

'There is,' he once wrote, 'more to be gained by watching the sun rise than by hearing the Pastoral Symphony. To some people rules are of primary importance. But my desire is only to reproduce what I hear. Music was intended to receive the mysterious accord that exists between nature and the imagination.' With Basho, he could have said, 'Learn of the pine trees from the pine trees.'[8]

Perhaps this is what art originally was: an act of collective imagination recapturing the memory of an earlier instinctual union. That union had been

cleaved, yet in a period when the European mind was imprisoned by the routine of the clock, the spell of logic, the totalitarian propensities of reason and what Jacques Maritain once called the finality of the useful, the Artists I have been discussing—Van Gogh, Monet and Debussy—offered a glimpse, albeit maybe only a fleeting one, of a timeless order of potential transformation, a momentary sense of freedom and wholeness. Art, one of the main regenerating elements of the human psyche, can have this function. When consciousness is most endangered it can heal by reconnection to the greater authority of spirit.

## WAGNER'S CELEBRATION OF COMMUNITY VALUES

Although appreciated for his great cycle of subjective mythological operas, based upon the Eddas, the Nibelungenleid and the Sagas—*Das Rheingold, Die Walküre, Siegfried* and *Götterdämmerung*, collectively called *Der Ring des Nibelungen*—Richard Wagner (1813-1883) should be remembered for the attention he drew to the lost world of tightly knit communities which in his lifetime European industrialism was in the process of destroying. *Die Meistersinger von Nürnberg* (sketched as early as 1845 and composed between 1861 and 1865), set in an archaised, imaginative-historic time—sixteenth century Nuremberg—is an impassioned celebration of a world before the scientific world-view and its progeny, industrialism, destroyed the mediaeval philosophical and social synthesis.

Here Wagner contrasted a world that was the opposite of his own society; a world of supportive and convivial Guilds rather than impersonal factories, of tradition rather than 'progress', of simplicity rather than endless complication, of communal cohesion and order rather than conflict and competition. Here, as families, friends and neighbours, people had to depend on other people; the fabric of local interdependence was the bedrock upon which society was based. Even more significantly, it was a world in which the arts were not the entertainment of an increasingly uncreative and decadent élite, the grandees of aesthetics, but the expressive manifestation of the creative popular spirit. In *A Communication to my Friends*, the composer singles out the chief character in the opera, the most famous of the 'mastersingers', Hans Sachs (1494-1576), as 'the final manifestation of that spirit'. Sachs, a cobbler, composed over 6,000 songs, two-thirds of which are 'master songs'.

At one level, *Die Meistersinger* is an opera about youthful love and ardour, mature and genial wisdom; it is also a celebration of the values of a thriving community and the traditional art of its Mastersingers. Its message to that effect is too clear and explicit to be unintentional. For a start, we know that its composer hoped that dramatic art rooted in popular local traditions would undermine the preponderance of contemporary 'opera', which he saw as nothing but a form of rank vegetation flourishing amongst the decaying splendours of metropolitan, and especially French, civilisation.

The opera's final scene is also one of the most triumphalist celebrations of a community ever written. Its final tableau with the city's townsfolk—the burghers, craftspeople, apprentices, stewards and their families—gathered to listen to the singing of the Prize song—was indeed something in the order of a didactic programme: a monumental, aesthetic Utopia, in which tradition was to be reconciled with progress and art with reality. In this respect, as Dieter Borchmeyer observes, 'Not only are the individual arts reunified on the Festival Meadow, but the entire life of the community is concentrated in a "total work of art" from which the individual work of genius no longer needs to be divided by a "mystical abyss". Rather it emerges from the total work of art as a flower grows from a plant: both are part of a single entity. Old ideals of Wagner's are once again revived here—a dream of "unity of being" far removed from Wagner's festival at Bayreuth, a festival conceived for the present prosaic state of the world and barely able to bridge the gulf between art and reality. Wagner, in fact, had no illusions that the bourgeois mentality dominated the present state of the world. *The Mastersingers* holds out the promise of its antithesis: the burgher whose art will banish the *Whan** of money.'[9]

Yet like his former friend the philosopher Nietzsche, who believed that Art was the sole justification for life, Wagner was also a child of his time. A persistent non-believer, he never doubted the merit of organising a religion of his own. In *Religion and Art*, he promised an exploration of the power of music to reveal the essence of religious symbolism, and what he intended to convey was put into words by his wife, Cosima, writing to a friend. 'Believe me', she wrote, 'our art is a religion. It has been made possible for art to rescue what is most holy to us from all dogmatism and rigid formalism.'

*folly, madness

Yet in a sense the 'religion' which the opera *Parsifal* (1882) celebrated is a fanatical belief not in God, not in the State, but the projection of the composer's inner life as a 'modern myth'. Thus Wagner's work culminated in a deification of his ego. Opera became a substitute for religion: for the deification of the ego could hardly go further than the Wagner cult at Bayreuth, where a temple was built for the performance of the Artist's creations. There is something about this development that is intrinsic to Humanism: arrogance. As Wilfrid Mellers writes, 'Instead of music being composed to fulfil the needs of the temple, as was Palestrina's to serve God, or Handel's to serve the State, Wagner himself said that Bayreuth was the fulfilment of the destiny which he had planned for himself and humanity.'[10] The cult of individualism which began with *David* reaches its apogee here.

Yet Wagner was not alone. The religion of Art was already well on the way to replacing Christianity as the West's most dynamic faith. 'Art is not only a profession,' wrote Jean Auguste Dominique Ingres (1780-1867), 'it is an apostolate... my elevated tastes are part of a religion.' The playwright Oscar Wilde (1854-1900) 'treated art as a supreme reality, and life as a mere mode of fiction', while in 1853 Victor Cousin declared that 'Art is referable to nothing but itself.' Thirty years later Matthew Arnold was to argue that increasing numbers of people would turn to poetry 'to interpret life for us, to console us, to sustain us.'[11] A century later, a small army of bureaucrats is active with the interpretation of his hopes.

Yet while Gauguin and Monet, Debussy and Wagner contributed a spiritual vision enriching 'the unrelieved darkness' of nineteenth and early twentieth century life, other Artists like Yeats and Picasso, Stravinsky and Proust set out in search of soul, but by different means: Yeats by envisioning the nature of a new paradigm, Picasso and Stravinsky by demolishing the past, that new life might grow to fill its place.

## YEATS FORETELLS THE ADVENT OF A NEW CYCLE OF CIVILISATION

As early as 1927 the critic I.A. Richards, writing about Yeats's 'effort to discover a new world-picture to replace that given by science', was stressing the reason why the poet looked towards an uncharted New Age of which his two earlier masters, Emmanuel Swedenborg and Blake, had earlier declared themselves the prophets. By that date, Yeats had declared that the current materialist ideologies

were mere ignorance. Man, he believed, could never be considered solely in terms of his physical organism but only as a living consciousness.

His progress towards this certainty was elaborated over many years. In the first year of the twentieth century, he addressed his fellow-members of the Magical Society of the Golden Dawn:

> We have set before us a certain work that may be of incalculable importance in the change of thought that is coming upon the world.

In *Ideas of Good and Evil*, written sometime before 1903, he wrote:

> I can not get it out of my mind that this age of criticism is about to pass, and an age of imagination, of emotion, of moods, of revelation, is about to come in its place; for certainly belief in a supersensual world is at hand again.[12]

Later he censored materialism as a passing heresy and dared to proclaim, in a prescient exclamation, 'the rise of soul against intellect now beginning in the world'. In 1926 he assured Sturge Moore that 'what Whitehead calls "the three provincial centuries" are over. Wisdom and Poetry return.' And in 1937 he declared in *A General Introduction for my Work* that:

> I am convinced that in two or three generations it will become generally known that the mechanical theory had no reality, that the natural and supernatural are knit together, that to escape a dangerous fanaticism we must study a new science...[13]

His poem, *The Second Coming*, written in 1919, and drawing upon several of these themes, predicts the arrival of a new age. Yet, in contrast to the bright, one-sided rationalism of Enlightenment life, it foretells the coming of a dark, unwelcome future characterised by (as he writes in a note to the poem in *The Double Vision of Michael Robartes*) the existence of a terrible 'stream of irrational force'.

> Turning and turning in the widening gyre
> The falcon cannot hear the falconer;
> Things fall apart; the centre cannot hold;

Mere anarchy is loosed upon the world,
The blood-dimmed tide is loosed, and everywhere
The ceremony of innocence is drowned;
The best lack all conviction, while the worst
Are full of passionate intensity.

Surely some revelation is at hand;
Surely the Second Coming is at hand.
The Second Coming! Hardly are those words out
When a vast image out of *Spiritus Mundi*
Troubles my sight: somewhere in sands of the desert
A shape with lion body and the head of a man,
A gaze blank and pitiless as the sun,
Is moving its slow thighs, while all about it
Reel shadows of the indignant desert birds.
The darkness drops again; but now I know
That twenty centuries of stony sleep
Were vexed to nightmare by a rocking cradle,
And what rough beast, its hour come round at last,
Slouches towards Bethlehem to be born?[14]

Much of this mysterious and hallucinatory poem is obscure, but we know that its central theme relates to the succession of civilisations outlined in his major prose work, *A Vision*, published in 1925. In this book he says 'that before Phidias, and his westward moving art, Persia fell, and that when the full moon came round again, amid eastward moving thought, and brought Byzantine glory, Rome fell; and that at the outset of our westward moving Renaissance, Byzantium fell; all things dying each others life, living each others death.'[15] Thus the poem's reference to the rough beast can be seen to refer to the coming upsurge of psychic energies which in Yeats's opinion would transform society, and the reference to the widening gyres can be seen to refer to the waning of the Christian era and the advent of a new cycle of civilisation, a 'New Dispensation'.

This civilisation, he predicts, will in no way resemble the one that has passed: it will be uncomfortable: a dark era of 'Terror and joy', a complete reverse of all the values cherished in the former era, emblemised by a visionary beast, a sphinx

arising out of the world's Great Memory, Spiritus Mundi.

A note to the poem *Michael Robartes and the Dancer*, where Yeats says that 'at the present moment the life gyre is sweeping outward... all our scientific, democratic, fast accumulating, heterogeneous civilisation belongs to the outward gyre and prepares not the continuance of itself but the revelation as in a lightning flash...' may further help the elucidation of what must always remain a disturbing poem. The reference to the falcon losing touch with his falconer is also unambiguous. The falcon is man, the falconer, Christ, whose birth was the revelation of the present cycle, now coming, as Yeats suggests, to its inevitable end in an anarchic loss of control. 'The loss of control comes towards the end,' he states in *A Vision*.

Thus, if the central theme of *The Second Coming* is the advent of a new cycle of civilisation, much of the poem still puzzles both those readers and critics who have sought to elucidate its meanings. One of these, Giorgio Melchiori, basing his interpretation on a study of Yeats's early play *Where There is Nothing* (1902) has offered an interesting view.[16] The play concerns an Irish visionary, Paul Ruttledge, who in order to subvert the established social order, has deserted his aristocratic family to join a company of tramps. In it, a 'fabulous beast' which stands for a 'terrible joy', is sent to 'overturn governments and all settled order', to 'bring back' the dream of every Artist labouring under the grey shadow of industrial regimentation and greed, 'the old joyful, dangerous, individual life'. This is the creative spontaneity celebrated by Dickens in *Hard Times*, by Gauguin in the South Seas and Van Gogh under the skies of Provence.

According to Melchiori, the relevance of this beast to the poem is emphasised in the play's last scene, where its emblem is painted on the banner of an army marching against all settled order: the Church and the World.

> We will have one great banner that will go in front, it will take two men to carry it, and on it we will have Laughter, with his iron claws and his wings of brass and his eyes like sapphires.

A moment later Paul Ruttledge exclaims:

> We cannot destroy the world with armies, it is inside our minds that it must be destroyed, it must be consumed in a moment inside our minds.

## A NEW BEGINNING

The desire for transformation was most keenly and widely felt at the turn of the century. Virginia Woolf encapsulated the advent of Modernism in a famous phrase: 'On or about December 1910 human character changed'. It is, of course, a phrase which is not to be taken literally, yet does capture a sense that some profoundly new developments were occurring shortly after the turn of the century. These developments may have been concentrated in the realms of the avant-garde Arts, but they also echoed simultaneously in other areas of human life.

The revolutionary process is—and continues to be—an extremely painful one, but at the time that pain was in few people's minds. What mattered, what inspired, were the possibilities inherent in the future—once, that is, the outdated structures had been torn down, the corrosive pollution of the past removed. 'All is possible,' cried the Cubist poet Andre Salmon, 'everything is realisable everywhere and with everything.' Moral constraints, social obligations, all forms of inhibition and control which stood in the way of these possibilities were to be swept away. 'Enter and sack the decadent civilisation... destroy its temples... tear the veil from its novices... not be stopped by altars nor by tombs,' exhorted Alezandro Lerroux, leader of the radicals in Barcelona nine years before the apocalypse of the Great World War. 'Our world, like a charnel house, is strewn with the detritus of dead epochs. The great task incumbent on us is that of... clearing away from our cities the dead bones that putrefy in them,' declared Le Corbusier in 1929.[17] Interestingly enough, something of the same ruthlessness inspired Lenin, whilst the phrase 'the New Man' was as much favoured by Hitler as by Le Corbusier.

All the figures within the development of what has come to be called 'Early Modernism'—Matisse, Picasso, Stravinsky, Schoenberg, Pound, Eliot, Proust, Joyce, Mann, Rilke and Apollinaire—also believed that their Art would prepare the ground for a new civilisation. Yet in so doing they had no intention of establishing a new order; rather their purpose, as Herbert Read observed, was 'to create a break-up, a devolution, some would say, a dissolution' of prevailing orthodoxies and traditions. It was therefore characterised by an attack on rationalism and a delight in all that previous generations had most vehemently denied: sexuality, the unconscious, the spontaneous and child-like. 'We are the primitives of an unknown culture,' boasted Umberto Boccioni in 1911.

Plate 52. PABLO PICASSO. Les Demoiselles d'Avignon. 1907. 243.9 x 233.7 cm. *Oil on canvas.*
The Museum of Modern Art, New York. Acquired through the Lillie P. Bliss Bequest. Photograph
© The Museum of Modern Art, New York. © Succession Picasso / DACS, London 1996.

It was this primivitism, this subversion of society, which the twenty-five year old Spaniard Pablo Picasso (1881-1973) brought into painting. In its rejection of perspective, its barbarism and renunciation of the contingent world of objective appearances previously considered the very essence of painting, his *Les Demoiselles d'Avignon* presaged the transformation of Western thought.

Blunted by the aggression of so much subsequent painting (and the violence recorded by manifold newsreels and commercial films), we have probably lost the capacity to be shocked by the brutality and disfigurement of this picture. Although *Les Demoiselles* depicts five naked women (in a brothel), these are painted with a violence, almost a hatred, unseen in Art for some nine hundred years. The friends who saw it in Picasso's Parisian studio were at first profoundly shocked. And it was meant to shock. ' It was,' says John Berger, 'a raging, frontal

attack not against sexual 'immorality', but against life as Picasso found it—the waste, the disease, the ugliness, and the ruthlessness of it.'[18]

But *Les Demoiselles* was not only a cry from the heart about the rottenness of Western civilisation; it was also a work of astonishing, prophetic and destructive originality. It initiated the destruction of Cartesian logic and Newtonian space, and broke with five hundred years of pictorial tradition. Picasso's outright rejection of ordered space, rational perspective and respect for appearances is said to have freed painting from the trammels of rationalism. This is true. But as it liberated, so it also loosened, made possible almost anything and gave further authority to the belief that experiment and originality were prime sacraments to be revered as a kind of Law of Nature. As early as 1912, Theodore Duret, the sturdy supporter of Impressionism, had already warned his readers that Art lovers were 'ready to swoon in front of any eccentricity'—a prophesy that has been subsequently verified over and above anything Duret could have suspected.

## ALEXANDER SCRIABIN & IGOR STRAVINSKY

As well as Picasso, Alexander Scriabin (1872-1915), Marcel Proust and Igor Stravinsky had similar premonitions about the future. Poised at the gates of the new-born century, the former was convinced that man's psyche needed to be shaken by what he called a 'hypnosis of apparitional rhythms'. He said that his ultimate aim was to create music which belonged to those 'theurgic arts of lost, ancient, mystic cultures'. Like Picasso, he sought to redress the one-sidedness of the prevailing culture, its untroubled belief in the efficacy of human control and elevation of the masculine, and initiate a world of unforeseeable otherness, 'a glimpse of higher spiritual planes: 'Light...rapture...soaring flight...suffocation from Joy!'

At the time of his death Scriabin was working on his *Prefatory Action* (1914), a composition intended to precede an even more gigantic opus, *Mysterium*, of which only fragments have been discovered. At the projected climax of what was to have been a seven-day festival in the Himalayas, the music of this composition would dissolve the world in an abyss of flame, returning all beings to their spiritual essence within the 'plane of unity'. These grandiose works, for which all his later music was merely a draft, reflected Scriabin's con-

cept of life—'eternally creative, full of miracles and revelations, ever new and deeper and deeper, limitless and inexhaustible'. Thus the central guiding principles of their performance were a premonition of more recent aspirations: that spectators and performers should remain largely undifferentiated. 'I cannot understand how to write *just* music now,' he said. 'How boring! Music surely takes on idea and significance when it is linked to a single plan within a whole view of the world... The purpose of music is revelation.'

The exotic hinterland inhabited by Scriabin has sometimes been interpreted as a cul-de-sac, but actually stretches, I believe, to the present. *The Firebird* (1910) and *The Rite of Spring* (1913) were born there; so too was the gaudy effloresence of sixties' spirituality, the quest for meaning in Eastern non-dualistic philosophies, the use of drugs to escape the meaningless mundanity of existence, even large-scale rock concerts with laser lights, smoke and a powerful performance element. Yeats's prophesy about the 'rise of soul above intellect' finds at least one of its innumerable embodiments here.

No less reminiscent of the dramatic totality of the shaman's approach to music are the violent, visceral rhythms of the early work of Scriabin's compatriot Igor Stravinsky (1882-1971). Stravinsky was, of course, the countryman of a nation where individualism was less developed than in the West; in his most famous ballet score, *Le Sacré du Printemps* or *The Rite of Spring* (1913), wherein there is neither melody (except brief but recurrent ostinato utterances) nor harmony, and virtually no modulation, the Western concept of individuality plays hardly any role. In point of fact the impersonality of ritual runs through *Le Sacré* like a thread, and indeed through all the composer's work to the very last, though he himself only gradually became aware that a ritualistic approach might be an answer, *the* answer, to the disrupted self-consciousness of the modern world. The ballet's jarringly dissonant and orgiastic music, both a fertility rite and a sacrificial act—'une sorte de cri de Pan', Stravinsky called it—can be interpreted as a deliberate turning back on the long-cherished values and assumptions of Humanist civilisation.

The original *mise-en-scene* had been contributed by Nicholas Roerich (1874-1947), a painter and archaeologist utterly absorbed in dreams of prehistoric, patriarchal and religious life. Around the time of the *Rite*, he was viewing the Stone Age as a golden period where, to quote his biographer Jacqueline Decter, 'man and nature were in harmony, and work and art were one.'[19] But Roerich

Plate 53. NICHOLAS ROERICH. The Great Sacrifice. 1910. Originally intended as the Backdrop of Act II. 73.5 x 81.3 cm. Bolling Collection, Miami, Florida.

not only suggested the original idea and worked in close collaboration with Stravinsky, he also created the sets and costumes for the original production, innovatively choreographed by Vaslav Nijinsky, who had already designed the ballet based on Debussy's L'après-midi d'une Faune. The first performance in the Theatre du Champs-Elysées on 29 May 1913, when, as it has been said, the 'civilised' met the 'raw', was the occasion of one of the greatest riots in the history of the theatre.

In its final form the ballet consisted of two acts. In the first, *The Kiss of the Earth*, the members of a pagan Slavic tribe congregate near a sacred hill. A three-hundred year old woman, the tribe's progenitress, foretells the rites to come, and the tribe performs a series of ritual dances to induce and celebrate the return of spring. In the second Act, *The Great Sacrifice*, the maidens of the tribe begin a mystical labyrinthine circle dance on the sacred hill and Fate (or Yarilo) chooses one of them for sacrifice. The ancestors of the tribe, clad in bearskins (an allusion to the ancient Slavic belief that the bear was man's ancestor), surround her as she, possessed, dances herself to death in order to save the earth.

Even an outline of the scenario and the fact that Stravinsky later confessed that he was only the vessel through which the music passed, may reveal some-

thing of the shamanic nature of *Le Sacré*. Only now, some eighty years after its first performance, are we beginning to appreciate the wisdom of the vernacular peoples who surrendered their egotism in a communal act, their sense of chronological time in a mythic and ancestral past. To the peoples of a decadent Europe, *Le Sacré du Printemps* offered the vision of a society in complete harmony with the earth and so aware of its total dependence upon nature that it was prepared to sacrifice a human life in return. We may flinch at their 'barbarism' until we remember that it was performed on the eve of an even greater one: the First World War, in which over seven million people were deliberately killed.

The importance of *Le Sacré* can not be exaggerated. It injected a stream of raw energy into the anaemic bloodstream of a degenerate civilisation; it restored nature to the realm of the sacred, and fed a hunger of the spirit for nourishment to face and fulfil its future.

## MARCEL PROUST & THE TRANSPARENCY OF CONSCIOUSNESS

At exactly the same time and place that Stravinsky was composing *Le Sacré*, the novelist Marcel Proust (1871-1922) was drafting the first book of an immense work of sixteen volumes, *A la Recherche du Temps Perdu*. Its first book, *Du Côté de Chez Swann*, was published only a few months after the ballet's first performance in 1913. Like the latter's composition, though in an entirely different way, Proust's novel also entered the battle for greater consciousness, the battle for awareness.

Time and memory, the fragmented nature of consciousness and the nature of personal identity, are the subject of his vast novel; the whole work is contained within the single consciousness of the Narrator, whose meditations on the nature of time fill hundreds of pages. Encapsulating the idea of the speed of light and spacetime, in the very last lines of his novel Proust wrote:

> But at least, if strength were granted me for long enough to accomplish my work, I should not fail, even if the results were to make them resemble monsters, to describe men first and foremost as occupying a place, a very considerable place compared with the restricted one which is allotted to them in space, a place on the contrary prolonged past measure—for simultaneously, like giants plunged into the years, they

touch epochs that are immensely far apart, separated by the slow accretion of many, many days—in the dimension of Time.

In the first sentence of the novel the word 'time' also appears. Thereafter, as William Sansom observes, it is 'reiterated, sung sometimes softly, sometimes drummed loud, but always there, until, in the very last sentence, this quintessence of the book receives the accolade of a last word.'[20] But in this novel time is never rationally measurable: it is elusive, transparent, shifting, then opaque: with its flashbacks and flashforwards, its sudden jumps over the years: one day can take 287 pages, yet years can pass unrecorded. People in the novel, too, are no less elusive, they are changing all the time, their characters remain only broadly the same with many hidden and disparate facets ready to reveal themselves. Charles Swann, Madame Verdurin, Baron Charlus, Odette de Crecy and others, are sometimes base, sometimes noble, true and untrue to themselves, and we can never be quite sure we have understood them. In this respect, the critic Harold Bloom makes a significant observation when he writes that: 'At the very close of the novel we don't necessarily believe that the Narrator has come to *know* a truth or a reality, but we sense that he is on the verge of *becoming* a kind of consciousness different from anything else that I at least have encountered in Western fiction.'[21]

Proust is one of the first great writers to be interested in the possibilities of process. Yet if he had preconceived ideas about people and events, he nonetheless believed that Art was one of the ways in which man could save himself. As André Maurois has observed, the main subject of *A la Recherche du Temps Perdu* is not the picture of the particular society to be found in France at the end of the nineteenth century, nor a new analysis of love and time, important as these are; it is 'The struggle waged by the spirit of man with Time, the impossibility of finding in actual life a fixed point to which the self can cling, the duty of finding that point within oneself, the possibility of finding it within a work of art.'[22]

*A la Recherche du Temps Perdu*, turning its back on Western concepts of time, rationality and control, is a profoundly metaphysical book. Its temper is Eastern; its nature leisurely, contemplative and poetic; its spirit closer to the process-world of Monet's elusive water-lily ponds than the clipped hedges and rigidly planned avenues of Versailles. It is then a very modern consciousness the novel explores, one that takes on the radical implications arising from quantum

theory, the findings of transpersonal psychology, Eastern thought in general and Buddhism in particular, a half century or more before their general acceptance.

Yet in this the book was not alone. Monet's researches into space, time and light, van Gogh's exploration of embodied or erotic knowledge, Gauguin's elevation of the feminine, Stravinsky's ritualism and the Cubist discovery of the dynamics of relationship which we shall explore, also opened up themes that dominated late twentieth century life. In the atonality of Arnold Schoenberg (from 1909 onwards), the pure abstractionism of Wassily Kandinsky (from 1910), the sexuality of D.H. Lawrence (*Sons and Lovers* dates from 1913) and the prophetic symbolism of Frans Kafka (*The Trial* dates from 1914), we can discover further evidence of the search to embody the premises, preoccupations and confusions of the 'New Age', which Yeats, following William Blake, was the first to prophesy.

## MODERNISM: THE BALANCE SHEET

Modernism (including Postmodernism, which I regard as a deviation rather than a radically new direction), to use a noun that has outlived more changes of connotation than almost any other in the language, is difficult to summarise. It is a complex field of imaginative energy with a number of pronounced propensities. These include, as have already been mentioned, anti-traditionalism, the defiance of convention, indifference to the expectations of an audience; to which should be added intensified forms of self-consciousness and various forms of alienation. Instead of the spontaneous and naïve involvement of the Middle Ages—an unquestioning acceptance of the external world, other human beings, and one's own feelings—both Modernism and Postmodernism have been imbued with hesitation and detachment, a division in which the ego disengages from the normal forms of involvement with nature and society, often taking itself, or its own subjectivity, as its own object. In fact, as Louis Sass observes, Modernists and Postmodernists have either 'opted for an extreme inwardness, an egoism or solipsism that would deny all reality and value to the external world, or else for a radical materialism or positivism in which not only nature but man himself is stripped of all human, and even organic qualities.'[23] For this reason both can be regarded as the logical end product of the Humanist phase, rather than the real

beginning of a new one.

The escape from convention and exploration of the new have also resulted in an extreme and off-putting degree of obscurity. Nonetheless, if Modernism introduced what Nietzsche called 'the most extreme form of nihilism', it would be foolish to deny that it also stimulated the creation of a great deal of wonderful Art. I therefore want to celebrate Modernism's fundamentally self-delighting inventiveness, its honesty, its surprises and self-bracing entity within the chaos of twentieth-century life. Without the novels of James Joyce, the plays of Samuel Beckett, the music of Janácek, the poetry of Rilke, we and our culture would be poorer than we are. As the curators and re-animators of the inner life of our civilisation, these and other Artists have offered images and dreams as urgent as they had been in our Promethean beginnings, and as relevant today as that of Pharaoh.

In a world dead to soul, twentieth-century Artists have kept alive, nourished and enriched the mulchy ground of the mystical pagan imagination. Gauguin's charged chronicle of myth and sensuality, Matisse's employment of fields of vibrating colour, Picasso's resurrection of primitive values, Proust's exploration of the dilating present, Max Jacob's appeal to magic and the occult, Kandinsky's desire to lock the viewer into a meditative trance, are examples of work which have helped to tilt the scales of reality towards some transcendent equilibrium. Painters like Joan Miró and Paul Klee, sculptors like Constantin Brancusi, filmmakers like Ingmar Bergman and Andrei Tarkovsky have also bridged the world of the everyday and the worlds of visionary power and presence. In them and others, some of whom I will be discussing in the next chapter, we see evidence of the extent to which twentieth-century Artists have prepared the way for a new Renaissance.

A further significant contribution begins with Cubism, the breakthrough to new understanding developed by Pablo Picasso and Georges Braque between 1911 and the outbreak of the First World War. In a Cubist painting, the idea of employing the picture plane to create the illusion of three-dimensional space, the idea of painting solid, apprehensible reality, the idea of a detached observer, an objective eye standing apart from the depicted scene, are all rejected out of hand. According to the Cubists, the world does not need to be processed in a logical sequence. Objects can be fractured into visual fragments then rearranged in such a way that the viewer does not have to move through space in an allotted period

of time in order to view them in sequence. Visual segments of the front, back, bottom, top, and sides of an object can be seen and experienced from a multiplicity of viewpoints, enfolding in the process both the painter and the observer of his painting *simultaneously*.

The importance of Cubism is, I suggest, at least threefold. First, it helped to subvert the authority of the reigning paradigm which asserted that classical causality rules the world. Second, it brought forth new ways of imagining both space and time which were a challenge to accepted understanding of the nature of reality. And its third, and by no means least contribution, was its proposition of the democratic view. After Cubism there could exist no one privileged, cyclopean viewpoint, no one sequential frozen moment in time, but rather a commitment to the idea that all frames of reference relative to one another are of equal importance.

These are shifts of understanding of no mean order. It is true that the multiperspectivism of analytic Cubism, in inaugurating a loss of the single, overarching viewpoint, has forfeited the selective principle or hierarchy of significance. In consequence anything can stand for anything else and all is relative and shifting. But it also initiated something akin to what has subsequently been called ecological thought: the idea of participation, the idea of engagement, relationship and mutuality, the idea of process as the starting points for a whole series of new methodologies, new cognitive strategies, new forms of thinking and new forms of justification. When an object, a process or situation, begins to be understood in terms of its relationships with other things, processes and situations, an environment's wholeness becomes the primary factor. We see and feel in terms of the way elements connect and influence one another. We become conscious not of the part, the fragment, but the *field*. In this epistemology, the field is more important than the particle, the process supersedes the object.

Picasso's and Braque's Cubism, Minkowski's spacetime continuum and Einstein's graceful equations about space, time, and light, all share something of the same desire for relationship. The recent wave of interest in deep ecology, nondualistic Eastern mysticism, archetypal and transpersonal psychology, the Gaia hypothesis and chaos theory, share something of the same commitment to wholeness.

## NIHILISM IN ART

*What is it I suffer from when I suffer from the destiny of music? From this: that music has been deprived of its world-transfiguring, affirmative character, that it is* decadence *music and no longer the flute of Dionysus...*

Friedrich Nietzsche[24]

So much for the credit side, but what about the darker side of Modernism, the side that, stampeding with a mad geometrical progress over every truer form of life, grows more decadent by the day. Didn't the early Modernists scream their contempt for the creativity of the individual human subject, for ornament and nature alike? Didn't Duchamp send a urinal to the Salon des Independents in New York? Didn't Warhol elevate boredom and repetition to the status of Art? 'I think somebody should be able to do all my paintings for me,' he said. And what about the cacophonies of noise, labelled avant-garde, to whose appeal concert-hall audiences remain so stubbornly resistant? Or the money-driven, fame-fuelled world of the visual Arts, whose attraction is limited to those who keep within its insincere and precious confines? Isn't this also often a kind of nothing presented as something? Isn't it even possible that the Arts of our civilisation—like that civilisation itself—have come to an end? That the avant-garde has nowhere to go beyond Postmodernism, itself an art of fragments, displacements, dissolves, flashbacks, accidents of quotation and collision?

Doubtless Modernism's iconoclasm had positive aspects; much nineteenth-century literary and pictorial lumber had little vital value, and needed to be abandoned. Into the dustbin it went, not only the passing and the trivial, but also the life-current of the sacred tradition which fertilises a culture at its roots. After the turn of the century, audiences, readers, concertgoers and the like went into the dustbin, too; Artists began to cultivate a stance that was ever more hermetic and incomprehensible, showing not the slightest impulse to express themselves in ways that might be understood. Attachment to experiment and originality legitimised an almost pathological insistence on discontinuity and novelty; commitment to the self induced an exaggerated narcissism sometimes verging on madness.

The striking similarities between Modernism and madness have been explored in a book of the same title by Louis Sass. They share, he argues, a common defiance of authority and convention; an extreme, often dizzying relativism

which can culminate in paralysis; a nihilism and an all-embracing irony; a tantalising, uncanny, but frustrating sense of revelation; an obliteration of the standard forms of time and narrative and a pervasive dehumanisation. Dehumanisation, fed by an appetite greedy for late-Roman sensations, takes numerous contemporary forms, of which the films resembling nightmares inhabited by a seemingly endless catalogue of every monster that has ever inhabited the memory of man, are the most popular. The thrill of fangs and claws, the thrill of copulation without commitment, the dog inside us going wild after a lifetime on the leash, are available in chilling verisimilitude in cinemas and videos across the land. But this is only one aspect of a madness which embraces the pious inanities of a Julian Schnabel, an Andy Warhol or a Gilbert and George, clothing the same desire for stimulation in a system which maintains not only the near-uniform frivolity on our magazine shelves and television programmes but a continuing commitment to light-hearted, unending consumption. The nihil of this species of 'Art' is scarcely less threatening to our inner universe than the pollution of the seas, forests, rivers, cities and populations of the earth. It is the agent of a destruction no less corrosive than the slow destruction of the world by deadly toxins.

In point of fact this anaesthesia, glamorised by an irresponsible media, is virtually ubiquitous in every industrialised nation where, as Harold Bloom puts it, a 'rabblement of lemmings' exercise their 'rights' to give euphoric, but ultimately futile expression, to that liberationalist ideal: freedom from all constraints and responsibilities. In these countries, as in every other department of their life, the distinction between right and wrong, true and false, beautiful and ugly, positive and negative values, has become confused; since the end of the second great European war, mental and moral atomism has grown, and with it mental and moral anarchy. To give a more precise idea of this species of cultural disintegration, it may be helpful to record the contents of the so-called Arts pages of today's *The Independent* (2nd February 1995)—the choice is arbitrary, and another day or 'quality' newspaper would have sufficed. To start with, there is a photograph of 'Kate Lennard, a functional pop artist, sitting at her home in south-west London with a chair which she built entirely from Bic razors.' There is then a substantial article entitled 'Muzak was my first love', in which Joseph Lanza explains his infatuation for the piped background music of airport, restaurant, mall and lift. There are articles on the contemporary world of Japanese pornographic films ('Every year we look for something to subvert the idea of

sacred good taste') and the highly successful career of horror-novelist Stephen King ('The literary equivalent of Big Mac and a large French fries'). Under the heading 'Milking the Violence for all its Worth', Kevin Jackson reviews new releases including Sam Peckinpah's *Straw Dogs*. 'After so many oceans of blood have poured across the screens,' he explains, 'the film's brutal finale now seems relatively moderate, though still uncomfortably exciting.'

Towards the end of his life, the poet and critic Herbert Read (1893-1968), a leading figure in the avant-garde of painting, sculpture, literature and aesthetics from the 1930s to the 1960s, became troubled by what he saw as the uncheckable permissiveness of Art. In a lecture four months before his death, he concluded that the great enterprise of Modernism was in danger of betrayal. 'Contemporary nihilism in art,' he said, ' is simply a denial of art itself, a rejection of its social function. The refusal to recognise the limits of art is the reason why as critics we must withhold our approval from all those manifestations of permissiveness characterised by incoherence, insensibility, brutality and ironic detachment.'[25]

In this lecture he uttered desperate words arising from embittered frustration. He described the later work of James Joyce as 'the witless wanderings of literature before its final extinction,' the later plays of Samuel Beckett as 'an apotheosis of futility', and much of the later poetry of Ezra Pound in terms of this 'stammering confusion'. He criticised action painting, pop art, op art, conceptual art, visual performance and 'all the (other) fragmented painting of recent years' with obvious distaste. Almost thirty years later, one can but speculate on Read's reactions to the sad apology for living human culture that continues to be described as 'Art'.

In truth, the contemporary condition of the Arts is a sad one. Norman Lebrecht, writing about music, says: 'Concert audiences are shrivelling, state subsidy is drying up. The social and economic structures that kept music alive since the days of Bach and Handel cannot withstand the pressures and counter-attractions of the information era. We may be reaching the end of the road for music as a lively art.'[26] At the same time that the galleries promulgate work of an increasingly abstruse nature, others have observed that the theatre has largely abrogated responsibility for addressing all the biggest issues of the day, leaving them to other media and footling around the edges—aiming to distract rather than confront. The tumultuous effects of an ethos of greed and growth are being felt in the aimlessness of life and Art equally.

## BETWEEN A DEATH & A DIFFICULT BIRTH:
## PROSPECTS FOR THE FUTURE

The modern condition of the contemporary Arts is so suffused with the ephemeral, fragmented and individualistic that it is difficult to preserve any sense of historical continuity, let alone a consistent set of values. As well attempt to describe the thrashing turmoil of waters as a tide, advancing, simultaneously appears to recede. To the eye there is a watery muddle; to the mind there is an understandable pattern.

Studying the pattern of recent events, we may be inclined to picture two layers of civilisation superimposed, co-existing though contradictory. Side by side with the mega-technological age with its late Humanist, interiorising culture, another civilisation (a civilisation without name) is struggling to be born. As Samuel Beckett described it, 'we are between a death and a difficult birth.'

Yet if any psychospiritual transformation is to succeed, we will need to reverse the premises of our present world-view and re-vision the sciences, customs and work which currently reflect, endorse and fortify its dominant philosophy. We will also have to challenge the underlying assumptions of its Art. We will have to start from scratch; to revision a sense of enchantment; revision the visionary function, revision our lost access to the magical world of archetypal myth and symbol; revision the role of art as a planetary healer, seek an integrated vision of the world. The challenge is to recover our lost souls, a task of stupendous proportions, the work of generations, but one that will release new creative forces.

But what might this 'art' of the future be like? In all truth no one can say: the future is unfathomable. Yet, on the basis of existing clues we may attempt to elucidate some of its propensities or tendencies, however diverse, complex and paradoxical these may be. It has occurred to me, for example, that whereas we now accept (and celebrate) the separation of the Arts from daily life, the new paradigm may well relate the aesthetic dimension to other fields of human endeavour. If we now encourage unlimited individuality and continuous progress, the future is more likely to endorse their reverse: the celebration of people on a human scale, local identity and the richness and importance of the non-human lives with whom we share the planet. If we now exalt the sensate values, the future is likely to be marked by their opposite: the growth of an ideational art dedicated to the expression of the supersensory and transpersonal—the kingdom

of God. And if we now endorse the idea of the Artist as a self-directed professional, the future is likely to accept that the deepest essence of every human is his or her creativity.

We might get a clearer understanding of the differences between present and potential future cultural values and attitudes by a perusal of the following lists. In presenting them in this bald fashion I am not unaware of the dangers inherent in the depiction of complex relations as simple polarisations, when almost certainly the true state of sensibility, the real 'structure of feeling' in both, lies in the manner in which these stylistic oppositions are mixed and synthesised. Nevertheless it is my hope that the schema will provide a useful starting point. The left hand list is intended to describe the characteristics of Art in the current, Humanist paradigm; and that on the right, the defining features of expression within the context of the new paradigm.

| PRESENT | FUTURE |
|---|---|
| Sensate | Ideational |
| Autocratic | Democratic |
| Ego-centred | Transpersonal |
| Stimulation | Transformation |
| Commodified | Interconnective |
| Patronised | Spontaneous |
| Secular | Sacred |
| Divisive | Cohesive |
| Purposeful | Playful |
| Personal creation | Co-creation |
| Competitive | Convivial |
| General | Local |
| Professionalised | Participative |
| Experimental | Organic |
| Luxury | Integral |
| Money-orientated | Use value |
| Spasmodic | Cyclical |
| Aggressive | Responsive |
| Demanding | Contractive |
| God the Father | The Goddess |

Thus a movement from the present to the future might be described as the movement from honouring a single ego, the isolated Artist, to a wider practice of our biologically given potentiality for aesthetic production. It is the movement from a Newtonian universe to a quantum universe: pluralistic, responsive, green, anti-hierarchical, indeterminate, unpredictable, holistic. It is the movement from isolation to communion, from arrogance to humility, from self-advancement to service to others, from secular to sacred, from an entrenched religious dogma to an intensely inner spirituality characterised by what Albert Schweitzer described as reverence for life. It is the movement from 'things'—an opera or a novel—to a vision of art as play, interaction and ceremony. Well, maybe it will never happen, but the basis of my hope is the subject of the next chapter.

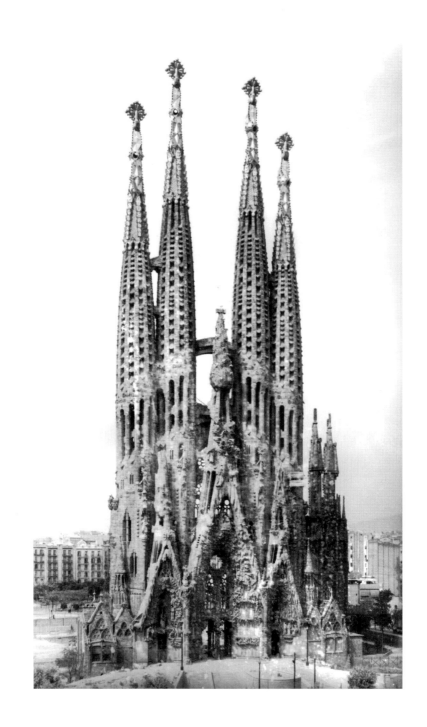

CHAPTER SIX

# PROPHETS OF THE NEW VISION

*This generation may either be the last to exist in any semblance of a civilised world or it will be the first to have the vision, the bearing and greatness to say 'I will have nothing to do with the destruction of life, I will play no part in this devastation of the land, I am determined to live and work for peaceful construction for I am morally responsible for the world of today and the generations of tomorrow.'*

Richard St Barbe-Baker

*A civilisation which has no creative people is doomed... The person who is really in touch with the future is the creative personality.*

Marie-Louise von Franz

OVER THE LAST DECADES a number of people—philosophers, economists, scientists and spiritual leaders—have been exploring the philosophical and practical implications of the next step for society.[1] Whereas the ideas of the post-war period were progressive and idealist—they believed in the continuing march of ever-more liberal, individualistic societies based on consumption—the ideas of the ecological thinkers are more circumspect, even conservative. They are less individualistic; more concerned with the bonds of community, trust and belonging; more open to the possibilities of process and relationship. They recognise a need for new forms emphasising our essential interconnectedness rather than our separateness, forms more imbued with a sense of the sacred rather than secular achievement.

But the exploration that has been and is taking place is not limited to thinkers. One can name others—physicists, for example, mythologists and Artists—whose thought has been informed, however implicitly, by the quest for wholeness, which may in future be seen as the defining spirit of the age. This chapter is about the latter and their ability to uncover the deep patterns upon

Plate 54. ANTONI GAUDI. Sagrada Familia. 1883-1926. Barcelona.
Ampliaciones y Reproducciones Mas (Arxiu Mas).

which both the natural world and the world of our own being seem to be already organised. As people especially responsive to the archetypal roots of their creative powers and the truths of the spirit, Artists possess, I believe, powers similar to that of the ancient seers and healers, the shamans, sibyls and prophets that belonged to societies with a tradition of ecstatic prophecy and oracular knowing. These also struggled to exalt existence, to invoke the mysterious totality of life, to return to the deep roots, the origins of things where the dreams and revelations come from—as some (but very far from all) living Artists still do today. Stravinsky, for example, believed he was but the vessel or conduit through which the origins of *Le Sacré du Printemps* passed; much of Mozart's music came to him largely in polished form, while Blake wrote his poetry by dictation from angels. None of this is new. The sacred texts of the Christians, Moslems and Jews, as well as those of Buddhists and Hindus, are full of dreams and visions, it being universally accepted that it is in such experiences that divinity is most likely to reveal itself. Prophetic dreams abound in both the Old and New Testaments, and much of the Koran was revealed to Mohammed in dreams. Whether or not the 'inner voids' are called upon, they are always there. Known or not known, despised or rejected, what Socrates called a 'Divine Something' exists to call each one of us to live and be our whole selves.

In the twentieth century, as Michael Tucker explored in *Dreaming with Open Eyes*, Western Art has been shot through with the ancient spirit of shamanism. Artists, in whom the faculty of oracular consciousness has penetrated the numinous forces beyond the personal self, have acted as pathfinders and guardians of the soul. They have sought to heal the split in consciousness that opened up when soul was rejected by the rational ego. They have retained a vision of the divinity at the root of life and sung, in a beautiful phrase of Federico Garcia Lorca's, 'the deep song'.

In this chapter I shall be considering a limited number of these.[2] Those, that is, who are seeking, more or less consciously, to transcend that Humanist, secular, largely materialist culture of a confident science which has been one of the most powerful achievements of a predominantly male aspect of the European mind. That tradition is more or less exhausted now and a new synthesis of the imagination, one which incorporates and celebrates all that was neglected, derided, and oppressed by the positivist tradition, is currently taking its place. Thus the work of those I shall be considering—with, as Shakespeare says, their

prophetic natures 'dreaming on things to come'—can be said to prefigure and symbolise the richer and larger perspectives which we associate with soul. I like to think that their insights and pronouncements can be interpreted as an early warning system, a kind of radar, of what John Cage saw as the social organisation of the future. Taken one by one, my examples may appear insubstantial, but their cumulative effect may suggest, as I hope, that in a natural and spontaneous way, the sick body of our society has been producing the psychological component of its own auto-immune system. As the sick animal searches out the healing herb, so we too are discovering the healing energies necessary for our survival.

## ARCHITECTURE

Architecture is the one Art which affects us all. People can choose not to listen to music or look at sculpture, to visit theatres and cinemas, but everyone's world is shaped by the buildings around us. The very health and sanity of a community is dependent on good architecture. Yet the supreme failure of twentieth century Art has been its architecture. All the disengagement and purity of Humanist aesthetics, the cold rationalism of Cartesian thought, the impersonality of science and mechanism has, it seems, been crystallised into those straight-lined monolithic slabs characterised by, as Jane Jacobs complained, 'the Great Blight of Dullness' which are uglifying the world's increasingly anonymous cities.

Looking at buildings from the Bauhaus to New Brutalism and up to and including Postmodernism—and I am thinking not only of most of the work of Le Corbusier, Mies Van der Rohe and Walter Gropius (and noticeably virtually all architects have been and are men) but their later and less talented cohorts—one's heart sinks at the agonising heartlessness of their designs. An interesting pointer towards this condition is to be discovered in Le Corbusier's highly influential *Towards a New Architecture* (1927)[3] where the cities, houses and rooms that he has illustrated are virtually empty. A great epoch had begun, but it was not one designed for people. 'If we see the majority of modern high-rise buildings,' says the architect Keith Critchlow in conversation with Richard Temple, 'looking like filing cabinets, that is exactly what they express: they are very efficient at filing human beings and filing objects and filing technology, but they have very little to do with what we would call the fuller or meaningful dimensions of being human.

They are really mechanistic solutions to mechanistic questions.'[4]

Although the majority of recent buildings are of this kind, there are yet a minority of architects (including Le Corbusier's Notre Dame du Haut at Ronchamp) who have chosen to ignore the supremacy of a dehumanised Modernism. Some of these are little known, their commissions relatively rare, their philosophies far from accepted. Nonetheless, their buildings remain important pointers to the architecture of a re-enchanted future. Gaudi himself was aware of the importance of his architecture for the future. When asked whether the Sagrada Familia was one of the great cathedrals, he replied: 'No, it's the first in an entirely new series.' The same could be true of the inspiring invention of Imre Makovecz, the vernacular of Hassan Fathy, the organic and ecological architecture of Ton Alberts and the commitment to traditional principles in the buildings of Keith Critchlow, which all point towards an architecture fit for humans, and in harmony with nature.

## ANTONIO GAUDI'S MYTHOPOEIC IMAGINATION

Of these five, by far the most celebrated is Antonio Gaudi (1852-1926), whose numerous buildings are concentrated in the Catalonian city of Barcelona. Here he designed and constructed villas for the well-to-do bourgeoisie, blocks of flats, the expansive Güell Park, and the famous church designed in honour of the Holy Family—a project which was begun over a hundred years ago and has yet to be completed. He regarded the Sagrada Familia as his greatest project and was absorbed in its design throughout his life. But its construction, like that of the great mediaeval cathedrals, was more than a personal endeavour; it was a national enterprise, the work of a whole people.

For Gaudi, as for the devout in the Middle Ages, utilitarian considerations were of a lower priority than purely transcendent aims. His collaborator Francesco de Paula Quintana has recorded how the hyperbolic paraboloid was for Gaudi nothing less than a religious symbol: a geometrical representation of the Holy Trinity. 'Two straight lines situated in space, both infinite and identical in kind: a third line also infinite and identical in kind, insinuating itself between the other two and uniting them: *Patre filioque procedit...*'[5] In a similar manner the cathedral's transept facade represented the Nativity; its three portals, faith,

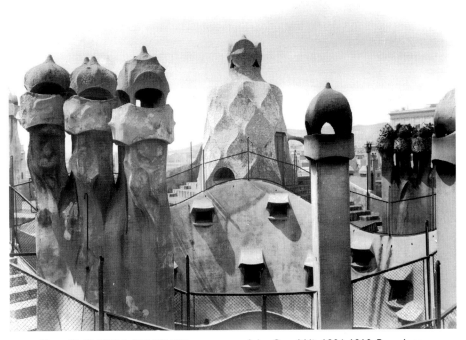

Plate 55. ANTONI GAUDI. Chimney-pots of the Casa Milà. 1906-1910. Barcelona.
Ampliaciones y Reproducciones Mas (Arxiu Mas).

hope and charity; and its four minaret-like spires the apostles Barnabas, Jude, Simon, and Matthew. In this building we enter territory where feeling, imagination and layers of meaning have greater resonance than reason, which subordinates everything to fixed purposes and principles. Thus it was that the poet Joan Maragall, who watched the colossus rising from the soil of his city and soaring skyward, could call the building 'not architecture, but architectural poetry'.

The vigour and coherence of Gaudi's vision is also to be seen in a building ostensibly less amenable to symbolic interpretation than a cathedral. This is a block of flats in Barcelona, the Casa Milà (Plate 55 above). Yet here, too, Gaudi designed a structure whose molten and organic appearance, riotous interlacings and visionary forms resemble, and are inspired by, a hallucinogenic kind of dream biology of the unconscious.

From a distance, the block's form looks as if it was modelled in a pliable material such as clay. Under the foaming crest of its extraordinary roof, curves

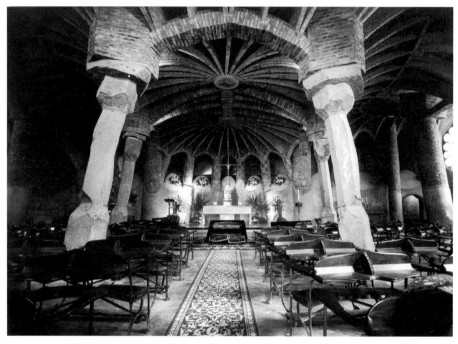

Plate 56. ANTONI GAUDI. Santa Coloma de Cervelló, Colonia Güell. Iglesia. Interior of the crypt. 1898-1917. Barcelona. Ampliaciones y Reproducciones (Arxiu Mas).

predominate, swaying in and out like larva or waves. No less organic is the building's curvilinear plan, and similarly the rich organicism of its architectural features: the gratings which resemble the organic veins of a leaf; the balcony parapet which resembles seaweed strewn across rocks; the stairway columns reminiscent of giant tree boles; the tribune corbels which conjure up memories of exotic shells and, not least, the chimneys like sinuous rock strata modelled by rain. Its interiors are also like sea-chambers hollowed out by waves. Even the smallest detail, such as a door handle (and Gaudi consistently aspired to a synthesis of arts and crafts), gives honour to vegetable or animal elements. Every feature of the Casa Milà embraces the body and links humanity, in a full and final participation, to a vision of the universe as a living whole.

It was, I suggest, through the intercession of the feminine that Gaudi, who lived an almost monk-like existence, devoted exclusively to his Catholic faith and his work as an architect, was able to create the imaginative and sinuously erotic

forms of his buildings. The roofs of the porter's lodge in the Güell park, the venti-lation pillar in the country villa of Bellesguard, the mighty pillars and sinuous forms of the Casa Batlló and, perhaps his masterpiece, the crypt of the Colonia Güell (Plate 56), suggest all that is most mysterious, alive and whole in the world. In these works Gaudi reclaims the runic script of nature, the serpentine movement of dark, telluric powers, rising from great depths to mirror the heavens.

When Gaudi died, he left behind no more than the beginnings of an architec-tural work which existed rather more in his imagination than in reality. That work has to be developed. And his comment on the second and last of his apart-ment house projects, Casa Batlló, could be taken as a prophesy for the future: 'The corners will vanish, and the material will reveal itself in the wealth of its astral curves; the sun will shine through all four sides, and it will be like a vision of paradise.'

## IMRE MAKOVECZ: ARCHITECTURE INFORMED BY NATURE

A living architect who shares with Gaudi much of the latter's feeling for the organic, the cosmic and transpersonal, is the Hungarian Imre Makovecz (b1935), who makes a similar use of natural materials and conveys a deep sense of harmony with the environment. But if, like Gaudi, Makovecz is no nostalgic traditionalist, he yet differs from the Catalan in one essential way. Born only nine years after Gaudi's death, he belongs to a different generation; one that, having experienced the Holocaust, Hiroshima, Chernobyl and the different but related horrors that they represent, holds a darker interpretation of our condition. 'We have polluted our soil, we have destroyed our forests; our springs, rivers and wells give poisoned water; our national holidays have perished; our traditions have sunk into a dishonoured past... In every country of the world, you can see machines selling Coca-Cola. This is what the world is like today, dominated by the monoculture of the white man,' he says.[6]

Therefore for Makovecz the architect (like any other Artist) must be always at the front line of the battle for sanity and survival. 'In both East and West,' he says, 'societies are going farther and farther away from original nature and an atmosphere of a coming tragedy is gathering... I like to think that architects are now on a border line and they must decide whether they will serve the coming

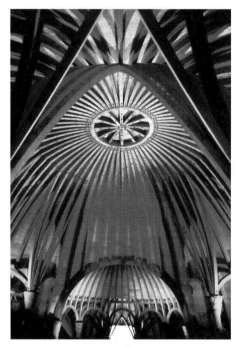

Plate 57. IMRE MAKOVECZ. Interior of Casino.
Szigetvar, Hungary.

tragedy or whether they are serving the new, "mythical" society.'[7] Although he does not expand on this point, I believe it is in sympathy with my own conclusions. Makovecz understands that by itself organic architecture is insufficient; it has to exist within and contribute towards the creation of a society which honours nature and humanity, the local culture and the traditions of the past.

Makovecz honours all three. 'My design does not come from me,' he says, 'it comes from the landscape. I always start my work with trying to get in contact with the landscape, full of mythology and full of ghosts. This speciality can be geological, it can be the flora, the traces of people who once lived there, or the buildings standing there. And lots of other things as well: how the wind blows there, for example. My designs for houses, schools or churches emerge out of this history.'[8] In other words, he is telling us that the architect who designs without reference to landscape, history, memory, the traditional social order, the vegetation and materials of the immediate environment, who fails to see his work

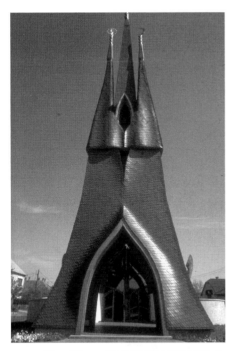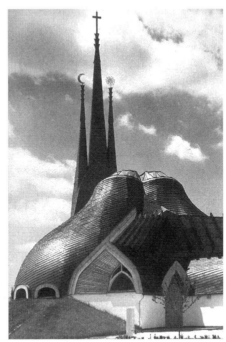

Plate 58 and 59. IMRE MAKOVECZ. Roman Catholic church. 1987. Paks, Hungary
photo Plate 59 © David Pearson from *Earth to Spirit* (Gaia Books).

within a larger context, who responds exclusively to economic and functional
needs, who glories solely in his own 'genius', is betraying the Artist's primary
task, which is to serve and inspire his community.

In the little town of Paks, Makovecz's Roman Catholic church (1987), even
if it is an ingenious solution to certain material interests, certain engineering
problems, certain problems of design, transcends these challenges to become an
inner sanctuary of God. Supported by nave columns rough hewn from whole
trees firmly planted in the ground, its pleated wooden roof and striking triple-
spired bell tower (which aspires to Moon, Sun and God) symbolise both rooted-
ness and aspiration. Even the rounded form of its nave is balanced by the rising
thrust of a carved angel, lightly poised with outstretched wings. In June 1990, a
Lutheran church was inaugurated in the Hungarian holiday resort of Siofok on
Lake Balaston. Using images from nature, Christianity and Transylvanian mythol-
ogy, the design is emblazoned with great wings. Its Tree of Life cross symbolises

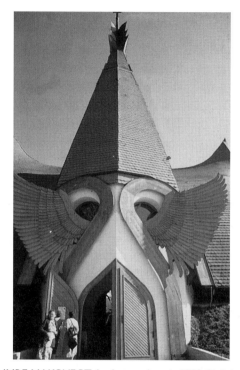

Plate 60. IMRE MAKOVECZ. Lutheran church. 1990. Siofok, Hungary.
photo © David Pearson from *Earth to Spirit* (Gaia Books).

life overcoming death. 'My architecture,' he says, 'creates a world of lifelike forms and shapes somewhere on the borderline between Heaven and Earth. It is meant to be the new alternative: life lived consciously, closer to a new frontier.'

## HASSAN FATHY: EARTH ARCHITECTURE FOR THE POOR

*New approaches to making shelters and buildings are long overdue. Such directions appear out of real needs and social shifts, not from self-serving 'statements' or 'gestures' by celebrity architects.*

Victor Papanek[9]

An architect no less repulsed by the heartlessness of twentieth-century urban

buildings is the Egyptian champion of indigenous building, Hassan Fathy (1900-1989).

Judged by the standards of the urban mega-projects under construction, Fathy's accomplishment and influence has been slight. Yet from a traditional perspective, his regeneration of the remains of the old order of Egyptian master builders, craftsmen and apprentices and restoration of the tradition of hand-built mud-brick buildings, has increasing relevance for a society committed to conservation and the recycling of materials. He has accomplished a model of what could be attempted elsewhere.

Almost alone in an industry dependent on mass-imported products, Hassan Fathy extolled the virtue of local materials and the importance of returning to traditional forms and time-honoured methods of construction. Architecture, he believed, should be concerned with a specific place and people. To create buildings that turned their backs on local distinctiveness, that ignored the nature of a specific environment, that were constructed from alien materials, was a betrayal of location, culture and people. It was to put ego in front of service, profit in front of people, the short-term gain in front of the long-term effect, utility in front of heart. 'If love goes into the work,' he said, 'it will always show.'

Another important difference between Fathy and almost every other twentieth-century architect was his commitment to self-help and participation throughout the design process. As he saw it, the architect was responsible not only for the skills but the involvement of local craftsmen. 'In the past,' he wrote, 'every village had its own skilled labourers and masons who were integrated into the social and economic web of the community. They were guided by age-old traditions in design and construction. Today, these traditions do not exist any more in most peasant societies and it is implicit that we secure the assistance of the specialised architect to revive the lost expertise and traditions among the peasants until a new tradition is established. Training in building techniques, especially the vault and dome construction for roofing, is one of the first things to do.'[10]

Such conviction stands in opposition to the orthodoxies of mass-manufactured urban housing, where the repetition of prototypes in ever-shifting combinations and the assembly-line approach to architecture have become the norm throughout the post-war industrialised world. It is true, of course, that Fathy can stand accused of ignoring new materials and having a preoccupation with rural housing for the poor, both of which have limited applicability in confronting the

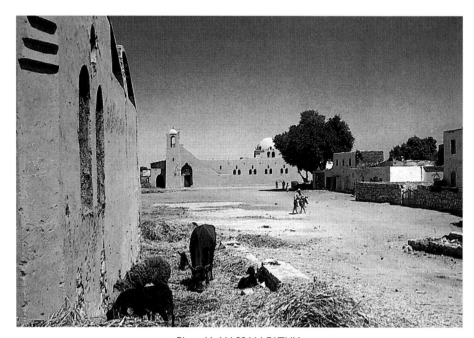

Plate 61. HASSAN FATHY.
Village square and mosque, New Gourna, Egypt.

challenge of large-scale urbanisation in the Third World, where high land values
and massive urban densities prevail. Yet, where sixties and seventies housing pro-
jects have blighted environments and proved unpopular with their residents,
Hassan Fathy's very human buildings are cherished by those who live in them.

His best known and most respected work, New Gourna (1946), was a com-
mission from the Egyptian Department of Antiquities, who wished to re-house
the inhabitants of five hamlets built along the hills of West Luxor, on the ancient
cemetery of Thebes. The Gournii were persistent tomb-robbers and Fathy was
requested to design a new village for them.

Originally planned for a population of 900 families, New Gourna has a cur-
rent population of approximately 130 families and covers one fifth of the origi-
nal site. Its construction began with the public buildings—the mosque, market,
*khan,* village hall, theatre, crafts exhibition hall and boys' school—and termi-
nated with the housing. Less than a quarter of the housing in the master-plan
(which also included a girls' school, dispensary, police station, public bath and

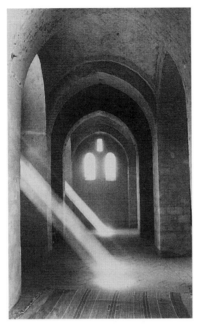

Plate 62. HASSAN FATHY.
Interior of mosque, New Gourna, Egypt.

sports club) was actually built. The planning intentions far exceeded the villagers' frame of social ambition; two buildings may have been built for folk art—the crafts exhibition hall and *khan*—but no industry was ever founded. The school, a mosque, and streets that accommodate social interaction, are the only communal buildings in permanent use. Nonetheless, the relocated inhabitants of New Gourna have exhibited a profound sense of identity with their village home. Throughout more than forty years of occupancy, the plan-form of public and private spaces has remained virtually unaltered.

Looking at photographs of these buildings (which I have never visited), I am struck by their seductive simplicity and unpretentious form. Nothing here corresponds to Jonathan Glancy's desire for the glamour of an exalted individualism nor his admiration of the architect who soars 'into the international stratosphere.'[11] The buildings are unpretentious, self-effacing, beautiful and eminently sane. The almost Cistercian austerity of New Gourna's domed mosque and the geometric proportions of its white-painted adobe houses share a timeless beauty

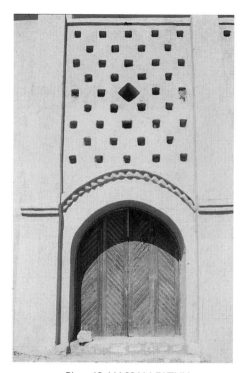

Plate 63. HASSAN FATHY.
Theatre portal, New Gourna, Egypt.

with vernacular buildings everywhere. 'Beautiful architecture,' writes Fathy, 'is an act of courtesy towards the man who comes to the building. It is as if the buildings were bowing to you at every corner, as in a minuet. Every building should add to the culture of man. But how can it do this if it does not respect human reference and human scale? We should reintroduce man into architecture; we must reintroduce human scale, human needs and human tradition.'[12]

His approach to architecture has a relevance, I believe, far beyond the small cluster of buildings he has actually built. As J.M. Richards writes of Fathy's philosophy: 'It includes the message that in solving human problems, one must not remove oneself too far from the human individual, and that even, perhaps especially, in our age of infinite technical resources, the simplicities inherent in the very nature of building must not be overlaid by the worship of progress.'[13]

Plate 64. TON ALBERTS & M VAN HUUT. INTERNATIONAL NETHERLANDS GROUP. (ING)
Bank Headquarters, Amsterdam. photo: Sybolt Voeten

## TON ALBERTS: A VISION OF WHOLENESS AND HARMONY, PEOPLE AND WORK, COMMUNITY AND COSMOS, CRAFT AND CULTURE

The effect of ecological thinking on the architectural profession, if slow, has stimulated the community architecture movement. It has also created an awareness of the need for architecture to be responsive to nature. Ecology, health and spiritual awareness are themes which underpin all natural architecture and are of central concern to one of its major contemporary exponents, the Dutch architect Ton Alberts.

Alberts' most celebrated building, the International Netherlands Group (ING) Bank in Amsterdam, comprises ten office towers, from three to six storeys high, spaced apart on an irregular S-shaped plan. An elevated indoor walkway links them and the restaurants, snack bars, library, auditorium, conference hall,

Plate 65. TON ALBERTS & M VAN HUUT. ING Bank Headquarters,
Amsterdam. photo: David Pearson.

and other facilities sited along its way. The building lets in the sun, collects solar
energy and rainwater, and through the intermediary of a large number of plants,
humidifies its own air. Regularly used by some 2,000 of the Bank's employees, it
is the most ambitious organic and ecological architectural project to have been
built so far.

According to Ton Alberts, a building should be related not only to the ambi-
tions of its architect, its client and the people who will use the building, but to its
local environment. A relationship of all three is the prerequisite of a socially and
environmentally responsible attitude to design. 'The first principle I try to prac-
tise,' he says, 'is to feel and sense the place where we are to construct a building.

I try to appreciate the energies, the powers that are at play in a particular place, in the physical surroundings—the trees, the hills, the rivers, the roads, the whole environment. I start by understanding the energies coming from the client and from the Earth and bringing them together... I like working organically... I try to have an approach of intuition which comes from the heart.'[14]

But for Alberts, the interdependence of the building and its environment does not stop at the material level; his approach includes elements ignored by those whose attitude to design is defined by the materialism of their culture. In reaffirming spirit, the divine life within, as an animating factor in the general flux and flex of life, Alberts is returning architecture to the place where it originally belonged. 'A house,' he says, 'is not only to house the human body, it should also house the human soul. Architecture can be a form of 'healing art' and all art is there to heal people. Art is the intermediary between God and humanity. Art is the work of God in forms. God talks to people through paintings, dance, architecture, colours and music. Art is the language of God. That is the great purpose of art and architecture.'[15]

In profound contrast to Alberts' approach of absorbing the energies of a particular place, Alberti planned one of the most influential designs in the history of Humanist architecture, S. Francesco (the Tempio Malatestiano), by correspondence. In our century, Le Corbusier also designed major buildings in the new town of Chandigarh at a distance. In the spring of 1951 he went to India and met the rest of his team in a rest house on the road to Simla; they worked together for about four weeks. The guiding principles were laid down in four days. How much Alberti and Le Corbusier were intimate with Rimini and the Punjab, the cultures of their respective communities, the spirit and climate of the sites where their work was to be built, is not recorded, but the suspicion remains that their knowledge was extremely meagre. What stands out in considering traditional systems, be they a peasant's wise management of his land or a healer's attitude to his patient, is the element of mutual trust placed in the collaborative process. When this trust is missing, when a building is imposed from high on a place or neighbourhood, we experience at best arrogance, at worst complete alienation. Keith Critchlow and Jon Allen observe that 'egocentricity, although inevitably an ingredient in life, is the principle of separation, and on its own (without the principle of unification as counter-balance) leads to discord and anti-social behaviour.'[16]

## THE SEARCH FOR TRUE OBJECTIVITY:
## THE ARCHITECTURE OF KEITH CRITCHLOW

*One of the most tenacious of typically modern prejudices is the one that sets itself up against the impersonal and objective rules of art, for fear that they should stifle creative genius. In reality no work exists that is traditional, and therefore 'bound' by changeless principles, which does not give sensible expression to a certain creative joy of the soul; whereas modern individualism has produced, apart from a few works of genius which are nevertheless spiritually barren, all the ugliness—the endless and despairing ugliness—of the forms which permeate the 'ordinary life' of our times.*

Titus Burckhardt[17]

A yearning to explore, recover, or remember the 'changeless principles' discussed by Titus Burckhardt is growing in popularity; as it grows, so too does the interest in the sacred canons of the arts that formerly existed in every tradition. One only needs to bring to mind the ancient texts which underlie the performance of a *Raga*; the underlying geometry of Egyptian art, the musical modes (in particular those of Gregorian chant), the strict rules which underlie Islamic calligraphy and Gothic and Islamic architecture, to appreciate the extent to which artistic endeavour has been governed, not by the whim or fancy of individual preference but by a timeless, impersonal and often hieratic set of changeless metaphysical principles in which the artist had a very different role to play.

The ancient traditions of Christianity, Buddhism, Shintoism, Islam, Hinduism, and more sparingly Judaism, held that after the Scriptures 'there followed the sciences of Number, Geometry, Harmony (or Music) and Astronomy—the four universal objective sciences of humanity. For sages like Plato, Arithmetic was the most refined and abstract of the 'thoughts of God' available to the human mind. Geometry, too, was considered the extension of pure number into space—the first gesture of the Creator in laying out the laws of the Creation.'[18] In this way the underlying laws of proportion, harmony, and rhythm which have a similar effect on us as music, are integral aspects of this language; they provide an objective basis for individual expression. They are advantageous to the soul's understanding, and timeless in their effect. 'The key significance of a great, sacred work of art, by its very nature, breaks what I

would call the time barrier—it is actually standing outside passing time,' says Keith Critchlow, talking about the cathedral of Chartres.[19] But if Chartres, perhaps the most beautiful and significant Christian artifact, is an outstanding example of traditional principles of design, it does not stand alone. Stonehenge, the Taj Mahal in Agra, the Temple of Heaven in Beijing, the Dome of the Rock in Jerusalem, the Cistercian abbey of Le Thoronet near Brignoles in the south of France, the great Shinto shrine at Ise in Japan and the Vedic temples of Khajuraho, Konarak and Thanjavur in India, are also buildings which also possess an essential geometry uniting the human microcosm to the greater macrocosm.

In this sense then, traditional art is traditional not because of its subject matter but because of its conformity to cosmic laws of form, to the laws of symbolism, to a balance of elements—proportionality, harmony and unity—and to the truth within the particular domain of reality with which it is concerned. Thus if the contemporary obsession with technology, and the refusal to admit the possibility of a metaphysical dimension to reality, have obscured its significance, the underlying principles and values of sacred geometry remain important because by their very nature they are as relevant to the future and the present as they were to the past.

A long-term student of these classical, timeless or archetypal themes is Keith Critchlow, whose designs include the Krishnamurti Centre at Brockwood Park in Hampshire (1986) and the second largest hospital in Asia, the Sri Sathya Sai Institute of Higher Medical Sciences in the village of Puttaparthi, 160 miles north of Bangalore in Andra Pradesh, India (1991).

The Krishnamurti Centre, whose construction began after Krishnamurti's death in 1986, was created to provide a place where people could come and study his ideas, meet, discuss, and most importantly, find space in which to grow without the encumbrance of the formal religions, whose 'isms' he so deplored. In his concept for the building, Krishnamurti emphasised the importance of the Quiet Room. 'There should be a room where you go to be quiet,' he told Mary Lutyens. 'That room should be used for that and not for anything else. It should be like a fountain filling the whole place. That room should be the central flame; it is like a furnace that heats the whole place. If you don't have that, the Centre becomes just a passage, people coming and going, work and activity.'

The night after first meeting Krishnamurti to discuss the design of the new

Plate 66. KEITH CRITCHLOW. Krishnamurti Centre. 1986. Brockwood Park, Hampshire, England. photo: Graham Challifour.

building, Keith Critchlow awoke with an image of its potential design—a cross-legged person seated on the ground looking at the view across the estate—a concept upon which he was later to base his composition. When Critchlow, in keeping with traditional practice, asked for a phrase to guide the building's design Krishnamurti responded: 'The world is you, and you are the world', an aphorism that not only corroborated the image of the seated person, but inferred the ancient idea of the interrelationship of microcosm and macrocosm—the integration of transcendent and immanent reality.

Critchlow's design is built around the Quiet Room as the hub or 'vertical axis' of the composition, with a forty-foot-square courtyard providing an additional central focus. The latter is flanked by sitting and dining rooms, while the Centre's kitchen and library look onto it across a wide ambulatory, paved with terracotta tiles. The 'legs' of the sitting person are incorporated into the design; these project in the form of accommodation wings, culminating in small 'cottages'.

Plate 67. KEITH CRITCHLOW. Central dome and flanking towers of the Sathya Sai
Institute of Higher Medical Sciences, Puttaparthi, South India. photo: Jon Allen.

The use of structural oak beams and columns, hipped tiled roofs, contrasting soft
grey and red Sussex bricks with local flints, is handsome, as is the level of crafts-
manship achieved throughout the building, which fits within its landscaped park
as if it had been there for centuries. But perhaps the Centre's most impressive fea-
tures are the light which permeates its rooms and passageways, and the harmo-
nious lucidity of its interlocking, open spaces.

Harmony also characterises the large, palace-like hospital that the architect
designed for south India, whose total planning, including rooms for every kind
of specialisation, was achieved in only three months; the Sri Sathya Sai Institute
of Higher Medical Sciences opened in November 1991, exactly one year after its
inception by Sai Baba.[20] Specialising in cardio-thoracic and kidney care, it today
employs a staff of 246 people; departments concerned with cancer treatment,
neuro-surgery and respiratory medicine are being added in a process of planned
expansion. Access to this highly specialised health care is completely free for

everybody—a unique and economically breathtaking expression of the concept of service to others which informs Sai Baba's teaching.

Seen across its sweeping lawns, the low, domed building, with its honey-coloured pillared hallways, colonnaded arcades, lotus-headed pillars, decorated carvings and high-domed, rose-windowed, central hall reflected in water, looks like a Mughal or a Hindu palace. It is peaceful and inviting; the visitor must feel welcomed by the beauty of such surroundings. In contrast to the undeviating functionalism of Western hospital design, Critchlow's building seeks to comfort and reassure.

In a report written by Keith Critchlow and Jon Allen, *The Whole Question of Health; An Enquiry into Architectural First Principles in the Designing of Health-care Buildings* (1994), written after the designs for the hospital had been completed, the authors enumerate their underlying aims for the architecture of health-care buildings and, in consequence, for the Sri Sathya Sai Institute of Higher Medical Sciences.

> Who would argue against efficiency, competence, convenience, stability, logicality, and effectiveness? Yet without the sense or reality of beauty how can we claim that our buildings are complete, truly fit for human use, wholesome and comprehensive, incorporating the very wholeness that lies beneath the etymological meaning and, arguably, also the establishment and maintenance, of health?

## FILM: THE MYTHOLOGIZATION
## OF CONSCIOUSNESS

*No period since the early Renaissance has been more concerned with, has addressed itself more insistently to, the nature of the mythical than our own. Remythologization in a time which has found agnostic secularism more or less unendurable may, in future, be seen as defining the spirit of the age.*

George Steiner[21]

In recent years the awakening to spirit has assumed diverse and imaginative forms. We see it, for example, in the return of many Central and Eastern Europeans to the Christian church; the return of 'assimilated' native peoples to

their ancient religions, and the growth of a creation-centred spirituality which unites Christian mysticism with the contemporary struggle for social justice, feminism, and concern for the environment. Other manifestations include the spread of Dhamma from Buddhist countries to the West; the appeal of Islam; the growing interest in shamanic practice and the widespread search for meaning in the modern West.

The revival of interest in the pre-scientific ways of picturing the world, the return to ancient mystery traditions as both a literal and metaphorical act of recovery, is especially strong in the contemporary Arts. In the last forty years Eurocentric culture has been reinvigorated by the discovery of the spirit-filled wisdom traditions and holistic thought forms of the East and of the indigenous peoples. 'World music' and Gregorian chant have never been more popular. Central to this enthusiasm is, I believe, an unconscious act of renewal—a going back to recover what has been despised, neglected or lost in order to renew the possibilities of life. It is an acknowledgement of the deep-seated need for magic and wholeness in contemporary life. To escape the tyrannies of time and rationality, to exchange the abstract for the visceral, to flee the mundanities of the daily news for the primal magic of the Dionysiac—even if this is only a surrender to the Dionysian ephemerality of mass-market music and drugs—is now not only an urgent, inescapable necessity but one which will become the more so if the frail dike of the sacred continues to be swamped by the rising tides of rational scepticism and technology. Say what you will about the catastrophe of our century, the future is far from hopeless.

At the end of the first part of the eight-part, and largely autobiographical film *Dreams* (1990) by the Japanese director Akira Kurosawa (b1910), a young boy walks into a numinous, almost psychedelic landscape, vaulted by an enormous rainbow. Discussing his film at a French press conference, Kurosawa commented: 'Dostoevsky once said that dreams express our deepest fears and greatest hopes more vividly than anything else. That's what I've tried to put on screen.'[22] Something of the same magic also informs the work of other great filmmakers such as Ingmar Bergman (b1918) and Andrei Tarkovsky (1932-1986), of whom Bergman said: 'Tarkovsky is for me the greatest, the one who invented a new language, true to the nature of film, as it captures life as a reflection, life as a dream.'

## ANDREI TARKOVSKY: LIFE AS A DREAM

Tarkovsky made in all only seven full-length films. Between 1962 and 1979 he directed five in his native Russia, and before his untimely death at the age of fifty-three, a further two in Europe. From the epic historical fresco *Andrei Rublev* (1966) onwards, each of his films was attacked and held back by the Soviet authorities. Of these, the densely personal *The Mirror* (1974), which gives life to the world of his childhood, recreates his home, peoples his memories and captures time, and *Andrei Rublev*, a vastly ambitious epic created around the life and work of the late mediaeval monk and icon painter who takes a vow of silence after having killed a Tartar during an assault on a cathedral, are my personal favourites. Yet *Stalker* (1966), an account of a journey by three men through a mysteriously unspecified zone filled with invisible dangers is unforgettable, and so too is his first major achievement, *Ivan's Childhood* (1962), about a 12-year-old boy who joins the partisans to fight the Nazi invaders of his land. Tarkovsky's last film, *The Sacrifice* (1986), made in Sweden, is no less resonant.

A work by Tarkovsky is always an act of magic; it may celebrate the material presence of the earth but do so in a manner which evokes the transcendent. It may be, like *Stalker* and *The Sacrifice*, set in the present time, yet exist in a mythic frame imbued with an indefinable poetry. The very texture, the very grain of a Tarkovsky film, its dream-like dislocations and unheralded lapses into reverie, its rich poetic images and uninhibitedly associative style, seem to be imbued with sacrality. Is this because he lingers like a contemplative? Has it to do with the way his camera slowly tracks across the earth, with its rich detritus of roots and leaves? Or is it somehow related to his careful and often beautiful arrangement of settings? There is no way of knowing, of being certain. Perhaps Tarkovsky's very *seeing* was in some sense open to the numinous, directed, as Siegfried Kracauer has suggested, towards 'the redemption of physical reality', to the extent that he could communicate the spiritual even when it was most deeply camouflaged.

'It seems to me,' Tarkovsky said, 'that the purpose of art is to prepare the human soul for the perception of the good. The soul opens up under the influence of an artistic image... I could not imagine a work of art that would prompt a person to do something bad... My purpose is to make films that will help people to live, even if they sometimes cause unhappiness—and I don't mean the sort

Plate 68. ANDREI TARKOVSKY. Scene from Zerkalo (The Mirror).
1974.

of tears that *Kramer vs. Kramer* produces… Art can reach to the depths of the human soul and leave man defenceless against the good.'[23]

This is true of *Andrei Rublev*, in some sense an historical film but far from entirely so. 'For me, the most important thing is to use historical material to create contemporary characters,' he wrote in 1967. So what is the film about? In the same journal, *Film Art*, from which I have just quoted, Tarkovsky says that 'in *Rublev* we want to describe the processes of the artist's relationship with his world… Rublev put man first. He looked for God in Man, and saw Man as the house in which God lived.' Tarkovsky himself described *Andrei Rublev* as a complete mystery. Yet in her study of the Artist, Maya Turovskaya has no hesitation in describing *Stalker* as a 'landscape of the soul'.[24] This is surely as apt an explanation as any for *Andrei Rublev*'s irredeemable power.

In this film we enter a Russia suffering under the invasion of the Mongol hordes; a Russia subjected to unrelieved brutality and hopelessness; an occupied, oppressed Russia. For once, the film's violence is essential to its theme.

One of its most awful sequences takes place after the Mongol warlord, guided by the Grand Duke's rebellious brother, has attacked and sacked the town of Vladimir. Its cathedral, as Tarkovsky writes in his original *kino-roman* for the film, 'is a terrible sight. The walls are blackened with smoke, the stucco under the paintings is cracked and in some places has fallen off. The dead lie amongst the debris, the pools of congealed blood and the horse-dung, and Rublev's ikonostasis is slowing burning out; heavy blue smoke curls up from cracks in the wood.'[25] Yet more terrible still are the frames in which the cathedral's sacristan is interrogated as to the whereabouts of the monastery's gold. He denies all knowledge of it, says that none exists. The soldiers bind him with cloths until only his mouth remains uncovered. They bring a ladle filled with molten metal. They pour it down his open throat. 'A terrible, inhuman roar, full of pain and powerless fury, tears the emptiness of the dead cathedral,' writes Tarkovsky.[26] Then the sacristan is tied to a horse and dragged to his death. The violence of this imagery is something I have to steel myself to watch.

Rublev's response to this, to other brutalities and his killing of a Mongol soldier, is to fall into silence. It is the silence of the sacristan after the molten metal burned his throat, the silence, too, of the grief-crazed dumb girl whom Rublev rescues from rape. It is the silence of the Artist—Osip Mandelshtam, perhaps—who in his agony of soul loses all desire to create.

The film's last scene, which relates the story of the casting of a new bell, how the work is undertaken by an adolescent boy, Boriskasity, and its final triumphant peal, is the celebratory heart of the film.

And the bell hums and hums, smoothly gathering power, the ringer is swinging the heavy tongue further and further, and shouting ecstatically at the top of his voice...

Boriska rises from the ground and takes a desperate gulp of cold spring air; he walks, without looking where he is going, with both hands on the back of his head, ruffling his coarse hair, and people stand aside to let him pass with curious, incredulous admiration. Uncontrolled, happy tears are pouring down his boyish face, which is contorted with sobs.

He stumbles, and a pair of hands seize him. Choking with tears he presses up against a chest that smells of smoke and peasant sweat, and he hears a strange, hoarse voice, comforting and hard to understand: 'It's all right... it doesn't matter... it's all over... it's finished... it's all right now... all is well...'

Plate 69. ANDREI TARKOVSKY. Andrei Rublev: the Tartars at the cathedral. 1966.

'The bastard... my father, the bloody monster.' Boriska is suffocating with his tears. 'The filthy skinflint... He never told me the secret, he died, without ever telling me... '

'And look how it has all turned out... it's all fine.' Andrei with trembling hands strokes the lad's hair and his thin neck, and his back, as skinny as an adolescent...[27]

Without realising he has broken his vow of silence, Andrei consoles him, ignoring the stupendous confession, saying, 'What a treat for the people! You've created such joy... and you cry!' 'You and I... we'll go together. You'll cast bells and I'll paint icons. We'll go to Troitsa Monastery.' Thus Andrei Rublev, the carrier of Soul, returns to the world. He awakens to the heart, and through the inspiration of the young bell-maker, rediscovers faith in his own Art. At his feet the wood of an abandoned fire begins to glow, and the glowing becomes the red background of a wall mural. The film's triumphant, penultimate frames reveal the great icons of Andrei Rublev, painted with an unearthly tenderness and stillness.

Art affirms all that is best in man—hope, faith, love, beauty, prayer... What he dreams of and what he hopes for... When someone who doesn't know how to swim is thrown into the water, instinct tells his body what movements will save him. The artist, too, is driven by a kind of instinct, and his work furthers man's search for what is eternal, transcendent, divine—and often in spite of the sinfulness of the poet himself.[28]

Andrei Tarkovsky wrote one book, a series of essays about his work, the problems of visual creativity and the cultural issues of our time. *Sculpting in Time: Reflections on the Cinema* (1986) ends with a credo which summaries the sense of high calling which informed all that this great film maker ever undertook. In it he enjoins the reader

to believe that the one thing that mankind has ever created in a spirit of self-surrender is the artistic image. Perhaps the meaning of all human activity lies in artistic consciousness, in the pointless and selfless creative act? Perhaps our capacity to create is evidence that we ourselves were created in the image and likeness of God?[29]

## INGMAR BERGMAN: THE HOLY ROOM

*It is my opinion that art lost its basic creative drive the moment it was separated from worship. It severed an umbilical chord and now lives its own sterile life, generating and degenerating itself. In former days the artist remained unknown and his work was to the glory of God. He lived and died without being more or less important than other artisans; 'eternal values', 'immortality' and 'masterpiece' were not applicable in his case. In such a world flourished invulnerable assurance and natural humility.*

*Today the individual has become the highest form and the greatest bane of artistic creation. The smallest wound or pain of the ego is examined under a microscope as if it were of eternal importance. The artist considers his isolation, his subjectivity, his individualism almost holy. Thus we finally gather in one large pen, where we stand and bleat about our loneliness without listening to each other and without realising that we are smothering each other to death. The individualists stare into each others' eyes and yet deny the existence of each other...*

*Thus if I am asked what I would like the general purpose of my films to be,*

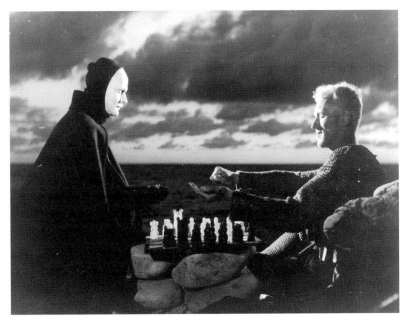

Plate 70 . INGMAR BERGMAN. Death and the Knight: Sjunde Inseglet (The Seventh Seal). 1957.

*I would reply that I want to be one of the artists in the cathedral on the great plain (Chartres). I want to make a dragon's head, an angel, a devil—or perhaps a saint—out of stone. It does not matter which; it is the sense of satisfaction which counts. Regardless of whether I believe or not, whether I am a Christian or not, I would play my part in the collective building of the cathedral.*

Ingmar Bergman[30]

In this section I address the genius of another film maker, one of the century's finest, who was also an innovative novelist, playwright, theatre director and the script-writer of many of his forty-eight films. Several of these—*The Seventh Seal* (1957), *Wild Strawberries* (1957), *The Virgin Spring* (1960), *Through a Glass Darkly* (1961), *The Silence* (1963), *Persona* (1966), *Shame* (1968), *Cries and Whispers* (1973) and the epic recapitulation of so many of his ideas and motifs, *Fanny and Alexander* (1982)—are classics of the cinema.

Few could be described as comfortable to watch; they are often painfully bleak. In concentrating on the breakdown of the West's moral, social and political

institutions, in charting the effects of what he calls this 'slippery slope' on our lives, Bergman has had no cinematic rival. Yet informing his films there is an even profounder and apparently unavoidable existential dilemma: the fate of man in a world abandoned by God. In *Cries and Whispers*, the priest, speaking for Bergman, begs the dead Agnes to intercede for him and all the living. 'Pray for us,' he says, 'pray for us who are left on this dark, dirty earth under a cruel, empty sky... to free us from our anxiety.' Ask God, the priest exhorts the dead woman, 'for a meaning for our lives... plead our cause.' In *The Seventh Seal*, the Knight's no less anguished search for faith informs the film with a similar brand of Bergmanian bleakness:

> Knight: I want knowledge, not faith, not suppositions, but knowledge. I want God to stretch out his hand towards me, reveal Himself and speak to me.
> Death: But He remains silent.
> Knight: I call out to Him in the dark but no one seems to be there.
> Death: Perhaps no one is there.
> Knight: Then life is an outrageous horror. No one can live in the face of death, knowing that all is nothingness.[31]

Few Artists of any time have faced both the plight of the individual in an indifferent universe and the darkness inherent in the human psyche with such unflinching honesty.

Yet the fundamental Bergmanian idea of the experience of film as a journey to the centre of the self is corroborated by something he said when directing *The Silence*. Admitting that he was 'still convinced that God is dead,' he went on to confess that nonetheless, 'I'm also convinced that in every man... there is... a room that is holy. That is, that is very special. Very high. Very secret room that is—that is a holy part of the human being.'[32]

Striking examples of Bergman's use of allegory and symbolic meaning are to be found in *The Seventh Seal*, a kind of morality play, intricately polyphonic in structure, many-layered and of incomparable artistry. Made in the mid-fifties when the fear of nuclear destruction was at its height, Bergman presents a world swarming with error and disease, ignorance and partiality, sin and death. Nonetheless, it is not an exclusively gloomy work. We can discover in it not only a defiant statement of faith in the validity of the creative act but a world

redeemable by neither abstractions and beliefs, but by 'right action' and love.

After ten years on a crusade to the Holy Land, Block and his squire Jons are returning to Sweden. 'I'll tell you,' Jons says to a church painter, 'our crusade was such madness that only a real idealist could have invented it.' The two characters first appear on a lonely beach, the Knight seated by his chessboard, the squire flung awkwardly in a lackey's sleep. In the midst of a dazzling progression of sun-setting dissolves, the hooded figure of Death confronts the gaunt figure of Block. The Knight challenges him to a game of chess, the former's life to be staked on the outcome. Death and the Knight resume their match at intervals throughout the film.

Bergman's characterisation of Block, Jons and the other major figures in *The Seventh Seal* is subtle and exact. Jons, like Sancho Panza, is a worldly realist, hard-headed and sceptical. Yet as the Knight continues his questioning, it is Jons who is by far the more compassionate. The Knight, on the other hand, performs his actions as if there were another task beyond that of living. He is abstracted from life, of no help to others and insistent with questions that can never be answered. On the other hand the entertainers, Jof and Mia, live in the present, live for one another, for their child and for their art.

In the film's most beautiful scene, the Knight sits with Mia, who offers wild strawberries from a bowl, and milk for the berries which symbolise the bread and wine of human redemption: 'the warmth of life, the human values, undamaged by metaphysical fear'. In the course of their discussion the Knight asks to be informed about their plans and, because of the plague, dissuades them from travelling to Elsinore . He suggests that they accompany him through the forest. This scene with the wild strawberries is the nucleus of Block's later impulse to sacrifice himself to save the innocent couple.

Mia: Do you want some strawberries?

Knight (*shakes his head*): Faith is a torment, did you know that? It is like loving someone who is out there in the darkness but never appears, no matter how loudly you call.

Mia: I don't understand what you mean.

Knight: Everything I've said seems meaningless and unreal while I sit here with your husband. How unimportant it all becomes suddenly.

*He takes the bowl of milk in his hand and drinks deeply from it several times. Then*

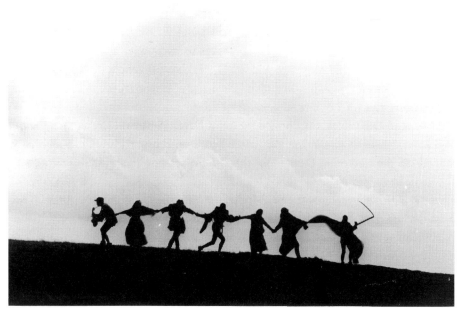

Plate 71. INGMAR BERGMAN. The Dance of Death: The Seventh Seal. 1957.

*he carefully puts it down and looks up, smiling.*
Mia: Now you don't look so solemn.
Knight: I shall remember this moment. The silence, the twilight, the bowls of straw-berries and milk, your faces in the evening light. Mikael asleep, Jof with his lyre. I'll try to remember what we have talked about. I'll carry this memory between my hands as if it were a bowl filled to the brim with fresh milk. *He turns his face away and looks out towards the sea and the colourless grey sky.* And it will be an adequate sign—it will be enough for me.[33]

Almost immediately Death reappears: 'I have been waiting for you,' he says. It is in these dramatic contrasts—and the almost Bill Brandtian richness of the film's black and white photography—that Bergman as dramatist and as a visual Artist says more than he does through words.

During the night, whilst the chess game is progressing, the Knight manages to perform one meaningful act. Sweeping the chessmen from the board, he detains his adversary long enough for Jof and Mia—the least self-absorbed, the

most innocent, the purest of heart, of all the characters in the film—to escape through the forest. 'I believe at times that to ask questions is the most important thing,' says Block, thereby intimating his faith in intellectual aspiration. But what remains purposeful in his life is still the one purely unselfish action: his salvation of the two jugglers. Like Kanji Watanabe in Kurosowa's *Ikiru*, he consummates his life through creative action and love.

The Knight arrives home and finds his wife. Then Death arrives. All present in the castle are then compelled to join in his dance. Against the distant sky, Jof sees the Dance of Death, Bergman's majestic summation of mediaeval imagery.

> 'I see them Mia! I see them,' he says. 'Over there against the dark stormy sky. They are all there. The smith and Lisa and the Knight and Raval and Jons and Skat. And Death, the severe master, invites them to dance. He tells them to hold each other's hands and then they must tread the dance in a long row. And first goes the master with his scythe and hourglass, but Skat dances at the end with his lyre. They dance away from the dawn and it's a solemn dance towards the dark lands, while the rain washes their faces and cleans the salt of the tears from their cheeks.'[34]

As Death leads his six victims, hand to hand, in the fierce merriment of their last revels, *The Seventh Seal* soars to the heights of imaginative cinema.

## AKIRA KUROSAWA: FIGHTING FOR HOPE IN A HOPELESS WORLD

Of all the Japanese film directors, Akira Kurosawa is probably better known to audiences outside his own country than any other. His early *Rashomon* (1950), which continues to be one of his most best-remembered films, was a revelation. Yet since then his work has displayed an ever greater breadth and strength, from the moral dedication of *Ikiru* (1952) to the naked violence of *Seven Samurai* (1954), from his masterly interpretations of *Macbeth* and *King Lear—Throne of Blood* (1957) and *Ran* (1986)—to the incisive humanity of *Red Beard* (1965) and the largely autobiographical *Dreams* (1990), Kurosowa has ranged far and wide to give expression to his essentially tragic vision of mankind.

'I suppose all my films have a common theme,' he says. 'If I think about it though, the only theme I can think of is really a question: why can't people be

happier together?' To ask that question is to answer it—which is what Kurosawa has attempted to do in every one of his films. They cannot be happy, he is telling us, because they are people, because they are human. But though weak, man can yet hope and through hoping he can prevail. The rice must be planted, the young people will fall in love and new life will spring forth. Man must not cease to hope in the midst of this hopeless world and in this fight all men are brothers, all women, sisters. This is the central theme of Kurosawa's films which, like *Ikiru* (Living), show how individuals try to give value to their lives.

Kanji Watanabe, a middle-aged government clerk and *Ikiru*'s central character, has spent his last twenty-five years at a desk in a city hall. The film tells the story of his life after he discovers that he has stomach cancer and only a few months left to live. At first we discover him seeking comfort from the person closest to him since the death of his wife—but the son is indifferent to his fate. Then we see him seeking consolation in the pursuit of a good time, drinking *sake*, playing pinball, going to a dance. We also see him resolving to make something of his remaining days. Little by little the story unfolds and we learn how Watanabe, with indomitable persistence, in the end gets what he sets his heart on achieving: the construction of a children's park on a patch of reclaimed city wasteland. The evening of the day on which the park is completed he is seated on a swing, swinging, and slowly singing the song we had heard him singing six months earlier in a bar:

> Life is so short,
> Fall in love, dear maiden,
> While your lips are still red,
> And before you are cold,
> For there will be no tomorrow.
> Life is so short,
> Fall in love, dear maiden,
> While your hair is still black,
> And before your heart withers,
> For today will not come again.

Thus he dies 'in harness' because it was in the nature of his quest to explore and fight until he died. The flame that has flared momentarily at the end of a small

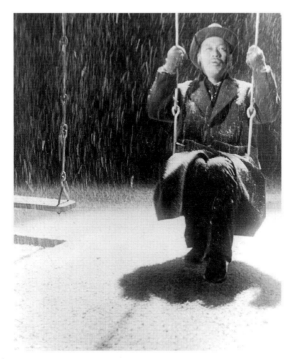

Plate 72. AKIRA KUROSAWA. Ikiru (Living). 1952.

man's life is yet, for all its seeming insignificance, a sign that he has lived. Just as dying, he had learned to live; so, dead, Watanabe becomes more alive for others than he had been before.

Like Kafka's Gregor, Dickens's Scrooge and Dostoevsky's Prince Myushkin (and Block in *The Seventh Seal*), Watanabe finally discovers what it means to exist. He finds that a man is not his thoughts, his ideals, his intentions; a man is what he does. He finds through creative action, creative *doing*, a way to vindicate the meaninglessness of death and, more importantly, the unfocused nature of his life. He experiences meaning for himself and gives riches to others. He finds, too, that meaning does not reside in status, fame, in material affluence, but in the personal, local, particular and compassionate. Watanabe's life, locked into the monotonous but comfortable oblivion of habitual practice, supinely acquiescent in the pursuit of a daily routine perpetuating its tyrannical hold, is, by all logical criteria, an absurdity. But Kurosawa emphasises a different truth: Watanabe is

redeemed by his capacity to refuse despair, his capacity for complete commitment, his self-sacrifice, his instinct for the self-expressive life. At the heart of the piece is the notion of following one's dream, one's vision, one's 'bliss'; of divining and pursuing one's own authentic journey through life. This surely was the 'message' of another teacher, who tells us that each man has to find his own path to final peace and knowledge through his own efforts. 'Work out your own salvation with diligence,' were the Buddha's final words.

## THE PRIVATE LIFE OF PLANTS

My final cinematic example comes from a completely different source: the world of television, where wildlife programmes are helping audiences to appreciate the damaging consequences of global industrialisation on the diversity of life on earth. This was undoubtedly true of the series of six films, *The Private Life of Plants* (1994), in which David Attenborough (with the help of camerawork by Tim Shepherd and Richard Curtis), set out to reveal the awesome ingenuity, ferocious vitality and seemingly endless inventiveness of the world of plants.

'Think what it would be like,' the Italian novelist Italo Calvino once wrote, 'to create a work outside the limited perspective of the individual ego, not only to enter into selves like our own, but to give speech to that which has no language, to the bird perching on the edge of the gutter, to the tree in spring.' In fact we did not need to imagine what it would be like because these films provided us with the vision. Watching the seed of a cheese plant thumping to the ground, seeing its tendrils germinating in the soil, struggling upwards towards the light, scrambling up the bole of the host tree, watching them break into a shimmering canopy of leaves hundreds of feet above the forest floor, induced a sense of the sacred 'other' which I had rarely experienced so vividly before.

## MIXED MEDIA WORK

*Recognise that the universe is a community of subjects, not a collection of objects.*

Thomas Berry[35]

*Relationship is to all things, to nature—the birds, the rocks, to everything around us and above us—to the clouds, the stars and to the blue sky. All existence is relationship. Without it you cannot live. Because we have corrupted relationship we live in a society that is degenerating.*

Krishnamurti[36]

The philosophers and scientists who created Classical science conceived the universe in terms of a mechanical system constructed of material parts: a congregation of objects assembled into something like a huge machine. Descartes compared a healthy man with a well-made clock. Isaac Newton suggested that God 'formed matter in solid, massy, hard, impenetrable, movable particles'. Common to both was the flawed assumption that knowledge and the universe were composed of separate parts.

The recent reawakening to the fundamental unity of life implies a new viewpoint: the contingent existence (rather than the reification) of all that surrounds us, of which we ourselves are an integral part. 'We must realise,' said Aldo Leopold, 'the indivisibility of the earth—its soil, mountains, rivers, forests, climate, plants and animals—and respect it collectively, not as a useful servant but as a living being.'[37]

In the first decades of the century, discoveries about the essential interrelatedness and interdependence of phenomena emerged from the work of a group of physicists including Max Planck, Albert Einstein, Niels Bohr, Erwin Schrodinger and Werner Heisenberg. In the 1930s, studying the dynamic and integrated web of living and non-living forms, the ecologist Arthur Tansley coined the term 'ecosystem', which he defined as a community. The anthropologist and psychiatrist Gregory Bateson likewise argued that relationships should be used as a basis for all definitions. Anything, he argued, should be defined not by what it is in itself, but by its relations to other things. 'What is the pattern that connects?', he asked.

In the slowly increasing sense of unity with and responsibility for the planet and the way that men and women have begun to relate to one another and their work, we can see a new sense of the pattern that connects. The renewed interest in co-operative procedures, permaculture, the politics of communitarianism and the networking potential of the new digital technology are further examples of the range of the current cultural transformation.

The interconnectedness characteristic of ecological thought is simultaneously altering assumptions about creative activity. Gone—or at least on the way out— is the hegemonic, masculine authority once vested in Western European culture and its most dominant institutions; going, too, is the idea of an aesthetics of individualism and the purity of isolation. In their place a new sense of the possibilities inherent in relationships is being discovered. This sees creative action in terms of process rather than as a manipulable product. It places an emphasis on collaboration, participation and interaction, engagement and dialogue. It seeks to reduce the separation of actors from their audiences, to build connections between architects and those who will live in their buildings, to bring music and theatre into a living relationship, and to value the process by which a work is created. It draws great opera companies into community projects, it takes painter-animateurs into hospitals and actors and musicians into schools. It mixes musical styles and professionals with amateurs. It involves Artists with social problems, problems of the environment, gender, multiculturalism and sexuality. It questions such traditional structures such as the mainstream gallery, the museum and the concert hall; the exclusivity and separation of Art forms. It mixes photography with music and both with 'theatre' in a cocktail which has no name.

In the fourteenth century, the artist was barely more than an artisan employed to articulate the ideals and aspirations of his community. Five hundred years later, his successors were specialist super-creators responsible only unto themselves. Even as late as the early years of the Russian revolution, its Artists regarded themselves as the cognoscenti, the ones chosen to 're-educate the aesthetic eye of mankind'.

One of the first to reject this assumption was the French theatre director Roger Planchon (b1931), at the Municipal Theatre of Villeurbanne, a working-class industrial suburb of Lyon. Planchon had a wish 'to bring things away from literature and connect them with real life, the everyday life of the next-door neighbour, the butcher, the grocer on the corner.' 'There are two parallel adventures,' he observed, 'the artistic and the social. They must be considered in conjunction.'

Like other new ideas, Planchon's may have seemed relatively benign; but they were dynamite. They implied that many cherished ideas should be jettisoned—that, for example, the idea of aesthetic purity and detachment should be replaced by accessibility; that the emphasis on *product*—the work of Art—

should be complemented by a consideration of *process*; that the assumption that the trained professional was exclusively entitled or able to make Art was fundamentally flawed—the practice of Art should be widened to include the once despised 'amateur'. They also implied that every human activity—sport, horticulture, carpentry, raising children, cooking, making rituals, town planning—could be performed with skill, with grace and artistry.

One of the first to explore the possibilities inherent in Planchon's ideas was John Fox; others included Joan Littlewood, Stephen Joseph and John and Margaretta Arden.

## WELFARE STATE AND THE LIBERATION OF IMAGINATION

*The poet of the future will make dreams concrete.*

Andre Breton[38]

In 1968, Fox and Sue Gill founded Welfare State International, which was to become an established company of freelance artists, writers, musicians, sculptors and performers who were subsequently to create hundreds of site-specific celebrations with communities all over the world. For almost thirty years the company has been researching new forms and contexts for celebratory art. These have included mammoth carnivals for and with thousands of participants to one-person story-telling.[39]

The company's resources have expanded, but the vitality of vernacular 'theatre' has been a continual inspiration. In selecting this tradition, John Fox has always wanted to present something more than entertainment as diversion. 'Our aim,' he says, 'is the liberation of imagination… It is to re-present myths and archetypes that are universally shared, and present them in an idiom accessible to a broad audience.' Yet, he of all people has no need to be reminded that in a society in which the shared culture is increasingly threatened by a largely imposed electronic entertainment industry, myths and archetypes have to be discovered and re-made, not simply revived.

We are seeking a culture which may well be less materially based but where more people will actively participate and gain the power to celebrate moments that are

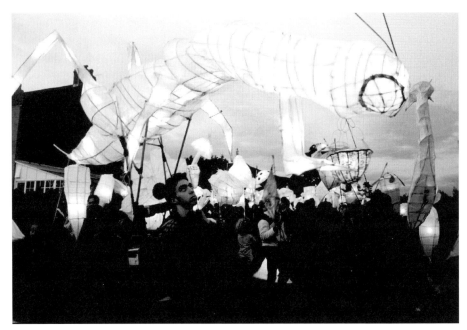

Plate 73. WELFARE STATE INTERNATIONAL. Lantern Festival. Ulverston, Lancashire.
photo: Nick Lockett.

wonderful and significant in their lives. Be this building their own houses, naming
their children, burying their dead, announcing partnerships, marking anniversaries,
creating new sacred spaces and producing whatever drama, stories, songs, rituals,
ceremonies, pageants and jokes that are relevant to new values and new iconography.[40]

Having gained a world-wide reputation for creating celebratory events with
communities, and for pioneering prototypes of site-specific events such as lantern
festivals, carnival bands and fire shows, the company has turned its attention to
vernacular art—highly personal forms of ceremony and celebration. Such cere-
monies include rites of passage such as the naming of children, the announce-
ment of partnerships, weddings, the opening of houses and, for those resistant to
the Christian burial service, memorial occasions (and the painting of biodegrad-
able cardboard coffins). At their base in Ulverston, Cumbria, the company also
runs summer schools, stimulating a new range of activities in the field of com-
munity theatre. 'After rigorously analysing the place of Art in our culture, we

Plate 74. WELFARE STATE INTERNATIONAL. Lantern Festival. Ulverston, Lancashire.
photo: Ged Murray.

have come to the conclusion that the radical edge is best sought by starting in our own back yard,' says John Fox.

> There are seeds to be sown in skills and social awareness, but the liberation of imagination is more urgent. Most politicians don't understand the first thing about art. They think it's to do with leisure. We need a major rethink about celebrating the everyday—in terms of working with our hands and gainful occupation, rather than the usual work ethic—gratification through a job and through money, and then buying leisure with the money we earn. William Morris was very clear about the connection between art, work and leisure... We need to think more about developing the imagination which is in us all.[41]

Though Welfare State is one of the longest-established and best-documented community arts group in Britain, it shares with others certain important assumptions. These include the belief that theatre (and the other Arts) should arise out

of a community rather than be imposed upon it and that the barriers which isolate Art into aestheticism should be recognised and taken down. Their strong moral, ecological and political concerns; their desire to liberate people's imaginations and give 'ordinary' people access to their unrealised creative powers, are also widely shared. The borders between entertainment and Art, Art and environmental regeneration, Art and therapy, Art and protest, Art and ritual, between performer and audience, between one Art form and another, between 'professional' and 'amateur', between 'performance' and the social event, have begun to meet, shift and expand.

## ANNA HALPRIN: RE-SACRALISING THE POISONED LANDSCAPE

Another Artist seeking to bridge the gap between people and their local environment is the American dancer Anna Halprin (b1920). Through her own medium she has worked to help communities develop their own vital life rituals, and through the shock of having cancer, to explore the relationship between dance and healing. She believes, as I do, that it is out of the raw materials of our lives and bodies that we make our art.

Long before the advent of Western civilisation, people gathered and unified themselves in order to confront the challenges of their existence. In *Circle the Earth: A Philosophy* she argues that in the struggle to find our own spiritual identity and rediscover the community we have lost, we must do so again: 'We can,' she writes, 'return to dance to recover an ancient tradition that will save us in today's culture. The wisdom of dance and body contains resources that can provide us with tools for the survival of life on this planet.'

> When the members of some hunting cultures needed food, they danced a hunting dance, preparing themselves for the rigours of the hunt and supplicating the divinities and animal spirits to bless their undertaking... Among many of the planting societies, dance rituals are also said to dissolve space and time. They allow the dancers to re-enter the sacred reality that existed before the beginning... Through these performances, the people were renewed and the cycle of life began again.
>
> To celebrate birth and marriage, to initiate the young into adulthood, to initiate adults into the sacred mysteries, to prepare for war or lament defeat, to heal the sick,

Plate 75. ANNA HALPRIN. Circle the Earth. Peace Dance meditation. 1986.
photo: John Werner.

to help the dying on their journey into the land of the dead, to maintain the life of the community on its proper path, the people sang their songs and danced their dances. Dance was the most important language people knew. It was a magical language of power. It was the language of the spirits...

In the evolution of Western industrialised urban culture, people gradually lost the language of dance as they lost the consciousness of spiritual and natural participation... The rediscovery of the lost language of dance now offers us the very vehicle which people traditionally used to form their cultures and face their crises... Now, in our time of need, we have the opportunity to bring that power to bear on our task of transforming, reuniting and renewing our society so that we may find harmony among and between the people of the earth.[42]

An outstanding example of this work has been related to the healing, *making whole,* of Mount Tamalpais, near her own home in California, where a trailside

killer murdered seven women over the course of two years; in 1981 she developed an event which has subsequently evolved into the world-wide gathering, *Planetary Dance*, held every spring, the time of renewal.

In pursuit of the mountain's reclamation, Anna Halprin and her husband Lawrence began to organise workshops to help local inhabitants to get in touch with and channel their feelings. They made drawings and dances exploring their responses to the environment. They worked for months, developed a dance score and then invited the community to climb the mountain. Eighty people climbed, some chanting, some in groups, large and small, young and old. 'At the top we invited spiritual leaders to make blessings and ceremonies for us. They led songs, said prayers, recited poems and told stories. An Indian planted corn between a male and female rock. Rabbis and priests delivered blessings. A genuine outpouring of love and concern brought us all together... We were investing energy back into the mountain. driving off the veil of fear that infected this sacred place. Individually and as a group, we helped bring the mountain back to life, back to its place of spirit. Two weeks after our ceremony a man was arrested who since has been convicted of the killings... I believe we cared so much for our mountain that our collective spirit brought the mountain back to us cleansed and healed.'[43]

It was soon after this event that Don Jose Matsuwa, a 107-year-old-Huichol Indian shaman, visited Anna Halprin and told her: 'The mountain is one of the most sacred places on earth, but for your ritual to be successful it must be repeated each year for five years. Only then will the mountain be purified.' And so the ritual has been repeated with variations, moving from the theme of peace on the mountain to peace within the individual, the community, the world. And each year those participating have made this simple declaration:

For the spirit of the Mountain we dance,
For those who consider her a holy place;
For the Miwoks who lived beneath her,
Gathered her herbs and sang her songs,
We dance.
And quietly we dance for those among us who have lost their lives on her trails.
Quietly we dance for them,
For the trails that lead us back to the Mountain,
We dance.

## MUSIC

More ubiquitous than cinema or even television, music has become our most pervasive Art. It is to be heard everywhere: in shops, in homes, in aeroplanes, in restaurants and dentists' surgeries; an aural medium required to destroy silence and create stimulation—the kind of stimulation silence no longer provides. The greatest quantity of this material is junk-sound; insidiously dangerous in its negation of imagination. Yet however vapid such music often is, some popular music is vitally alive, and a minority of rock, reggae and jazz is inspired. In different ways, such Afro-American performers as Cecil Taylor, John Coltrane, Miles Davis and Albert Ayler, such groups as The Doors, Led Zeppelin, The Rolling Stones and The Beatles as well as songpoets like Van Morrison, Jimi Hendrix and Bob Dylan have over the past quarter of a century returned their listeners to some sense, however crude, of the archaic life. Speaking at the Berlin Jazz Festival in 1964, Martin Luther King underlined the importance of jazz in the fight against meaninglessness. 'Jazz speaks of life,' he declared. 'When life itself offers no order and meaning, the musician creates an order and meaning from the sounds of earth which flow through his instrument.' Rock concerts have carried multitudes beyond ordinary states of feeling and perception into a surrender to ecstatic frenzy.

Only their most dedicated followers could claim the same for most of this century's Art-music composers, whose work has left generations of audiences bored, baffled and outraged. Some of these—say Igor Stravinsky, Béla Bartók and Dmitry Shostakovich—have a genuine following, but since the breakdown of tonality in the years leading up to the First World War, others like Anton Webern, Arnold Schoenberg, Alban Berg, Karlheinz Stochhausen, György Ligeti and Witold Lutoslawski, have attracted only minority support.

Yet recent years have seen a kind of reconciliation. The sense of contrast with what has gone before is essential to the characterisation of any artistic period. It can also be a symptom of profound changes in dominant states of mind and feeling. The current interest in plainchant and world music, the fact that composers have returned to melody, the interest in the music of Arvo Pärt, John Tavener, Henryk Górecki, James MacMillan, Steve Reich, Philip Glass and Alan Hovhannes, suggest that something new and important is appearing right across our cultural life.

## OLIVIER MESSIAEN AS LOVER AND CELEBRANT

Before the all-male Armaggedon of the First World War, the Arts in general and music in particular were especially informed by a prophetic honouring of the feminine. Examples include, apart from the paintings of Gauguin, Thomas Hardy's *Tess of the D'Urberville's* (1891), Debussy's *Pelléas et Mélisande* (1902), Janácek's *Jenufa* (1894-1903), Puccini's *Madame Butterfly* (1904) and *Der Rosenkavalier* (1911) by Richard Strauss. In the compositions of Olivier Messiaen (1908-1992), plumbing depths below the surface of New Testament theology, we can also discover a host of further pointers, including the cult of Mariolatry—a Mariolatry directly related to that of the mediaeval troubadours, for whom the Eternal Beloved was at once the Virgin Mary and an Earth Goddess of the pre-Christian era.

Messiaen might have been a writer, not a musician, had it not been for the decisive impact of a gift on his tenth birthday, the score of Debussy's *Pelléas*; yet according to his wife, Yvonne Loriod, even before this he had discovered a love of birds. As a child Messiaen felt that their song was neither twittering ornament, nor merely a signal of defence and recognition, but *music*. And what he called, 'our little servants of immaterial joy' for him continued to rank as the greatest musicians on the planet.

Of comparable importance to this love was Messiaen's Catholic faith, his sole reason for composing. Nonetheless he wrote almost no liturgical music, and his compositions, saturated with rhythms calculated according to the patterns of ancient Indian music, dense harmonies chosen with an eye for the 'colour' of sounds, can never be described as even remotely 'ecclesiastical'; they were songs of praise and rapture and sometimes as paganly erotic as the Song of Solomon.

Messiaen shared with Gerard Manley Hopkins not only a dedicated commitment to Catholicism but a visionary ecstasy devoted to the celebration of the minute characteristics which differentiate one thing from another. In *Catalogue d'oiseaux* (1958), a collection of thirteen piano pieces, he celebrated the diversity and specificity of birds—Le Loriot, Le Merle Bleu, Le Chocard des Alpes; in *Vingt regards sur l'enfant Jésus* (1944), a two-hour cycle of meditations for piano, he celebrated glimpses of the Child Jesus; in *Des Canyons aux étoiles* (1974), a vast symphonic cycle on the subject of awe—awe at the majesty and multiplicity of creation—he celebrated the grander spectacle of the American landscape and the

immensity of space, both seen as metaphors and manifestations of divinity.

*Des Canyons aux étoiles* conveys through every gesture the unforgettable impact of the vividly coloured rock formations, the deep ravines and towering pinnacles of Southern Utah. The three landscape pieces are punctuated by five movements based on the song of birds, including two of the most lyrically beautiful of all Messiaen's ornithological studies and, in the virtuoso piano solo describing the American mocking-bird, one of his most dazzlingly brilliant. The *étoiles* (for Messiaen stars have always had as much to do with theology as astronomy) are reflected in a formidable image of divine judgement 'written upon the stars', an 'interstellar cry' of mankind towards God (for solo horn) and a serenely luminous passage of resurrected souls among shining stars. *Des Canyons* is a deeply religious work; a view of creation and eternity in which both sin and evil are absent. In this 90-minute composition, flawed humans are also missing. The only living personae are birds.

The return to nature as a release from human turmoil has a long history in European music. In modern times it begins with the bird that warbles to Siegfried from the depths of the dark forest in Wagner's opera of the same name. A comparable yearning is active in the nature-music of Debussy, Delius and Sibelius, in Janácek's evocations of the Moravian forests, and in the night-music of Bartok. In the work of these composers, nature's otherness is experienced as distinct from the human; man and the natural world are apart. In significant contrast, Messiaen moves us onto a new terrain: he experiences man as part of nature. He seeks an equilibrium between the human, the natural and the divine; his birds are nature's voice, and God's. As Wilfrid Mellers has observed: 'More than any other composer of our time he represents modern man's weariness with a literate, will-dominated 'patriarchal' culture, and his desire to recover a 'matriarchy' that worships the White Goddess and respects the Terrible Mothers.'[44]

Messiaen's retreat from Humanism is a significant addition to our theme. 'I am no Cartesian Frenchman,' he is reported to have said, and he certainly abjured many of the aural incarnations of the Western aspirational pilgrimage—the symphony and sonata form. His compositions have no beginnings, middles and ends, and with these the European concept of linear time. Nor do they have a pretence of growth; they are timeless in their spiritual power. Yet 'Despite his Catholicism,' says the composer George Benjamin, who spent two years in Messiaen's famous Paris Conservatoire class, 'he barely mentioned God. But he

made you constantly aware of the spiritual values of being an Artist. In that room it was unquestionable that beauty could still exist in music today.'

## TORU TAKEMITSU AND HIS TIMELESS ART

A contemporary, whose Art and philosophy shared something in common with Messiaen, was the Japanese composer Toru Takemitsu (1930-1996), one of the most distinguished figures to have emerged from East Asia since the Second World War. Although Takemitsu provided the aural dimension for over a hundred feature films, including Teshigahara's *Woman of the Dunes* and Kurosawa's interpretation of King Lear, *Ran*, his significance rests in the radiant music he wrote for the concert hall. What Takemitsu says of *To the Edge of Dream*, 'melodic fragments float(ing) in a transparent space like so many splinters of dream', could be a description of the character of his other work.

His starting point was the burgeoning of Modernism at the end of the last century; Ravel, Debussy and Messiaen all influenced him, and at scarcely past the age of twenty he had already started composing with the characteristically rich, chromatic harmonic vocabulary which was to remain the hallmark of his style. It is a heavily sensuous mixture, and Takemitsu's works are characterised by their textural refinement, unhurried pace, Buddhist reticence and uncannily precise aural imagination. But, as with Debussy, one is left in no doubt that elemental forces lie beneath the surface.

The return to nature has a long history in European music, but a longer one in Japan where, in the art of Zen, any seemingly insignificant detail—a bird on a bough, a blossoming branch, a weed bent under the weight of snow—can provide an evocation of life's totality without the need for ponderous literal explanation. Concentrating on the evocation of states of being informed by a contemplative inwardness, Toru Takemitsu's sonorities and haunting melodic lines similarly inspire and focus a perception of the universe as an organic and sacred whole.

In fact Takemitsu's concept was always profoundly Eastern; it engendered a rare and dream-like spaciousness, a reflection of, and contemplation of, nature's slowly evolving changes. Listening to his music can perhaps be best described as the aural equivalent of a visual journey round a Kyoto temple garden, each

sound savoured cyclically in turn. 'You view a Japanese garden by circulating through it,' he says. 'It's not a linear experience at all. I write music by placing objects in my musical garden.' Another thing he liked about gardens was that 'they never spurn those who enter them', and he tried to ensure his own music had a similarly welcoming, unaggressive character.

Aspects of this state of being are conjured up in the evocative titles which preceded and stimulated the actual process of composition. These include: *Dreamtime* (1981), *Star-Isle* (1982), *Riverrun* (1984), *Tree Line* (1988), *From me flows what you call time* (1990) with its sections variously called: *A Breath of Air, Curved Horizon, The Wind Blows, Mirage, Waving a Wind Horse, The Promised Land* and the final, short *Prayer*, with its haunting sound of bells. Takemitsu's elegant, gentle, conciliatory music, which defines a world somewhere between Debussy, Cage and old Japan, is always informed by a sense of being and becoming and the endless flow—evoking the nature of the Goddess.

The Goddess, according to Edward Whitmont, is not concerned with achieving or ideating, analysis and abstraction. She is not heroic, self-willed and bent upon battling against opposition. What delights and interests her are the vegetal dimensions of growth and decay, the life-death continuum of existence, the continuity and conservation of natural orders; unity, patterns, and analogy. She expresses, Whitmont says: 'the will of nature and of instinctual forces rather than the self-will of a particular person. The feminine form of consciousness is global, field and process orientated... It is devoid as yet of the strict dichotomy of inner-outer and body-kind.'[45]

A new symbology and mythology are in the making, and Whitmont has described it. But Takemitsu entered it, gave it being, evoked its presence, learned to speak its language of evolving consciousness. Once again an Artist proved to be the prophet and healer, the one to open the awareness of another dimension of reality than the conventionally acceptable.

## JOHN TAVENER & ARVO PÄRT: REINSTATING THE SACRED INTO THE WORLD OF THE CONTEMPORARY IMAGINATION

Two decades ago, knowledge of the music of the Estonian Arvo Pärt (*b*1935) and the Englishman John Tavener (*b*1944) was limited to a small clique; the work of

Henryk Górecki (*b*1933) was virtually unknown. Today the music of these composers speaks directly to people, of whatever religious or philosophical direction, searching for an experience of soul.[46] In November 1993, a recording of Górecki's *Third Symphony* (1976) received an award as a best-selling record. With sales exceeding a million copies, it has become the biggest selling disc by a contemporary classical composer. John Tavener's *The Protecting Veil*, written for 'cellist Steven Isserlis and premiered at the Proms in 1989, has also received huge popular acclaim. Subsequent performances and recordings of his *The Akathist of Thanksgiving*, *We Shall See Him as He Is* and *Mary of Egypt* have confirmed that the depth of the hunger for transcendence is larger than generally assumed by those out of touch with the zeitgeist.

Tavener himself is an Orthodox and his compositions, redolent of Christian confidence, are inspired by the music of other sacred cultures—Byzantine chant, Indian music (Drupad in particular) and the ecstasies of Sufism. Stravinsky's *Canticum Sacrum*, with its concern with the timeless rituals of religious observance, has also been a profound influence. God and His praise remain in fact the exultant theme of all Tavener's recent music. The vision of Paradise glimpsed in the *Ikon of Light* (1984), the *Hymn to the Mother of God* (1985) or the *Akathist of Thanksgiving*, carry the conviction of unquestioned faith. This is especially true of the latter, written for soloists, choir and orchestra in honour of the Millennium of the Russian Orthodox Church, and first performed to a packed audience in Westminster Abbey in November 1988.

An akathistos is a long hymn used in the Orthodox rite, prescribed liturgically in modern Russian use to be sung at matins on the Saturday of the fifth week of great Lent. The text Tavener set is not liturgical. It was written strictly according to the liturgical structure by Archpriest Gregory Petrov, shortly before his death in a Siberian prison camp in the late 1940s. Petrov took as his inspiration the dying words of the martyr St John Chrysostom, 'Glory to God for everything', and created within the traditional set patterns of *Kontakion* and *Ikos* a soaring hymn of radiant faith.

This faith, this radiance, Tavener expresses in music of power, unearthly stillness and purity. *Akathist*, with its hushed choral textures, hypnotically repeated chanting phrases, dark-hued, quasi-Bulgarian male voice sections, sparkling counter-tenor duets, tolling bells, recurring *Amin* and unexpectedly quiet climax in the ninth Kontakion, leaves one with an impression of prayerful, meditative

praise. 'In everything I do, I aspire to the sacred... music is a form of prayer, a mystery,' he says.[47]

In contrast to the individualism, the alienating atonality and complex structural abstraction of contemporary Western music, Tavener's compositions are largely meditative, ritualistic, static, even impersonal; his work is imbued with a spacious sense of glorification, an eloquent and moving simplicity and lack of the developmental structure common to the music of the non-Humanist world. 'It is a pity,' he reflects, 'that we in the West have gone in the direction of innovation rather than, as in the East, in the direction of continuing the line. The danger with innovation is that it turns into chaos. Of course, the danger with the Eastern way is that it stultifies and dies. One has to find a balance, but I lean towards the Eastern ethos, more now at fifty than when I was twenty.'[48]

A potent feature of our cultural transformation is Tavener's ambition, through his Art, to reinstate the sacred into the world of the contemporary imagination in music of timeless praise.

The music of Arvo Pärt is no less unaffected by the plethora of styles, techniques and values informing the individualistic West. He has also been affected by plainchant and the spirituality of the Eastern Orthodox Church, of which he is a member. Yet unlike Tavener, who has on occasion employed massive forces, Pärt uses the simplest of means to achieve the most magical ends; his music is often determinedly simple, static and unhurried. It has its own order of time: an almost obsessive, unwavering pace, a primal drone like a beating heart.

Although his *Passio Domini Nostri Jesu Christi Secundum Joannem* (1982), *Te Deum* (1984/5, revised 1986), *Magnificat* (1989), *Miserere* (also 1989) and *Berliner Messe* (1990-92) are explicitly liturgical, other compositions, however ritualistic in spirit, are without a specific programme. In fact, the earliest work mentioned above, the Passion according to St John, makes no concessions to modern conventions of Passion music. Stubbornly repetitive, deliberately anti-dramatic and neutral, it achieves its extraordinary and noble effect through the simplest of means: measured recitative, piquant chanted choruses and the clear, bright timbres of a small instrumental ensemble. The austere ritual of the *Te Deum* is no less mesmerising in its heart-rending effect. Beautiful sounds, these— gripping yet remote, communicative yet deeply personal in their serenely moving affirmation of holiness.

*Arbos* (1977-86), an exultant yet hieratic composition for brass ensemble

and percussion, has a different spirit. With its sounds of pristine melody and spine-tingling harmonic dissonance, its sonorous brass and reverberating bells and gongs, it is at once accessible and highly original, ancient and completely contemporary, plangent and inspiring. It is a revelation of the nature of mythological time and an entry into a kind of meditative trance.

## THE BEATLES: ART WITHOUT 'ART'

*The creative impulse is something that can be looked at as a thing in itself, something that of course is necessary if an artist is to produce a work of art, as also as something that is present when anyone—baby, child, adolescent, adult, old man or woman—looks in a healthy way at anything or does anything deliberately, such as... prolonging the act of crying to enjoy a musical sound. It is present as much in the moment-by-moment living of a backward child who is enjoying breathing as it is in the inspiration of an architect who suddenly knows what it is he wishes to construct, and is thinking in terms of material that can actually be used so that his creative impulse may take form and shape, and the world may witness.*

D.W. Winnicott[49]

Self-taught composers like Edward Elgar, Charles Ives and (almost) Toru Takemitsu, are rare. Yet if novelists and poets can also write with little training, other Artists, especially architects, dancers, choreographers, film-makers, composers of Art music and instrumentalists, invariably require a strenuous apprenticeship. The exceptions among musicians are those who perform in the folk, jazz, pop and rock idioms, where native talent can flower through living experience, not academic study. An outstanding example of this method is the group of unschooled musicians from Liverpool called the Beatles.

The founder of the group, John Lennon (1940-1980), had no musical training; Paul McCartney (b1942), brought up in a home with an amateur musical culture, taught himself to play the guitar; apart from an attempt to form a duo with his younger brother his musical development was fairly solitary. George Harrison (b1943) and Ringo Starr (b1940) were also self-taught; the latter's schooling virtually non-existent. Starr's main enthusiasm was for playing drums; Harrison's, like that of his contemporaries, the guitar. Yet from these

unpromising beginnings, the four adolescents were to conquer the music world with an original amalgam of American black blues and white rock, Country and Blues, Anglo-Irish folk music and song and dance from music-hall and pub with a touch of avant-gardism and a great deal of native imagination. From 1962 to 1970 they recorded thirteen albums and twenty-two singles, in all more than 200 songs, mostly their own compositions.

The transformation of these folk-artists into artists of genius is difficult to explain—but will always remain a model for others with not much less talent to follow.

Working empirically, teaching one another guitar chords, inventing their own lyrics, creating songs by a process of trial and error, it took them a mere three years to bridge the gulf in style and sophistication between the simple ebullience of *She Loves You* (1963) to the complex, prismatic music of John Lennon's *Strawberry Fields Forever* (1966). The gestation of the latter song, loosely inspired by a real place, was typical of their working method up to 1969 when the group split up. The song, as its composer first played it, was a simple, reflective melody. In sessions that stretched over five weeks, the group recorded three different versions. The one released, a composite of two arrangements; was a collaboration between the Beatles and their producer George Martin, with whom they worked in the recording studio. The published song includes brass and strings, cymbals played backwards, the sound of a seordmandel (a harp-like Indian instrument), and trumpets.

The Beatles next disc, *Sgt. Pepper's Lonely Hearts Club Band* (1967) which explores the perennial as well as current problems of adolescence in an industrialised culture—loneliness, friendship, sex, the generation gap, alienation, fear, nightmare—contains some of the group's most hauntingly memorable songs. It transformed, as Wilfrid Mellers writes, 'ordinary Liverpool lads into extraordinary mythic heroes'.[50]

Their achievements, I would suggest, are fourfold: they lie in their capacity to give life-affirming expression to the experience of a whole generation; in their rediscovery of music as fiesta and orgiastic magic; in the way that they honoured and developed their own creativity and how through them some larger force, which has to do with the ancient roots of music and its primary importance to human beings, was set in dynamic motion. Yet when all is said and done—and a great deal has been said about the Beatles—they demonstrate one simple truth:

that we are all creative, and that, as Anna Halprin writes, 'creativity is a source from which we may all drink, and everyone's participation enlarges everyone's potential and expands everyone's life.' What has been so repressed and degraded in our culture, the Beatles simply allowed to come through.

## THE NOVEL

### JOHN COWPER POWYS AND THE MAGICAL VIEW OF LIFE

In the vast world of the twentieth-century novel, the dream and its longing have never been discouraged. Nonetheless, many writers have believed that their job was best done by telling stories with consistent characters engaged in coherent actions which reflected conventional pictures of social and psychological realism. They have been more concerned with the naturalistic approach, the extroverted study of social relationships, than with charting those shifts of consciousness which happen when the inner world encounters the outer world in the equivalent of a transforming rite of passage. In contrast, I intend to discuss a number of works which attempt to evoke the mysteries which awaken our innermost mythic response.

This is found only rarely in modern books—in, for example, the symbolic and metaphysical orientation of Thomas Mann's *The Magic Mountain* (1924), the at once absolutely familiar yet estranged world of Franz Kafka's *The Castle* (published 1926) and the lyrical fantasy of Virginia Woolf's *Orlando: A Biography* (1928). It is also to be found in the painful and consuming radiance of Malcolm Lowry's *Under the Volcano* (1947), the philosophic nature of Hermann Hesse's *Narziss and Goldmund* (1959), Doris Lessing's *Shikasta* (1979) and a book which takes its bearings from the tradition of mediaeval romance: *The Chymical Wedding* (1989) by Lindsay Clarke.

A similar kind of imaginative vision is strikingly present in the writings of John Cowper Powys (1872-1963), the author of *Wolf Solent* (1929), *A Glastonbury Romance* (1933), *Weymouth Sands* (1934) and *Porius* (1951).

Although Powys invented a host of peculiarly Powysian men, women and children—Rook Ashover, Wolf Solent, Dud Norman, Porius, Perdita Wane amongst them—it is the omnipresence of the natural world which provided the

metaphors, symbols and myths for his fiction's psychic and planetary themes, where his genius as a novelist is at its most potent. In all Powys's landscapes, water, moisture and mist play an especially important part (the symbolic and actual association of water with the female principle was fundamental to him); as do the borderlands which feature in his work. For this novelist, as for other Artists inspired by the feminine principle, transference and metamorphosis, fluidity and imagination, were of greater significance than the exercise of will, volition and power.

'In every sense Powys is an explorer of thresholds, margins and boundaries,' observes Jeremy Hooker, 'the poet of the twilights that open out on a fourth dimension between the mundane periods of night and day, and of the supernatural divisions between the seasons of the year and between different ages... Having grasped this essential fact, we can then see how Powys's exploration of the borderland between male and female, the natural and the supernatural, and the human and the non-human is related organically to the geographical location and the temporal dimension of [all his] novel[s].'[51]

Tender and profound feelings for the living cosmos, the elemental world creaturely in all its forms, are also recurrent motifs. The worm, the feather, the leaf, the stone, moss—all he feels have lives to live. Cruel sports were anathematised by him, but so too were other infringements of the freedom of the inanimate. This respect for things-as-they-are-in-themselves certainly underlies Wolf Solent's (and Powys's) anger against 'the Monstrous Apparition of Modern Invention' which he describes near the beginning of *Wolf Solent*. Wolf, a 35-year old teacher who has lost his job in London after making a wild outburst against every aspect of modern civilisation, is returning by train to his native Dorset to be the secretary of Squire Urquhart of King's Barton:

By the time the hill of beeches had disappeared, he caught sight of a powerful motor-lorry clanging its way along a narrow road, leaving a cloud of dust behind it, and the sight of this thing gave his thought a new direction. There arose before him, complicated and inhuman, like a moving tower of instruments and appliances, the Monstrous Apparition of Modern Invention.

He felt as though, with aeroplanes spying down on every retreat like ubiquitous vultures, with the lanes invaded by iron-clad motors like colossal beetles, with no sea, no lake, no river free from throbbing, thudding engines, the one thing most precious

of all in the world was being steadily assimilated.

In the dusty, sunlit space of that small tobacco-stained carriage he seemed to see, floating and helpless, an image of the whole round earth! And he saw it bleeding and victimised, like a smooth bellied, vivisected frog. He saw it scooped and gouged and scraped and harrowed. He saw it hawked at out of the humming air. He saw it netted in a quivering entanglement of vibrations, heaving and shuddering under the weight of iron and stone.

Where, he asked himself... where, in such a vivisected frog's-belly of a world, would there be a place left for a person to think any single thought that was leisurely and easy?[52]

It comes as no surprise, then, that towards the end of his *Autobiography* (1934), Powys proselytises for 'the magical view of life' as opposed to the Cartesian and mechanical way of being. 'What is wrong,' he writes, 'with so many clever people to-day is the fatal distrust lodged in their minds—and lodged there by a superstitious awe in the presence of transitory scientific theories—of the power in their own souls. What we need—and the key to it lies in ourselves—is a bold return to the *magical* view of life.'[53] That power within us, as Powys knew and practised, is the imagination. One of his great achievements was to affirm the value of imagination for the twentieth century. 'We are still potential magicians,' he wrote in his *Autobiography*, 'as long as we have faith in our powers.'

## PATRICK WHITE AND THE CHALLENGES TO SPIRITUALITY

A similar affirmation of the role and importance of imagination informs the work of the Australian novelist Patrick White (1912-1990). All his novels, which include *Voss* (1957), *The Tree of Man* (1956), *Riders in the Chariot* (1961) and *The Twyborn Affair* (1979), re-examine the nature of realism and question the apparent opposition between flesh and the spirit.

*Riders in the Chariot* portrays four characters: a half-mad Australian spinster, Mrs Hare; an orthodox refugee Jew, Mordecai Himmelfarb; an evangelical washerwoman, Ruth Godbold, and a mixed-caste aboriginal, Alf Dubbo—who share in common a mystical illumination of the Divine. 'What I want to emphasise through my four "Riders",' he wrote to Ben Huebsch of the Viking Press, 'is

that all faiths, whether religious, humanistic, instinctive, or the creative artist's act of praise, are in fact one.' *Riders* is a study of the challenges to personal spirituality to be found in a world of pervasive evil.

White's imaginative grasp was colossal. Dubbo, the black painter, half artist/mystic, half squalid fringe-dweller, is his invention; the novelist had never met an aboriginal. The laundress who discovers the chariot in the Evangelical hymns she had sung as a child, he based on memories of the devoted servants he had known in his youth. The old spinster, Mrs Hare of Xanadu (she sees the chariot in her fevers) is based on an aunt's spinster sister; the Jewish refugee, Himmelfarb, who finds himself in the presence of the chariot as he walks through the bombs falling from the RAF planes on to the town of Holunderthal, is based, at least in part, on White's own experience as an outsider—he was homosexual. In the novel, Himmelfarb is a key figure and, too, a key to White's intentions. 'He (Himmelfarb) had searched through recondite books,' writes David Marr in his biography of the writer, 'for the secret of the ecstasy he now experienced, "an ecstasy so cool and green his own desert would drink," but found it in the revelation of man's bestiality in war.'[54]

This sense of the inner life which might be called mystical, this sense of the possibilities for redemption and the encounter with God in ordinary things, pervaded every one of White's novels and short stories. 'In the course of her life, she had discovered a love and respect for common and trivial acts,' he says of Mrs Godbold, and asks, 'Did they, perhaps, conceal a core, reveal a sequence?' And again in his *Australian Letters* (1958) the novelist confides, 'I have tried to uncover the extraordinary concealed behind the ordinary—the mystery and the poetry which alone enable such beings to support their lives.' To live sacramentally, he tells us, is to cherish and revere everything we see, touch and do.

Thus dumpy Miss Hare, with her short arms and skin blotched with red patches, walks among the leaves and brambles of her garden run wild:

Each pool would reveal its relevant mystery, of which she (Miss Hare) herself was never the least. Finally she would be renewed. Returning by a different way, she would recognise the hand in every veined leaf, and would bundle with the bee into the divine Mouth.

In Patrick White we find not only the traditional fictional gifts, but something

more: the uncompromising stance, the tough voice and human compassion of the true religious visionary.

## GABRIEL GARCIA MARQUEZ: POWER TO THE IMAGINATION

Today, the novel belongs to the world. Its exponents are as likely to be Japanese, West Indian or Czech as English-speaking European or North American. Indeed, few of the latter can sustain a full comparison with such Latin American writers as Jorge Luis Borges, Alejo Carpentier, Pablo Neruda, Carlos Fuentes and the Colombian Gabriel García Márquez (*b*1928), awarded the Nobel Prize for Literature in 1982.

This prize followed the publication in 1967 of *One Hundred Years of Solitude*, one of the greatest novels of the Hispanic tradition since *Don Quixote*, and almost as popular worldwide. An eerie study of a dictator, *The Autumn of the Patriarch*, followed in 1975, and a decade later, *Love in a Time of Cholera*.

*One Hundred Years of Solitude* is a phantasmagorical novel, at once bizarre, exasperatingly rich and magical. To say that it is the story of the Buendia family and the jungle settlement of Maconda hardly touches its fantasy. It is true that the patriarch José Arcadio Buendia marries his cousin, Ursula, and they are the illustrious first generation of a prodigious seven-generation family. Yes, they live under the threat and terror of engendering a child with a pig's tail and the characters return from death, fly into the sky and forget the names of the most everyday objects. Much of the novel is in this vein. This semi-supernatural fiction modulates from real-life naturalism to a kind of mesmeric surreality, a wonderful non-rational, non-logical, non-linear state of being unlike anything else I know. Yet in the final analysis it is not the narrative but the prose, sumptuous but precise, which registers an extravagance unsanctioned by rational consciousness and therefore never fully explicable.

The publication of *The Autumn of the Patriarch* disappointed readers who had associated García Márquez exclusively with the enchantment and accessibility of Maconda. Yet, judged strictly on its own merit, *The Autumn of the Patriarch* is a major novel, a powerful indictment of absolute male power.

The book's plotless structure is based upon a series of anecdotes about a dictator, the General, the story of whose life is related by a number of anonymous

voices. Yet if this sounds plain sailing, nothing could be further from the case. The further one reads, the less one feels sure about what is going on; all is, rumour, allusion, supposition, distortion, deception and untruth. Even in the presence of the dead body of the patriarch, one of the book's narrators can say: 'We knew that no evidence of his death was conclusive, for there was always another truth behind the truth.' Furthermore, none of the novel's many anecdotes are related in a chronological order, and to add to the sense of living in a hall of mirrors, there is a total absence of logical consistency: Christopher Columbus and American marines at one point appear in the same scene.

To give some indication of the novel's prose, at once poetic, grotesque, funny and deadly in turn, I quote the passage where the General, having detected a plot against his own government, decides the culprit will be his most intimate and loyal friend, General Rodrigo de Aguilar. The guests have waited for his arrival:

> and then the curtains parted and the distinguished Major General Rodrigo de Aguilar entered on a silver tray stretched out full length on a garnish of cauliflower and laurel leaves, steeped with spices, oven brown, embellished with the uniform of five golden almonds for solemn occasions and the limitless loops for valour on the sleeve of his right arm, fourteen pounds of medals on his chest and a sprig of parsley in his mouth, ready to be served at a banquet of comrades by the official carvers to the petrified horror of the guests as without breathing we witness the exquisite ceremony of carving and serving, and when every plate held an equal portion of minister of defence stuffed with pine nuts and aromatic herbs, he gave the order to begin, eat hearty gentlemen.[55]

The basic anecdote as described above, and indeed of the entire book, could be reduced to: 'A corpse is found.' Each chapter begins with a description of the discovery of the dictator's corpse in the presidential palace. But, I suggest, it is more than a dictator's death that the book recounts. It is the death of the over-rational mind and its replacement by dream and myth. It is the death of linearity and its replacement by a cyclical time-frame. It is the death of the patriarchy's pursuit of wealth, fame and power and its replacement by a more sensuous, flowing, less driven consciousness. That consciousness also pervades Márquez's most recent novel, *Love and Many Demons* (1995), and an earlier love story.

*Love in a Time of Cholera* (1982) is a romantic novel about love, sexual and romantic, and intermittently about old age, memory, passion, death and, not

least, the spirit of place; Márquez is the master of descriptive atmospheres. Its basic plot is almost incredibly simple. When one of its two central characters, Florentino Ariza, is eighteen, on sight he falls in love with a girl five years his junior. They correspond, he declares his ardent affection, Fermina agrees to marry him. But her father takes her away into the interior of Colombia and on her return she marries the immensely respectable Dr. Juvenal Urbino, with whom she lives for fifty years. Yet in her marriage Fermina largely ceases to exist except as the source of happiness and security for her husband. 'It is incredible,' she laments, 'how one can be happy for so many years in the midst of so many squabbles, so many problems, damn it, and not really know if it was love or not.' After Urbino's unexpected death, Florentino renews his hitherto repressed declaration of love. The couple renew their acquaintance and travel together on a boat up the river Magdalena where, at the novel's end, they make love.

> Contrary to what the Captain and Zenaida supposed, they no longer felt like newly weds, and even less like belated lovers. It was as if they had leapt over the arduous cavalry of conjugal life and gone straight to the heart of love. They were together in silence like an old married couple wary of life, beyond the pitfalls of passion, beyond the brutal mockery of hope and the phantoms of disillusion: beyond love. For they had lived together long enough to know that love was always love, anytime and anyplace, but it was more solid the closer it came to death.[56]

Told by a less sophisticated master the story might pall. Yet García Márquez's writing has a quality close to bewitchment. *Love in a Time of Cholera* offers a wildly affirmative and irrational refutation of the dead hand of rationalism. Florentino's life has been, by all logical criteria, an absurdity. But the truth is that he does make his love last a lifetime, and, in the end, the account of his strange self-sacrifice and belated triumph does allow him to achieve his long-held desire. His refusal to accept the logic of decline, his discovery of old age as a vital area of human experience, his commitment to his one clear goal, is a triumph of instinct over reason, spontaneity over calculation, the uncertain, sprawling confusion of the heart over the comforting, dull pretension of authority—the authority of class, reason and money—all of which weigh down upon the novel's characters like the oppressive Colombian heat.

'The heart has its reasons which know no reason,' wrote Blaise Pascal, the

French scientist, religious writer and contemporary of Descartes. Perhaps this is where the fault line lies—the fault line between the volitional and the spontaneous, the head and the heart, even one might say science and the Arts. Yet it is all too clear where Márquez, like Bergman, Powys and Messiaen, stand: neither rejecting the intellect nor the feminine in life but seeking a direction of the spirit which exalts them equally.

## PAINTING

*The feminine call for a new recognition arises simultaneously with the violence that threatens to get out of hand. This strange coincidence eludes our understanding. Here mythology unexpectedly comes to our aid... The archaic goddesses... monitored the life cycle throughout its phases: birth, growth, love, death and rebirth. Evidently today our endangered life cycle again needs divine monitoring. In the depths of the unconscious psyche, the ancient Goddess is arising. She demands recognition and homage. If we refuse to acknowledge her, she may unleash forces of destruction. If we grant the Goddess her due, she may compassionately guide us toward transformation.*

<div align="right">Edward. C. Whitmont[57]</div>

*One of the main crises in our civilisation, or one of the main causes, rather, is that the feminine principle is missing from our education; the feminine psychology; the loving, caring, affectionate, nourishing; the feminine genius for relationship which is deep in the psychology of the feminine; the simultaneous, multidimensional nature of feminine consciousness.*

<div align="right">Cecil Collins[58]</div>

Given the history of the West's patriarchal religion, its rationalist philosophy originating in Greece and the Christian bias against the feminine, the long rule of male power and ego-consciousness was almost inevitable. Yet the need of the psyche for equilibrium cannot be forever frustrated. The harmonious balance of male and female elements in *The Magic Flute*, Rousseau's commitment to childhood, the Romantic appreciation of nature and imagination, were early signs of the rise of a new mythologem—a mythologem now more broadly accepted and

in the process of being practised throughout the Western world. The ready appreciation of the Gaia hypothesis, the increasing appreciation of indigenous and archaic cultures, the new awareness of feminine perspectives of the divine and the widespread urge to reconnect with the intuitive and imaginative, are evidence of the shift in the contemporary psyche. The development of depth psychology has further hastened the rise of a phenomenon which, according to Richard Tarnas, 'looks very much like the death of modern man.'[59]

In this section I discuss four painters whose work foreshadows or is responsive to this shift.

## PIERRE BONNARD'S CELEBRATION OF RELATIONSHIPS

Unexpectedly prophetic of the new consciousness is the work of Pierre Bonnard (1867-1947), whose light-filled, inimitable and delicious canvasses hide a seriousness of intent that is essentially ecological.

Look, for example, at his *Nude in Bathtub* (1941-46), the last and most extraordinary of the three paintings of his companion and wife, Marthe, in the couple's much-loved home at Le Cannet in the hills above Cannes. She lies immobile in a claw-footed, old-fashioned bath; her basset hound keeping guard (or is he asleep?) on a neat mat. Yet we have only to gaze at the painting for any length of time to note how first one object, then another, swims into view, holds our attention, then melts away as another object takes its place in our ever-shifting field of vision. Reality here is not, as it were, ready-made; it progressively unravels with an elusive indeterminacy keeping the observer, not at a distance, but enfolded within the process of seeing itself. We are not looking *at* but rather participating *in* what we see.

In Bonnard's Art there is a stance of open-hearted engagement and acceptance of the world. His mind was unusually free of calculation and pretence; his paintings, simple and pure on the surface, contain profound inner feeling for what the Japanese call *mushin*, the mind free of contrivance, and *mujo*, the sense of the impermanence of all things. Commenting upon these characteristics, the painter Howard Hodgson observed: 'He never jumps to conclusions about appearances, and he lacks any kind of framework on to which to hang his fleeting impressions. In the end he allows himself to float out to sea. I find that more

Plate 76. PIERRE BONNARD. Nude in Bathtub. c1941-46. *Oil on canvas.* 122 x 151 cm.
The Carnegie Museum of Art, Pittsburgh. Acquired through the generosity of the Sarah Mellon
Scaife family, 70-50. © SPADEM/ADAGP, Paris & DACS, London 1996.

courageous than depending on a system... Bonnard wanted nature to have its
way with him, always.' [60] We have only to remember Poussin and Versailles to
realise the extent that consciousness has moved.

## CECIL COLLINS: A VISION OF THE ANIMA

*The new civilisation was hidden underneath in the catacombs. Today we don't
have physical catacombs, we have mental catacombs that we live in—small
groups of people who think and feel these seeds (of potential renewal) in them-
selves. It is these cells which are eventually going to determine the contours of a
new civilisation—a world civilisation, for this is what the creative spirit of life is
manifesting.*

Cecil Collins[61]

Plate 77. CECIL COLLINS. The Sleeping Fool. 1943. *Oil on canvas.* 298 x 400 cm.
Tate Gallery, London.

Another painter to have sustained the consciousness of a child into adult life was Cecil Collins (1908-1989). He spoke about the Eye of the Heart, and painted mesmeric images prophetic of a new mysticism and its associated Art. Nonetheless his work, if paradisical and sharply innocent, had a more explicit intent than that of Bonnard, an earlier painter and therefore one less anguished by the spiritual crisis of the modern world. At first sight Collins's work can seem deeply private, yet his esoteric images are not quite what they seem.

Take, for example, *The Sleeping Fool*, painted at the height of the last war. Lying asleep in a grassy meadow under a branch whose glowing blossoms spread above his head, the Fool is dreaming. In front of two breast-like hills, a Lady sits beside him, her eyes also closed. On one level the image could be taken as the charming rural idyll it was intended to be. Yet Collins had more serious intentions. It was painted about the same time that he was writing an essay, *The Vision of the Fool*, in which he expounded the idea of the importance of the poetic and creative life that the Fool represented for him. Without what he called

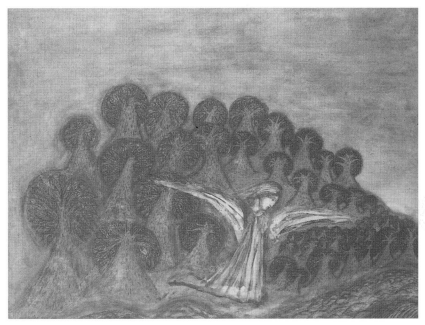

Plate 78. CECIL COLLINS. By the Waters. 1980. *Gouache on paper.* 46 x 59 cm.
Private collection.

'virginity of consciousness', without the curiosity of a child, without purity and
visionary intention, there would be (he argued) only ugliness and consumerism;
'the crucifixion of the poetic imagination in man by the Machine Age is a religious
fact.'[62] The Lady in *The Sleeping Fool* is another recurrent archetypal figure. She
is the Anima, representing soul as woman, the 'eternal bride' as receptacle of the
divine mystery. Thus the painting invokes a number of symbols that reflect the
paradise that we have lost and are perpetually seeking. At a moment of European
crisis, it offered a glimpse of an alternative, a world to which 'we turn incessantly
and without knowing it.'

Collins himself wished his Art to contain a reflection of paradise; *By the
Waters* (1980), painted in his seventy-second year, is a numinous and sacred
object, whose radiation is like a prayer. It has an other-worldly numinosity, its
power augmented by being located within the force-field of an archetype.

Cecil told me that the painting was inspired by the landscape of the Dart val-
ley near Dartington where he and his wife lived from 1936 to 1943. But eyes of

flesh would never see what he saw: a vision of beauty some have called the lost paradise. The Russian poet Alexandr Blok once defined the artist as 'one who by some fatality independent of his own volition, sees not only the foreground but that which is hidden behind it.' Collins, too, once described the purpose of man's existence as 'an instrument for transforming the raw, dark energy of the demonic world into the radiant light of the angelic world; the transformation from the world of darkness into the world of light.' *By the Waters* evokes both Blok's hidden world and the transformative journey of the human soul. It is also a painting that looks forward to a reaffirmation of 'a normal view of art that reigned for 20,000 years, which we have temporarily lost, owing to the use of technology', and which Cecil Collins, working beyond the reach of merely ego-bound self-expression, sought to revive.

Another artist to share something of the same commitment to the feminine spirit moving through creation is the American painter and writer Meinrad Craighead, for whom the Goddess is not so much a mythic image as a presence vibrating with soul, or *anima*. 'The creative spirit I know within me has the face and the force of a woman,' she writes, 'She is my Mother, my Mothergod, my generatrix, the divine immanence I experience signified in all of creation...'

## MEINRAD CRAIGHEAD: EARTH AS BODY OF THE MOTHER

*We should let ourselves be touched and moved by natural symbols. They point the way to the sacred. Each symbol, no matter how elemental— bread and wine, sun and moon, river and stone, tree and fruit, milk and blood—opens a window on a reality immensely larger than itself... any object exceeds what the senses can describe. It is a vehicle of mystery, and the incarnated presence of the holy. Any natural object can represent the sacred, guarantee its presence and evoke worship...'*

Meinrad Craighead

In *The Mother's Songs*, Craighead writes: 'Each painting I make begins from some deep source where my mother and grandmother, and all my fore-mothers, still live: it is as if the line moving from pen or brush coils back to the original matrix. Sometimes I feel like a cauldron of ripening images where memories turn

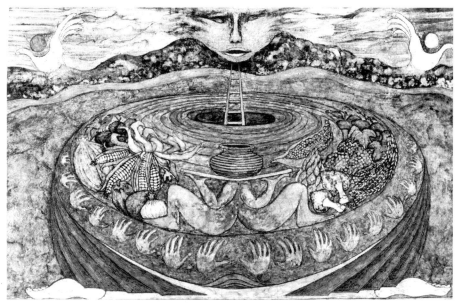

Plate 79. MEINRAD CRAIGHEAD. Vessel. 1983
*Coloured inks on scraperboard. 25.5 x 40.5 cm.*

into faces and emerge from my vessel. So my creative life, making out of myself, is itself an image of God the Mother and her unbroken story of emergence in our lives.'[63]

To feminine consciousness, the spiritual and the physical are integrated; they are two aspects of one totality. Spirit is not separate from creation as Jehovah is separate from his, as presented in Michelangelo's painting on the Sistine Chapel ceiling—with Eve coming as a reluctant afterthought. Craighead, like other women Artists, proposes a different message, an explicit longing and a new dream about the role of the feminine in our culture.

In *Vessel* (1983), we have an image of the Creative Spirit woven into Her Creation, in this case a cauldron or pot overflowing with humans and the fruits of the earth. It is an image of the goddess as the cosmic womb of life which poured forth from her in never-ending abundance, regenerated or reborn anew in the eternal process of creation. It is an image of the Divine Feminine, lost or discarded from Western culture some three thousand five hundred years ago.

According to the Artist, the painting was inspired by a visit to a *kiva*, the

womb-like, underground chamber used by the Hopi Indians of New Mexico for their religious ceremonies. She writes:

> I climbed down the ladder and sat in the centre of the cool dark vessel. The walls of this womb are painted. Hares and birds are spitting seed. Clouds and rain fertilise maize and jimsonweed. Shafts of lightning flash into pots and are held there. Human handprints chase a trail of deer hooves. Masked dancers, girded with conch shells, spin hoops and rattle gourds. The snakes and eagles bear their messages to me.[64]

When I contemplate this image—or for that matter the work of Collins, Messiaen, Makovecz and Brancusi, I am reminded of some words that Pitirim Sorokin wrote over fifty years ago that are, I believe, prophetic of the future. Its Art, he said, '[will pay] little attention to the persons, objects and events of the sensory world... [Its objective will not be to] amuse, entertain or give pleasure, but to bring the believer into a closer relationship with God. [It will be] a part of religion, and function as a religious service. [It will be] a communion of the human soul with itself and with God. [It will be] sacred in its content and form... its style symbolic.'[65]

## ANDRZEJ JACKOWSKI & THE CREATION OF PRIMORDIAL IMAGES

*Something sacred, that's it. We ought to be able to say that word, or, something like it, but people would take it the wrong way, and give it a meaning it hasn't got. We ought to be able to say that such and such a painting is as it is, with its capacity for power, because it is 'touched by God'. But people would put a wrong interpretation on it. And yet it's the nearest we can get to the truth.*

Pablo Picasso[66]

*To be an artist is to believe in life. Would you call this basic feeling a religious feeling? In that sense an artist does not need any church and dogma.*

Henry Moore[67]

It seems clear that in the context of history, the Arts and the metaphysical, the Arts and religious feeling, have been virtually inseparable. As Leibniz put it,

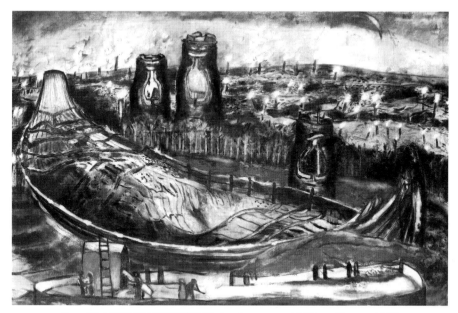

Plate 80. ANDRZEJ JACKOWSKI. Settlement—with Three Towers. 1986.
*Oil on canvas.* 152.5 x 233.5 cm. Private collection.

'music is a secret arithmetic of the soul', and this can be true whether we are considering the great religious traditions or a more personal and less organised revelation. There is, then, in one sense, no distinction between a formally religious painting (such as Duccio's *Maesta*), an intuitively sacred work like the atheistic Picasso's etching *Minotauromachia* (1935), or the marvellous water-colours of flowers in a chalice by the Catholic David Jones—so long, that is, that they draw their primary inspiration from a transcendent dimension. In neither of the latter did the flash of insight require a temple to sanctify it. Something similar is true, I suggest, of the paintings of Andrzej Jackowski (*b*1947), himself no stranger to the archaic and the mythic.

Jackowski's threshold, somewhere between waking consciousness and the imaginative space where, according to Bruno Schultz, 'the stories come from', has always existed and will always do so because it is an archetypal element of the psyche. Like Tarkovsky, whom he admires, Jackowski cannot help making images which show forth the affirming spiritual flame. 'I'd like my pictures to serve as keys for people to unlock or enter into, their own self.' he says.

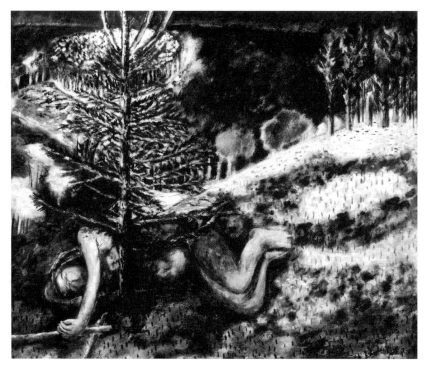

Plate 81. ANDRZEJ JACKOWSKI. *The Fir Tree.* 1983. *Oil on canvas.* 182.5 x 152.5 cm.
Harris Museum and Art Gallery, Preston.

Once such entry is *Settlement—with Three Towers* (1986), with its haunting sense of exile, brooding mystery and mythic potency. *The Fir Tree* (1983, see above) is similarly potent with energies, visible and invisible, resonant but indefinable. Here, in the fold of two sweeping hills, a naked woman lies recumbent on the grass, her body touching a growing spruce. Under her outstretched arm and hand a stick lies on the ground. Yet, immobile as the foetal figure is—and she seems to lie in the deepest sleep—the valley in which she reclines, the grass on which she lies, the groves of trees beyond, are bristling, crackling even, with a fierce, thrusting, immemorial life. This, one feels, is a landscape as old as the mysteries of the Great Mother, Demeter, held at Eleusis; a landscape for the marriage of the Goddess and nature. *The Fir Tree* can be a symbol of the sacral recognition that human and the natural are not separate, but aspects of the one living matrix.

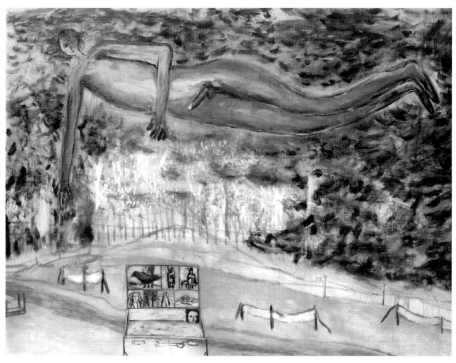

Plate 82. ANDRZEJ JACKOWSKI. The Beekeper's Son II. 1991. *Oil on canvas.* 167.7 x 233.7 cm.
Private collection.

Further evidence of Andrzej Jackowski's time-travelling shamanic concern can be seen in another painting, *The Beekeeper's Son II* (1991). At its top floats a weightless, naked figure of a small-headed adolescent; one of his arms points downwards and his long but slender penis is erect. Beneath him, a shimmering grove of trees, an open suitcase and a silver-coloured stream present themselves as naturally as the images within a dream; but a dream, like all dreams, only 'understandable' to the poetic mind. I cannot tell you what they 'mean'. There is, in fact, nothing rational to say about Jackowski's work except that its images, arising out of the deepest levels of the mind, evoke energies and knowledge from beyond the consciousness of the empirical ego. They build for the soul invisible sanctuaries and regions of contemplation. They have entered the imagination and become an essential window onto the future world.

## POETRY

### PETER REDGROVE AS RE-ANIMATOR OF THE INNER LIFE

The first colleges in Britain—and for centuries the only ones—were the Poetic Colleges of the ancient Celtic world; the old Irish word for the poets they trained was *fili*, meaning 'seer'. Celtic tradition dwells on the paranormal, clairvoyant, somewhat magical powers of these *fili* who, once graduated, were considered second in rank to the King. In the context of this chapter we might think of them as poetic servants of their communities.

One such modern day *fili* is the poet Peter Redgrove (*b*1930), whose inexhaustible fertility, resonating imagination and erotic sensuality are offered to a culture whose inner life is in need of re-animation.

In *On the Patio*, the first poem in his collection *The Apple-Broadcast and other new poems* (1981), the poet evokes a wineglass caught in a downpour of rain. But it is not like the 'nature poetry' of three centuries of mechanistic science: a descriptive evocation of a particular scene; it is rather a depiction of the energies in nature, seen in continuum with humanity and its deepest concerns. The poem's language reveals that the emphasis on disengagement and self-consciousness fostered by Descartes and Kant have been abandoned in favour of an unfettered consciousness, at once creaturely and magical, in touch with the total alchemy of the natural world. Here, then, in *On the Patio*, as elsewhere in Peter Redgrove's work, we are bathed and purged, transmuted and cleansed, by a swirling rhythm of healing energies. These energies may be different from the ones pictured in the canvasses of Andrzej Jackowski but contain something of the same visionary timelessness:

A wineglass overflowing with thunderwater
Stands out on the drumming steel table

Among the outcries of the downpour
Feathering chairs and rethundering on the awnings.

How the pellets of water shooting miles
Fly into the glass of swirl, and slop

Over the table's scales of rust
Shining like chained sores,

Because the rain eats everything except the glass
Of spinning water that is clear down here

But purple with rumbling depths above, and this cloud
Is transferring its might into a glass

In which thunder and lightning come to rest,
The cloud crushed into a glass.

Suddenly I dart out into the patio,
Snatch the bright glass up and drain it,

Bang it back down on the thundery steel table for a refill.[68]

## THOMAS BLACKBURN & THE VERITABLE METAPHORS OF HEAVEN

In his poem *Hallowed*, Thomas Blackburn (1916-77) reveals another world perceived by imagination. From his home in Putney he imagines himself back to his cottage in North Wales from where he could see to the sweep and grandeur of the Snowdon range:

I could look from that window dawn and noon
And watch the scree shoots of the mountain side,
Whether in brightness or in massive rain,
With joy for the most part but in part afraid
Of the intensity of my looking as if
To stand against such seeing we're not made;
Since I become what I have scope and sight of,
Like being one yet also everything,
Myself in a chair and a particular stone,

Or sheen of grasses overcasting shale,
So there's no meaning in my being alone
Or any truth but what I see to tell.

I don't mind though living in Putney here,
Not seeing the mountain clarity of stars
And a certain over-used quality of the air,
Since I follow, as well as I can, that which occurs
And find a curious loving in what's near,
Like letters in the morning and the smell
Of Watney's brewery sluiced in with the Thames,
And each first morning wanton with bird call:
All occult underneath their temporal signs.

Early I am, and watch the dark thin out
In skeins of light generated from the East,
Three hundred miles from that mountain called the Knight:
But I'm here you know and still in that north west
Of feeding air. One is imagination,
Not as a gloss on facts or wished for haven,
But what all facts and livings rest upon,
The veritable metaphors of heaven.[69]

'Since I become what I have scope and sight of / Like being one yet also everything,' he writes, and, later in the poem, exults in the sheen of grass or the smell of beer, with 'a curious loving in what's near'. Something of this heightened perception of the mundane recalls, in the plainness of its joy, the work of another poet, Kathleen Raine, who shares with him a deep instinct for the life of the soul—yet Blackburn's was characterised by addiction. After the frightening and complete blackness of alcoholism and nervous breakdown, he encountered a special gratitude—a deep feeling of arrival after the descent. 'One of the victories his poems share with us,' writes Grevel Lindop, 'is the victory over the baleful alliance of circumstances and self-pity, for increasingly, by way of poem, dream and vision, he came to accept his life and problems without recrimination and even to believe (what so few can ever bear to see) that he had himself in some

profound way chosen the circumstances of his own life.'[70]

During Blackburn's last years—indeed his last hours—he wrote poems and letters telling how he had risen, as he wrote in a notebook, 'through and upwards to the starlit air and on to silence and unalcoholised energy to purgatory, and with Beatrice's occasional visits, I have glimpsed the celestial.' Significantly, *Hallowed* was written after he had suffered such an ego death and had 'glimpsed the celestial' on the other side. To hallow means to make holy, to sanctify and to bless.

Towards the end of his life, as he lay sleeping, Thomas Blackburn experienced such an opening. 'In the dream,' he wrote, 'I was dying and for a few moments felt an extreme terror, sensing an invisible hand feeling for certain nerves in the region of my throat... I felt the fingers undoing a ganglion, almost a knot of nerves. The knot came free, there was a click, and my next impression was one of blinding light particularly associated with lilies, and irises of blue and red, although the whole was of an intense gold I have only seen on some dawn in the Italian dolomites... I saw a silver garment suitable for either male or female, and if it fitted me, I understood I would have achieved a certain wholeness, in that I would have come into communication with the female component of my soul...'[71] The garment of which Blackburn dreamed is one we all, women and men, need now to put on.

## WENDELL BERRY & COMMITMENT TO PLACE

There are, of course, more celebrated poets than Wendell Berry (*b*1934), who, though one of the 'greenest' voices of our time, is not even mentioned in Terry Gifford's survey of contemporary nature poetry, *Green Voices* (1995).[72] Nonetheless, few have written more critically of the most destructive and hence the most stupid period of the history of our species—and, in contrast, few have attempted to live more responsibly and sanely.

He was born some sixty years ago in the part of Kentucky in which he still lives. Home, in fact, is a small farm near Port Royal in Henry County. Generations of Berrys have lived in or about this place, and all but one of them have farmed their own land. Wendell Berry farms his own and also writes; his writings include eight novels, eleven books of essays (on agriculture, stewardship and community) and thirteen books of poetry including *Collected Poems: 1957-1982*.

I have emphasised one of Wendell Berry's defining characteristics, that of social responsibility, because it is in contrast to the orthodoxy that an Artist's prime responsibility is to his own Art. 'That work,' he writes, 'contains much of value that we need to cherish and to learn from. (But) it is only necessary to understand that that work has flourished upon, and has fostered a grievous division between life and work, as have the other specialised disciplines of our era, and that division has made it possible for work to turn upon and exploit and destroy life.'[73] Divisions of this kind, undue specialisation and the departmentalisation of writing and farming into two carefully segregated parts, are anathema to a man who sees life all of a piece. Indeed, you can no more separate his activities as a farmer from his activities as a poet than you can detach his polemics from his religion, and either from his loyalties to a particular place. They all go together. 'My work,' he writes, 'has been motivated by a desire to make myself responsibly at home both in this world and in my native place.'

Few writers since Hardy have spoken of or from place with more knowledge and simplicity. The wind in the leaves, the flight of a kingfisher, the first hard frost are the material out of which his poetry is fashioned. Yet if its starting point is a knowledge of his own land, Wendell Berry does not function on the level of a descriptive nature poet. For him, the presiding, yet often concealed, interpreting intelligence is, as Seamus Heaney writes of Yeats, 'the existence of an energy and an order which promote the idea that there exists a much greater, circumambient energy and order within which we have our being.'[74] 'The Creator's love for the creation,' Berry writes in *The Gift of Good Land*, 'is mysterious precisely because it does not conform to human purposes. The wild ass and the wild lilies are loved by God for their own sakes and yet they are part of a pattern which includes us. This is a pattern that humans can understand well enough to respect and preserve, though they cannot control it or hope to understand it completely. The mysterious and the practical, the Heavenly and the earthy, are thus joined.'[75] The effect is to render the world porous to its own radiance.

> I part the out thrusting branches
> and come in beneath
> the blessed and the blessing trees.
> Though I am silent
> there is singing around me.

Though I am dark
there is vision around me.
Though I am heavy
there is flight around me.[76]

Living in one rural place, observing its slow-burning layers of meaning, teaches an irrefutable sense of human scale. More surprisingly, rootedness can teach us love. 'I am perfectly aware how badly and embarrassingly that word now lies on the page,' he writes, ' for we have learned at once to overuse it, abuse it, and hold it in suspicion. But I do not mean any kind of abstract love, which is probably a contradiction in terms, but love for particular things, places, creatures, and people, requiring stands and acts, showing its successes or failures in practical or tangible effects.'[77] In a world substituting global markets for local interdependence, replacing the corner shop with a supermarket owned by a distant company, where, too, face-to-face contact is in the process of being replaced by written contact on a computer screen, Berry's insistence that we should focus on the place where we live, makes great sense to me. You start wherever you live.

When despair for the world grows in me
and I wake in the night at the least sound
in fear of what my life and my children's lives may be,
I go and lie down where the wood drake
rests in his beauty on the water, and the great heron feeds.
I come into the peace of wild things
who do not tax their lives with forethought
of grief. I come into the presence of still water.
And I feel above me the day-blind stars
waiting with their light. For a time
I rest in the grace of the world, and am free.[78]

## SCULPTURE

*One night in particular will always live for me, because that night I think I learned just how far we civilised human beings have drifted from reality. The*

*moon was full, so that the dancing had gone on for longer than usual. Just before going to sleep I was standing outside my hut when I heard a curious noise from the nearby children's bopi (playground). This surprised me, because at night time the Pygmies generally never set foot outside the main camp. I wandered over to see what it was. There, in the tiny clearing, splashed with silver, was the sophisticated Kenge, clad in bark cloth, adorned with leaves, with a flower stuck in his hair. He was all alone, dancing around and singing softly to himself as he gazed up at the tree-tops.*

*Now Kenge was the biggest flirt for miles, so, after watching for a while, I came into the clearing and asked, jokingly, why he was dancing alone. He stopped, turned slowly around and looked at me as if I was the biggest fool he had ever seen: and he was plainly surprised at my stupidity.*

*'But, I'm not dancing alone, ' he said, 'I am dancing with the forest, dancing with the moon.' Then with the utmost unconcern, he ignored me and continued his dance of love and life.*

<div align="right">Colin Turnbull[79]</div>

*Artistic appreciation of nature may be the key to our survival not only as individuals but as a species.*

<div align="right">Michael Tobias[80]</div>

I introduce Colin Turnbull's words because they are a moving reminder of the communion with nature we have lost—yet perpetually desire. In the seventeenth century the way was cleared for a purely utilitarian and quantitative approach; in the twentieth we still harbour the illusion that we live *outside* or *above* the natural world, and can turn it into an object of exploitation for our exclusive benefit, yet—and with an increasing urgency—we dream that that rupture can be healed. Sculptors like Brancusi and Noguchi have been at the forefront of this intention while others, especially those associated with the Environmental or Land Art movement, are also playing an important role in the process.

## CONSTANTIN BRANCUSI'S STAIRWAY TO HEAVEN

Entering the mainstream of Modernism from a more distant origin than many

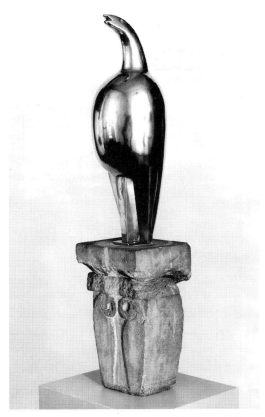

Plate 83. CONSTANTIN BRANCUSI. Maiastra. 1911. 55.2 x 17.8 cm (bronze part).
*Bronze and stone.* Tate Gallery, London. © ADAGP, Paris & DACS, London 1996.

others, Constantin Brancusi (1876-1957) was born in a farming village in the foothills of the Transylvanian Mountains. At the age of twenty-eight he walked to Paris, and in doing so introduced not only a view of life rooted in the traditional peasant culture of Eastern Europe but a closeness to the soil unknown to his contemporaries in the visual Arts. 'He brought with him,' wrote Isamu Noguchi, who studied with Brancusi in the 1920s, 'more than learning: the memory of childhood, of things observed not taught, of closeness to the earth, of wet stones and grass, of stone buildings and wood churches, hand-hewn logs and tools, stone markers, walls, gravestones. This is the inheritance he was able to call upon when the notion came upon him that his art, his sculpture, could not

go forward without first going back to the beginnings.'[81]

The body of work Brancusi left behind is not large; the extant sculptures number 216 pieces, of which 36 are of human beings but a larger number are of other species: 27 of birds and 23 of other animals, including a cock, a seal, a turtle and a fish. Thinking of these, I am reminded of Marija Gimbutas's observation about the nature of the Goddess: 'In all her manifestations (she) was a symbol of the unity of all life in nature. Her power was in water and stone, in tomb and cave, in animals and birds, snakes and fish, trees and flowers. Hence the holistic and mythopoeic perception of the sacredness and mystery of all there is on Earth.'[82] Another example of Brancusi's instinctual feeling for the cosmic and the cyclical is the way his work never progressed through a series of clearly definable periods. It is as unchangeable as a tree, a fish or a stone. 'Everything—animate or inanimate—has a spirit,' he said.[83]

'Nothing could convince him,' wrote Mircea Eliade, 'that a rock was only a fragment of matter; like his Carpathian ancestors, like all neolithic men, he sensed a presence in the rock, a power, an 'intention', that one can only call sacred.'[84] This sense of the spiritual power inherent in material is strongly apparent in one of his most celebrated works, the *Maiastra*, continuing in the slimmer forms of the series called *Bird*, and reaching its apogee from 1923 on in numerous versions of the still more attenuated and streamlined image called *Bird in Space*.

As an image the *Maiastra* is suggestive of the eternal longing for heavenly flight: the quest for transformation inherent in the soul's desire to progress from the realm of the personal to the realm of the suprapersonal. At the same time, with its outstretched neck and long, rounded body, it evokes an undoubted phallic form. A related sculpture, *Bird in Space* (1923-4), as pure as anything in Western art since Cycladic sculpture, similarly expresses Brancusi's yearning to ascend towards a realm of supernatural, weightless purity. 'I asked him once,' wrote James Thrall Soby, 'whether the reflections caused by his sculptures' high polish ever bothered him or altered the meaning he had in mind. 'I don't care what they reflect, so long as it's life itself,' he told me.[85] The life stream flowed undivided for Brancusi, it joined godhead and world, animal and man, in the shine and reflectivity of the nearby. 'The artist,' he said, 'should know how to dig out the being that is within matter and be the tool that brings out its cosmic essence into actual visible existence.'

The sculpture of his maturity is characterised by a desire to hone down to the irreducible core of things and, too, an unquestionable sense of equilibrium: in it rationality exists in the service of intuition; sophistication in the service of primal innocence; an almost total abjuration of will in the service of life as a living unity. Quietness, contemplation and what Sidney Geist has called 'the making of relationships,' also characterised what Mircea Eliade has described as Brancusi's 'going beyond [an] objectivising scientific perspective... for the purpose of recreating another new, and 'pure' universe, uncorrupted by time and history.' That Brancusi was also aware of his contribution towards the making of a new cycle of life can be seen in his ambitions for one of his later works.

*Endless Column* (frontispiece) originally painted a bright metallic yellow that gleamed in the sun, is part of an ensemble designed for the war memorial park at Tîrgu Jiu in Rumania. A cast-iron column over ninety-six metres high, it stands at the end of a heroic mall which incorporates the low *Table of Silence* and the *Gate of the Kiss*, perhaps the ultimate reductive statement in the sculptor's *oeuvre*. Brancusi's declaration that the *Gate of the Kiss* is a 'gateway to a beyond' was matched by his intention that the *Endless Column* should be 'a column which, if enlarged, would support the vault of heaven.'[86] 'Let's call it a stairway to heaven,' he said.[87]

The details of *Endless Column* and its upwardly pulsing movement signify, as Eric Shanes writes, 'some divine and infinite rhythm of existence, the continuum of life itself.' Like the Gothic spire, it points upwards towards an unearthly, suprapersonal force providing guidance and inspiration for man in his earthly home. Yet at the same time that it penetrates the heavens, it is also rooted in the earth. It acts as the axis mundi, 'the central pillar,' as Eliade observes, 'that upholds the cosmos and that exists within each person as the physical and spiritual axis of his own world.'

But what did the idea of heaven mean to the sculptor? It was not, for certain, the heaven of the Judaeo-Christian civilisation with its myth of exile from the Garden of Eden, flawed man expelled from the Divine world, and heaven's dark opposite, hell. It was something purer, like the flight of a bird or the movement of a fish. 'Once (we are) rid of the religions and the philosophies,' he said, 'art is the thing that can save the world. Art is the plank after the shipwreck, that saves someone...'[88]

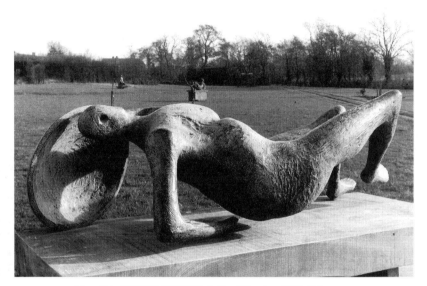

Plate 84 . HENRY MOORE. Falling Warrior. 1956-7. *Bronze.*
© The Henry Moore Foundation.

## HENRY MOORE: SCULPTURE GROUNDED IN THE EARTHBODY

*Every idea has a physical shape.*

Henry Moore

If the work of Henry Moore (1898-1986) has received considerable critical attention, its significance has been ignored by those whose viewpoint is informed by ecological thought. Yet the grammar of his images was, I believe, always largely, if intuitively, in accord with those in sympathy with the fundamental shift in belief structure of Western society. From this point of view *Family Group* (1948-9) can be interpreted as a celebration of human scale, the vernacular and traditional, while both *Warrior with Shield* (1953-4) and *Falling Warrior* (1956-7) can be interpreted as emblems of the defeated heroic adventure. Moore's commitment to natural forms—sea-worn pebbles, shells, bones, skulls, stones and earth-forms—can also be seen as a celebration of and identification with the organic.

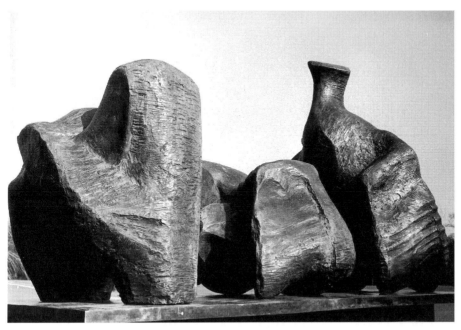

Plate 85. HENRY MOORE. Three-piece reclining Figure No 1. 1961/62. *bronze.*
© Henry Moore Foundation.

The sculptor's metamorphic forms reveal marvellous and unsurpassed corre-spondences between disparate things; the idea that a figure could be a range of mountains was a conscious factor at least as far back as 1930, when he wrote of mountains as a sculptural ideal[89] and carved the *Reclining Woman* in green Horton stone. In the second half of the thirties he was also carving his first fig-ures penetrated with holes and writing of 'the mysterious fascination of caves in hillsides and cliffs.'[90] The first time Henry Moore published his thoughts about Art, he said that the sculpture which moved him most gave out 'something of the energy and power of great mountains.'[91] This refusal to accept the boundaries between animal, vegetable and mineral, this sense of the unity of life and the cor-respondences between the human and the natural, of the undulations of a land-scape and the forms of sculpture, of knees and breasts and hills, informed many of his finest works. These include his bronze *Two-piece reclining figure* (1959), the carved wood *Reclining figure* (1959-64) and the *Three-piece reclining figure No 1* (1961-62), all of which are telling us that to comprehend the human we

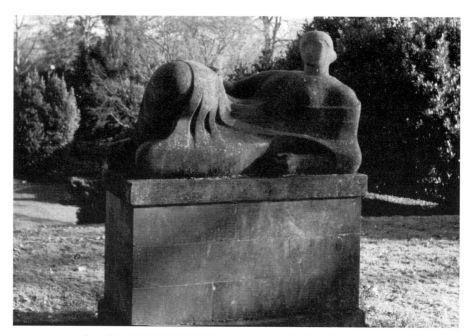

Plate 86. HENRY MOORE. Reclining Figure. 1945-6. *Horton Stone.*
Dartington Hall, Devon.

can do so only through the earth, and the earth only through the human.

Two-thirds of Moore's sculptures of full-length figures are reclining figures. One of the most contemplative, its stone darkened by exposure to the elements out of which it seems to have been composed, is in the gardens of Dartington Hall in south Devon. 'It is situated,' Moore wrote at the time of its carving, 'at the top of a rise, and when one stands near it and takes in the shape of its relation to the vista one becomes aware that the raised knees repeats or echoes the gentle roll of the landscape. I wanted to convey a sense of permanent tranquillity, a sense of *being* from which the stir and fret of human ways had been withdrawn, and all the time I was working on it I was very much aware that I was making a memorial to go into an English scene that is itself a memorial to many generations of men who have engaged in a subtle collaboration with the land.'[92]

By ambiguously mingling man and nature, Moore is emphasising that the human is part of the world, not separate from it.

Plate 87. ISAMU NOGUCHI. Chase Manhattan Bank Plaza Garden. 1961-4.
New York.

## ISAMU NOGUCHI: ART AS A CHANNEL TO SPIRITUALITY

Another artist seeking to embody a more direct expression of man's relation to
the earth and his environment was the Japanese-American sculptor Isamu
Noguchi (1904-1988), in whose work, as in that of Takemitsu, European and
Oriental influences coexisted and mutually enriched themselves. Although he
briefly studied with Brancusi in the 1920s and was influenced by the ancient her-
itage of Japanese art, especially its temple gardens, his work exists outside cur-
rent styles.

Gardens played a significant role in his career: he designed them in Paris at
the UNESCO building, in Seattle, at Yale University (1960-64), at the headquarters
of IBM, Armonk (1964) and in New York for the Chase Manhattan Bank Plaza
(1961-64). About the latter he wrote in his autobiography:

I have noticed that when one visits the plaza on a quiet but somewhat windy Sunday,

Plate 88 & 89. ISAMU NOGUCHI. Chase Manhattan Bank Plaza Garden. 1961-64. New York.

the great building emits eerie music, and looking down into the garden with its flowing water is like looking onto a turbulent seascape from which immobile rocks take off for outer space.

Nature and non-Nature. There will come other gardens to correspond to our changing concepts of reality; disturbing and beautiful gardens to awaken us to a new awareness of our solitude. Can it be that nature is no longer real for us or, in any case, out of scale?'[93]

The Garden is composed of a deeply sunken, circular space in which carefully selected black river boulders have been set on a base of granite sets patterned with concentric circles that suggest ocean currents; Noguchi likens such forms to the representation of water in Chinese painting. In the summer, water springs from a cluster of fountains installed in the granite floor and around the boulders, intensifying the observer's illusion of islands in the sea. Like the contemplative spaces of certain traditional Japanese gardens, such as Ryoan-ji Temple Garden in Kyoto, the Chase Manhattan garden cannot be entered by visitors, but is viewable from above and visible to employees on the lower level banking floor. The effect is extraordinary. In the ceaseless turmoil and confusion of New York's Wall Street area, the space acts as a pure restorative, a haven of meditative calm; its immobile rocks and glistening waters helping to resurrect the ancient and embodied mysteries of the earth. 'In my work I want something irreducible...' he says.

Yet if the garden of the Chase Manhattan Bank Plaza is evocative of the ele-

Plate 90. ISAMU NOGUCHI. Horace E. Dodge and Son Memorial Fountain. 1972-78
*Stainless steel with granite base, electricity, and water. Detroit Civic Plaza, America.*

mental, its employment of the language of abstraction is unashamedly contemporary. Abstraction, Noguchi believed, can evoke a sense of transcendent order through aesthetic gesture without heavy doctrinal reference. In a lecture at Yale University (1949), he stressed the possibility of entering the sacred realm, of encountering the 'divine', through the medium of the contemporary Arts:

> If religion dies as dogma, it is reborn as a direct personal expression in the arts. I do not refer to work done in churches... but to the almost religious quality of ecstasy and anguish to be found emerging here and there in so-called abstract art. Using the ever more perceptive truths of nature's structure, the invocation is still to God. I see no conflict between spirituality and modern art as some do; rather it opens another channel to our non-anthropomorphic deity.[94]

Equally 'spiritual' in purpose and achievement is Noguchi's massive 30-foot high fountain, a sculptural and technological marvel in Detroit's Civic Center Plaza

(1972-78). Here, as in the garden for the Chase Manhattan Bank Plaza and the playground he designed for children in Atlanta, Noguchi realised his aim to create sculptures which enhance the places where people live rather than the galleries which they rarely, if ever, visit. 'I don't consider myself a high priest of art,' he said, 'I am a practical artist.' In Detroit, Noguchi combined two opposing but complementary elements: a machine-tooled structure—a monumental stainless steel tubular ring supported by two rounded diagonal supports—which represents 'our time and our relationship to outer space,' and a rising aquatic column, utilising every manner of control to orchestrate its effects, emblematic of untameable natural forces. Incorporated in its four-foot diameter ring are huge nozzles and a complicated lighting system to illuminate the spray, programmed to change with the weather conditions. From the pool below, a circle of jets forms definable columns of water that interact with the great circle's downward spray. Here in Detroit the imaginary landscape achieves its grandest scale. In the city's everhustling commerce, Noguchi created a place of veneration, a place in accord with the feelings once evoked by standing stones and sacred wells, holy mountains, rivers, forest and wilderness. He called it 'a close embrace of the earth'.

'What is the artist,' he asked in his autobiography, ' but the channel through which spirits descend—ghosts, visions, portents, the tinkling of bells?'

## ANDY GOLDSWORTHY: A NEW WAY OF LOOKING AT HUMANITY'S RELATION TO NATURE

The sculptor Peter Randall-Page speaks for others in the Environmental or Land Art movement, when he writes about his desire to heal the estrangement between the natural world and the human soul:

> From quite early on, I felt aware that although human beings are obviously part of nature, we have a painful sense of detachment from the rest of the natural world. Our consciousness separates us, but we are obviously part of the world as well. A desire to reconcile this sense of estrangement has been a driving force behind my work.[95]

This desire to embody a belief that Art should be more modest in its relations with nature, that it should acknowledge that man's aesthetic endeavours are part

Plate 91. ANDY GOLDSWORTHY. Bright Sunny Morning. 1987. *Frozen snow.*
Izumi-Mura, Japan. Photo: Andy Goldsworthy.

of the whole system of the earth and not in egocentric confrontation with it, that we can relate as participants rather than voyeurs, emerged during the late 1960s and early 1970s, at a time of growing awareness of the worsening degradation of the planetary environment. Andy Goldsworthy, one of its leading practitioners, has been working with natural materials for almost twenty years. Of his desire and ability to work with nature with very little interference he writes:

Place is found, by walking, direction determined by weather and season. I am a hunter, I take the opportunities each day offers; if it is snowing, I work with snow; at leaf-fall it will be with leaves; a blown-over tree becomes a source of twigs and branches. I stop at a place or pick up a material by feeling that there is something to be discovered. Here is where I can learn. I might have walked past or worked there many previous times. There are places I return to over and over again, going deeper. A relationship with a place is made in layers over a long time, staying in one place makes me more aware of change.

Plate 92. Pebbles around a hole. 1987.
Kinagashima-Cho, Japan. Photo: Andy Goldsworthy.

...When I work with a leaf, rock, stick, it is not just material in itself, it is an opening into the processes of life within and around it. When I leave it, these processes continue... When I touch a rock, I am touching and working the space around it. It is not independent of its surroundings and the way it sits tells us how it came to be there.'[96]

*Pebbles around a hole* (Plate 92), finished and photographed on 7th December 1987 at Kinagashima-Cho in Japan, is a superbly chaste but sensual example of his capacity to reveal the beauty of the most ordinary and commonplace thing. 'You wouldn't believe,' he observes, 'the effect of picking up a maple leaf that looks a little dull and then dropping it in the water where the colour become so intense.' In fact this work, no more than a few hundred stones carefully arranged

around a shallow pit dug in the sand, could hardly be simpler. The materials are limited, the colours austere, the concept rudimentary, yet the result has something of the calm, compelling mystery of the late thirteenth-century Zen painting of *Six Persimmons* by Mu Ch'i (Mokkei), itself no more than a merely artful arrangement of six fruits in an empty space. Goldsworthy's work shares a number of other features with the art of Zen: neither suggest 'religion' in the accepted sense of the term; both are characterised by simplicity and an unhurried, seemingly artless, pace. 'It takes only one blade of grass to show the wind's direction,' might have been spoken by Goldsworthy. It is in fact Zen.

On some land leased to him by Lord Dalkeith, heir to the Duke of Buccleuch, at Stoewood, Dumfriesshire, is an example of his aptitude for creating bridges between Art and ecology, nature and people, countryside and artifact. 'Part of the lease,' Goldsworthy explains, 'required me to build a dividing wall. I have made a give-and-take wall between the farmer and myself. Two sheep folds are incorporated into the wall: one opening on the farmer's side for sheep, one opening on my side for sculpture. The sheep will in effect be on my land and the sculpture on the farmers.' The wall exists, it is required; but the two functions, the neighbours' lands, mutually interpenetrate, as man and nature also interpenetrate like the wedges of a mortise joint, creating a perfect whole. It is also an emblem, not of division and dualism, but of the deep longing of men and women for wholeness.

## THEATRE

### PETER BROOK EXPLORES THE ROOTS OF THEATRE

Another Artist in search of an Art 'speaking to a man in his wholeness'[97] is the theatre director Peter Brook.

Brook's fabled production of the two thousand five hundred year-old Sanskrit epic *The Mahabharata* may be his maturest expression of this search. First performed in 1985, the English-speaking production toured the world between 1987 and 1989; in May 1990 it came to Glasgow, where I saw it in the old Museum of Transport, extensively converted to house the production. Brook has always argued for difficulties of access: attendance should be like a pilgrim-

Plate 93. PETER BROOK. Scene for the Mahabharata.
1990. Glasgow.

age, as much an act of displacement as an event in its own right.

The *Mahabharata*, the world's longest narrative, was chosen for its current relevance no less for than its mythological power. Jean-Claude Carrière, the writer who adapted it for the stage, explained: 'We live in a time of destruction—everything points in the same direction. Can this destruction be avoided?' The relevance of this story of desolation, reconciliation and healing, to our own time, if never emphasised, could not be avoided.

In an interview with Georges Banu, Peter Brook expanded this theme. 'In the *Mahabharata*,' he said,' there is a constant appeal to a positive attitude. The epic tells a story which is as dark, tragic and terrible as our own story today. But tradition allows us to see on every page, in every word, that the attitude when confronted with that situation was not negative, not Spenglerian. There is no pessimistic despair; neither nihilism nor empty protest. It is something else. A way of living in the world in a catastrophic predicament without ever losing contact with what enables man to live and fight in a positive way. But what does

'positive' mean? It's a word that takes us back to our starting point, and in a very concrete way that points to the epicentre of the *Bhagavad Gita*: should you reject and withdraw from confrontation, should you act, or what? That question 'or what?' is on everyone's lips today, and although the *Mahabharata* provides no answer, it gives us immense food for thought.'[98]

It is, I suggest, relevant to the spirit of our time that some of Europe's creative minds should find nourishment in tradition. To Brook and Tavener, to Tarkovsky and Pärt, to Collins, Fathy and Critchlow, it is clearly more than a decorative, value-free assemblage of usable styles which can be treated as historically or ideologically innocent; it is a way out of the solipsism of subjective individuals, the impasse of late Modernism. Looking at the world today, it is understandable why this orientation is attractive. For all his high quality and brilliant variety, man must sooner or later obey the same laws, as Homer writes, 'as the life of the leaves'.

Peter Brook catches this note of humility when he writes:

People take themselves for artists. They will use the word 'creator'—and I am worried by that because it is infinitely too pretentious. In the theatre you are working for something indefinable to appear, which is of a certain intensity, a certain quality, through human actions, not through artistic means. The theatre work itself is highly practical. For the most marvellous thing to appear, the person must be speaking loud enough, the tempo must be right. The work is only good if you bring it down to its artisan basis.[99]

## FOOTSBARN: COMMUNITY RATHER THAN COMPETITION

*It's the Inn of Mr. Foot, suffice to say it's a 'gas'. It is the theatre of which we dream, inventive and itinerant, a group always on the move, one actor with twenty heads like a dream we've all had. Impossible to say more: one must see to believe.*

Jean-Claude Carrière

Over twenty years ago a band of painters, actors and musicians, created a theatre group near Liskeard in Cornwall. They adopted a communal life and began to work in a barn belonging to Oliver Foot. Like the travelling jugglers Jof and Mia

in *The Seventh Seal*, they played their shows wherever people gathered. In 1975, the Footsbarn Travelling Theatre acquired its first theatre-tent; they journeyed further afield and with more complex productions. In 1981, they left England to travel the world with an extensive suite of caravans and trucks. In the course of these journeys, new members joined and Footsbarn developed an increasingly international membership. In 1990 the company settled in France, near Herisson. Their base is equipped with offices, rehearsal rooms, workshops, a camping area for its transport and even a classroom for their children.

Paddy Hayter, whom I have known for close on twenty-five years, is the company's longest serving member; he has a wife and four children. In discussion he told me: 'It's very rare in theatre to have the chance to "reste en famille", as they say in French. My family and I are able to travel and live and work together creatively. In the course of the last few years we have done a big trip to Russia; we journeyed on from St Petersburg to Warsaw and then on to Prague, Copenhagen, Berlin, Basle and Paris, performing along the route. We have also been to Australia (where we created *Macbeth*, inspired by our time with the aboriginals) and most recently to Kerala, where we worked with Indian artists studying ancient theatrical and dance techniques.' In this apparently leaderless community, in their preparedness to work and take risks together, in this sharing of tasks (and everyone, whatever they do or for however long they have been with the company, receives an identical financial reward), in this commitment to trust which is vital to building the long-term relationships upon which they depend for success; in this lies, I suggest, not only Footsbarn's undoubted success but a possible future for the Arts. We are entering an era where people work not only across boundaries but collectively.

I met up with Footsbarn on the playing fields of Tavistock's Community College where they were presenting a production of *The Odyssey* in their 200-seater tent. Its atmosphere was animated with expectations of the future performance. Few were to be disappointed; the audience was bewitched to the last. The silly aphorism of Theo de Wyzewa, spokesman for the French Symbolists, that 'the aesthetic value of a work of art is always in direct inverse proportion to the number of people who can understand it,' was decidedly contradicted here.

In its twenty four years of existence, Footsbarn has created over fifty productions. These have included adaptations of *Beauty and the Beast* (1975), *Robin Hood* (1977) and *The Golden Fleece* (1979). Like Kurosawa they have

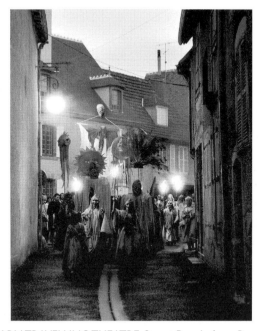

Plate 94. FOOTSBARN TRAVELLING THEATRE. Street Parade from Romeo and Juliet. 1992. Herisson, France. Photo: Jean Pierre Estournet.

also adapted a number of Shakespeare's plays: *The Tempest* (1978), *Hamlet* (1980), *Macbeth* (1986), *A Midsummer Night's Dream* (1990) and *Romeo and Juliet* (1993). *The Dream* was given four hundred performances; *The Odyssey* will be on the road for the best part of two years. The life of the strolling player is stressful as well as creative, unexpected, thrilling and laborious. 'The theatre is the focus,' says Paddy Hayter, 'that is what brings the energy together and that is what people are here for.'

To its members Footsbarn seeks to bring, I believe, a consoling antidote to the sense of despair or nourished grievance of the 'average' Westerner; it seeks to introduce beauty, humour, magic, some hours of enchantment, to lives bereft of wonder. 'Yes, indeed!' exclaimed Paddy Hayter in answer to my question as to the truth of this statement. 'I think it's a bloody good thing if the experience of theatre takes people into dreamtime for a while. It was, if I remember rightly, Alfred Jarry who said that the best way for the public to leave a theatre is bemused and excited, but not clear. That is that they should not be thinking, "he

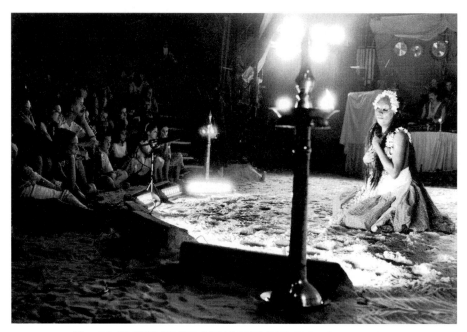

Plate 95. FOOTSBARN TRAVELLING THEATRE. The Odyssey. 1995.
Photo: Jean Pierre Estournet.

did that and he did that and I understand that" but enchanted by and entered into by the dream-like flow of a "reality" without logic or utilitarian purpose.' Art of this kind is never escapism but as essential to the soul as food to the body.

'One of the most obvious characteristics of a future "planetary culture", writes Morris Berman in *The Reenchantment of the World*, 'will be the straightforward revival and elaboration of analogue modes of expression... Such a culture will be dreamier and more sensual than ours. The inner psychic landscape of dreams, body language, art, dance, fantasy, and myth will play a large part in our attempt to understand and live in the world. These activities will now seem as legitimate, and ultimately crucial, forms of knowledge...'[100]

Interestingly, Berman's description has much in common with the present character of Footsbarn, yet he goes on to say something of even greater significance. According to him the future culture will most likely possess 'a fluidity of interests (and) working and living arrangements'. It will also see, in contrast 'to the competitive and isolating nuclear family that is today a seedbed of neurosis',

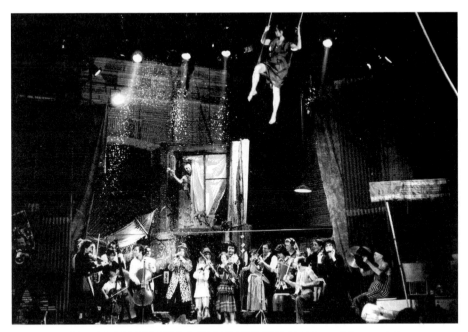

Plate 96. FOOTSBARN TRAVELLING THEATRE. Cabaret 'L'Inattendu'.
1995.

'a revival of the extended family'. It will similarly encourage 'a shift in focus from the ego to the self and the interaction of this self with other selves'. Utopianism of this order would be derisory if Footsbarn were not already practising a community-based, decentralised, co-operative way of life and creation.

In this chapter I have described the work of over thirty Artists, some famous, some less known, and presented their work on the basis of a certain interpretation. It may be that these Artists do not subscribe to that interpretation; in point of fact some—like Cecil Collins, Anna Halprin and Andy Goldsworthy would almost certainly do so, while others might well reject the claim. However that may be, it is not the point I am seeking to make. It is rather that a significant number of this century's Artists have been open to a new strain in the vast symphony of life. They have begun to detect a different strain from that which issued from the Humanist centuries and one which draws its energies from quite a different source. They have begun to heal the crisis in the collective imagination of Western culture and affirm a visionary relation with a world luminous with soul.

They have begun to discover a whole new culture that is trying to learn the language of those realms.

The scientific models of today are, in almost every area, radically different from those of two centuries ago. Who knows what the paradigms of the next millennium will look like? Who knows what form imagination will take, or the larger perspectives that we associate with soul? We can never know, yet in contemplating what has happened in history, we may discover that there has always been a tendency for men and their societies to swing from one pole to its opposite, as Jung more than once observed.

CHAPTER SEVEN

# A NEW SEED MUST SPROUT

*It is almost terrifying to consider upon how slight a basis of agreement and fact are founded all our ideas of art or philosophy or even religion, and how small a universal change could transform these out of all recognition... We are at the beginning of an era, and who creates a new world must create a new art to express it.'*

James Stephens[1]

## TRANSFORMING THE WAY WE THINK
## ABOUT AND PRACTISE ART

'THINGS ONLY CHANGE,' said the painter Antoni Tàpies (*b*1923), 'when the conception of the world changes. When the thinkers and scientists change our conception of the world, we are forced to reflect on the way we draw, or use colour, or the way we write.' Transformation begins then, as Tàpies says, when we re-imagine what had previously been taken for granted and see it from a fresh perspective. Turning a cherished assumption on its head can be an uncomfortable, even a painful task: but it can be a liberating one too.

Imagine, for example, the effect of including (rather than excluding) the making of gardens, hairdressing, cake-making and the preparation of carnival floats, in our definition of Art. Imagine the province of the artistically gifted to include those who give significant shape and form to their lives. Imagine raising ephemerality to the status of permanence and valuing co-operative creativity as much as individual work. Imagine creative activity not isolated, but related to and interconnected with everything else. Imagine the idea of creative action as an anonymous act of service to a community. What would happen if we were to imagine these things? At the moment virtually nothing. Such ideas are largely, if not completely, unimaginable. The Arts are arrested within the thought-forms of

Plate 97. FERNAND CHEVAL. Le Palais Idéal: large grotto with three gigantic figures. 1891-1924. Hauterives, France.

265

the current paradigm and will remain so until, as Pitirim Sorokin suggests, there is a more widespread, deeper and prompter realisation of 'the extraordinary character of the contemporary crisis of our culture and society. It is high time to realise that this is not one of the ordinary crises which happen almost every decade, but one of the greatest transitions in human history from one of its main forms of culture to another.'[2]

Historians may point to the relatively recent development of community arts, community architecture and the Environmental or Land Art movement as examples of a response to this crisis. This is true, yet the latter, in spite of its example of good practice in forging a new relationship between human endeavour and the natural world, is still Art. It is made by Artists and discussed and photographed in Art journals (and sold in dealers' galleries). For all its strengths it has understandably failed to escape from the pervasive shackles of the prevailing Humanist aesthetic. It has failed to find an audience beyond a tiny, faddish, media-centred minority. It has failed to embody the encompassing vision of the ecological world-view.

One of the main purposes in writing this book has been to explore that far-reaching, and often staggeringly novel, yet unrealised, vista. It has been to offer new perspectives. It has been to consider the nature of creative activities within the context of a metaphysics and epistemology which offers the affirmation of life, that seeks to heal the degradation of our planetary home, that changes our whole idea of reality with the notion of interconnectedness—an understanding of the unified nature of the universe. Writing it has amounted to an exploration of a society where imagination is integral to every aspect of its culture. But writing is not enough. The next step, the big step and the necessary one is, I believe, a twofold practice. There is first the need to recover the place and role of the human imagination, trivialised and made mandarin by a mass society whose governing classes have been permitted to define the parameters of our understanding. There is also the need to transcend the Humanist invention we call Art, a luxury product beyond the reach of the general public.

The enterprise implies the dissolution of the idea of Art as consumption, as the exclusive preserve of specially gifted individuals and the return and acceptance of imaginative power by the entire population. Such a step, unthinkable at the present time, cannot yet be taken. For a start it would be resisted by all the beneficiaries of the present system: Artists themselves, the cultural agencies of the

State, the media with its vested interests in controlling what people believe, the small but very vocal audience for opera, classical music and other performance work, and the small army of bureaucrats whose livelihood depends on the administration of the Arts (at a time when Arts administration is being funded—rather than the Arts themselves—this is of singular importance). But that is not all; the vast majority, trained in impotence, diverted by consumerism, denied the sensory life that informed and sustained their predecessors, would be completely indifferent if the subsidised opera, ballet, theatre etc. ceased to exist at all. In fact the Empire of the Arts cannot be dissolved until the civilisation that produced it is either reduced to penury (when subsidies would cease) or replaced by a more creative one.

Such a civilisation would not entertain the idea of Art as a separate profession, or culture as a separate entity. It would encourage people to recognise their innate creativity without the mediation of professionals and officials, and would not tolerate the social injustice of Art as the exclusive preserve of a tiny minority while the majority remained alienated from, or cut off from, opportunities for imaginative expression. 'Culture' in such a civilisation would not be, as Eric Gill described it, 'added like a sauce to otherwise unpalatable stale fish,' but integral; the way of life itself. In other words, art would not exist as a separate and distinguishable thing—a body of objects that can be put into books and museums—but the growth and expression of a new sense of abundance, beauty and potentialities. 'The priest departs, the divine literatus comes,' wrote the poet Walt Whitman.

> We consider bibles and religions divine—I do not say
>     they are not divine,
> I say they have all grown out of you, and may grow out
>     of you still,
> It is not they who give the life, it is you who give the life,
> Leaves are no more shed from the trees, or trees from
>     the earth, than they are shed out of you.

I should make it clear that I do not believe that liberation from the domination of a professionalised élite would bring forth a sudden flowering of great Art, nor would I hope that it should do so. It is not more Art and Artists I am

hoping to see, but a foundation of unpretentious and yet exacting artistry: more not less union between living and the fully embodied imagination; more not less awareness of everyday wonders; more not less appreciation of the deep pleasures of everyday life. These are already functions on which we all occasionally draw. What I am hoping to see is their systematic and widespread expansion so that we may become the proud masters and humble servants of our own gifts. For, as Richard Webster suggests:

> We need to take back our imaginative powers from the artists, novelists and poets to whom we have delegated them. For there is a danger in delegating imaginative powers just as there is a danger in delegating any powers. We need our own imagination. For the imagination is not something God gave us so that a few men and women might write poetry and a few others read it. It is a capacity of the human animal which has evolved its rich complexity through all the millennia of our mammalian evolution. By far the most probable explanation for its intricate and extraordinary power is that it has survival-value. If this is so it would be no more sensible to renounce its full power than it would be to forego the use of our legs or of our hands. It is only when we have learnt again how to use our imagination—to use it not impulsively or whimsically, but systematically, consistently and coherently—and when we have applied the full resources of our imaginative intellect to the construction of an adequate theory of human history, that we will ever begin to grasp the realities of our own nature and our own historical predicament.
>
> Until we have done this it seems likely that we will remain in thrall to the dissociated, intellectual culture which we inhabit today, where an austere and politically influential scientific and technological culture, devoid of human sympathy and understanding, exists side by side with a weak literary and artistic culture which, because it has unconsciously internalised the image of its own superfluity, is prepared both to stand back from the political process and to concede to the natural sciences the exclusive right to explore reality systematically and to pronounce authoritatively upon it. Such a dissociated intellectual culture, together with the riven sensibility which belongs to it, is one which, whatever its members may consciously profess, exists in unconscious complicity with those political strategies which seek to subordinate human needs to technological progress, which defer meekly to imaginary economic laws, and which are committed to squandering human wealth in the compulsive pursuit of material riches. It is an intellectual culture which, by its very nature, tacitly

endorses the assumption that human feelings, human fulfilment and the wealth of our intimate and community relations should be discounted as factors in the equations of politics, and that men and women should submit willingly, pacifically and even eagerly to government by the cruel junta of the rational and the quantitative.[3]

With these thoughts in mind I should like to make a few tentative suggestions to help those seeking to navigate beyond conventional paradigms of Art and move towards a more inclusive role of the imagination in society.

## THE ARTIST IN EVERY MAN

*The greatest art is the art of living, greater than all things that human beings have created by mind or hand, greater than all the scriptures and their gods. It is only through this art of living that a new culture can come into being.*

Krishnamurti[4]

*Both men and women want to play. Picasso played until he died. By play I mean being so closely related to the imagination that you're constantly creating. Every minute is new, spontaneous. That's the feminine principle. Life is never boring because there's always something new happening, Without that we just die. In a marriage each has to say, 'Let's figure out how we can play.' It doesn't take any money, just a huge leap of faith.*

Marion Woodman[5]

*There's an artist imprisoned in each of us. Let him loose to spread joy.*

Bertrand Russell[6]

The wisdom teachings of East and West may differ about the ultimate nature of the universe, but almost all of them recommend the cultivation of simplicity as an integral factor in the successful art of living. Summarising the accumulated experience of countless generations, they conclude that delusions, attachments and an undue addiction for consumerism are nothing less than distractions. An over-complicated, over-stimulated life and too much harried speed congests the day, distracts attention, dissipates energies and weakens the ability to find the

space for timelessness and meditation—not necessarily the technique, but the contemplative, appreciative attitude of mind. As Henry David Thoreau scribbled in his journal: 'A man is rich in proportion to the things he can afford to let be.'

Without a superabundance of objects, we can begin to live more aesthetically. There is a charming Japanese maxim that says that civilisation was born when the first person picked a flower and gave it to another lovingly. Aesthetics here connotes harmony, a feeling for unity, the gift of beauty. It means sensing the things of the world in their sacred particularity and being affected by the vivid ways that they present themselves. It means being receptive, as Gerard Manley Hopkins was responsive, to their individual languages of colour and form, to what he called their 'inscape'. It means being creative in regard to everything we do. It means making an art form out of every act. It means a responsibility based on appreciation, affection and relatedness. It means embracing the world as artists, trying somehow to become what we behold. It means being unselfconscious about all these things; regarding 'art', like love, as a by-product rather than an aim or intention. It means working on ourselves with the help of the great masters. 'Why,' asked Thoreau in his study of the pleasures and responsibilities of life in the woods in *Walden*, 'has man rooted himself thus firmly in the earth, but that he may rise in the same proportion into the heavens above?'[7]

Thus aesthetics, like praise, has its beginnings in the simplest and most mundane aspects of our day-to-day lives. It is directly related to the care with which we choose the ingredients for a meal, cook it and attend to the appearance of its serving; with the mindfulness with which we purchase books and newspapers; with the attention with which we play and listen to music and the care with which we practice our most intimate acts—coring an apple, cleaning a pair of shoes, making a bed, making love upon it, wrapping a present and playing tennis. Cooking, cleaning, sewing, knitting, carpentry, arranging flowers, making repairs, telling stories, nursing, gardening, writing letters, bringing up children, singing, talking, entertaining, even shopping, can be practised with—or without—imagination, with—or without—regard for the process with which we do these things. A helpful guide to the spirit in which these activities might be practised may be found, I suggest, in the discipline of a ceremony at utter variance to the systematic analysis, agitated speed and addictive greed of the industrialised world. This is the underlying philosophy of Tea, a religion of the art of life, as taught and practised in Japan since the sixteenth century.

Sen Rikyu (1522-1591) summarised the principles of the discipline of Tea into the four concepts of *wa*, *kei*, *sei*, and *jaku*; and these continue to offer us insights into a way of living of profound contemporary relevance. They offer an alternative to our alienation from nature, our unsatisfiable cravings and inner restlessness, our loss of moral values and descent into triviality. The ceremony is a function at which host and guest join to produce for the occasion the utmost beatitude of the mundane.

The first is *Wa,* harmony, the feeling of oneness with nature and people. At a tea ceremony, the host chooses utensils, flowers, and a scroll to match the season. This should induce a feeling of harmony between host and guest, between guest and guest, the food served, the utensils used and the flowing rhythms of nature.

*Kei* is respect. It is the sincerity of heart that liberates the feelings of an open relationship with the immediate environment. The hospitality of the host, the concern of the guests for each other and the host, and the careful handling of the utensils exemplify this respect.

*Sei* is purity. Cleanliness and orderliness, in both the physical and spiritual sense can also enable us to sense the pure and sacred essence of things, man and nature. In Zen, even the most mundane acts—washing dishes or cleaning floors—can provide the seeds of enlightenment.

*Jaku* is tranquillity, an aesthetic concept unique to Tea, which comes with the constant practice of the first three principles of harmony, respect, and purity in everyday living. 'Sitting alone, away from the world, at one with the rhythms of nature, liberated from attachments to the material world and bodily comforts, purified and sensitive to the sacred essence of all that is around, a person making and drinking tea in contemplation approaches a sublime state of tranquillity.'[8]

Thus *Chado*, the Way of Tea, commends a way of life for the individual that is still viable because it can be applied to daily experience. It can lead us to remember that profound sense of the sacred which is never concerned with display for its own sake, nor with progressing ever forwards in our own ingenuity. It can introduce us to an aesthetics in which beauty is not lofty and unapproachable but humble and innocent. Awakened life is not a birthright, but something to be won along the path beyond the self.

The poet and Anglican divine George Herbert (1593-1632) also spoke of the imaginal richness that can surround simple acts like sweeping a floor when done with care and dignity and, as he put it, in the service of God. 'A servant

with this clause,' he sang, 'Makes drudgerie divine: / Who sweeps a room, as for thy laws, / Makes that and th' action fine.'[9] Even without the aid of the canonic formalities of traditional religion, we may yet re-sacralise the ugly, heal the unwholesome and make the world more beautiful with the gift of our work. Even if we have no faith in the religion of love or mindfulness, we can give praise for life's gift:

> Wherefore with my utmost art
>  I will sing thee,
> And the cream of all my heart
>  I will bring thee.

In a secular age such as our own, where so much is measured in terms of time and money saved, where comforts and luxuries matter more than service, Herbert's search for the deity on the home ground can seem merely quaint. Indeed, had I not myself lived amongst people for whom sweeping floors, washing bullocks, preparing vegetables and serving a meal, were not chores but expressions of 'traditional sanctity', I might not have quoted a long-dead Christian poet who advocated a life of simple acts, offered as a prayer. But for my hosts in Rajasthan, utility, sanctity and beauty were normal requirements rather than rare achievements.

It is never soon enough to de-anaesthetise ourselves and let beauty into our lives. The contemporary American sculptress Rachel Dayton, in conversation with Suzi Gablik, averred that daily life can be a prayer and that everything is holy. 'You are holy, everything around you is holy, rinsing a vegetable in the sink is holy. When we were in LA, and even before then, I lived my life *for* my art. I destroyed relationships, my body, my health, all kinds of things for the art. That's the ideal of the artist in this culture. Living on the prairie, in the context of the larger nature that has nothing to do with culture, we started living life *as* an art. It's as if washing dishes, if done with presence, is as much as an art form as painting a picture or making a sculpture.'[10]

Art, she had discovered, need not be a product but a living process, a process whose enactment can contribute to an infinite richness of collective life. In this at least, she had found common ground with perhaps the most far-seeing philosopher of our century. 'The divine is in the world or nowhere, creating continually

in us and around us,' said Alfred North Whitehead. 'The creative principle is everywhere, in animate and so called inanimate matter, in the ether, water, earth, in human hearts. But this creation is a continuing process and the process itself is the actuality, since no sooner do you arrive than you start on a fresh journey. In so far that man partakes of this creative process, so far does he partake of the divine.'

According to Soetsu Yanagi, founder of Japan's modern craft movement and an unrivalled interpreter of traditional aesthetics, beauty is that which gives unlimited scope for the imagination; beauty, he says, is a source of imagination that can never dry up.[11] Far from being a cultural accessory, it is, I believe, an essential aspect of existence.

## SOCIAL LIFE & RITUALS

*Just as an individual person dreams fantastic happenings to release the inner forces which cannot be encompassed by ordinary events, so too a city needs its dreams.*

Christopher Alexander[12]

The need for community and its rituals has been built into the human psyche over thousands of generations and hundreds of thousands of years. In a challenging phrase, Jung described 'the two million-year-old human being in us all'; the ancient person who never lacks either the desire or energy to celebrate, express his joy and ritualise his feelings in the company of others.

All over the earth people have sung and made music, acted and danced. In the mediaeval period, Europeans regularly did so, all day long: maybe church songs, maybe bawdy songs, maybe lullabies, work songs, and the like. Rituals, church processions, Feast of Fools days, mystery plays and festivals, provided opportunities for transcending the confines of the self. Festivities and celebrations were also important for the social health of the vernacular communities. The anthropologist David Maybury-Lewis has described how a South American tribe, the Xavante, enjoyed in their major ceremonies continuous singing and dancing. At certain times, he says, people danced themselves literally into a coma. They even sang and danced around their villages during the night. 'When

Xavante want to praise a community,' he writes, 'they say, "There is a lot of singing." They mean by this that people get together, ceremonies are performed together and frequently, and the young men are alert, wakeful, and in good voice during the night. It is a severe condemnation when they say of a community (invariably not their own) that it is 'sleepy'. That means that it is a community without much spirit and, of course, without much singing during the night.'[13]

That 'sleepiness' characterises an increasing number of industrialised or industrialising countries, where jeans have replaced the decorative exuberance of the national costume; the nondescript monolith, the diversity of vernacular architecture; the television soap, the narrative of story and ballad, intimately told. 'Sleepiness' is simply the effect that a modern, exploitative, industrialised economy always has. The message is plain enough, and we have ignored it for too long.

Yet there is still time to repair the extensive cultural damage the economic entities of our time have imposed and continue to force upon us. There is still time to reconstruct our broken communities, heal the damaged earth and sing and dance; to rediscover festivity, celebration and local identity. Forty years ago Erich Fromm argued the need. 'The transformation of an atomistic into a communitarian society,' he wrote, 'depends on creating again the opportunity for people to sing together, walk together, dance together, admire together—together, and not, to use Riesman's succinct expression, as a member of a "lonely crowd".'[14]

In this work of re-enchantment the role of the especially imaginative person—an Anna Halprin or a John Fox—is an advantage, and particularly so where links between people and the places in which they live can be forged. A celebration rooted in the place and the people by whom and for whom it is made, is probably the most effective vehicle for community building. Unquestionably, my friend the poet John Moat had this aim in mind when he initiated North Devon's First Christmas Festival in 1995. It lasted a week and involved numerous local groups and individuals from commerce, industry, museums, libraries, youth groups, bands and choral societies, bell-ringers, newspapers, town councils, schools, churches, arts activities and voluntary organisations. He writes:

> For more than thirty years I've seen the efforts to import Arts programmes, many wonderful programmes, into North Devon. And would argue almost without

exception... they have failed to touch any but the predictable few. To the huge majority, here as elsewhere, these imports remain an irrelevance. Local people tend to shrink from them—because they're imposed by outsiders, perhaps because they seem to condescend, and to imply a judgement of the native lack of vision. Or just because they're irrelevant.

So, as we agreed, the object of this festival was to affirm the validity and the absolute quality of the community's own imagination. The idea being that if this could be achieved, so that a community begins to *own* its *own* imaginative life, and become assured in it, then that surety is the measure of a profound shift of energy. By creating its own living imaginative context the community need no longer be threatened by visiting Arts and Artists, but can welcome them into its own assurance knowing that they can only complement its own imaginative expression.

...And it holds the key to living, convivial community.[15]

Anna Halprin's ritual on Mount Tamalpais had similar aims. 'I wish to extend every kind of perception,' she writes, 'to involve people with their own environment so that life is lived as a whole.' To this end, she envisages the Artist not as a solitary creator but rather as a special guide 'who works to evoke the artist in us all.' In his work, John Fox also proposes a shift from that of a self-directed, achievement-orientated professional to something like a cultural awakener or healer. He writes: 'I think at some point, whether you use Jungian phraseology or not, you're looking down into the Collective Unconscious through your own subconscious. Like a glass-bottomed boat, and the artist is floating around letting people see down into the images. The job of the artist is to have antennae, to pick it up and articulate it for other people to read. It is to objectify his subjective experience in a form that's accessible to the majority.'[16] This is work that others, not necessarily 'professional' Artists can set out to achieve; anyone, that is, called to the task of identifying, celebrating and expressing a community's shared emotional and social life.

A ritual provides such a journey. In the present secular climate this can be anything from a solitary and personal event like a rite of passage marking a stage in an individual's life—her birth, her naming, her puberty, his betrothal, his marriage or their parenthood—solemnised and celebrated by relatives and friends, to a major social event involving hundreds and lasting several days.

Only a few decades ago, the idea that people might gather together to recon-

struct a new ground of rejoicing would have been inconceivable. But the mood has changed and is changing fast. The signs of vernacular regeneration can be seen all about us as much in the celebration of local identity as in the making of rituals to heal the earth. The American writer Charlene Spretnak describes such an occasion when she and her friends gathered to gave thanks at a spring equinox:

A group of some forty people in spring colours walk from our cars in procession to a gentle rise in a spacious park, carrying armfuls of flowers and greens, food and drink, and burning incense. Musicians among us play instruments as the children toss a trail of petals. We form a circle and place the flowers and greens at our feet, forming a huge garland for the Earth, one foot wide and half as high. In the centre on colourful cloths we set baskets of food and objects of regeneration—feathers shed by eagles and other birds, a bowl of water, a small statue of a pregnant female, and several sprays of pink and white blossoms. We breathe together and plant our feet squarely on the warming earth, drawing up its procreative powers into our being. Working mindfully, we take some flowers and ivy from the Earth garland and make individual garlands with trailing ribbons for ourselves, then weave together the stems and greens in the grand garland. Standing, we call upon the presence of the East and the cleansing winds that clear our minds. We call upon the presence of the South and the fires of warmth and energy that enliven us. We call upon the presence of the West and the water that soothes and renews us. We call upon the presence of the North and the earth that grounds and feeds us. We sing, perhaps the Indian song 'The Earth is Our Mother'. We seat ourselves around the garland and offer into the circle one-word poems about spring in our bioregion. Someone reads a favourite poem. A storyteller, accompanied by soft drumming and bird-song flute, tells an ancient tale of the meaning of spring. We sing a lilting song with her. A second storyteller tells another story of spring. We sing a rhythmic chant with him. The two bards put on masks they have made and dance and leap around the circle, sprung with vernal energies. In counterpoint, the men sing his song, the women hers. We rise and sway like saplings as we sing. We move as the spirit moves us, dancing, turning. When we come to rest, we sit, emptied of song, on the ground and let the flute song fill our bodies. We pass around a bowl of cherries, each person taking one and offering into the circle thoughts of thanks-giving for particular gifts of spring. Brimming with love for the embodied wisdom of Gaia, we bid farewell to the presence of the four directions and break the circle. Then come feasting and visiting. Thus do we welcome spring.[17]

## DELIGHT IN EXPRESSION

*Our sole obligation to life is to be as beautiful as we can in every way. For ugliness is an insult to the beautiful God.*

Gustav Mahler

*The sterility of the bourgeois world will end in suicide or a new form of creative participation.*

Octavio Paz

The number of people in Britain engaged in one or other of the various expressive forms is not inconsiderable. It has been estimated that just under 1.8 million are involved in 'amateur' music of every description. Singing in a choir, performing in a local orchestra, mounting, say, a performance of Handel's *Acis and Galatea* or playing drums in a group, can provide not only opportunities for aesthetic expression but purposeful delight. From the RSGB Omnibus Arts Survey, commissioned by the Arts Council in 1991, we learn that as many as fifty-three per cent of the population take an active part in at least one arts-related, cultural or craft activity, the most popular being photography, disco dancing, working with textiles, woodworking, painting and drawing. The same Survey estimates that 3.7 million people regularly practice photography; 3.0 million are regularly involved with one or more of the textile crafts and a further 1.8 million regularly draw and paint. An incalculable number write poetry and are involved in other forms of creative expression such as hairdressing and cooking. Some 31 per cent of the population also claim to have purchased an art or craft work in the last twelve months.[18]

To this active participation must be added those who listen to music, read imaginative literature, visit galleries, the theatre and cinema and watch videos and plays on television. Given the modern desire for diversion, many such activities may be little more than an entertainment, yet for others, contact with one or other of the Arts may be much more: a lifeline to transcendence. 'For many human beings, religion (is) the music they believe in,' writes George Steiner.[19] The American poet Wallace Stevens has expressed a not dissimilar faith: 'After one has abandoned a belief in God, poetry is the essence which takes its place as life's redemption.' Which is to say, very plainly, that the Arts can transform, irradiate and give splendour to matters otherwise 'undreamt of'

in our materiality. They can be an indispensable alternative to the impoverishment of industrial culture.

Yet does this wholesale *consumption* of Art provide a substitute for the direct experience of creative activity lived at first hand? I doubt it. For all their ignorance of Stendhal and Shelley, Bruckner and Scott Joplin, Chagall and Brecht, the 'undeveloped' tribal almost certainly lives in closer contact with his deep self than the average Art-loving Westerner. The latter may have seen the latest ballet; the 'primitive' experiences himself through dancing; the latter may have visited an exhibition of African art, the tribal will have participated in communal ceremonies; the latter may have read the latest volume of verse, the 'primitive' will have experienced the poetic through involvement in traditional storytelling practices. But that is not all. The tribal also knows more about what he can see and touch, hear and smell, eat and use as a medicine. He can scan the world with intense insight and give greater responsibility to the unconscious end of his spectrum of intelligence. The same was once true, I suspect, of those skilled artisans who, seeking no praise from the world, created the physical fabric of Western life: its marvellous patterns of walls and hedges, its cities and churches, barns and farmsteads, tables and wagons, as well as its treasury of stories and songs. Yet now, after some two centuries of reliance upon machinery, the 'average' Westerner can make and do none of these things; his manual skills have become redundant, his dance forms rudimentary, his use of language utilitarian, his cooking out of packets, his music out of the radio or compact disc; his entertainment dependent on the video. These are not accidental attributes of industrialism; they are intrinsic and ineluctable. Small wonder he feels an unease that neither money nor consumption can fully satisfy or console.

Yet the unlicensed exercise of imagination in music, painting, drama and the other Arts offers a way out, one might say *the* way out, of this lack of personal authenticity. It offers not only novel and original possibilities, the fulfilment of dreams and an innate potential which heightens, transmits, refines and explores the world of feeling, but a unique sense of personal enlivenment and affirmation. It also offers the opportunity to work and share with others the work of co-creation.

An example of this enrichment (though in this case a solitary one) is found in the life and work of Ferdinand Cheval (1836-1924), who worked alone for thirty-three years on the creation of one monument to the imagination, one of the most moving ever made. It is still to be found in Hauterives, the village where

he was born, in the Department of the Drôme, France. Cheval, a postman, spent some ninety-three thousand hours on his colossal creation. All his sustained energy, all his dedication, all his skill, every ounce of poetry in him, went into creating his 'palace passing all imagination', a dreamlike structure of infinitely reinterpretable fantasy. Like van Gogh, Cheval was one of those who after a life-time's work could have admitted: 'As far as I know that word (artist) means: "I am seeking, I am striving, I am in it with all my heart." '

In the evening when night has fallen,
And other men are resting.
I work at my palace.
No one will know my suffering.
In the minutes of leisure
Which my duty allows me
I have built this palace of a thousand and one nights—
I have carved my own monument.

Cheval explains the origin of his Palace:

A country postman, as my 27,000 comrades, I walked each day from Hauterives to Tersanne—in the region where there are still traces of the time when the sea was here—sometimes going through the snow and ice, sometimes through flowers. What can a man do when walking everlastingly through the same setting, except to dream? I built in my dreams a palace passing all imagination, everything that the genius of a simple man can conceive—with gardens, grottoes, towers, castles, museums and stat-ues: all so beautiful and graphic that the picture of it was to live in my mind for at least ten years...

When I had almost forgotten my dream, and it was the last thing I was thinking about, it was my foot which brought it all back to me. My foot caught on something which almost made me fall: I wanted to know what it was: it was a stone of such strange shape that I put it in my pocket to admire at leisure. The next day, passing through the same place, I found some more, which were even more beautiful. I arranged them together there and then on the spot and was amazed... I searched the ravines, the hillside, the most barren and desolate places... I found tufa which had been petrified by water which is also wonderful...

This is where my trials and tribulations began. I then brought along some baskets. Apart from the 30 kilometres a day as postman, I covered dozens with my basket on my back, full of stones. Each commune has its own particular type of hard stone. As I crossed the countryside I used to make small piles of these stones: in the evenings, I returned with my wheelbarrow to fetch them. The nearest were four to five kilometres away, sometimes ten. I sometimes set out at two or three in the morning.[20]

Despite its title, its model is not a palace but a forest. Within it are contained many smaller palaces, chateaux, temples, houses, lairs, earths, nests, holes and crypts. Composed of lime, cement, iron girders, and masonry, it contains an Indian temple, a Swiss cottage, the White House, the Algerian House of Dice, and a mediaeval castle. Inside are also a labyrinth, a catacomb and a burial vault where its creator wanted to be laid to rest in the manner of the pharaohs. It has towers, too, and surfaces encrusted with a bizarre population: a snake, a horse, a tree, a lighthouse, a snail, giants and angels, dogs and soldiers, temples and fountains in a coral reef of the imagination. Here nothing in us is dwarfed. We are inspired to emulate this peasant genius of the people.

In a famous phrase, Coomaraswamy summed up the genius of the ordinary person, the kind of person Cheval was, and we all can be: 'The artist,' he wrote, 'is not a special kind of man, but every man is a special kind of artist.'[21]

## THE FUTURE ROLE OF THE ARTIST

*A democracy of the spirit; an aristocracy of the soul.*

<div align="right">Hazrat Inayat Khan</div>

*It is imperative to bear in mind that human creativity is not a claim or a right on the part of humanity. God awaits humanity's creative act, which is the response to the creative act of God.*

<div align="right">Nicholas Berdyaev[22]</div>

How should the Artist respond to our a great and tragic moment? This was the question that Hölderlin, a poet contemporary with Beethoven, asked when he became prophetic of the European madness into which we have since fallen:

'Und wozu Dichter in duerftiger Zeit'—'What are poets for in a barren time?' he asked. More recently, in 1972, another Artist asked the same question: 'The nub of the question remains for me as it did for Hölderlin,' reflected the composer Michael Tippett: 'What does this music—or any music—do within our present society, and what do I think I am doing by composing it.' His response remains no less valid than it did to the Romantics:

Deep within me, I know that part of the artist's job is to renew our sense of the comely and the beautiful. To create a dream. Every human being has this need to dream. It might seem that this need is satisfied by the simplicities of popular art but behind the mass demand for entertainment lies somewhere the desire for something more permanent, for the deeper satisfaction of proportion and beauty in a world of impersonal exploitation—a world that has no care for the inner person...

Whether society has felt music valuable or needful I have gone on writing because I must. And I know that my true function within a society which embraces all of us, is to continue an age-old tradition, fundamental to our civilisation, which goes back into prehistory and will go forward into the unknown future. This tradition is to create images from the depths of the imagination and to give them form whether visual, intellectual or musical. For it is only through images that the inner world communicates at all. Images of the past, shapes of the future. Images of vigour for a decadent period, images of calm for one too violent. Images of reconciliation for worlds torn by division. And in an age of mediocrity and shattered dreams, images of abounding, generous, exuberant beauty.[23]

These are brave words, incapable of being bettered. Tippett is telling us that the Artist's significance at this time is his capacity to act as a critical counterpoint to the imperial advance of science and technology. It lies in his capacity not only to nourish the culture with regenerative symbols but to fathom the voices of the unknown—prophetic, oracular—essential to our capacity for wholeness, which may be otherwise unheard. It is a generous vision.

The painter Cecil Collins would have broadly agreed. Although he censured the irredeemable decadence of aspects of the contemporary Arts, he believed the true Artist could and should play an important role. That role, he saw, was to carry the torch of light through the darkness of the effortless barbarism of our calamitous times. The monks and early Christians had done so; they had kept

alive and transmitted the life within man's inner nature from the chaos of the Dark ages to the new civilisation of the Church. Now it was the Artist's turn to carry forwards the seeds of the future civilisation. However few such carriers might be, their importance lay in their capacity to go

> deep into the desert [of their own selves], communing there, and trying to keep alive that vital spark which has no name but which is the real seed and foundation of creative civilisation in every man, no matter who he is. That is the position. Our historical position today is a desert of death, intolerance and vulgarity, in which the hermit-artist tries to keep alive that spark of creative life... We artists and poets know one thing for certain: that the life within man's inner nature must be kept alive and transmitted and carried through this tragic transitional period. This is crucial. We must reject the prison of political civilisation. Man is a metaphysical being with a hunger for life which no political or scientific solution can satisfy.[24]

Few Artists of the twentieth century have fulfilled the noble functions envisaged for them by Tippett and Collins. Rather than compensating for our culture's disintegration, rather than looking beyond the contemporary wasteland to find life-enhancing possibilities, too many have produced work only symptomatic of its decline. Settling for the fashionably despairing or fashionably ironic, they have reneged on their social or planetary responsibilities. Fighting for personal fame, they have conspicuously abjured any accountability for the sickness of their cultures. Glorifying in their own uniqueness and the central role of their own subjectivity, they no longer see its shadow: a disengagement and reflexivity which ignores the world beyond the personal. Not all, of course, but given the condition of our culture and the earth, too many, far too many. The loss of transcendent energies in our society has been taken by too few Artists to be a privation as great as any due to physical handicap or the violation of personal dignity.

In contrast, a minority, true to the creative, redemptive activity of Art, have sought to work for their societies' renewal. To do so, like Halprin and Fox, they have worked on behalf of their communities. Like Bonnard and Takemitsu, they have contributed towards a culture of caring. Like Hassan Fathy and Noguchi, they have been involved with the making of nourishing public places. Like Pärt and Tavener, they have sought to restore a sense of holiness. Like Collins and Messiaen, they have attempted to liberate the visionary powers from the lesser

reality in which they have been confined by urban-industrial necessity. Like Brancusi and Powys, they have carried us into that elemental ground beyond the externally visible—beyond the personal even—so that our imaginations may be enriched, our spirits exalted, our lives inspired.

In a time when so many Artists have learned to confabulate with extremes of horror and alienation, the most daring thing an Artist can do is to fill a book, a gallery, or a concert hall with an enduring affirmation of hope. Górecki did just this when he composed *Miserere* (1981) in heartfelt response to the political events of 1981. It is a 32-minute journey through five words of text, 'Domine Deus noster, Miserere nobis' ('Lord our God, have mercy on us'), for unaccompanied choir.[25] Written immediately after the militia had attacked a Rural Solidarity sit-in and seriously injured over twenty of its members, battened when forced to run the so-called 'path of health', the score carries a simple dedication to the city of Bydgoszcz.

This prayerful music is a prophetic utterance: it inspires us in vision and endurance, and in so doing strengthens our determination to resist the forces of destruction. 'The world will be saved by beauty,' said Dostoevsky, and as I listen to this music I have no doubt that he is right.

Yet, faced with so many unknowns and a paradigm whose consequences are uncertain, it is not only difficult to envisage how beauty will save the world but even the role of the exceptionally imaginative person in a future society. It would be simplistic to speculate but nonetheless I can hazard what might happen and would like to see. And that, I believe, will be very different, if not the polar opposite, of prevailing assumptions. For that reason we may begin to see the especially imaginative person acting as the servant of and subordinate to the wishes of the majority. We might see her creating without any attempt at self-expression or display of personality. We might hear music created for a particular occasion; we might see paintings created for the collective; we might find dance and ritual released in definite action, toil, worship or festival. We might see him sharing his talents with others. We might see imaginative expression not separate from but interwoven with the activities of life. We might see the concept of the Artist replaced by a more broadly shared understanding of the artist in everyone. This is what is to be found in traditional tribal societies, rooted in ancient animistic, autochthonous tradition, and what, I believe, we may eventually achieve in our own—if, that is, we humans are to survive in harmony with the earth.

## THE REDISCOVERY OF MEANINGFUL WORK

*My object in living is to unite*
*My avocation with my vocation*
*As my two eyes make one in sight.*
*Only where love and need are one,*
*And the work is play for mortal stakes,*
*Is the deed ever really done*
*For Heaven and the future's sakes.*

Robert Frost[26]

In pre-industrial society, adult working life gave scope for skill and expression through craft. No one told the countryman who shaped the handle of a scythe or the complex construction of a wagon how to produce these objects beautifully. He did what he did because he had been taught to do it in a certain way and held beauty in his unconscious. He worked for long hours and, as H.J. Massingham discovered, found pride and satisfaction in his labour. Such was the life of the rural craftsman, and before him the Roman craftsman and the neolithic farmer.

The introduction of machinery destroyed the rural culture at breakneck speed. Dickens portrayed the impalpable sorts of bondage to routine that are the subject of *Hard Times*, and Carlyle cried out that 'men are grown mechanical in head and heart, as well as in hand.' At a later date, a less famous writer, George Sturt, wrote about the losses inherent in the transition from village or provincial industry to city or cosmopolitan industry which he experienced at first hand. In *The Wheelwright's Shop* (1923), he expands upon this theme:

> Already, during the eighties and nineties of last century, work was growing less interesting to the workman, although far more sure in its results. Whereas heretofore the villager (a provincial craftsman, say) had been grappling adventurously and as a colonist pioneer with the materials of his own neighbourhood—the timber, the clay, the wool—other materials to supersede the old ones were now arriving from multitudinous wage-earners in touch with no neighbourhood at all, but in the pay of capitalists. So the face of the country was being changed bit by bit. Incidentally, occasion was arising for the 'Unrest' of the present day, Village life was dying out; intelligent interest in the country-side was being lost; the class-war was disturbing erstwhile

quiet communities; yet nobody saw what was happening. What we saw was some apparently trivial thing, such as the incoming of tin pails instead of wooden buckets. Iron girders had hardly yet begun to oust oak beams from buildings; corrugated iron sheets were just beginning to take the place of tiles or thatch. If an outhouse was boarded up with planed deal match-boarding from Norway instead of with 'feather-edged' weather-boarding cut out locally by sawyers one knew, who was to imagine what an upheaval was implied in this sort of thing, accumulating for generations all over Europe? Seen in detail the changes seemed so trumpery and, in most cases, such real improvements. That they were upsetting old forms of skill—producing a population of wage-slaves in place of a nation of self-supporting workmen—occurred to nobody.[27]

Sturt's language, like the country culture he knew and loved, is uncontroversial but the story he tells—and knew he was telling—is a harsh and tragic one, whose effects continue to be experienced in the remotest corners of the world where the rush towards urbanisation continues to undermine the time-honoured ways of interweaving home and work life. Local wisdom is now subject to the demands and instructions of 'employers', often remote. But these are not the only consequences inherent in the adoption of the mechanical culture and the traducing and spurning of the hand-based crafts. People now work for wages with which to buy the things they had formerly made or grown for themselves. They live cut-off from opportunities to exercise their native creativity and skills. In consequence, they can become emotionally deprived of the pride that comes from authentic work and only partially compensated for that loss by opportunities offered by consumer affluence and 'entertainment'. Thus if it is true that the Westernised world enjoys unprecedented levels of material affluence, it has never been more ravening and violent, unsatisfied and aimless.

With the introduction of automation, robotization, information technology—the promise of the electronic age—we have reached a turning point at which the assumptions about living and working of the last hundred and fifty years will again have to be revised. The social, political and ecological implications of this technological revolution will be immense. In the US alone, more than 90 million jobs in a labour force of about 124 million are potentially vulnerable to replacement by machines. The wholesale adoption of new technologies and the attendant decline of mass employment will affect the securities of perma-

nence in full-time work; people will work under arrangements too fluid and idio-syncratic to be called jobs; work may consist of moving from project to project within the same organisation or in activities carried out at home. We are also informed that 'labour' and 'manual skills' will yield to 'knowledge'; 'industry' will decline as services grow in importance; the one-organisation career will give way to mobility and career changes. We are also led to believe that what is called discretionary time will increase, and with it a vast vacuum in people's lives. So what will happen? What will people do with their time? The possibility offers the most wonderful chance ever presented for man to develop the contemplative and creative life. It also offers even broader scope for boredom to be sated with mind-less, passive but money-making 'entertainment' and a more active but no less mindless vandalism.

But what if we were to be more imaginative—to leap into the dark where some of the wildest, finest things have been found in the past and wait to be found for the future? What if we were to let go of the old ways of living, which sooner or later we will be forced to do if the planet is to survive? What if we were to reject the dehumanising constraints of the prevailing mechanistic attitude and encourage the spirit to flow through life and livelihood? What if work were to be re-visioned within the context of a different paradigm? What kind of work would follow from the vision of a new conceptual framework, a new way of thinking?

In an essay entitled *The Roots of Ecological Crisis*, Gregory Bateson pro-posed 'that the ideas which dominate our civilisation at the present time date in their most virulent form from the Industrial Revolution... may be summarised as follows:

(*a*) It's us *against* the environment.

(*b*) It's us *against* other men.

(*c*) It's the individual (or the individual company, or the individual nation).

(*d*) We *can* have unilateral control over the environment and must strive for that control.

(*e*) We live within an infinitely expanding 'frontier'.

(*f*) Economic determinism is common sense.

(*g*) Technology will do it for us.[28]

He then went on to say—as long ago as 1970—that since 'these ideas are simply

proved *false* by the great but ultimately destructive achievements of our technology in the last 150 years,' that they must change. 'That change in our thinking,' he continues, 'has already begun among scientists and philosophers, and among young people... The changes will continue as inevitably as technological progress... (but) nobody can predict what new patterns will emerge.' The implications of such a reversal of premises are no easier for us to visualise than they were for Bateson, but at least by implication he was clear about their general character. He proposed that future work should be the opposite of the destructive paradigm he summarised.

# AN UNCERTAIN CONCLUSION IN SIX IMAGES

## ICARUS & THE HUBRIS OF THE MODERN SCIENTIFIC CIVILISATION

*There is only one history, and that is the soul's.*

W.B. Yeats

IN ABOUT 1555, the Flemish artist Pieter Brueghel the Elder (1515-69) painted two pictures of the *Fall of Icarus* (Plate 99).[1] They were painted at a moment when Europe was poised to dominate the peoples of the earth. The magnetic compass and gunpowder, the mechanical clock and the printing press already played a pivotal role in the evolution of the new order. Only twelve years before Brueghel's picture had been created, Copernicus had hypothesised a sun-centred universe with a planetary Earth. Nine years after its completion Galileo Galilei had been born in Pisa. Like Brueghel's painted galleon setting forth across a peaceful sea, the idea of a continuously expanding future, energised by the uninhibited organisation of economic resources through a market economy, was in full sail.

Yet *The Fall of Icarus* is also prophetic of the coming catastrophe—the catastrophe which always befalls a civilisation when triumphalist ambition overreaches natural limits. By the mid-sixteenth century Europeans were already well on the way to conquering the elements, and, through a powerful combination of courage, butchery, and scientific ingenuity, to mastering the globe. Yet Brueghel asks: what does it amount to, and where will it all end?[2] His picture is a meditation on these issues, more crucial for us now than when he painted it.

## EDVARD MUNCH & THE SENSE OF INNER DEVASTATION

Four hundred years later, Western civilisation had largely conquered the world,

Plate 98. CECIL COLLINS. A Fool Praying (detail). 1976 *Pencil on paper.* 24 x 21.5 cm.

Plate 99. PIETER BRUEGHEL. Landscape with the Fall of Icarus. c1555. 73.5 x 112 cm. *Oil on canvas*. Musées Royaux des Beaux-Arts, Brussels. Brussels/Bridgeman Art Library, London.

but in the process had emptied itself of meaning. One of the first to lay open this emptiness was the philosopher Friedrich Nietzsche (1844-1900), the central prophet of the modern mind. Writing after Darwin and Marx, the emergence of rampant industrialism and colonial expansion ('the blood on our hands is unbelievable,' he said), Nietzsche anticipated the emerging nihilism of Western culture and the cataclysm that would befall it in this century. He argued that when 'nothing is true' and then 'everything is permitted', a consciousness of purposelessness must inevitably follow. His Norwegian contemporary Edvard Munch, as we have seen, also understood how the disappearance of an entire metaphysical universe centred on God would lead to fatigue, sterility, perversion and meaninglessness. A testament to this loss of soul, this alienation from the natural world, is his famous image of *The Scream* (1893), a painting that might well stand as an archetypal emblem over the gateway of this century's disregard of the collective human fate and of the earth from which our civilisation extracts its wealth.

I stopped and leant against the railing, half-dead with fatigue. Over the grey-blue

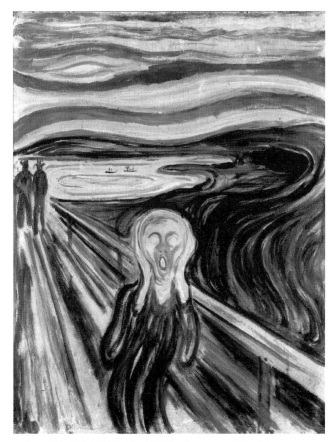

Plate 100. EDVARD MUNCH. The Scream. c1893. *Oil on canvas.*
Munch Museum, Oslo. Photo: Munch Museum.
© The Munch Museum/ The Munch-Ellingsen Group/ DACS 1996.

fjord clouds hung, as red blood and tongues of flame. My friends drew away. Alone and trembling with fear, I experienced Nature's great scream.[3]

So Munch described the experience behind the painting in his journal.

In the last decades of the nineteenth century, thinkers and Artists like Nietzsche and Munch, repudiating the materialism of their time, were in a minority. But by the end of the second decade of the twentieth century, the undercurrent of despair had grown more widespread. The work and attitudes of

Marcel Duchamp, Jean Paul Sartre, Samuel Beckett, Franz Kafka and the Dada movement, celebrating chaos and mocking all the collective values, faithfully registered the ensuing spiritual catastrophe.

## ALBERTO GIACOMETTI'S NIGHTMARE VISION
## OF A DESACRALISED WORLD

The Dada movement, developed between 1915 and 1922, is a clear example of the pessimism of the time. Learned lectures on Paul Klee and Lao-tse alternated with scandalising or mystifying entertainments designed to undermine the traditional bases of culture and social order. Its adherents set out to shock the bourgeoisie; their activities were a cry of disgust against a civilisation seen in terminal decline. The Dadaists' elevation of objects like bottle-racks and urinals to the dignity of Art objects, their employment of litter and rubbish in the place of traditional oil paint and canvas, their defacement of the canon of Western art (in 1916 Marcel Duchamp exhibited an urinal which he signed 'Mutt') and their construction of absurd machines that had no function, intended as mockeries of science and efficiency, were bizarre manifestations of an emergent neo-Luddism.

Surrealism was no less despairing. In a Foreword to the International Surrealist Exhibition held in London in 1936, Herbert Read reminded its visitors that what they saw was 'the desperate act of men, too profoundly convinced of the rottenness of our civilisation to wish to save a shred of its respectability.'

The surrealist Alberto Giacometti's (1901-66) sculpture, *Femme Egorgée* ('Woman with her Throat Cut', Plate 101), an ambiguous fusion of a female figure and a weird insect form, is in perfect accord with the harsh events, tonalities and predicaments of the period. Sexual violence and hideous murder are implicit in the contorted torso, wide-open legs and exposed wind-pipe of the nearly headless corpse. In retrospect we can see how this sculpture anticipated the horrors of the Second World War. Like Jean Paul Sartre's *Being and Nothingness* (1943), completed a decade later, it proposes a world completely without meaning. The same spirit was expressed by Samuel Beckett, the bard of a condition of near-terminal detachment, in his *Waiting for Godot* (1952), which tells the story of the alienated man who fears that his life has lost all meaning or purpose, all power to love:

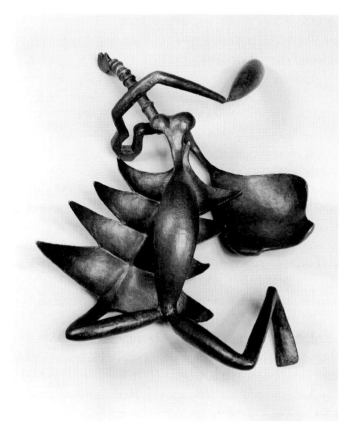

Plate 101. ALBERTO GIACOMETTI. Femme Egorgée. 1932. *Bronze.*
20.3 x 87.5 x 63.5 cm. Scottish National Gallery of Modern Art, Edinburgh.
© ADAGP, Paris & DACS, London 1996.

We are waiting for Godot to come... or for night to fall.
We are all born mad, some remain so.
In an instant all will vanish and we'll be alone again,
in the midst of nothingness.[4]

The novelist Robbe-Grillet's *The Secret Room* is no less bleak. The book consists of static descriptions of a woman's corpse. Its clinical detachment expresses better than any purely abstract art the triumph of alienation over feeling. The stabbed corpse could be said to stand in for the body in general, and its fate at

the hands of Modernism. A not dissimilar wasteland of the spirit has been conveyed in such films as *Serial Born Killers*, *Silence of the Lambs* and *Trainspotters*.

It would be no more than a comfortable fiction to imagine that this nihilism is limited to a smattering of avant-garde Artists and Hollywood entrepreneurs. It is now endemic. It is to be found among the urban unemployed trapped in a cycle of hopelessness and alienation. It is to be found in many of those using drugs as an escape from the sterile boredom of 'straight' life. It is to be found in those with jobs who yet suffer from the *anomie* of unrealised potential. Something of the same sickness is also to be found in other inescapable results of our industrial civilisation: environmental overload, social dislocation, dehumanised cities, the uncontrolled growth of technology. What, after all, is the ecological crisis but the inexhaustible extraversion of a blighted psyche? Ugliness and blight follow us like shadows which do not pass away. Embedded in the present paradigm is a subtle undercurrent of despair, loneliness and destruction.

## THE TWIN FACES OF JANUS: FRANCIS BACON, PAINTER OF DAMNATION; WINIFRED NICHOLSON, PAINTER OF PARADISE

As a phase in the history of consciousness, Humanism, from its early optimism to the profound foreboding of the present time, is not yet ended. Imagine, then, what follows it, how it evolves. It is possible that our civilisation will end in a collapse no less extensive and thoroughgoing than the fall of the Roman Empire—or be renewed by some vision of human regeneration. The French novelist and politician André Malraux saw both possibilities very clearly. He said: 'Either the twenty-first century will not exist at all, or it will be a holy century.'

To conclude this chapter, I would like to consider two further images, each expressive of these very different possibilities. One is by Francis Bacon (1910-92); the other by Winifred Nicholson (1893-1981); they are *Second Version of Triptych 1944* and *The Gate to the Isles*, the latter painted in the Artist's eighty-sixth year.

Plate 102. FRANCIS BACON. Second Version of Triptych 1944. 1988.
*Oil on canvas.* Tate Gallery, London.

## BACON'S *SECOND VERSION OF TRIPTYCH 1944*

In his *Principi di una Scienza Nuova* ('New Science', 1725), the Neapolitan philosopher of history Giovanni Battista Vico (1668-1744) observed that the cycles through which Western civilisation has passed had their counterparts in the history of the antecedent Graeco-Roman civilisation. Vico therefore posited a cycle of three civilisational phases: a Theocratic age which exalted the gods, an Aristocratic age which celebrated the heroes and a Democratic age which valued human beings, which would be followed by a chaos out of which a New Theocratic Age—maybe Malraux's 'holy century'—would eventually emerge. As Vico put it: 'The nature of people is first crude, then severe, then benign, then delicate, finally dissolute.' But for Vico there was no Chaotic age as such, only a Chaos during which recourse to a Theocratic age would commence.

Surely nowhere has this Chaos been more compellingly presented than in Bacon's fantastic canvas, *Second Version of Triptych 1944* (1988), where eyeless furies, part human, part beast, scream into empty space. Never before, not even in Goya, has the chaos of human desolation been pictured with such genius.

From my viewpoint, in this and other images, Bacon is the unrivalled chronicler of the 'underbelly' of our culture, the one painter with the courage to reveal the hidden shadow of our soulless condition. According to Michel Leris, a personal friend, his aim was to strip down the world to its 'naked reality'—to

cleanse it of 'both its religious halo and its moral dimension'.⁵ Such 'realism' is rooted, I don't doubt, in the painter's clear-sighted conviction of life's irredeemable meaningless. As Bacon himself observed:

> Man now recognises he is an accident, that he is a completely futile being, that he has to play out the game without reason. I think that when Velasquez was painting, even when Rembrandt was painting, they were still, whatever their attitude to life, slightly conditioned by certain types of religious possibilities, which man now, you could say, has had cancelled out from him. Man now can only attempt to beguile himself for a time, by prolonging his life, by buying a kind of immortality through the doctors. You see, painting has become, all art has become—a game by which man distracts himself. And you may say that it has always been like that, but now it's entirely a game. What is fascinating is that it's going to become much more difficult for the artist, because he must really deepen the game to be any good at all, so that he can make life a bit more exciting.⁶

Thus without the camouflage of self-deception, Bacon represents our Chaos: a world feverish for change and sensation, sated with hedonism, reeking with the odour of human ignominy. *Second Version of Triptych 1944* is a register of the pain and darkness in and of the modern world. It is a register of all its ugliness; the monster in ourselves glimpsed in the pages of the gutter press and films like *Reservoir Dogs*, *Taxi Driver* and *Henry: Portrait of a Serial Killer*; the progressive corruption and debauchery recorded by Oscar Wilde in his *Portrait of Dorian Grey*; the square miles of urban concrete through which rapists walk at night; the violence of children smashing the head of a young boy with bricks. It is a register of Auschwitz and Buchenwald and the killing fields of Vietnam; of Stalin, Pol Pot and Saddam Hussein. A register of overlogged forests, overdrained wetlands, overtapped ground waters, overfished seas and the terrestrial and marine environment overpolluted with chemical, toxic and radioactive poisons. It is the register of all our horrors, ignominies and humiliations and yet for all its heartbreaking honesty, Bacon's painting offers no melioration, no catharsis, no relief of desolation, no compassionate opportunity for redemption. It is *Timon of Athens* without *The Tempest*.

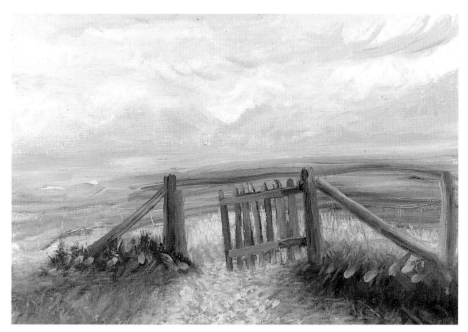

Plate 103. WINIFRED NICHOLSON. The Gate to the Isles. 1980.
*Oil on canvas.* 45.7 x 61 cm. Private collection. © Winifred Nicholson Trustees.

## NICHOLSON'S *THE GATE TO THE ISLES*

On an axis running from the horizontal to the vertical, from Hell to Heaven, Winifred Nicholson's little oil is the polar opposite of *Second Version of Triptych 1944*. Painted on an expedition to the Island of Eigg, *The Gate to the Isles* (1980) takes us from the darkness of the human condition to nurture, sanity and home. It was almost her last work, and according to its present owner its title is not just a bald description of physical facts, but a poetic reminder that in Highland folklore the Isles of the Blest, or Paradise, lie over the horizon. Originally she painted the ultramarine gate closed, then re-painted it open—an invitation to explore the light-filled radiance of the distance. 'She liked,' writes Judith Collins, 'to paint the beginnings of things, the dawn of a new day, a young baby, the first snowdrop of spring.'[7] Rainbows were another love. 'We keep our Eyes at the back of our eyes,' the Artist wrote towards the end of her life, 'and can divide and dissect the rainbow so long as we look inward and not only outward.'[8]

297

This communion with beauty and innocence in life, the touchstone of her Art, she shared with others like Paul Klee, who also sought to express the sacred in his work. Yet, as the latter admitted, 'The people are not with us.'

Interestingly enough, when David Sylvester asked Bacon about the contradiction between his painterly figures and their flat, bright backgrounds, the Artist told him: 'Well, that may be because I hate a homely atmosphere... I want to isolate the image and take it away from the interior and the home.'[9] In opposition to this, Winifred Nicholson adored home, children, animals, relationships; her painting arose out of the wisdom of her children, her contact with flowers and plants, her love of animals and people. This perhaps was part of her secret: to create from the flow of her life as the flowers she painted grew from the living earth, opened to the light. In her painting the outer world, so long inert, comes radiantly alive. Objects have psyche; places speak; soul in-forms. In contrast to the compelling nihilism of Bacon's triptych, *The Gate to the Isles* registers health and wholeness, generosity and respect for the world. The vision of the open gate leading to the distant horizon at the moment of her visitation is an epiphany of God. It is also the voice of Gaia, the embodied soul of the earth. It is the promise of hope for a better human world. Without pretension, fuss or heroics, it is an intimation of Malraux's unexpected 'holy century'.

The Romans introduced a Latin God, Janus, well known to pre-Roman cultures in Gaul and elsewhere. He was two-faced; one of his faces turned to see what had passed and the other turned towards what would become. From the core of the past to the edge of the future, he scanned two worlds, two possibilities. Vico's Chaos and Bacon's descent into hell represent one of these; *The Gate to the Isles* could represent the other.

But these alternatives are false, a trap and a decoy. Such apparent contraries do not exist; they never have, and never will. The problem is not to choose between the inferno or to dream about a bliss that can never exist; it is to bring them together into an appropriate, balanced relation in a way which diminishes neither. It is to insist on a 'both this and that' approach rather than the apparently clearer 'either/or'. It is to endure the creative tension of holding together in our awareness those oppositions which rational analysis splits into contradictory alternatives. It is to find the pass between the clashing rocks—the absolute opposites—and to move towards their integration. It is the ancient alchemical problem of how to celebrate the chymical wedding.

But how then can this be done? There exist, of course, many different ways but the path of the Artist is one of the oldest—and also, I believe, one of the most authentic. In their time, George Eliot and Dostoevsky, Beethoven and Shakespeare, Emily Dickinson and Schubert negotiated between scepticism and belief, distance and connection, desire and constraint; they looked into the void, entered the chaos, the obscure, incomprehensible paradox of human life, and presented their meaning and their necessity, in opposition and in reconciliation. They dealt with the only issues that seem to me to count—renewal, harmony, compassion—and kept alive a striving for authenticity in dark and troubled times. They facilitated the individual's attainment of what he could become. They showed the possibilities of deep personal and cultural transformation and how things might be made whole. They enlarged the scope of consciousness and revealed the shaping spirit of imagination not as an abstract concept but as a vital spirit—the continuous process of inspiration and exhalation by which we sustain and disclose our lives. And they showed how this spirit works to bring order and proportion, sanity and meaning, to lives that might otherwise be restricted by the mundane patterns of daily life. At their most illuminated the Artists of the Humanist era not only subverted the positivistic, overly ratio-nalised models of reality which still have too tight a grip on the functioning of the contemporary imagination, but kept alive, at a time of erosive spiritual decline, a pathway—indeed for many *the* pathway—for the soul. The high value we continue to attribute to the Arts of the past is based on an acknowledgement of these factors.

Yet today, at the end of the Humanist era, when its immanent defects become ever more apparent, we have to ask ourselves whether the post-Renaissance con-ception of the self-directed professional Artist was a great step forward in the story of human self-realization, or whether it was, on the contrary, a dehumanis-ing aberration in the history of mankind. At the very least, it is a phenomenon with a very short history and one that has led to creative exhaustion and the deep isolation of the Artist from society. 'Art no longer cares to serve the state and religion,' the Russian Artist Kasimir Malevich (1878-1935) declared. 'It no longer wishes to illustrate the history of manners; it wants to have nothing to do with the object as such, and believes that it can exist, in and for itself, without things.' A half-century or more later, this attitude, essentially the Artist's forced response to a culture he could no longer affirm, has reached the limit of its

extreme form of egoistic separation. Finding no direction from society at large, prostituted by the various and irredeemable corruptions of a sick civilisation, the Arts turn their backs on a compassionate engagement with the sorrows and joys of normal human existence. Best understood either as expressions of an extreme self-consciousness or as a rather desperate attempt to escape from alienation, they have refused all that is 'human'; that is, as Pierre Bourdieu says, all that is '*common*, easy, and immediately accessible.'

It is, of course, true that some Artists (including those discussed in Chapter Six) have attempted to reject the heroics, the hyper-reflexivity and alienation inherent in the Modernist myth; they have sought, like Bonnard and Arvo Pärt, Noguchi and Peter Redgrove, to re-enchant the wasteland of contemporary culture. Yet these are but a small minority; the majority have succumbed or are succumbing to the prevailing alliance of ego, commercialism, fashion and aesthetic self-referentiality. Think what you will, the Arts now live, as Bergman says, their shameless, feverish life, 'like a snake's tail full of ants. The snake is long since dead, eaten, deprived of poison, but the skin is full of meddlesome life.' Of course this is nothing less than the treason so aptly described by the French as *trahison des clercs*; the betrayal of man by the guardians of his spirit, the poets, painters, film-makers, playwrights, composers and novelists of the day.

So how can we restore a culture that is in serious decline? For a start we might seek ways to remove ourselves from the attitudes of defiance, negativity and alienation which characterise Modernism. We might purge ourselves, by a willed ignorance, of many features of the professionalised Arts, their refusal of the sacred, their refusal to accept any limits, their fecklessness, irresponsibility and retreat from rhapsodic enchantment. We might also withdraw from the least attractive features of our culture; exchange consumerism for *participation*, the culture of death for the culture of life. To do so we need to activate, engage and honour our own imagination, our inborn and inexhaustible creativity—the element most likely to stir our hearts into ethical awareness and compassion and release the forces necessary for survival. As our ancestors fought to free themselves from the decadence of an overweening Church, so we now need to forge our own Reformation of imagination.

We are all participants in a dangerous race between destruction and preservation. Destruction has the power of death, which is final and irrevocable. Preservation has the power of life, which is fragile and creative. To preserve the

immense dynamic pattern of renewal deep within ourselves we have to be open and creative every day of our lives; every moment is the right moment to begin. We have to learn to re-enchant all that has been damaged, neglected and abused. We have to learn to be creative in a new way. We have to question the province of expertise. We have to go back before Romanticism, before Humanism, back to mediaeval culture, back to the vernacular cultures, back to the ancient Japanese way of graceful living, back to a world where people put their trust in the mysterious processes which sustain our lives and lived for beauty and imagination. We have to be creative, no longer in autonomy but in mutuality; no longer privately but in service to the world; no longer solely with paint and clay but with the shape and form of our experience—in homes, gardens, neighbourhoods and cities, with other people. Van Gogh said, 'An Artist is a man with his work to do.' Today, that work must include the re-animation of community; it must include aesthetics in every form of life; it must include the healing of the earth and the creation of a new culture. 'For we all—each one of us—' wrote Cecil Collins, 'have within us a fountain of life—and contact with it is our real hope. We carry this fountain within the secret recesses of our own hearts—this fountain—which our civilisation has forgotten as it speeds on its way to the abyss.'[10] That fountain of the imagination bubbling up from the depths is our hope for renewal, our hope for authenticity, our hope for the holy century that may lie ahead.

## YUKIO NINAGAWA & THE FORMS OF THINGS UNKNOWN

Last night I watched *A Midsummer Night's Dream* presented by Japan's greatest stage director, Yukio Ninagawa, in Japanese.

The production, interspersing contemplative calm with enormous, spellbinding magic and populist comedy, was unlike any other theatrical experience I had ever seen. Every element was a small tribute to the imaginative whole: the forest of falling sand; the stone-and-sand garden; the incredible characterisation; the unearthly music caught me, and the audience, in the compulsive thrall of a dreamscape through which the characters find their love restored and renewed. The play's message has something to say about our absurd capacity for self-delusion, that love and its rapturous expression in Art, as in life, is always all that

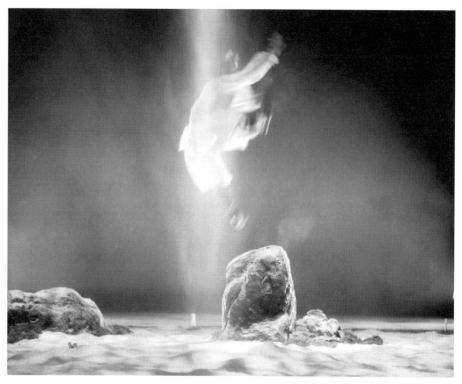

Plate 104. YUKIO NINAGAWA. A scene from A Midsummer Night's Dream. 1995.
Plymouth, Devon. Photo: Adam Eastland.

really matters. It also confirmed the necessity for chaos as a prelude for creation.

And it ended on a note of genius. From the moment I saw Puck (played by a white-faced Chinese opera actor) I succumbed to his magicianship. Puck had woven his own weave of enchantment through the play and at its end he alone of all the characters stood to face the audience. He was absolutely still. He made no gesture, spoke no sound, faced us in silence. Then imperceptibly he began to move, to gather momentum, to tumble and leap until with one enormous stride he disappeared into the darkness of the empty stage. No one knew what would happen next until we began to hear the sound of the street—traffic, klaxons, pattering feet, growing louder and louder, louder and louder. And then suddenly it came. This was the world into which Puck's other-world enchantment had penetrated. This was the world of the city, the world of 'ordinary' human life, into

which he had taken imagination. With sand and a white-faced acrobat, Ninagawa had made vivid what my words have groped to express.

# REFERENCES & NOTES

## PREFACE

Sorokin, Pitirim. *The Crisis of our Age*, Oneworld, Oxford, 1992.
Morris, William. 'The Art of the People' (1879) in *William Morris: Prose, Verse, Lectures and Essays*, The Nonsuch Press, 1974.
Carpenter, Edmund. *Eskimo Realities*, Holt, Rinehart and Winston, 1973.
Wilber, Ken. *A Brief History of Everything*, Shambhala, 1996.

## FOREWORD

1.  Sherrard, Philip. *Human Image, World Image: The Death and Resurrection of Sacred Cosmology*, Golgonooza Press, 1992.
2.  Stevens, Anthony. *Private Myths Dreams and Dreaming*, Hamish Hamilton, 1995.
3.  Stevens, Anthony. *On Jung*, Penguin Books, 1991.

## CHAPTER 1

1.  Levi-Strauss, Claude. *Tristes Tropiques*, Plon, Paris, 1955.
2.  Morris, Desmond. *The Human Animal: A Personal View of the Human Species*, BBC Books, 1944.
3.  Kühn, Herbert. *The Rock Pictures of Europe*, Sidgwick and Jackson, 1966.
4.  Gombrich, E.H. *The Story of Art*, Phaidon Press, first published in 1950, reprinted and revised several times.
5.  Krishnamurti, J. *Commentaries on Living, Second series*. Victor Gollancz, 1977.
6.  Huizinga, Johan. *Homo Ludens. A Study of the Play Element in Culture*, Paladin, 1970.
7.  Dissanayake, Ellen. *Homo Aestheticus: Where Art comes from and Why*, The Free Press, 1992.
8.  Van der Post, Laurens. *The Lost World of the Kalahari*, Penguin Books, 1958.
9.  Paulme, Denise. 'Adornment and Nudity in Tropical Africa' in Anthony Forge (ed.), *Primitive Art & Society*, Oxford University Press, 1973.
10. Jacobs, Julian. *The Nagas: Hillpeoples of Northeast India*, Edition Hansjorg Mayer, Stuttgart, 1990.
11. Carpenter, Edmund. *Eskimo Realities*, Holt, Rinehart and Winston, New York, 1973.
12. Ford, John Bevan. 'All Pervasive Art' in *Resurgence*, Issue 170, 1995.
13. Frater, Judy. Introduction to an exhibition at the Indira Gandhi National Centre for the Arts (IGNCA) in New Delhi, 1995.
14. Chernoff, John Miller. *African Rhythm and African Sensibility*, The University of Chicago Press, 1979.
15. Coomaraswamy, A.K. *Introduction to Indian Art*, 1923. Ananda Coomaraswamy (1877-1947), orientalist, philosopher and art historian, has been called one of the greatest intellectuals ('intellect'—the habit of first principles) of the modern era. The scope and penetration of his studies is beyond compare. See Further Reading.
16. Shearer, Alistair. *The Hindu Vision*, Thames and Hudson, 1993.
17. Yeats, W.B. 'By the Roadside' in *The Secret Rose and Other Stories*, Macmillan, 1978.
18. Highwater, Jamake. *The Primal Mind: Vision and Reality in Indian America*, Meridian, New York, 1981.
19. Wittgenstein, Ludwig. untraceable.
20. Parlow, Anita. *Cry, Sacred Ground*, The Christie Institute, Washington D.C., 1988.
21. Several versions or translations of this prayer would seem to exist. The one printed here is taken from *Millennium: Tribal Wisdom and the Modern Age* by Maybury-Lewis,

David. Viking Penguin, 1992.
22.  *The Navajo Blanket.* Catalogue of an exhibition organised by The Los Angeles County Museum of Art, Praeger Publishers Inc, 1972.
23.  Spinden, Herbert Joseph. trans, *Songs of the Tewat*, The Brooklyn Museum, New York, 1933.
24.  Burckhardt, Titus. *Fez, City of Islam*, The Islamic Texts Society, 1992.
25.  Carpenter, Edmund. See 11 above.

## CHAPTER 2

1.  Crichton, Michael. *Jurassic Park*, Arrow, 1991.
2.  Pagden, Anthony (trans & ed.) *Hernando Cortes: Letters from Mexico*, 1986.
3.  Margolin, Malcolm. *The Ohlone Way: Indian Life in the San Francisco-Monterey Bay Area*, Heyday Books, 1978.
4.  Bullock, Allan. *Hitler and Stalin: Parallel Lives*, Harper Collins, 1991.
5.  Mumford, Lewis. *The Transformations of Man*, Harper and Row, 1956.
6.  Dam, Hari N. *Reflections on Life East and West*, Ensign Magazine, 1971.
7.  Sorokin, Pitirim A. *The Crisis of our Age*, One World, 1992.
8.  Weber, Max. *The Protestant Ethic and the Spirit of Capitalism*, Unwin University paperback, 1971.
9.  Nietzsche, Friedrich. Untraceable.
10. Sorokin, Pitirim. See 7 above.
11. Descartes, René. *Discourse on the Method of Rightly Conducting the Reason and Seeking the Truth in the Sciences*, Penguin Books, 1972.
12. Descartes, René. See 11 above.
13. Nietzsche, Friedrich. *The Wanderer and his Shadow*, Penguin Books, 1978.
14. Evans-Wentz, W.Y., editor of the Tibetan religious classics and *The Fairy Faith in Celtic Countries*, published in 1911.
15. Van der Post, Laurens. See Chapter 1, note 8.
16. Hanley, Keith. 'The Discourse of Natural Beauty' in *Ruskin and Environment*, ed. by Michael Wheeler, Manchester University Press, 1995.
17. Havel, Vaclav. From a speech delivered at Stamford University, 1994.
18. Guenon, René. *The Reign of Quantity*, Penguin Books.
19. Capra, Fritjof. *The Web of Life*, HarperCollins, 1996.

## CHAPTER 3

1.  Jung, C.G. *Memories, Dreams, Reflections*, Vintage Books, 1963.
2.  Although the word Humanist was used in late fifteenth century Italy to describe a teacher of the humanities (that is, those subjects which formed the curriculum in the educational programme formulated by Florentines like Leonardo Bruni), it is here used to describe the West's dominant cultural faith.
3.  Carson, Rachel. *Silent Spring*, Penguin Books, 1991.
4.  A research team led by David Pimental, Professor of Ecology and Entomology at Cornell University, estimates that erosion removes about 75 billion tons of topsoil a year and destroys about 20 million acres of farmland.
5.  Schwartz, Hillel. *Century's End: An orientation manual towards the year 2,000*, Doubleday, 1990.
6.  Ehrenfeld, David. *The Arrogance of Humanism*, OUP, 1981.
7.  Taylor, Charles. *Sources of the Self: The Making of the Modern Identity*, Cambridge University Press, 1989.
8.  Baldass, Ludwig. *Van Eyck*, Phaidon Press, 1952
9.  Taken down in 1506, in 1771 the altarpiece was sawn into pieces and parts sold. However most of it is still in the Cathedral Museum in Siena.
10. Alberti, Leon Battista. *Della Pittura libri tre.*

11. Charpentier, Marc-Antoine (*c*1648-1704) compiled numerous Masses, motets and other church works.
12. White, John. *Duccio*, Thames and Hudson, 1979.
13. Berger, John. *Ways of Seeing*, Penguin Books, 1972.
14. Vasari, Giorgio. *The Lives of the Artists*, Penguin Books, 1979.
15. Berman, Morris. *Coming to our Senses: Body and Spirit in the Hidden History of the West*, Unwin Paperbacks, 1990.
16. Gablik, Suzi. *Progress in Art*, Thames and Hudson, 1976.
17. Blacking, John. *How Musical is Man?*, Faber and Faber, 1976.
18. James, John. *Chartres: The Masons who built a Legend*, Routledge and Kegan Paul, 1982.
19. Blake, William. 'On Homer's Poetry & On Virgil' in *Poetry and Prose of William Blake*, ed. Keynes Geoffrey, The Nonsuch Press, 1927.

## CHAPTER 4

1. Vasari, Georgio. see Chapter 3 note 14.
2. Berman, Morris. *The Reenchantment of the World*, Cornell University Press, 1981.
3. Burckhardt, Jacob. *The Civilisation of the Renaissance in Italy*, Phaidon Press, 1950.
4. Pope, Alexander. Untraceable.
5. Eliot, T.S. 'The Metaphysical Poets' in *Selected Prose*, Penguin Books, 1955.
6. Wilmot, John. *Complete Poems*, ed. D.M. Vieth, 1968.
7. Priestley, J.B. *Literature and Western Man*, William Heinemann, 1960.
8. Till, Nicholas. *Die Zauberflote: An Opera and its Symbols,* compact disc, L'Oiseau-Lyre.
9. *Revelations* Chapter 22, Verse 1-2.
10. Blake, William. From the *Laocoon Group*. See Chapter 3, Note 19.
11. Rosenblum, Robert. *Modern Painting of the Northern Romantic Tradition*, Thames and Hudson, 1975.
12. Carlyle, Thomas. untraceable.
13. Blake, William. From *Jerusalem*. See Chapter 3, Note 19.
14. Tourism is the world's largest industry. Its turnover in 1996 was 3,000 billion dollars. 450 million people travel internationally each year. The destruction and pollution caused by holiday-making continues to grow.

## CHAPTER 5

1. Lopez, Barry Holstun. *Of Wolves and Men*, Charles Scribner, 1978.
2. Solzhenitsyn, Alexander. 'As Breathing and Consciousness Return' (1973) in *From Under the Rubble*, Collins and Harvill Press, 1975,
3. Forster, E. M. *Howards End*, Penguin Books.
4. Buber, Martin. *I and Thou*, T & T Clark, Edinburgh, 1979.
5. Richter, Gottfried. *Art and Human Consciousness*, Floris Books, 1985.
6. Teilhet-Fisk, Jehanne. *Paradise Reviewed: An Interpretation of Gauguin's Polynesian Symbolism*, U.M.I. Research Press, 1983.
7. Small, Christopher. *Music: Society: Education—A Radical Examination of the Prophetic Function of Music in Western Eastern and African Cultures with its Impact on Society and its Use in Education*, John Calder, 1977.
8. Basho, Matsuo. *Narrow Road to the Deep North*, Penguin Books, 1986.
9. Borchmeyer, Dieter. *Richard Wagner: Theory and Theatre*, Clarendon Press, Oxford, 1991.
10. Mellers, Wilfrid. *Caliban Reborn: Rebirth and Renewal in Twentieth Century Music*, Gollancz, 1967.
11. Arnold, Matthew. *The Study of Poetry* in *Selected Poetry and Prose*, Dent, 1993.
12. Yeats, W.B. 'Ideas of Good and Evil' in *Essays and Introductions*, Macmillan, 1980.
13. Yeats, W.B. 'A General Introduction for My Work' in *Essays and Introductions*.
14. Yeats, W.B. *Collected Poems*, Macmillan, 1965.
15. Yeats, W.B. *A Vision*, Collier Books, New York, 1978.

16. Melchiori, Georgio. *The Whole Mystery of Art; Pattern into Poetry in the Work of W.B. Yeats*, Routledge and Kegan Paul, 1960.
17. Le Corbusier. *The City of Tomorrow*, John Rodker Ltd, 1929.
18. Berger, John. *The Success and Failure of Picasso*, Penguin Books, 1965.
19. Dector, Jacqueline. *Nicholas Roerich: The Life and Art of a Russian Master*, Thames and Hudson, 1989.
20. Sansom, William. *Proust and his World*, Thames and Hudson, 1973.
21. Bloom, Harold. *The Western Canon*, Macmillan, 1995.
22. Maurois, Andre. *A la recherche de Marcel Proust*, Paris, 1949.
23. Sass, Louis. *Madness and Modernism*, Basic Books, 1995.
24. Nietzche, Friedrich. *Ecce Homo* (1908), various translations.
25. Read, Herbert. 'The Limits of Permissiveness', reprinted in *The Black Rainbow: A Symposium of essays on the state of contemporary culture*, ed. Peter Abbs, Heinmann, 1974.
26. Lebrecht, Norman. *When the Music Stops*, Simon and Schuster, 1996.

## CHAPTER 6

1. Amongst those who have contributed towards an understanding of the new paradigm I include: Gregory Bateson, Morris Berman, Wendell Berry, David Bohm, Fritjof Capra, Mircea Eliade, Erich Fromm, Edward Goldsmith, Willis Harman, Ivan Illich, Leopold Kohr, James Lovelock, Lewis Mumford, Arne Naess, Seyyed Hossein Nasr, Theodore Roszak, Rupert Sheldrake, E.F. Schumacher, Henryk Skolimowski and Brian Swimme.
2. It is important to understand that the Artists I have chosen to write about are not the only one I might have considered. I might for example have discussed Paul Klee, Marc Chagall, Henri Matisse, Frans Widerberg, Alan Davie, Ken Kiff, David Jones, Max Beckmann and Emil Nolde's late water-colours, instead of Bonnard, Cecil Collins and Andrej Jackowski; or the poetry of Rainer Maria Rilke, Kathleen Raine, George Mackay Brown and Edwin Muir instead of Thomas Blackburn, Peter Redgrove and Wendell Berry.
3. Corbusier, Le. *Towards a New Architecture*, Architectural Press, 1965.
4. Critchlow, Keith. 'The Golden Proportion', a conversation between Richard Temple & Keith Critchlow, *Parabola*, Vol. XVI, No 4, 1991.
5. Quintana, Francesco de Paula. *Les Formes Guerxes del Temple de la Sagrada Familia*, La Ciutat i la Casa, no 6, Barcelona, 1927.
6. Makovecz, Imre. 'What Do We Have To Take Notice Of?' in *Catalogue of Exhibition of the works of Imre Makovecz*, University of Toronto, 1991.
7. Makovecz, Imre. Nigel Hoffman's Interview with Imre Makovecz in *Transforming Art*, No 5, Sydney, 1991.
8. Makovecz, Imre & Ossko, Judit. *Interview.* See 6 above.
9. Papanek, Victor. Introduction to *In Search of Natural Architecture* by David Pearson, Gaia Books, 1994.
10. Fathy, Hassan. untraceable.
11. Glancy, Jonathan. *The New Spirit of Modernism*, The Independent, Dec. 1995.
12. Fathy, Hassan. untraceable.
13. Richards, J.M. *Hassan Fathy*, A Minar Book, Architectural Press, 1985.
14. Alberts, Ton. 'The Architecture of Harmony', interview in *Resurgence*, Issue 159, 1993.
15. ibid.
16. Critchlow, Keith & Allen, Jon. *The Whole Question of Health*, Prince of Wales Institute of Architecture, 1994.
17. Burckhardt, Titus. *Sacred Art East and West*, Perennial Books, 1967.
18. Critchlow, Keith. *Unpublished paper*, 1994.
19. Critchlow, Keith & Temple, Richard. See 4 above.
20. Video, *The Miracle of Puttaparthi*, Cosmic Boomerang, 1994.

21. Steiner, George. *Real Presences*, Faber and Faber, 1989.
22. Quoted in Tucker, Michael. *Dreaming with Open Eyes*, Aquarian Harper, 1992.
23. Tarkovsky, Andrei. *Sculpting in Time; Reflections on Cinema*, Bodley Head, 1986.
24. Turovskaya, Maya. *Tarkovsky Cinema as Poetry*, Faber and Faber, 1989.
25. Tarkovsky, Andrei. *Andrei Rublev* (screenplay), Faber and Faber, 1991.
26. ibid.
27. ibid.
28. See 23 above.
29. See 23 above.
30. Bergman, Ingmar. *Introduction: The Seventh Seal (screenplay)*, Faber, 1993.
31. ibid.
32. Bjorkman, Stig. *Bergman on Bergman*, Secker and Warburg, 1973.
33. See 30 above.
34. ibid.
35. Berry, Thomas. *A Dream of the Earth*, Sierra Club Books, 1988.
36. Krishnamurti. *Letters to Schools*, Gollancz.
37. Leopard, Aldo. *A Sand County Almanac*, Oxford University Press, 1953.
38. Breton, Andre. untraceable.
39. Coult, Tony & Kershaw, Baz. *The Welfare State Handbook*, Methuen, 1990.
40. Fox, John. *A Plea for Poetry,* Arts Council of Great Britain (National Arts and Media Strategy Unit), 1991.
41. Fox, John. 'Taking Theatre to the People' in *Resurgence*, No 159, 1993.
42. Halprin, Anna. 'Circle the Earth: A Philosophy' (1986) in *Moving Towards Dance: Five Decades of Transformational Dance* Wesleyan University Press, 1995.
43. Halprin, Anna. 'Circle the Earth: A World Peace Dance' in *The Power of Place & Human Environments* by James A. Swan, Gateway Books, 1993.
44. Mellers, Wilfrid. 'Mysticism and Theology' in *The Messiaen Companion,* ed. Hill, Peter. Faber and Faber, 1995.
45. Whitmont, Edward C. *Return of the Goddess*, Routledge and Kegan Paul, 1983.
46. Other twentieth century composers who have written sacred music include: Anton von Webern, Gyorgy Ligeti, Krzysztof Penderecki, George Crumb, Alfred Schnittke, Edison Denisov, Sofia Gubaidulina, Giya Kancheli, Karlheinz Stockhausen and Alan Hovhannes.
47. Moody, John. 'Commentary on John Tavener's Music' in *Ikons: Meditations in Words and Music* by John Tavener and Mother Thelka, Fount, 1994.
48. Tavener, John & Kimberley, Nick. *The Tavener's Tale*, BBC Music Magazine, 1995.
49. Winnicott, D.W. *Playing and Reality*, Routledge, 1991.
50. Mellers, Wilfrid. *Twilight of the Gods: The Beatles in Retrospect*, Faber, 1973.
51. Hooker, Jeremy. *John Cowper Powys and David Jones: A Comparative Study*, Enitharmon Press, 1979.
52. Powys, J.C. *Wolf Solent*, Penguin Books.
53. Powys, J.C. *Autobiography*, John Lane, The Bodley Head, 1934.
54. Marr, David. *Patrick White: A Life*, Jonathan Cape, 1991.
55. Márquez, Gabriel García. *The Autumn of the Patriarch*, Penguin Books.
56. Márquez, Gabriel García. *Love in a Time of Cholera*, Penguin Books.
57. Whitmont, Edward. See 45 above.
58. Collins, Cecil. 'The Vision of the Fool' in *The Vision of the Fool and other Writings* ed. Brian Keeble, Golgonooza Press, 1994.
59. Tarnas, Richard. *The Passion of the Western Mind*, Ballantine Books, 1993.
60. Hodgson, Howard. *With Love*, Independent Magazine, June 1994.
61. Collins, Cecil. 'To the Gates of the Sun', interview with John Lane, *Resurgence*, Issue 122, May-June 1987.
62. See 58 above.
63. Craighead, Meinrad. *The Mothers' Songs*, Paulist Press, 1986.
64. ibid.
65. Sorokin, Pitirim. *The Crisis of Our Age*, One World, Oxford, 1992.

66. Picasso, Pablo. *Picasso Says...*, ed. Helene Parmelin, London, 1969.
67. Moore, Henry. *Henry Moore on Sculpture*, ed. Philip James, Macdonald, 1966.
68. Redgrove Peter. *The Apple Broadcast and other new poems*, Routledge and Kegan Paul, 1981.
69. Blackburn, Thomas. *Post Mortem*, Rondo Publications, 1977.
70. Lindop, Gravel. *The Keystone Splintering*, Temenos No 10, 1989.
71. Blackburn, Thomas, *The Adjacent Kingdom: Collected Last Poems*, Peter Owen, 1988.
72. Gifford, Terry. *Green Voices: Understanding Contemporary Nature Poetry*, Manchester University Press, 1995
73. Berry, Wendell. 'The Specialization of Poetry' in *Standing by Words* by Wendell Berry, North Point Press, San Francisco, 1983.
74. Heaney, Seamus. 'Joy or Night: Last things in the Poetry of W.B. Yeats and Philip Larkin' in *The Redress of Poetry*, Faber and Faber, 1995.
75. Berry, Wendell. *The Gift of Good Land*, North Point Press, 1981.
76. Berry, Wendell. 'Woods' in *Collected Poems 1957-1982*, North Point Press, 1985.
77. Berry, Wendell. *Standing by Words*, North Point Press, 1983.
78. Berry, Wendell. 'The Peace of Wild Things' in *Collected Poems*. See 76 above.
79. Turnbull, Colin. *The Forest People*, Pimlico, 1993.
80. Tobias, Michael. *A Vision of Nature: Traces of the Original World*, Kent State University Press, 1995.
81. Noguchi, Isamu. *Noguchi on Brancusi*, Craft Horizons, August 1976.
82. Gimbutas, Marija. *The Goddesses and Gods of Old Europe: Myths and Cult Images*, Thames and Hudson, 1982.
83. Zarnescu, Constantin. *Aforismele si textele lui Brancusi*, Craiova, 1980.
84. Eliade, Mircea. 'The Sacred and the Modern Artist' in *Criterion*, Divinity School, University of Chicago, 1965.
85. Spear, Anthea T. *Brancusi's Birds*, New York University Press, 1969.
86. Jianou, Ionel. *Brancusi*, New York, 1963.
87. Zarnescu, Constantin. See reference 83 above.
88. Geist, Sidney. *Constantin Brancusi: A Study of the Sculpture*, Studio Vista, 1968.
89. Moore, Henry. *The Listener*, Vol. XXV, No 641, 1941.
90. Moore, Henry. *The Listener*, 5 June, 1935.
91. Moore, Henry. *Architectural Association Journal*, Vol. LXV. No 519, May 1930.
92. Moore, Henry. Letter in the archives of the Dartington Hall Trust.
93. Noguchi, Isamu. *A Sculptor's World*, Thames and Hudson, 1967.
94. Noguchi, Isamu. *Towards a Reintegration of the Arts*, College Art Journal, Autumn 1949.
95. Randall-Page, Peter. untraceable.
96. Goldsworthy, Andy. *Andy Goldsworthy*, Viking, 1990.
97. Brook, Peter. *The Empty Space*, Penguin, 1990.
98. Williams, David. *Peter Brook and the Mahabharata: Critical Perspectives*, Routledge, 1991.
99. Brook, Peter. untraceable.
100. Berman, Morris. See Chapter 4, note 2.

## CHAPTER 7

1.   Stephens, James. Introduction to *Collected Poems*, Macmillan, 1926.
2.   Sorokin, Pitirim. See Chapter 6, Note 65.
3.   Webster, Richard. *Why Freud was Wrong: Sin, Science and Psychoanalysis*, HarperCollins, 1995.
4.   Krishnamurti. *Letters to the Schools*, Gollancz
5.   Woodman, Marion. 'A Conversation with Marion Woodman' in *Conscious Feminity*, Inner City Books, Toronto, 1993.
6.   Russell, Bertrand. untraceable.
7.   Thoreau, Henry. *Walden*, Penguin Books, 1981.

8.  Rikyu, Sen (Soshitsu Sen XV). *Tea Life, Tea Mind*, Weatherhill, New York, 1985.
9.  Herbert, George. 'The Elixir' in *A Choice of George Herbert's Verse*, selected by R.S. Thomas, Faber and Faber, 1988.
10. Gablik, Suzi. *Conversations before the End of Time*, Thames and Hudson, 1995.
11. Yanagi, Soetsu. *The Unknown Craftsman: A Japanese Insight into Beauty*, Kodansha International Ltd, 1973.
12. Alexander, Christopher. *A Timeless Way of Building*, OUP, 1979.
13. Maybury-Lewis, David. *Millennium Tribal Wisdom in the Modern World*, Viking, 1992.
14. Fromm, Erich. *The Sane Society*, Routledge and Kegan Paul, 1971.
15. Moat, John. *General Report on North Devon's Christmas Festival*, private publication, December 1995.
16. Fox, John. 'Commissions and Audience', an interview published in *Engineers of the Imagination*, Methuen, 1990.
17. Spretnak, Charlene. *States of Grace: The Recovery of Meaning in the Postmodern Age*, Harper San Francisco 1991.
18. Research Surveys of Great Britain Ltd. *Report on a Survey on Arts and Cultural Activities in Great Britain*, Arts Council of Great Britain, 1991.
19. Steiner, George. *Real Presences*, Faber and Faber, 1989.
20. Cheval, Ferdinand. In *Keeping a Rendezvous*, John Berger, Granta Books, 1992.
21. Coomaraswamy, Ananda. *Christian and Oriental Philosophy of Art*, Dover, 1957.
22. Berdyaev, Nicholas. untraceable.
23. Tippett, Michael. 'Poets in a Barren Age' in *Moving into Aquarius*, Paladin, 1974.
24. Collins, Cecil. 'The Artist in Society' in *The Vision of the Fool and other writings*, edited by Brian Keeble, Golgonooza Press, 1994.
25. Górecki, Henryk. *Miserere*, Chicago Symphony Chorus, conducted by John Nelson, Elektra Nonsuch 755-79348-2.
26. Frost, Robert. 'Two Tramps in Mud Time *or*, A Full-Time Interest' in his *Selected Poems*, Penguin Books, 1955.
27. Sturt, George. *The Wheelwrights Shop*, Cambridge University Press, 1963.
28. Bateson, Gregory. 'The Roots of the Ecological Crisis' in *Steps to an Ecology of Mind*, Paladin, 1978.

## CHAPTER 8

1.  Brueghel, Peter. *The Fall of Icarus* is in the Musées Royaux des Beaux-Arts de Belgique, Brussels.
2.  I am indebted to Anthony Stevens for his interpretation of this painting in *Private Myths: Dreams and Dreaming*, Hamish Hamilton, 1995.
3.  Munch, Edvard. See *Munch: His Life and Work* by Reinhold Heller, John Murray, 1984.
4.  Beckett, Samuel. *Waiting for Godot*, Faber and Faber, 1965.
5.  Leris, Michel. *Francis Bacon*, Phaidon.
6.  Sylvester, David. *Interviews with Frances Bacon*, Thames and Hudson, 1975.
7.  Collins, Judy. Introduction to Catalogue *Winifred Nicholson*, Tate Gallery, 1987.
8.  Winifred, Nicholson. *Unknown Colour Paintings, Letters, Writings by Winifred Nicholson*, Faber and Faber, 1987.
9.  See 6 above.
10. Collins, Cecil. 'Art and Modern Man' in *The Vision of the Fool and other Writings*, Golgonooza Press, 1994.

## FURTHER READING

Alexander, Christopher. *A Pattern Language*, Oxford University Press, New York, 1977.
Anderson, William. *Cecil Collins: The Quest for the Great Happiness*, Barrie and Jenkins, 1988.
Anderson, William. *The Face of Glory*, Bloomsbury, 1996.
Beardsley, John. *Earthworks and Beyond: Contemporary Art in the Landscape*, Abbeville

Publishers, New York, 1984.
Berry, Wendell. *The Unsettling of America*, Sierra Club Books, 1978.
   *The Gift of Good Land*, North Point Press, 1981.
   *Standing by Words*, North Point Press, 1983.
   *Home Economics*, North Point Press, 1987.
   *Standing on Earth: Selected Essays*, Golgonooza Press, 1991.
Bloom, William. *Sacred Times: A New Approach to Festivals*, Findhorn Press, 1990.
Blunt, Anthony. *Artistic Theory in Italy 1450-1600*, Oxford University Press, 1940.
Bly, Robert (ed.). *News of the Universe: Poems of Twofold Consciousness*, Sierra Club, 1980.
Brook, Peter. *The Shifting Point: Forty Years of Theatrical Exploration*, Methuen, 1988.
Campbell, Joseph. *The Masks of God: Primitive Mythology*, Penguin Books, 1976.
   *The Masks of God: Oriental Mythology*, Penguin Books, 1976.
   *The Masks of God: Occidental Mythology*, Penguin Books, 1976.
   *The Masks of God: Creative Mythology*, Penguin Books, 1976.
Capra, Fritjof. *The Turning Point*, Wildwood House, 1975.
Cashford, Jules and Anne Baring. *The Myth of the Goddess: The Evolution of an Image*,
   Penguin Books, 1991.
Clarke, Robin & Hindley, Geoffrey, *The Challenge of the Primitives*, Jonathan Cape, 1975.
Coomaraswamy, Ananda. *The Transformation of Nature in Art*, Dover, 1956.
   *The Bugbear of Literacy*, Perennial Books, 1979.
   *Christian & Oriental Philosophy of Art*, Dover Publications, 1956.
   *The Dance of Shiva*, Dover, 1985.
   *What is Civilisation and other essays*, Golgonooza Press, 1989.
Day, Christopher. *Building with Heart*, Green Books, 1988.
Eco, Umberto. *Art and Beauty in the Middle Ages*, Yale University Press, 1986.
Eliade, Mircea. *Myths, Dreams and Mysteries*, Harper Torchbooks, 1960.
   *The Myth of the Eternal Return, or, Cosmos and History*, Princeton Univ. Press, 1974.
Fathy, Hassan. *Architecture for the Poor*, University of Chicago Press, 1973.
   *Natural Energy and Vernacular Architecture*, University of Chicago Press, 1986.
Fox, Matthew. *The Re-invention of Work: A New Vision for Livelihood in Our Time*, Harper,
   San Francisco, 1994.
Fuller, Peter. *Beyond the Crisis in Art*, Writers and Readers, 1980.
   *The Australian Scapegoat*, University of Western Australian Press, 1986.
   *Theoria: Art and the Absence of Grace*, Chatto and Windus, 1988.
Gablik, Suzi. *Has Modernism Failed?*, Thames and Hudson, 1984.
   *The Reenchantment of the Arts*, Thames and Hudson, 1988.
Gadon, Elinor. *The Once and Future Goddess*, The Aquarian Press, 1990.
Gimpel, Jean. *Against Art and Artists*, Polygon, 1991.
Guenon, René. *The Reign of Quantity*, Penguin Books, 1972.
   *Crisis of the Modern World*, Luzac, 1975.
Handy, Charles. *The Future of Work: A Guide to a Changing Society*, Blackwell, 1984.
Harpur, Patrick. *Daimonic Reality: A field guide to the Otherworld*, Viking Arkana,
   1994.
Hillman, James. *Inter Views: Conversations with Laura Pozzo*, Harper and Row, 1983.
   *A Blue Fire: The Essential James Hillman*, Routledge, 1989.
Hoover, Thomas. *Zen Culture*, Routledge, 1988.
Hughes, Ted. *Shakespeare and the Goddess of Complete Being*, Faber and Faber, 1992.
Hutchinson, Robert & Feist, Andrew. *Amateur Arts in the UK*, Policy Studies Institute, 1991.
Jones, David. *Epoch and Artist*, Faber and Faber, 1959.
Jennings, Humphrey. *Pandaemonium: The Coming of the Machine as seen by
   Contemporary Observers*, Andre Deutsch, 1985.
Jung, C.G. *Man and his Symbols*, Aldus Books/Jupiter Books, 1974.
Kandinsky, Wassily. *Concerning the Spiritual in Art*, Dover, 1977.
Lane, John. *The Living Tree: Art and the Sacred*, Green Books, 1988.
Lipsey, Roger. *An Art of our Own*, Shambhala, 1988.

Male, Emile. *The Gothic Image: Religious Art in France of the Thirteenth Century*, Fontana, 1961.

Mander, Jerry. *In the Absence of the Sacred: the Failure of Technology and the Survival of the Indian Nations*, Sierra Club Books, 1992.

Merchant, Carolyn. *The Death of Nature*, Harper, 1990.

Moore, Thomas. *Care of the Soul: A Guide for Cultivating Depth and Sacredness in Everyday Life*, Harper Collins, 1992.

Morris, William. *Lectures and Essays*, various publishers.

Mumford, Lewis. *Interpretations and Forecasts 1922-1972*, Harcourt Brace, 1972.
*The Pentagon of Power*, Secker and Warburg, 1971.

Nasr, Seyyed Hossein. *Man and Nature; the Spiritual Crisis of Modern Man*, Unwin Paperback, 1976.
*Knowledge and the Sacred*, Edinburgh University Press, 1981.
*Islamic Art and Spirituality*, Golgonooza Press, 1986.

Pepperell, Robert. *The Post-Human Condition*, Intellect, Oxford, 1995.

Ortega Y Gasset, José. *The Revolt of the Masses*, University Nôtre Dame Press, 1985.

Papanek, Victor. *The Green Imperative: Ecology and Ethics in Design and Architecture*, Thames and Hudson, 1995.

Raine, Kathleen. *Blake and the New Age*, Allen and Unwin, 1982.
*The Inner Journey of the Poet*, Allen and Unwin, 1982.
*Defending Ancient Springs*, Golgonooza Press, 1985.
*Yeats the Initiate*, Dolmen Press, 1986.

Richards, Sam. *John Cage as...*, Amber Lane Press, 1996.

Richie, Donald. *The Films of Akira Kurosawa*, University of California Press, 1970.

Robertson, James. *Jobs, Self-employment and Leisure after the Industrial Age*, Gower/Maurice Temple Smith, 1985.

Romanyshyn, Robert D. *Technology as Symptom and Dream*, Routledge, 1989.

Rosenberg, John (ed.). *The Genius of John Ruskin; Selections from his Writings*, Routledge and Kegan Paul, 1979.

Roszak, Theodore. *Making of a Counter Culture*, Faber, 1970.
*Person/Planet: The Creative Disintegration of Industrial Society*, Gollancz, 1979.
*The Voice of the Earth : an Exploration of Ecopsychology*, Bantam Press, 1993.

Sale, Kirkpatrick. *Rebels Against the Future*. Quartet Books, 1996.

Schenk, H.G. *The Mind of the European Romantics: An Essay in Cultural History*, Oxford, 1978.

Schumacher, E.F. *Good Work*, Jonathan Cape, 1979.

Sherrard, Philip. *The Sacred in Life and Art*, Golgonooza Press, 1990.
*The Rape of Man and Nature*, Golgonooza Press, 1987.

Skolimowski, Henryk. *The Participatory Mind : A New Theory of Knowledge and of the Universe*, Penguin Books, 1994.

Snyder, Gary. *The Real Work: Interviews and Talks 1964-1979*, New Directions, 1993.

Temenos. *A Review Devoted to the Arts of the Imagination; Volumes I to 13* ed. Kathleen Raine, 1981-1992.

Tolstoy, Leo. *What is Art?* Oxford University Press.

Tucker, Michael. *Dreaming with Open Eyes: The Shamanic Spirit in Twentieth Century Art and Culture*, Aquarian/Harper San Francisco, 1992.

Vale, Brenda and Robert. *Green Architecture*, Thames and Hudson, 1991.

Van der Post, Laurens. *Jung and the Story of Our Time*, Hogarth Press, 1976.

Wheeler, Michael (ed.), *Ruskin and Environment: The Storm-Cloud of the Nineteenth Century*, Manchester University Press, 1995.

Whitmont, Edward. *The Symbolic Quest*, Princeton University Press, 1969.
*Return of the Goddess*, Routledge & Kegan Paul, 1983.

Williams, Raymond. *The Politics of Modernism; Against the New Conformists*, Verso, 1989.

Yeats, W.B. *Essays and Introductions*, Macmillan, 1980.

# INDEX

Numbers in **bold** refer to illustrations and follow on after textual references